17. March 2000

There are very few times in my life when I actually want to be on the other side of the camera, but today, as I walked through the trenches of the Indian Army ~~along~~ side of the LoC (Line of Control) between India + Pakistan, with a bullet-proof vest and helmet, I thought to myself that I ought to be able to rekindle the moment in years to come. I have finally embraced war photography. At a loss for how to fill the days in Delhi preceeding president Clinton's visit to India, my Editor John + I came up with the brilliant idea of my traveling to where Clinton recently claimed "The most dangerous place on earth." No, I didn't share this one with my mother.

So, I made all the arrangements through none other than ~~xxxxxxx~~ Brigadier Gulshan, and presto. here I am, riding in army jeeps from the main post to the frontier lines, escorted by ~~an~~ dark-faced, adorable soldiers in fatigues with big rifles and an immense fear of looking me in the eye. There is a continuous exchange of gunfire + shelling between the Pakistanis + Indians, and so, my access to the real dangerous posts is limited to basically where they eat + stand guard, but I have requested to spend the night actually with the soldiers so I can shoot some real photos of what their lives are like.

Arent you glad I left New York? I never thought
I'd be attracted to these kinds of pictures, Vin, but I
guess I am trying to capture their lives, the
tangible tension along the frontier, to put
some faces to all the quarrel + constant aggression
between the two countries that I read about every
day in the papers. Somehow, I always end up
seeing everything through this humanistic looking
glass, without ever perceiving my own danger.

Of Love
& War

*To all the brave and resilient women and
men who have shared their lives with me*

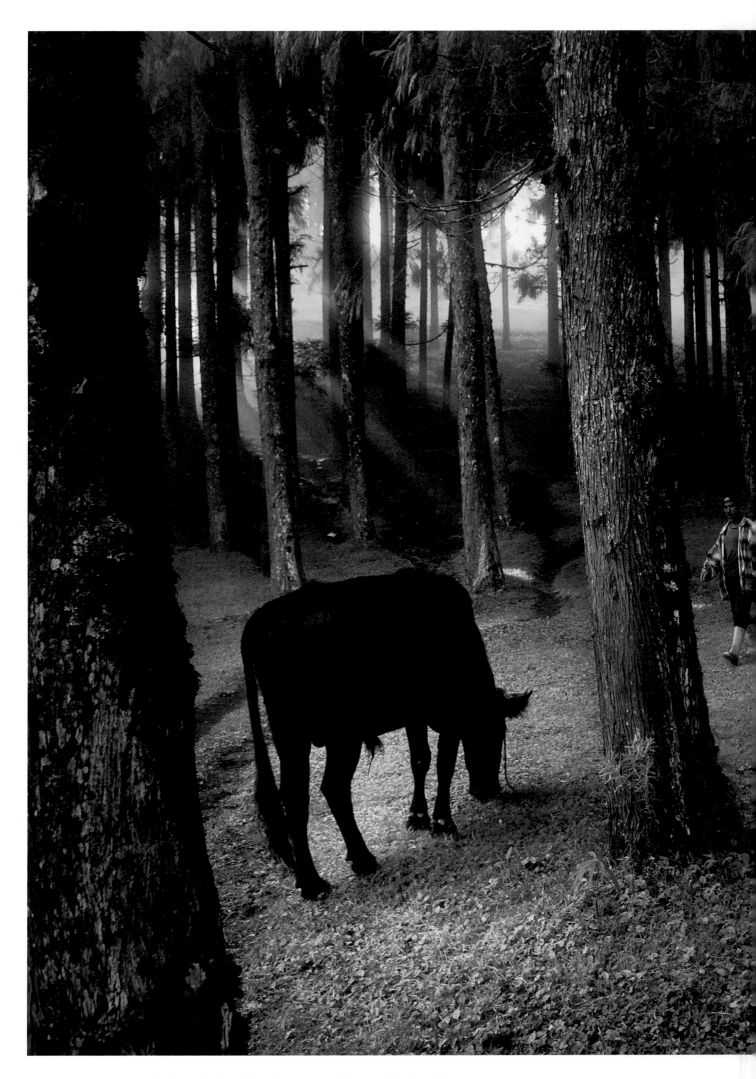

A man walks through a forest in Rethung Gonpa village outside of Trashigang,
in east Bhutan, August 2007.

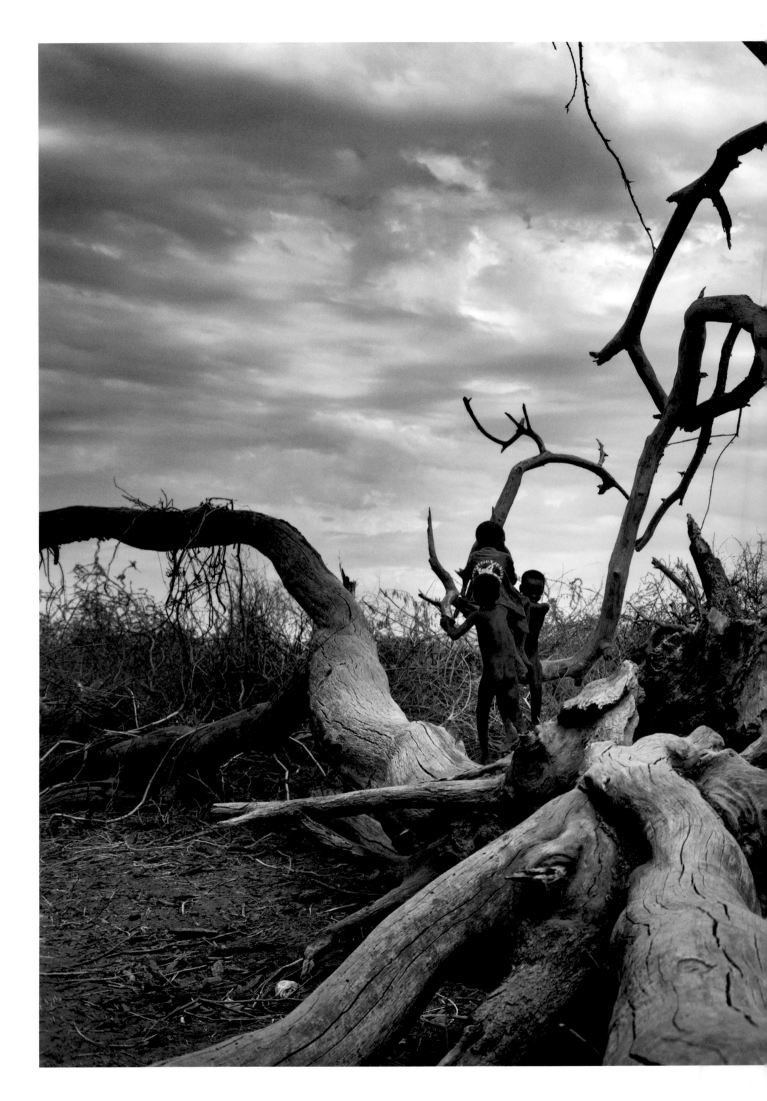

Children play on fallen trees during a drought in Turkana, Kenya, August 2011.

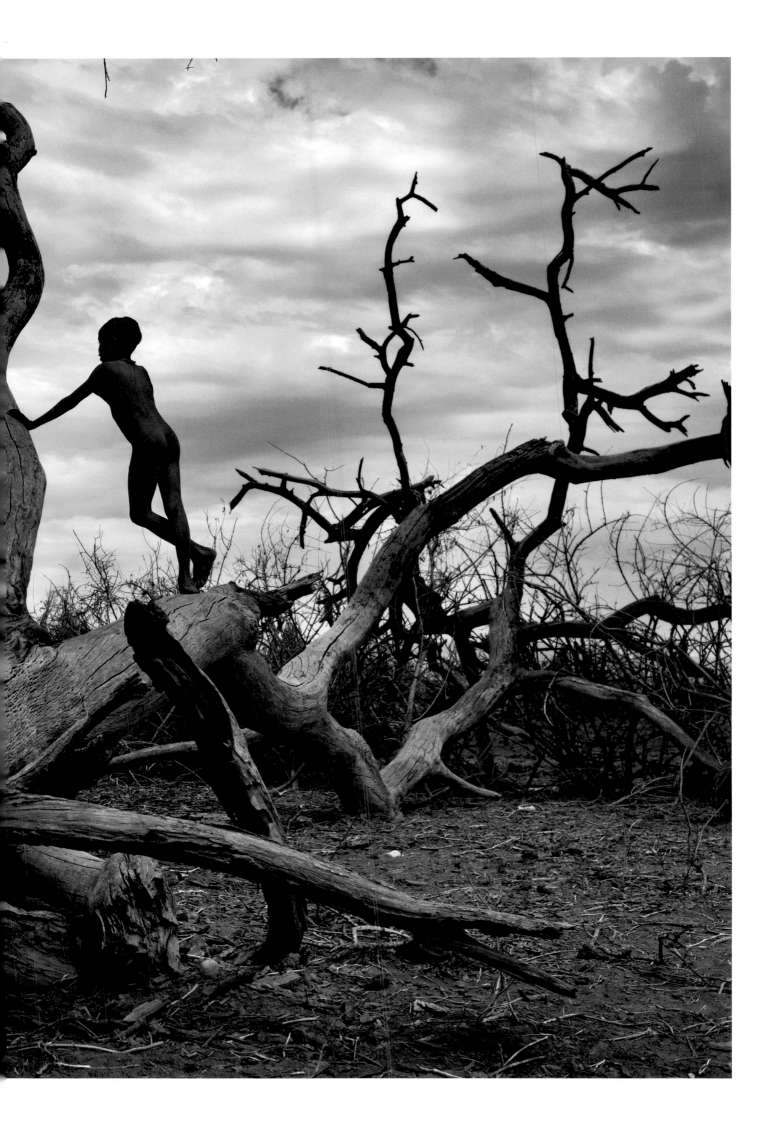

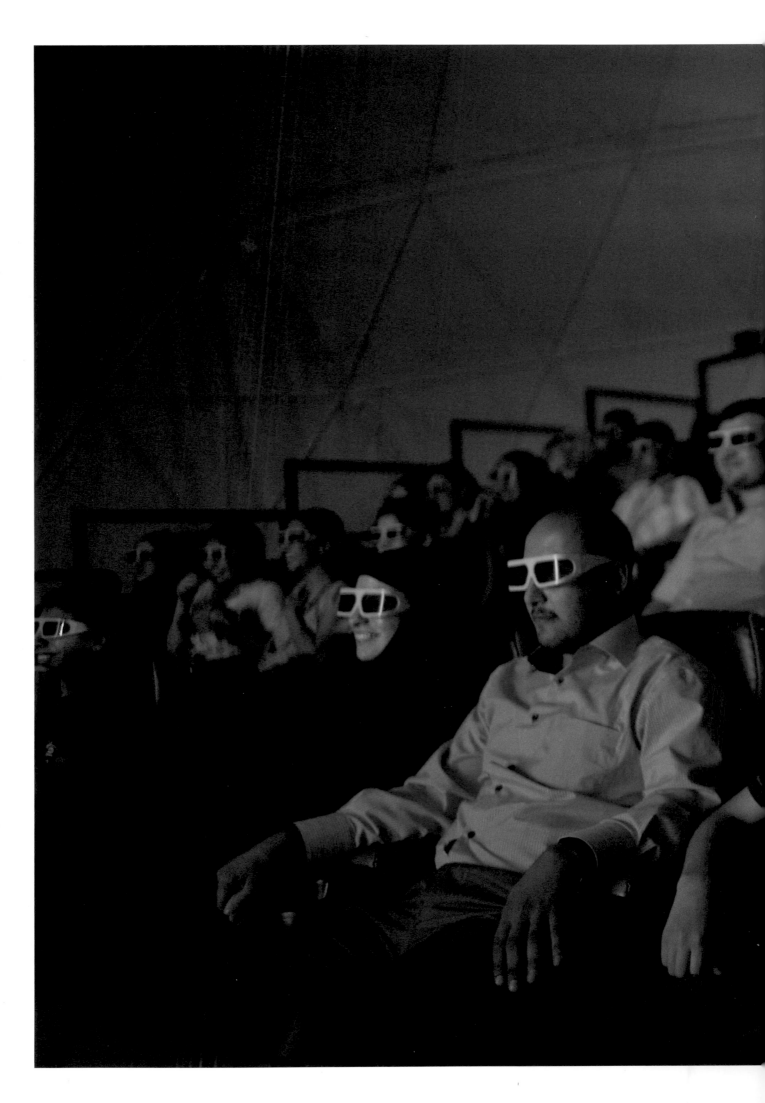

Iraqis watch a 3-D movie in Baghdad, February 2010.

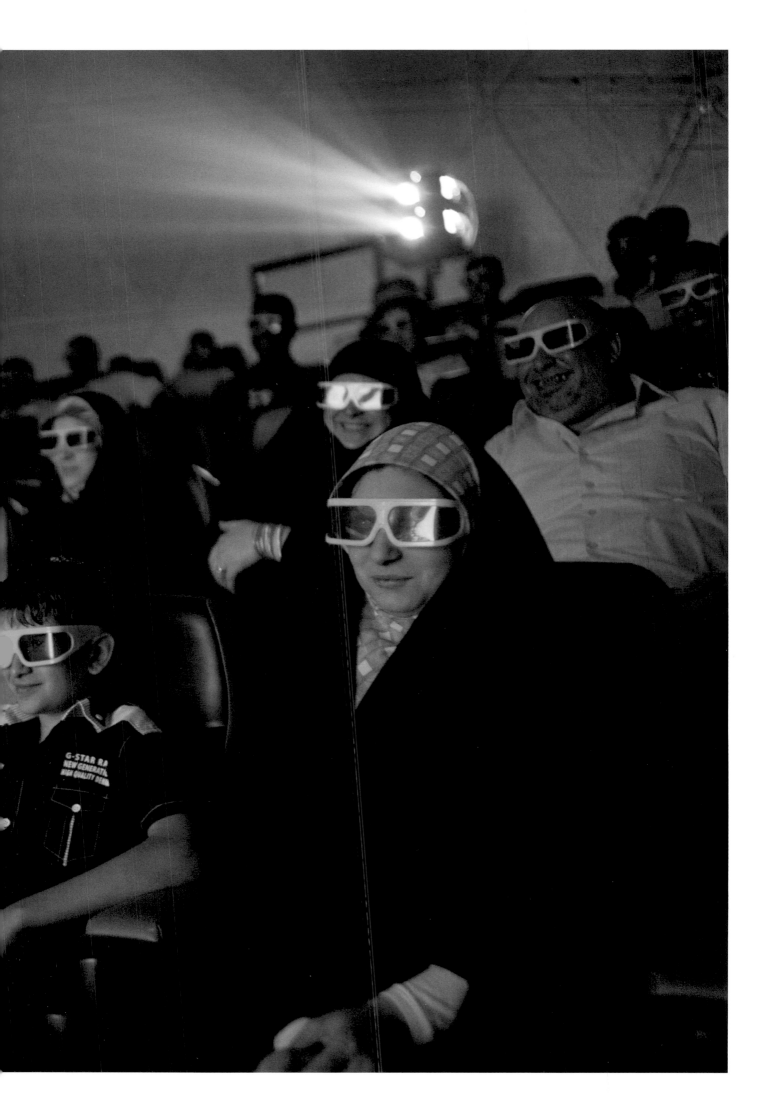

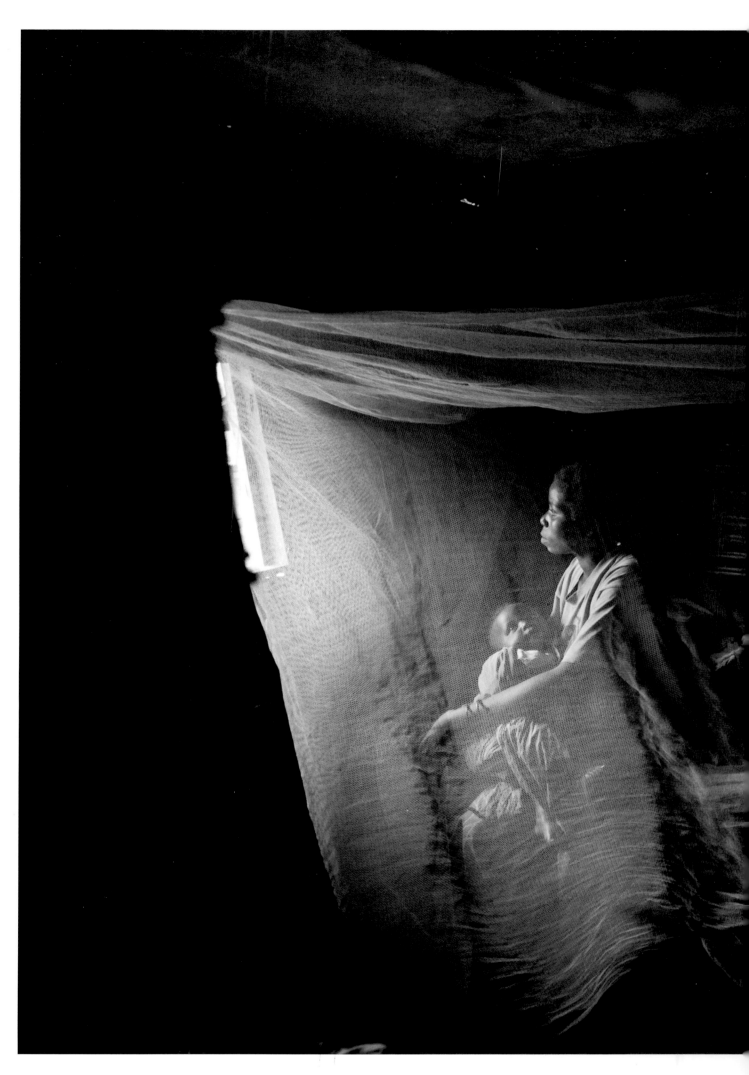

Kahindo, twenty, sits in her home with her two children born out of rape
in North Kivu Province, eastern Congo, April 2008.

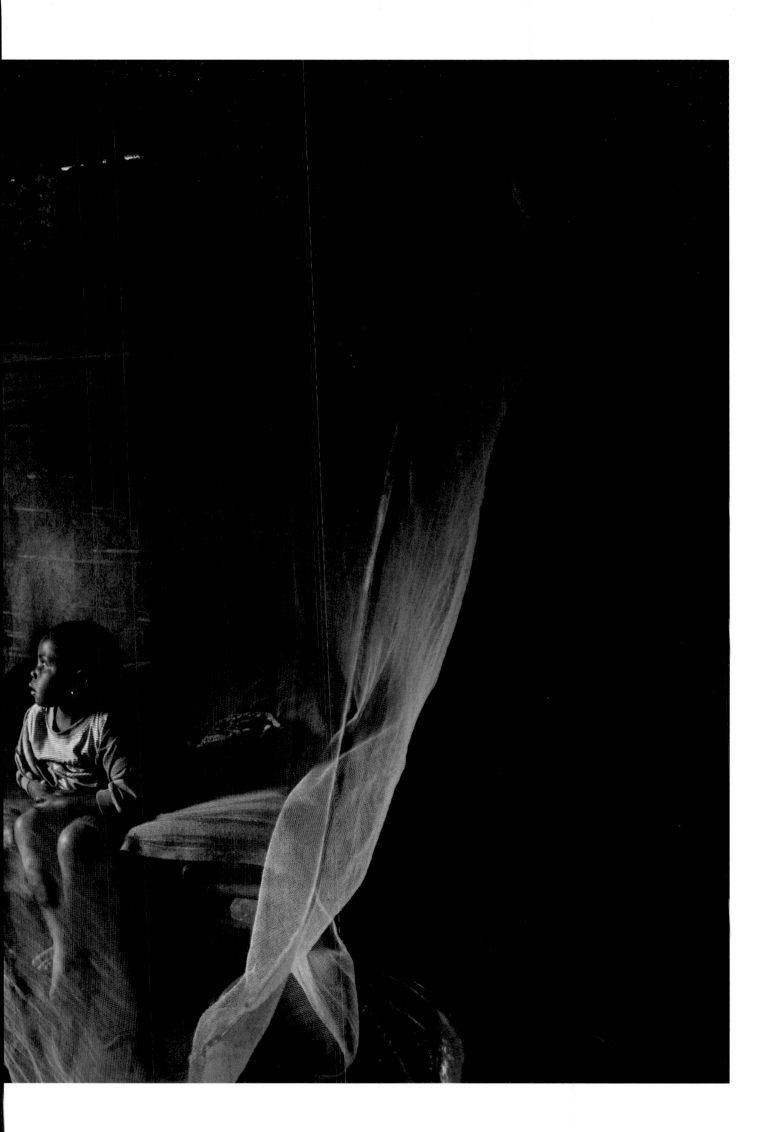

Prisoners wait in the remand section of the Pademba Road Prison in Freetown,
Sierra Leone, November 2006.

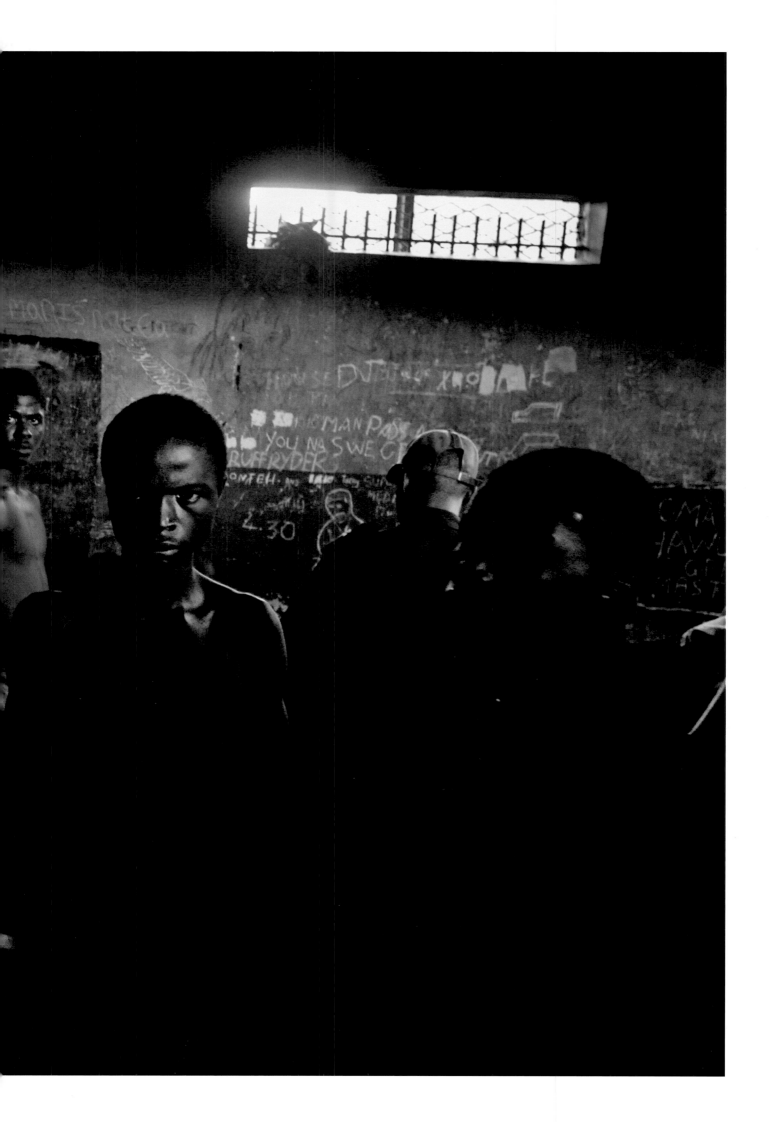

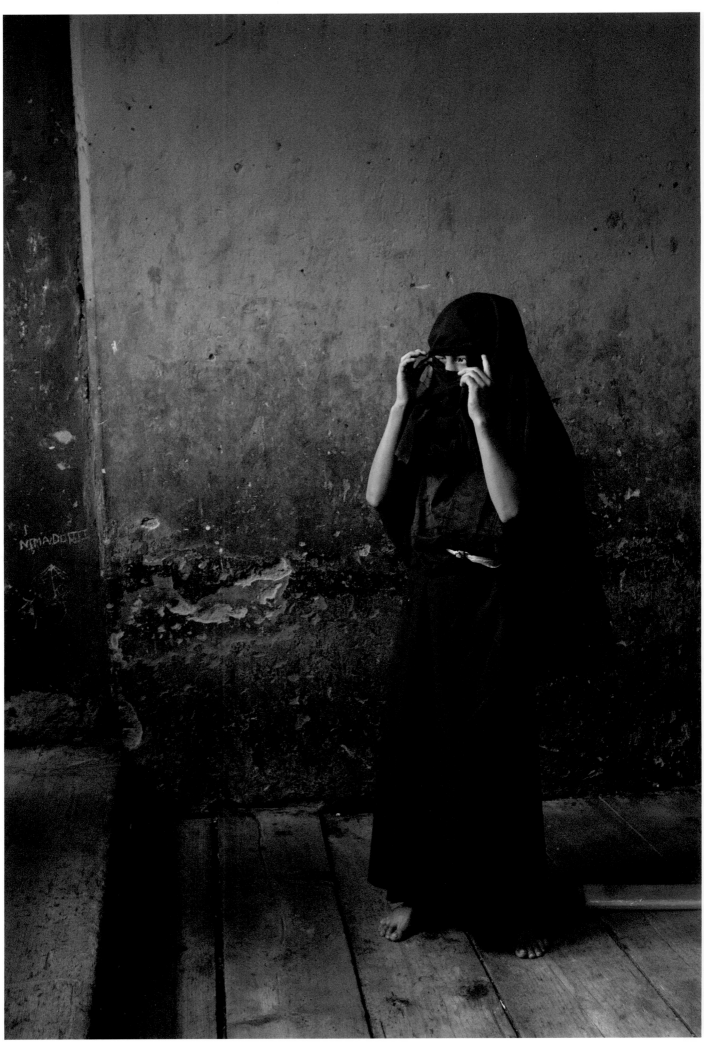

A monk lines up for a disciplinary session, in which older monks check younger monks'
robes for cleanliness, as part of training at the monastery at the Paro Dzong in Paro,
Bhutan, May 2007.

Of Love & War

Lynsey Addario

PENGUIN PRESS

New York

2018

At the time of this writing I am forty-four years old, and I have been a photographer for twenty-three years. I have likely taken—if one eight-week assignment can equal as many as fifty thousand photos, and if I worked some nine months out of the year—millions of photos in my lifetime. I have photographed in more than seventy countries; covered wars in Afghanistan, Iraq, Darfur, South Sudan, the Democratic Republic of the Congo, Lebanon, Libya, and Somalia; documented the lives of thousands of men, women, and children; and witnessed countless moments of tragedy, joy, despair, and humor. I was published in the *New York Times* and *National Geographic*, won awards, wrote a memoir, even found financial stability. But I never produced a book of photography. I hadn't believed my photos were good enough.

Contributing to this belief was simply my personality; I always wanted to do better, and I always wanted to do more. In this book, I have decided to include, from my early years, several emails and handwritten letters to my mother and a dear friend, Vineta, which I wrote faithfully from my first postings in Argentina in 1996, and then from India and Afghanistan in 2000 and 2001. Over time, writing letters, and then emails, and eventually journals, would be the way I processed the terrible things I'd witness in places like Iraq and Darfur. I include the earliest letter because I wanted to convey, and in some ways understand myself, the youthful ambition that propelled me into this exhilarating and often difficult life. The writings record what it's like to experience something for the first time—the first time I walked in a trench; the first time I heard a bullet; the first time I saw a government fall; what it was like to be poor and struggling; what it was like to be lonely; the thrill of getting that first big assignment; the day I chose my career over romance; the day I gave myself permission to be selfish: *I don't think I can come home, I think I am in the middle of something good here.* The moment I realized what was important to me in photojournalism: documenting injustice.

I also bristled against the idea of a photo book because books somehow seemed like an ending. Yet my stories about people and places never end. I am always finding new stories and revisiting the ones I have done in the past, always wanting to tell the entire narrative behind the images, to follow them on their natural course. So many stories of the twenty-first century spawn new stories. It has been a century of never-ending wars, never-ending side effects, never-

ending tragedy—and never-ending resilience. From these turbulent decades, I wasn't sure what images to choose. It seemed logical to do a book about the wars in Iraq and Afghanistan, but what about women's issues and civilian casualties and military deaths and refugee crises? Perhaps there was a book about Darfur or about the drought in the Horn of Africa, but what about the stories specific to women in all of those places, stories that could populate entire books of their own? What about breast cancer in Uganda or maternal mortality in Sierra Leone? I couldn't choose just one or leave any of them out, because they were all special to me. I almost never covered a place only once. I always went back and planned to go back again.

The beautiful thing about photography, though, is that you can sit with images over time and discover which ones are lasting, which ones resonate with you, and which ones suddenly capture your attention in new ways. I realize now that I hadn't felt ready to publish a photo book because I hadn't sat with my photos long enough. Some photos I believed to be special at the time have since faded, and others that didn't make a big impression on me or on the public have risen in my estimation over time. Many places that were where I came of age have stayed with me to this day, too. For this book, I asked friends, colleagues, and subjects I have worked with over the years—Dexter Filkins in Iraq; Lydia Polgreen in Sudan; army veteran John Clinard in Afghanistan; Aryn Baker, with whom I covered the Syrian refugee crisis; and Christy Turlington Burns, with whom I have collaborated on maternal mortality—to reflect on what it took for all of us to produce the stories we did.

During the past two decades, I have also changed both as a photographer and as a person—I was kidnapped twice, I married and had a son, and I have branched out into writing and speaking and advocacy for issues that are close to my heart. But in many ways I am still the same young photographer I was when I wrote those letters home—wide-eyed and curious, full of energy and wonder. I hope that what I have chosen for this book conveys those things that, for all those years, remained consistent in my work and in my life: love, passion, a sensitivity to injustice, a desire to provide evidence, a will to inform policy makers, and a commitment to doing justice to the stories of people who—for reasons I sometimes cannot fathom— opened their doors and hearts to me. It is for them that I returned and will return again.

3

So, I have spent the month of January figuring out what my plan will be, and what the hell I'm doing here. It became clearer only after my most recent shooting trip to a "Holy City" called Varanasi, where I spent 6 glorious days (with the exception of the 1½ where I was throwing up) shooting a series on Hindu ~~other~~ religious rituals in the Gangas river. I got back 80 rolls of film yesterday, and answered the question of "why" that has been hanging over my head since I left New York. The pictures are gorgeous. I guess it's worth the sacrifices to me -- to answer my own retorical questions -- to come back with no more savings and a series of beautiful pictures. Its inspiring to be out of New York for a while -- a change of scenery, and the answer to ~~the fucking~~ what lies over here.

The religious festival of Kumbh Mela, Allahabad, India, February 2001. 19

Life Under
the Taliban

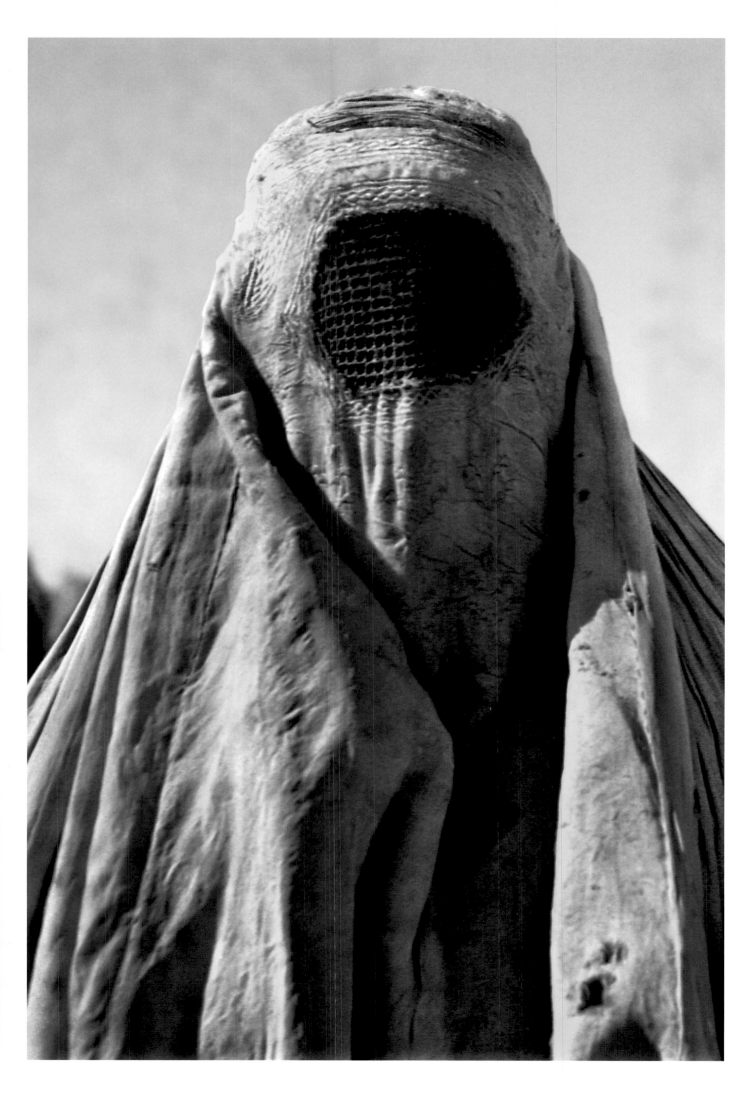

An Afghan woman living in a refugee camp near Peshawar, Pakistan, May 2000.

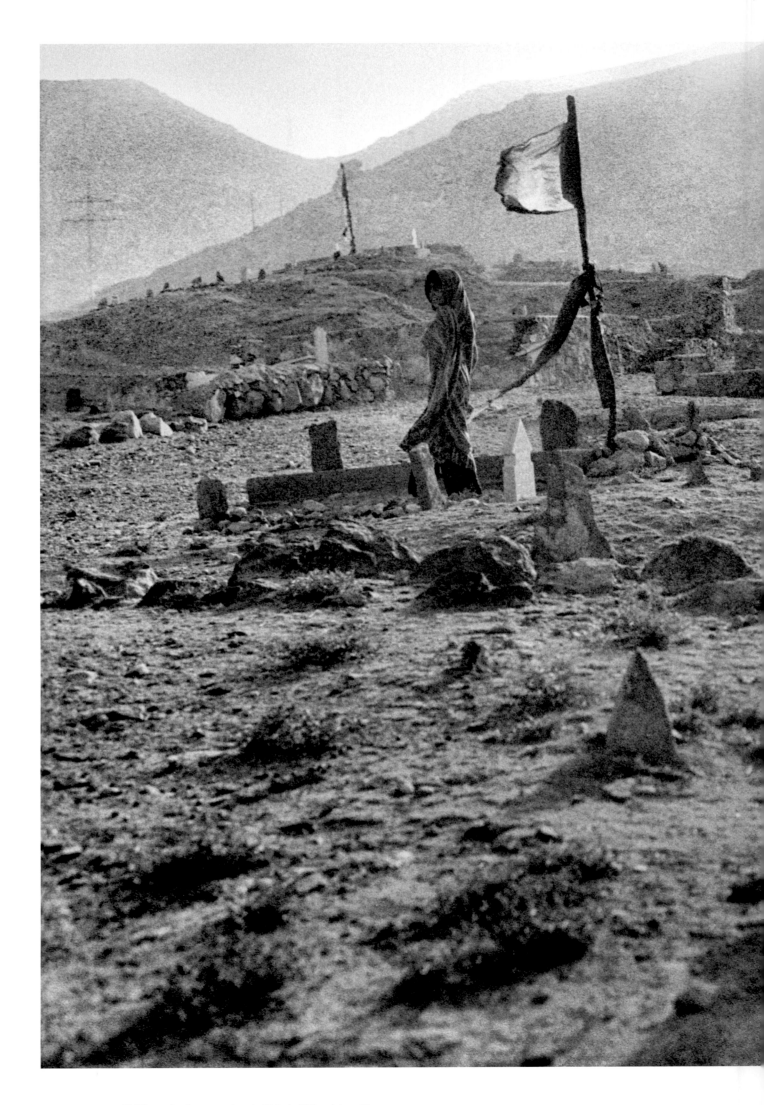

Children play in a cemetery in Kabul, Afghanistan, May 2000.

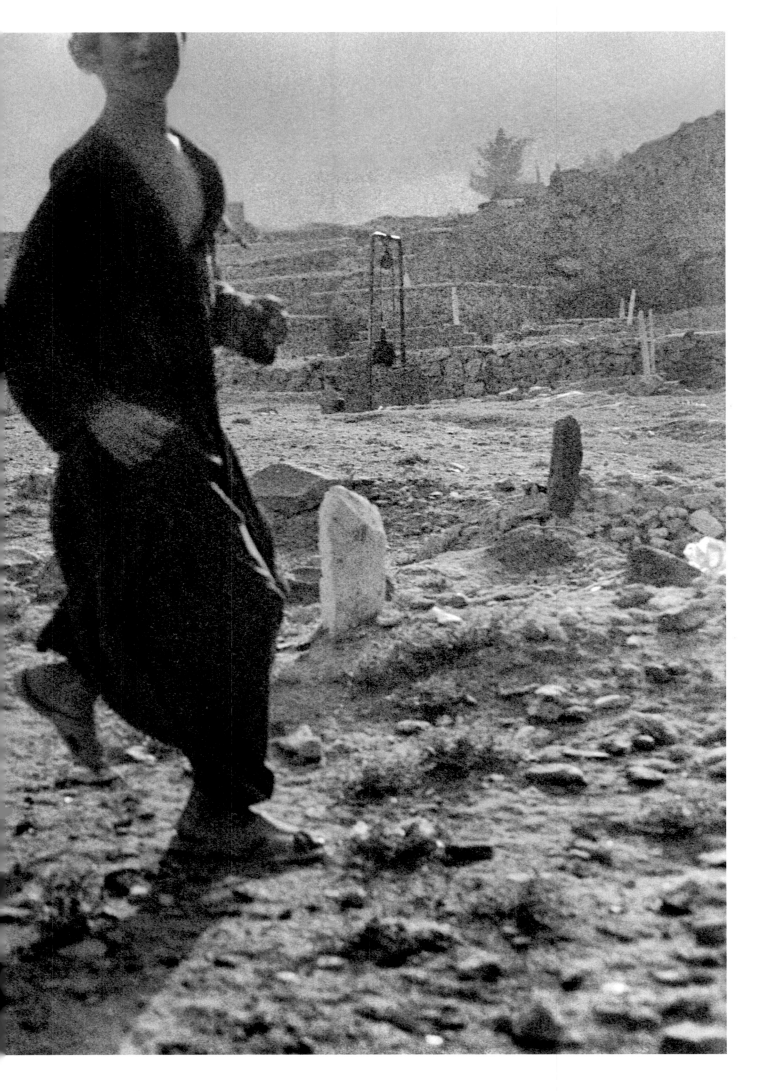

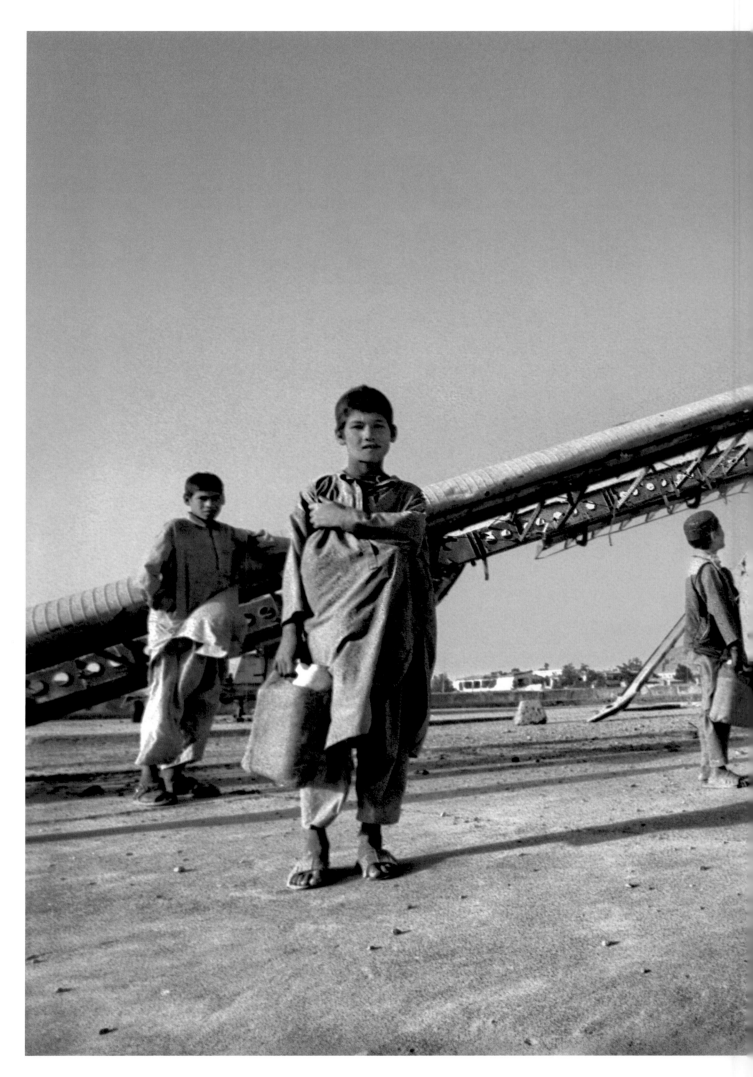

Boys play around a destroyed plane left over from the Soviet-Afghan War
in Kabul, Afghanistan, May 2000.

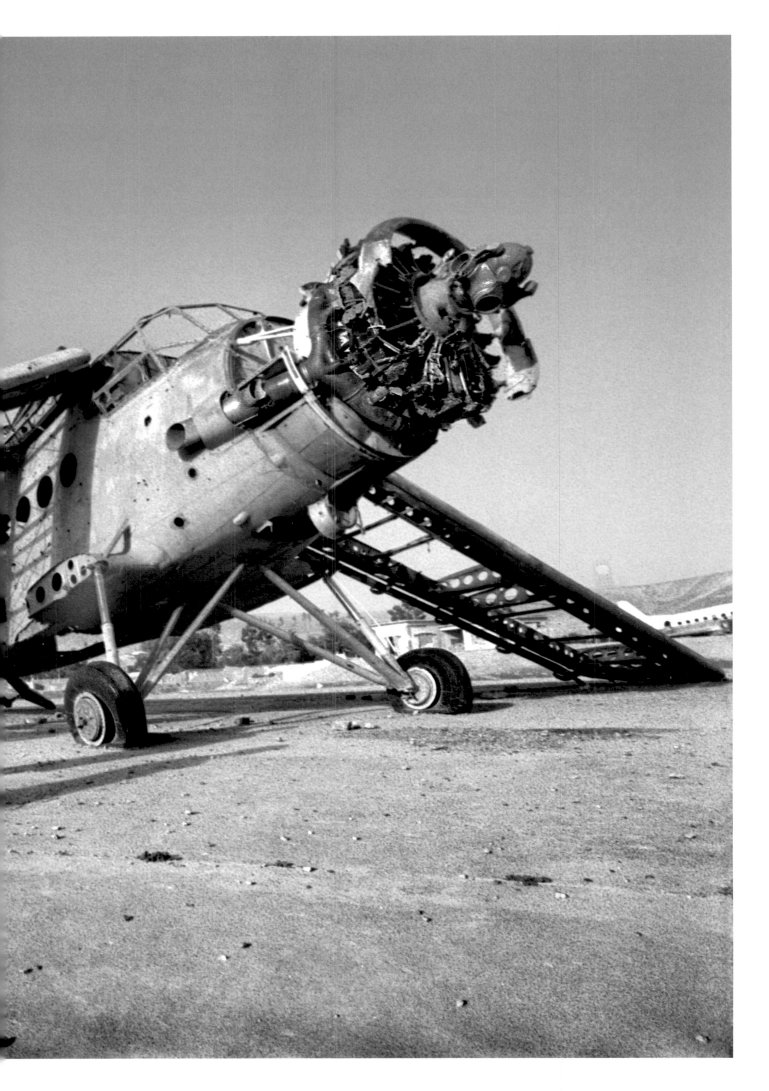

Contact sheet of photographs from a covert women's work training program at home in Kabul, Afghanistan, May 2000.

WOMEN IN EMPLOYMENT

COVERT WOMENS WORK TRAINING PROGRAM AT HOME IN KABUL, AFGHANISTAN. THROUGH UNITED NATIONS HIGH COMMISSION OF REFUGEES. FIVE WOMEN, HIRED BY UNHCR, GO FROM HOUSE TO HOUSE OF VARIOUS WIDOWS IN KABUL, AND TEACH THEM WORK SKILLS TO HELP THEIR FAMILIES SURVIVE - SEWING CLOTHES, JEWELRY, HANDBAGS, CROCHETED BOWLS (SHOWN IN PICTURE). UNDER THE TALIBAN SINCE 1996, WOMEN HAVE BEEN BANNED FROM WORKING OUTSIDE THE HOME + OFTEN TURN A BLIND EYE TO NGO + UN PROGRAMS LIKE THIS:

IN RESPONSE TO WOMEN'S WORK BAN:
MAHSHEED, 28 YRS. UNMARRIED "WHEN I WAS HOME, I FEEL VERY BAD BECAUSE I WAS THE ONLY SUPPORTER OF MY FAMILY. IT IS GOOD TO WORK. FUTURE IS PROBLEMS WEARING A BURQUA IS NOT A PROBLEM. NOT BEING ABLE TO WORK IS THE PROBLEM."

DO YOU LIKE THE TALIBAN?
NO. I DO NOT LIKE THE TALIBAN. I HATE THEM. EVEN IF IT WERE MY FATHER, I WISH THEM DEAD. IF WE ARE TIRED OF WEARING BURQUAS, WHAT COULD WE DO? THERE IS NO OTHER WAY. BEFORE 1997, IN EACH HOUSE IN AFGHANISTAN, THE WOMEN ARE THE POOREST IN THE FAMILY. THE ONLY THING THE THINK OF IS HOW TO FEED THE FAMILY NOW WE ARE FACING THE SAME PROBLEMS. WE ARE BEATEN IN THE STREETS. THROWN IN PRISON.

Contact sheet of photographs from an underground school in Logar Province, Afghanistan, May 2000.

Contact sheet of photographs of Afghan refugees who fled Taliban
rule at a girls school in Peshawar, Pakistan, May 2000.

12/2/2001

To: P

The night I got here, I was put on assignment for the new york times magazine, basically paid to sit and wait for a path to clear into kandahar. They didnt even want any photos, this assignment ended today, with a stunning trip up to the afghan border through the drug smuggling route where arabs and deflecting taliban are allegedly sneaking across into pakistan, and I start a new assignment for the new york times magazine tomorrow. I think they will have me as well wait in kandahar for a bit, before sending me into kabul to do another women's story similar to the last. Vin, they are actually asking me to do a full features that i report and shoot all on my own! The new york times magazine. who would have ever thought?

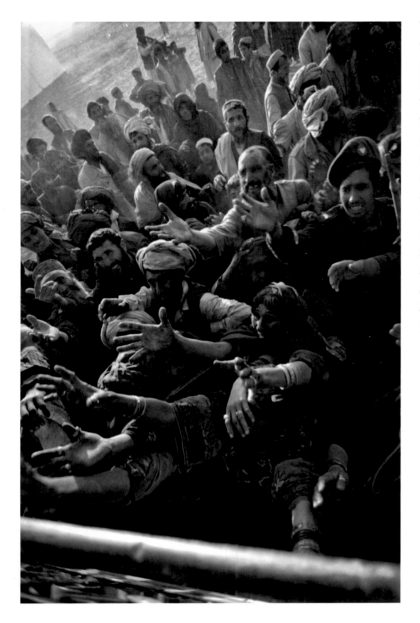

Detail of frame from contact sheet opposite, December 2001.

Contact sheet of photographs from Pakistan and Afghanistan
refugees, December 2001.

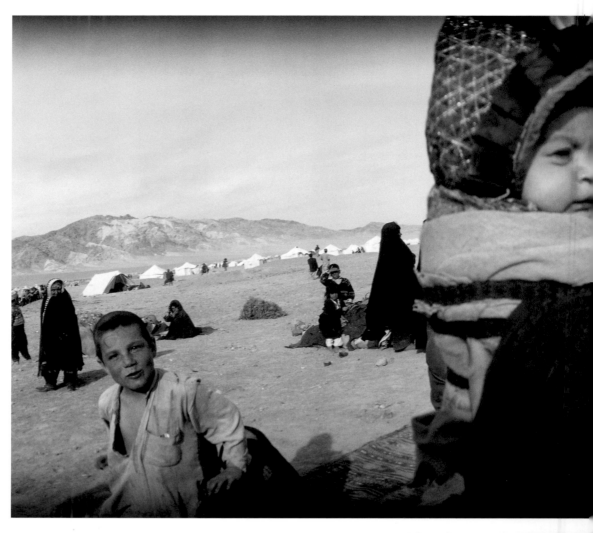

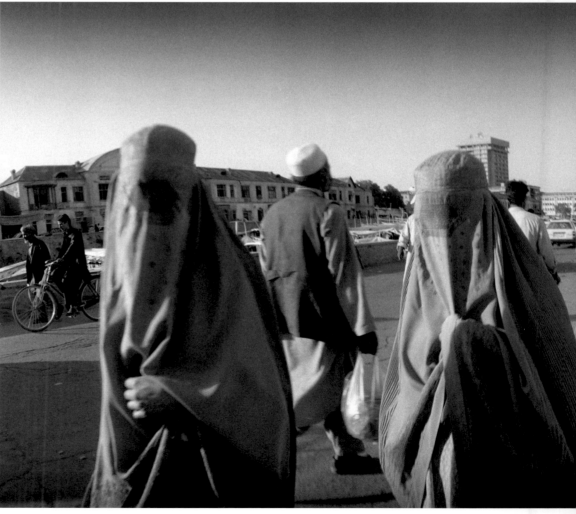

Top Afghans gather at a camp for internally displaced people on the outskirts of Herat during a drought in Afghanistan, March 2001.
Bottom Kabul, Afghanistan, July 2000.

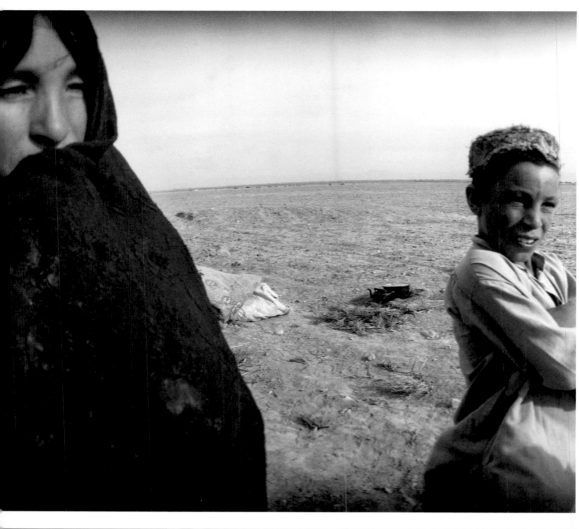

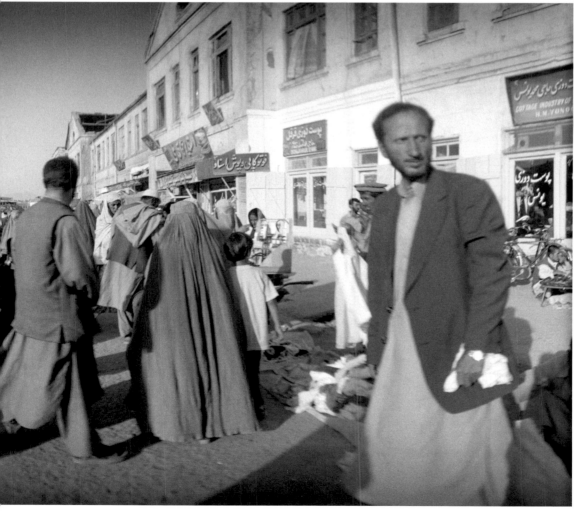

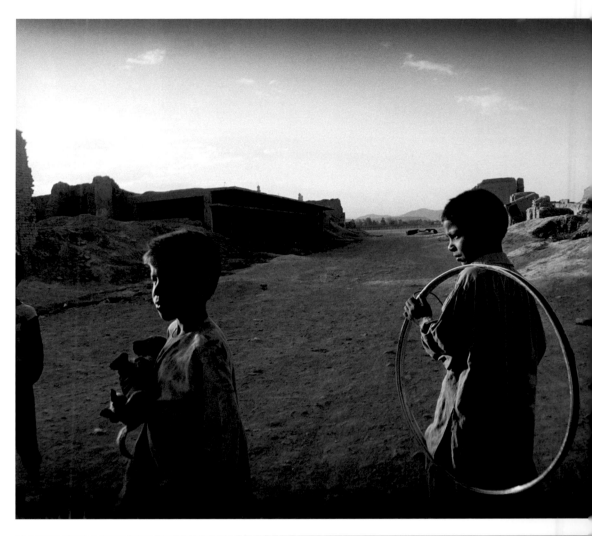

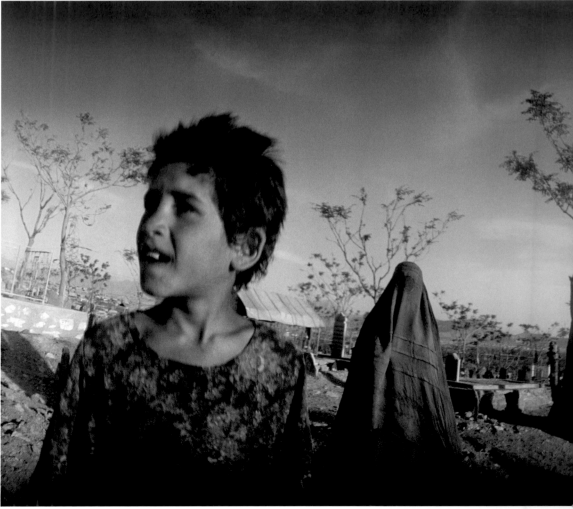

Kabul, Afghanistan, May 2000.

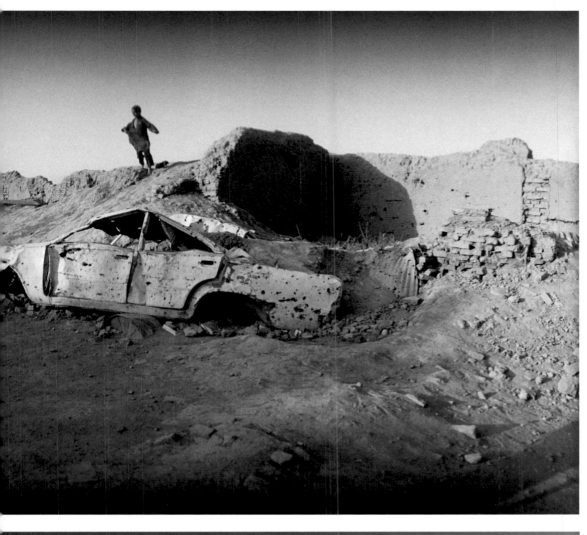

Afghan woman inside the Rabia Balkhi Women's Hospital in Kabul, Afghanistan, May 2000.

9.3.2000

Vin.

I photographed an abortion yesterday. There really is no diplomatic way for leading into that kind of sentence, so I'll go ahead and dive in. I have finally started work on my women's issues series, and I can not believe how things have begun to take shape. I arranged a photo shoot at one of the Red Cross hospitals on the periphery of Delhi, and was swiftly taken there in a cool, sporty red cross jeep by a (thank God) silent driver who didn't even venture to say, "which country?", & arrived to awaiting female doctors to show me around and ask me my interests in reference to angle of the story. The efficiency killed me. Without a moments delay, (which never happens in india) they ask if I want to see + photograph "ligation + MTP" surgery. Without having any idea what MTP surgery was, I said an emphatic yes, and was immediately brought upstairs to the surgery room to gain approval from the head doctor. (Through all this, all I could think of is how this would never, in a million years, happen in America.) She asks nothing more that what I am doing in india, and after hearing only the first two sentences of my stock answer, "I am a freelance photographer for the AP and many internationally distributed newspapers, permanently based in New York, and here in India for several months documenting women's issues..." She heard enough. "OK. Just take off your street clothes and put on a surgical gown."

I have never been so ill-prepared for access to something in my life.

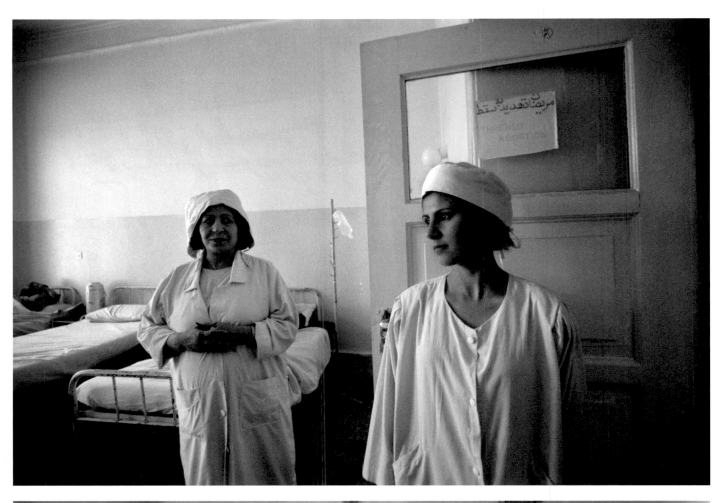

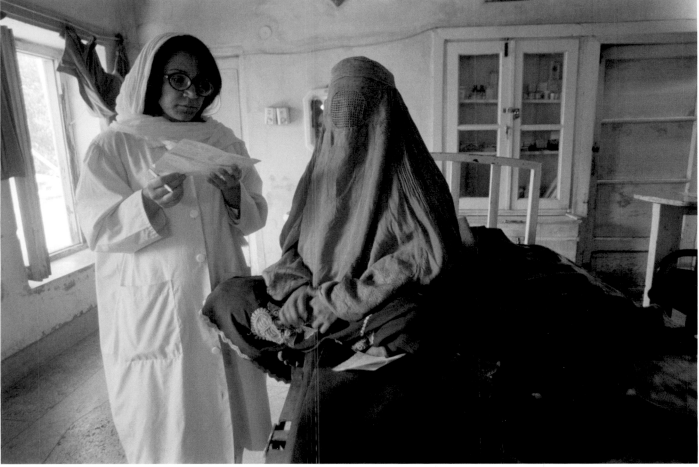

Afghan women inside the Rabia Balkhi Women's Hospital in Kabul, Afghanistan,
May 2000.

A secret girls school off the main road from Kabul to Ghazni Province, May 2000.

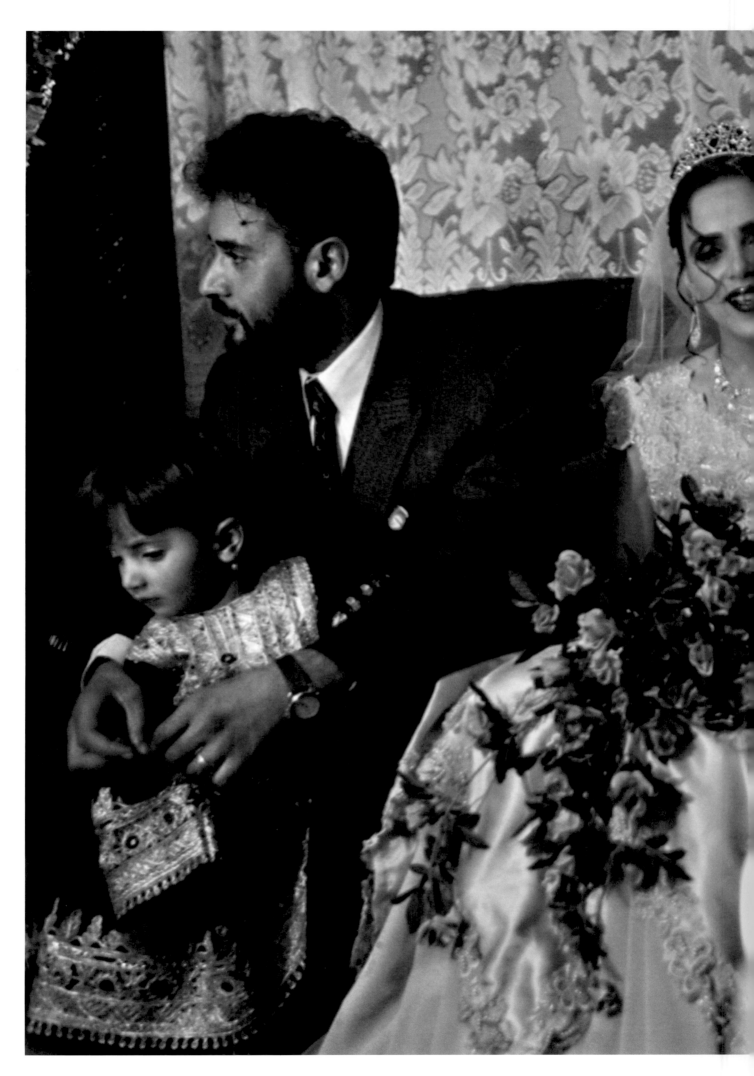

Above and following pages An underground wedding celebration in a private residence in Herat, Afghanistan, March 2001.

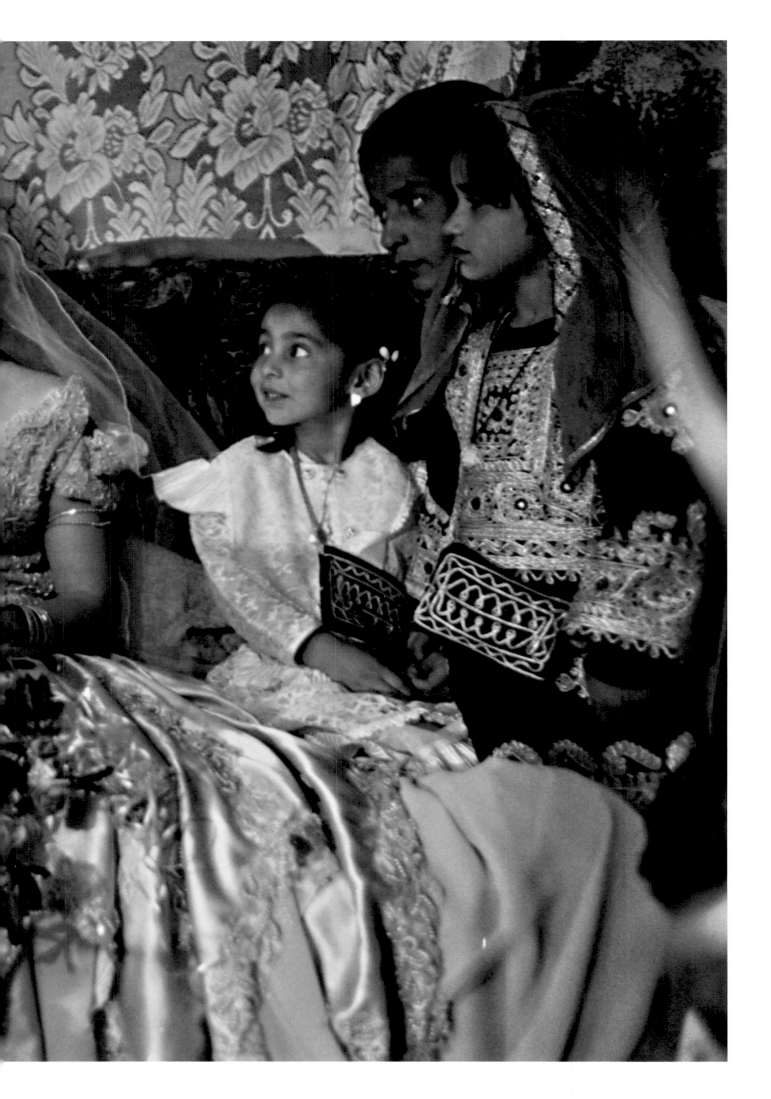

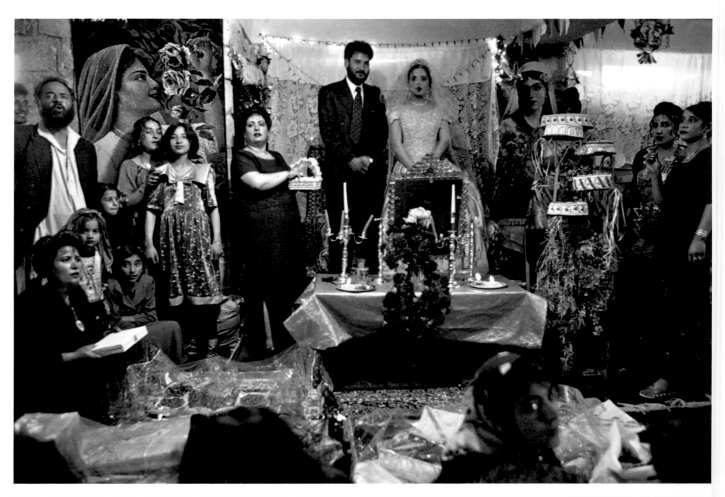

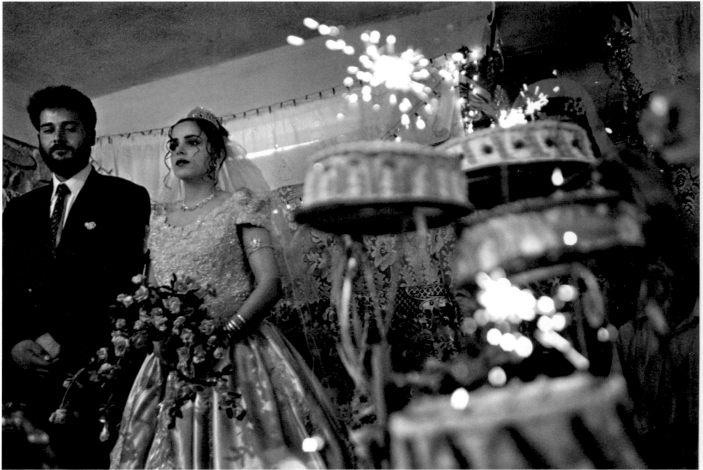

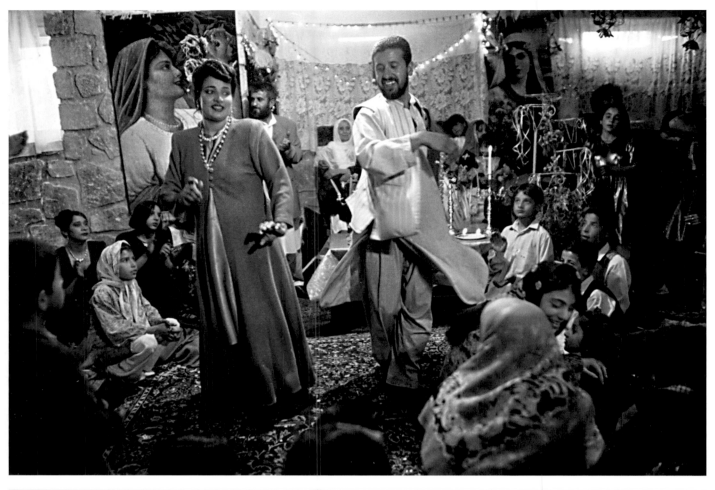

Bottom An Afghan woman prepares to leave the wedding party by throwing her burka over her head to venture out into the street, Herat, Afghanistan, March 2001.

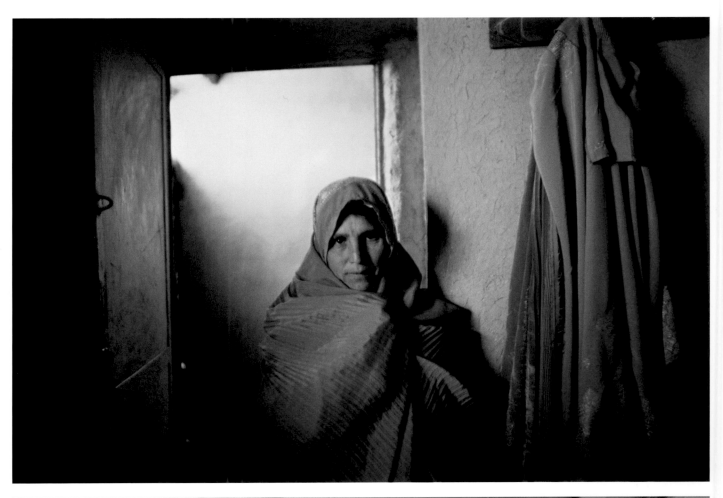

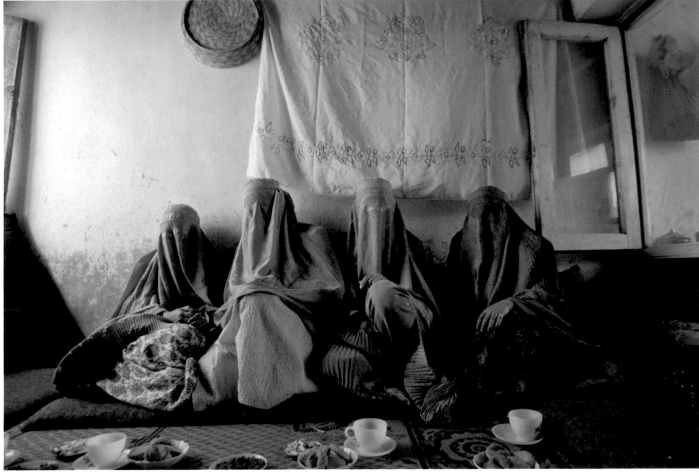

Life under the Taliban in Kabul, Afghanistan, May 2000:
Clockwise from top left An Afghan woman inside her home; women line up in front
of the Rabia Balkhi Women's Hospital; Afghan working women relegated to a life
at home, without and with burkas, over tea.

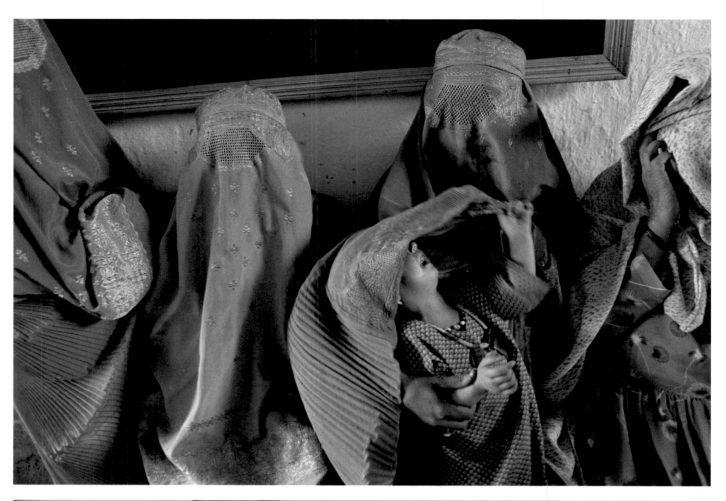

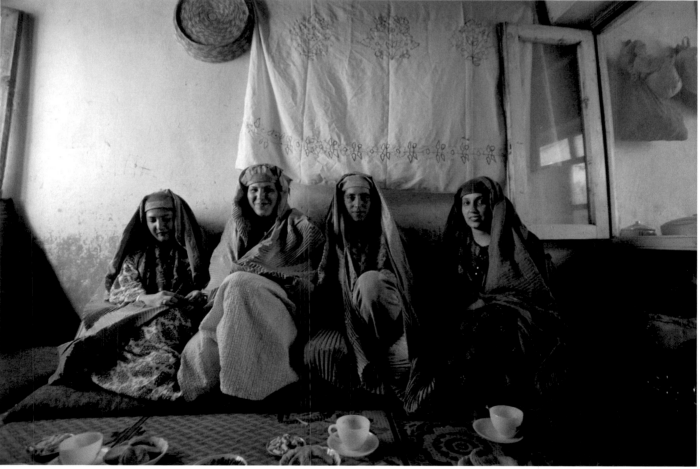

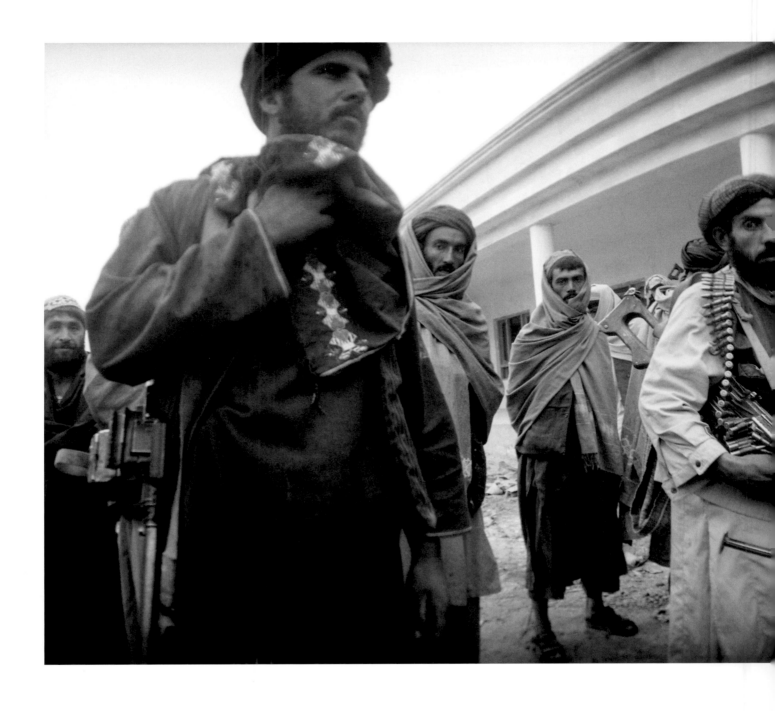

Pakistan, October 1, 2001

How did I ever forget? How did I forget how much the men's stares make me feel sick? How the long gowns and the head scarves get tangled in my cameras in 90 degree heat, and the only thing to watch is BBC at the end of a 20 hour workday? How men grab my ass and crotch while I am photographing a demonstration? How I had to knock out a man with my 80–200mm lens while dozens of his friends burned an American flag and George Bush effigies because his hand crept so far between my legs, my temper soared? How

did I forget I need to hire men to protect me, to stand next to me, and to speak for me? How did I forget how much I would miss my boyfriend, and know and fear in the bottom of my heart that he will probably leave me by the time I get back?

These trips to South Asia are long— weeks and weeks and possibly months, with no sign of a glass of wine in sight. We are waiting in Peshawar, near the Pakistani border of Afghanistan, for the United States to retaliate against Afghanistan for the happenings of September 11. Until last night,

Men stand outside the governor's house hours after the fall of the Taliban, in Kandahar, December 2001.

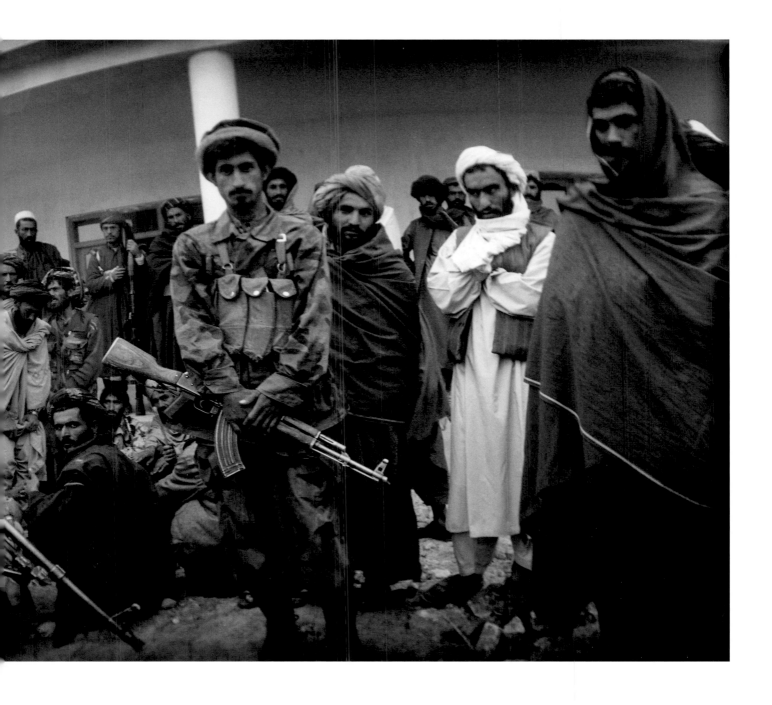

when I mustered an incredible 7 hours of
sleep, I hadn't slept more than three hours
a night for 11 days. My mind is misty, and I
am weary about the length of my stay here.
I want to go home, to make my own coffee.
I want to be surrounded by people around
whom I can wear a tank top. I want to go
for a run. But my return looks grim. There
is talk of an attack tomorrow or within the
next 48 hours, and I know my life will hit
an infinite frenzy.

The photos: It never fails in this region—
point the camera and wonders appear.

A prisoner is chained to the wall at an underground prison in Kandahar, Afghanistan, December 2001.

Korengal Valley,
Afghanistan

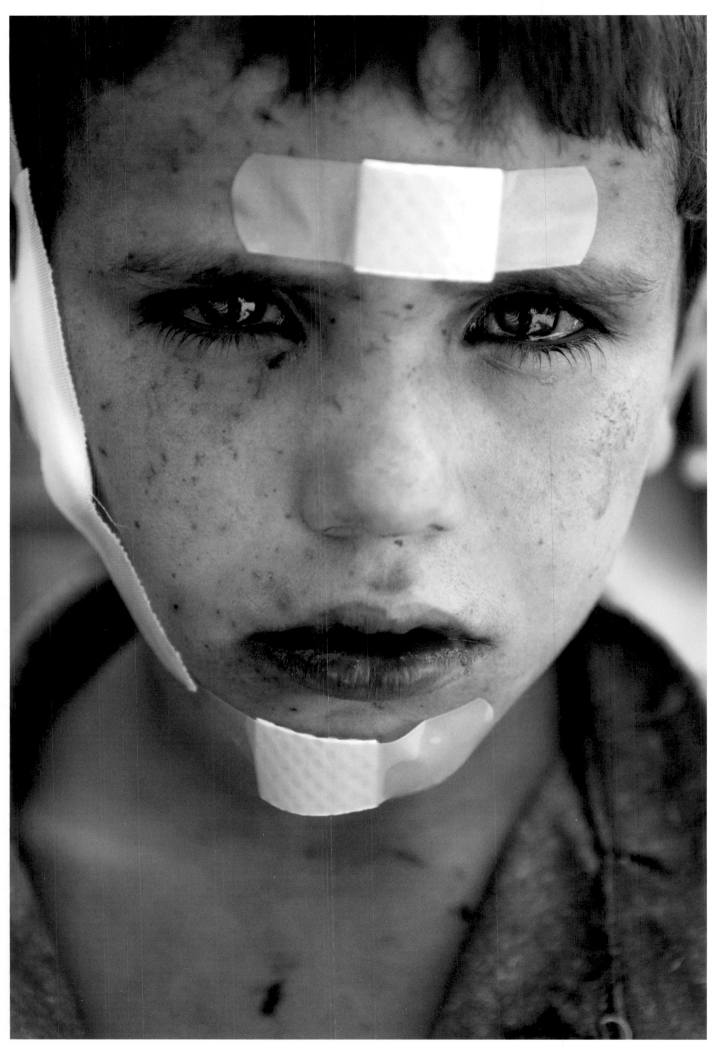

Khalid, seven, sits outside the medical tent of a US military base after elders from
a village claimed he was injured by shrapnel from a bomb dropped by the Americans
near his home in the Korengal Valley, Afghanistan, October 2007.

Lieutenant Matt Piosa of the 173rd Airborne, Battle Company, sits in a bunker following a week of heavy fighting to take the outpost from anti-coalition members in the Korengal Valley, Afghanistan, October 2007.

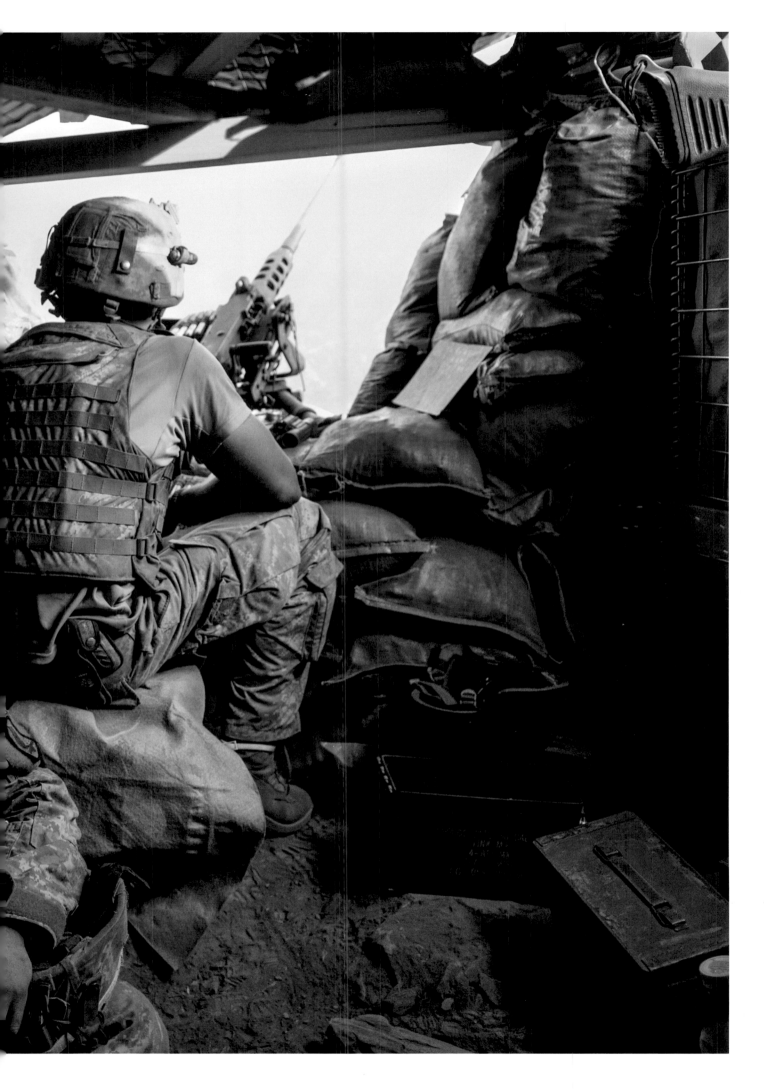

American soldiers with the 173rd Airborne, Battle Company, are thrown back as a mortar fired by the Taliban lands about twenty feet from the opening of the bunker at the Korengal Outpost forward operating base, Afghanistan, October 2007.

An airforce Joint Terminal Attack Controller (JTAC) attached to the 173rd Airborne, Battle Company, "sparkles" a target during a battalion-wide mission in the Korengal Valley, Afghanistan, October 2007.

Captain Dan Kearney looks out at the landscape while patrolling in search of caves and weapons caches along the Abas Ghar ridgeline in the Korengal Valley, Afghanistan, October 2007.

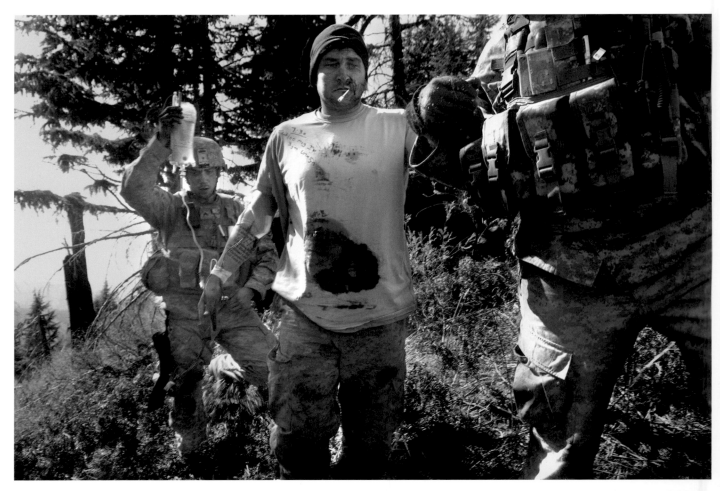

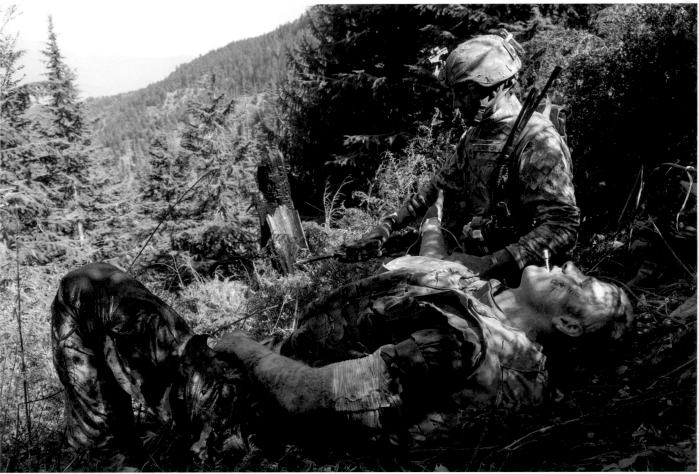

Top Sergeant Kevin Rice is assisted as he walks toward the landing zone of a medevac helicopter shortly after being shot in the stomach by the Taliban in the Korengal Valley, Afghanistan, October 2007.
Bottom Sergeant Tanner Stichter tends to Specialist Carl Vandenberge in the bushes moments after Vandenberge was shot in the stomach during the Taliban ambush.

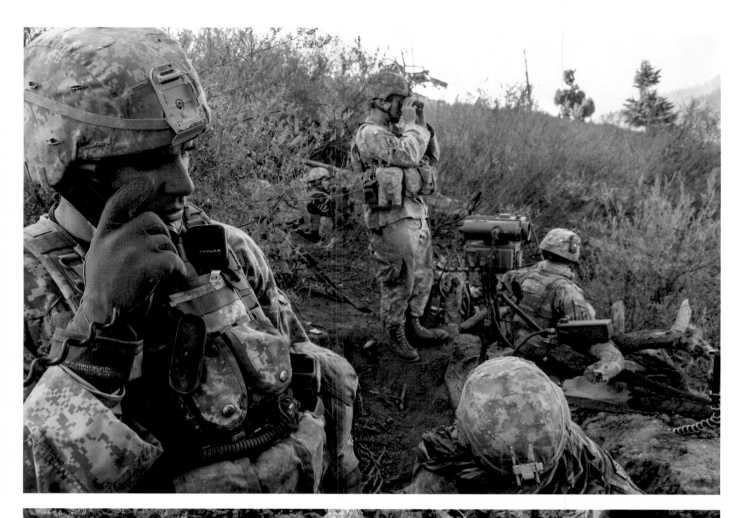

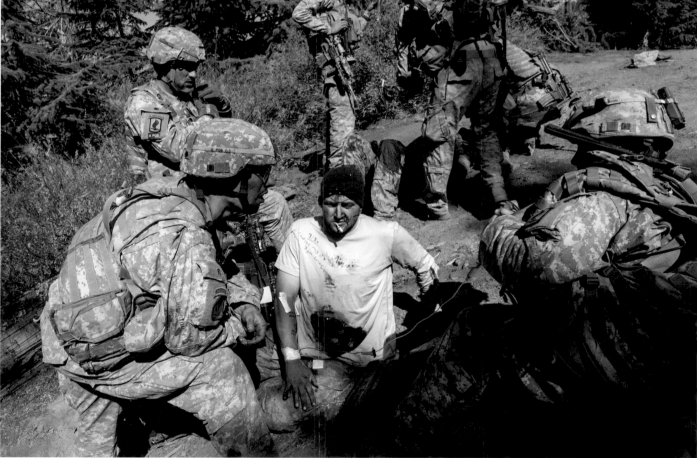

Top Captain Dan Kearney speaks with the command center while he oversees his troops and controls close air support from across the valley where his troops patrol in the village of Yaka China in the Korengal Valley, Afghanistan, October 2007.
Bottom Sgt. Rice (center) and Spc. Vandenberge (behind) are assisted by Doc Dean (left) and other soldiers as they pause during their walk to a medevac helicopter.

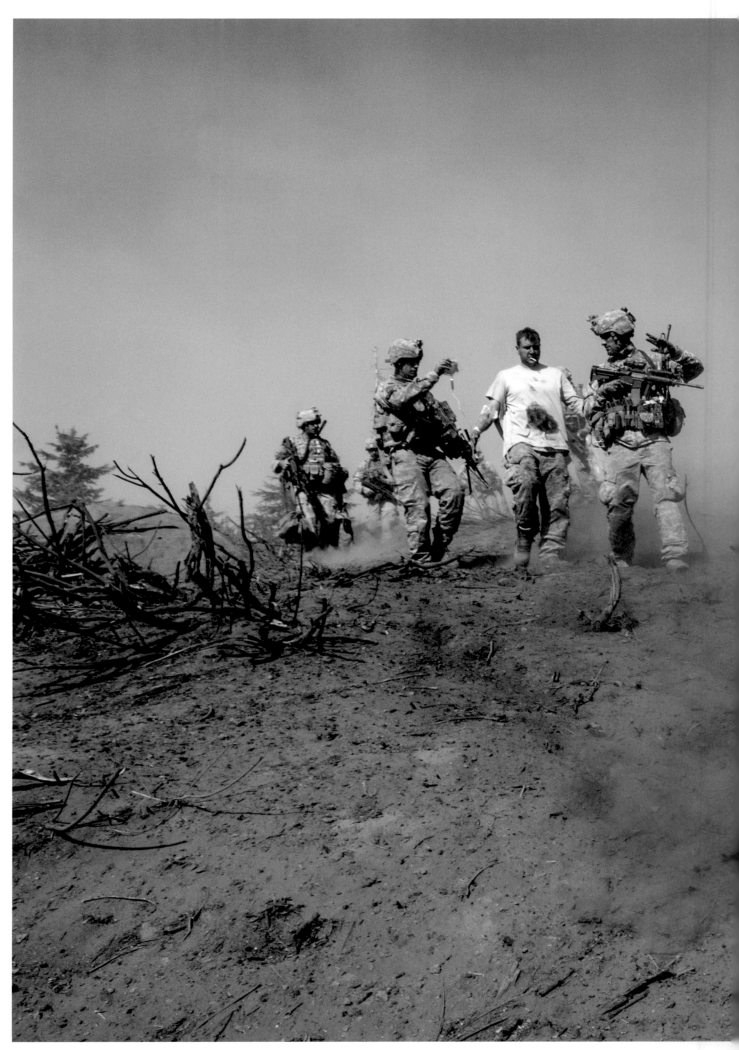

Sgt. Rice (left) and Spc. Vandenberge (right) are assisted as they walk toward the landing zone minutes after being shot in the stomach during a Taliban ambush. Both were flown out immediately for surgery. Abas Ghar ridgeline, Korengal Valley, Afghanistan, October 2007.

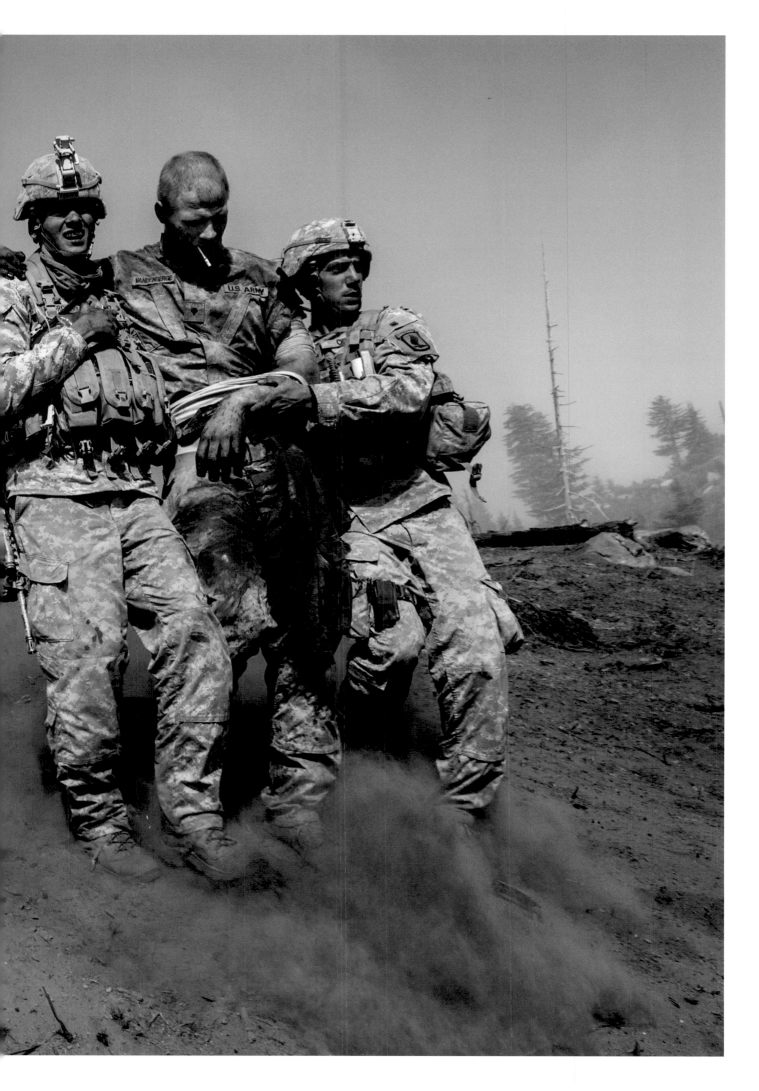

Rougle's Death,
Operation Rock Avalanche

The soldier in the front of the bottom photo and in the following spread is John Clinard, a member of the scout team attached to the 173rd Airborne while it was deployed in Afghanistan. He was twenty-two years old at the time. In 2017, I interviewed him about the photo, and that day in the Korengal Valley.

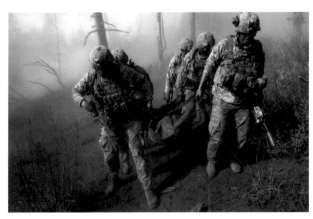

What was Operation Rock Avalanche?
It was a pretty big operation. It was battalion-wide, so every company had a piece. We were to go into [the village of] Yaka China and try to clear it out.

I remember that morning we were listening to Taliban chatter on the two-way radios with the command team.
The headquarters unit was intercepting chatter and passing the information on to us. That morning, I remember it being pretty chilly. It was October. I remember Sergeant Larry Rougle, the leader of the scout team, whose call sign was Wildcat 1, was saying to Captain Kearney that either we need to move or we need more men up here. They sent Sergeant Rice and his team with the [M240] machine gun up to our position, and then we split. They were in one area of the hilltop, and we moved over to the other hilltop. That morning Rougle wanted to go over to check on Rice to see how they were doing. We were just sitting in our position watching. And I remember the MTT guy [Military Transition Team personnel, who was sent from the United States to work with the Afghan troops] said over the radio that one of their guys thought they saw movement on a hilltop across the way. I [climbed a nearby tree] . . . to get a better look with some binoculars, but I remember while we were checking them out, the firefight erupted.

We had been there a few months, and this wasn't our first firefight. It seemed pretty routine until I couldn't get ahold of Rougle or Rice on the radio. My guys were shooting into the positions in the mountaintops where they thought the rounds were coming from. I was trying to get ahold of Wildcat 1 and Rice, but there were no comms.

I remember Specialist Solowski came over to us, and all he said was something like: "They are all fucking dead." Meaning our guys.

I am still trying to get Rougle on the radio—yelling "Rougle!"; yelling "Rice!" Every time we popped our heads up to make an advance, rounds kept coming in.

That's when we got up to the hilltop and saw Larry lying there, away from second platoon. Larry and I first met in 2006, when I got back

from my first deployment with the 173rd. They put a poncho liner over him because he had been shot. I did hope he was still alive. I kind of was in shock, and I let my emotions get to me a little bit up there. And then I regained myself and found out that Rice was still alive and that Vandenberge was hit, but he was alive. More of the second platoon got up there, and we reestablished our position and our perimeter and started tending to the casualties.

I remember we walked Rice and Vandenberge down the hill [for treatment], and we went back up. And I believe Specialist Mitchell Raeon stayed at the top with some guys, and they put Rougle into the body bag—which we had with us because we were low on ammo and water from the previous days of the mission and they had dropped a resupply onto us in body bags to keep it all together. That's how we got the body bag. We never carried body bags with us. They called me on the radio, and I said, "We gotta go back to the hilltop and get the KIA [killed in action]."

What are you thinking at that point?
I broke down up there on the hill for a second, but then I got back because, now that Rougle was dead, we were still in the middle of a hazardous area. Bombs are starting to come in and stuff, but it was a pretty well coordinated all-sides attack.

We had to go back into operational mode, suppress the emotions, go up there, get Larry, and bring him down. The fist medevac got Rice and Vandenberge, and then we had to wait for the next [helicopter] to put Larry on. We had mortar rounds coming in, and they had to wait a minute for a break to put Larry on.

Right then, I was just thinking, *We got to get him off there*, and then . . . went into revenge mode. Larry was one of the toughest, baddest guys we had out there. From that point on in the deployment, it just made it more surreal. You know when you deploy, you can end up dying over there, but when you lose a guy like Larry, it just puts it all into perspective. He was the best guy we had out there in the Korengal.

As I made my way toward the scene of the firefight, the hilltop, after things calmed down, I came upon wounded Rice and Vandenberge en route to where they would be airlifted off the mountain by a medevac team and spent some time photographing them, bloodied and traumatized, though miraculously walking themselves to the helicopter. And then, minutes later, I saw you and the several others carrying Rougle in a body bag toward the same spot.

What do you think when you see someone like me, a photographer? Do you understand what I am doing as a photographer at that moment? Or are you not thinking anything?
At that moment I wasn't thinking anything. I mean—I know you were there because you took the picture, and I have seen it. But my mind was so focused on getting him out of there and, you know, making sure the rest of the guys got back safe.

What were you thinking about the war then?
At that moment I wasn't thinking, *Why are we in Afghanistan? What are we doing here?* It was more like, *What are we going to do now to make sure the rest of us get back safe, and to avenge Larry's death and make sure he didn't die for nothing?*

I remember when they [pulled troops out of the Korengal] it pissed me off. All the blood, sweat, and tears that was put in—not just from our unit but after us, too. They said [that over the course of] a couple of years in that valley, fifty American lives were lost. I mean, that's just like—If you're going to put us through that, then why are you going to decide to give up such a key terrain?

So when you look at that photo, what do you think? Do you not want to look at that photo, or are you happy there is a record of that day?
Honestly, I have looked at that photo quite often, and I think it just brings up a lot of emotion. . . . We are all dirty, dirt is all over our face, and there are, like, fires going on around us. . . . Looking at that photo, I just think: *How the hell did the rest of us make it out that day?*

Now, in 2017, how do you feel about your time in Afghanistan?
I would still go back tomorrow if they would let me. I would go back because I miss it. I miss being with my guys. I miss the camaraderie. Yes, it was dangerous. It was my job. Felt like I had purpose. I honestly felt like we were making a difference in the world.

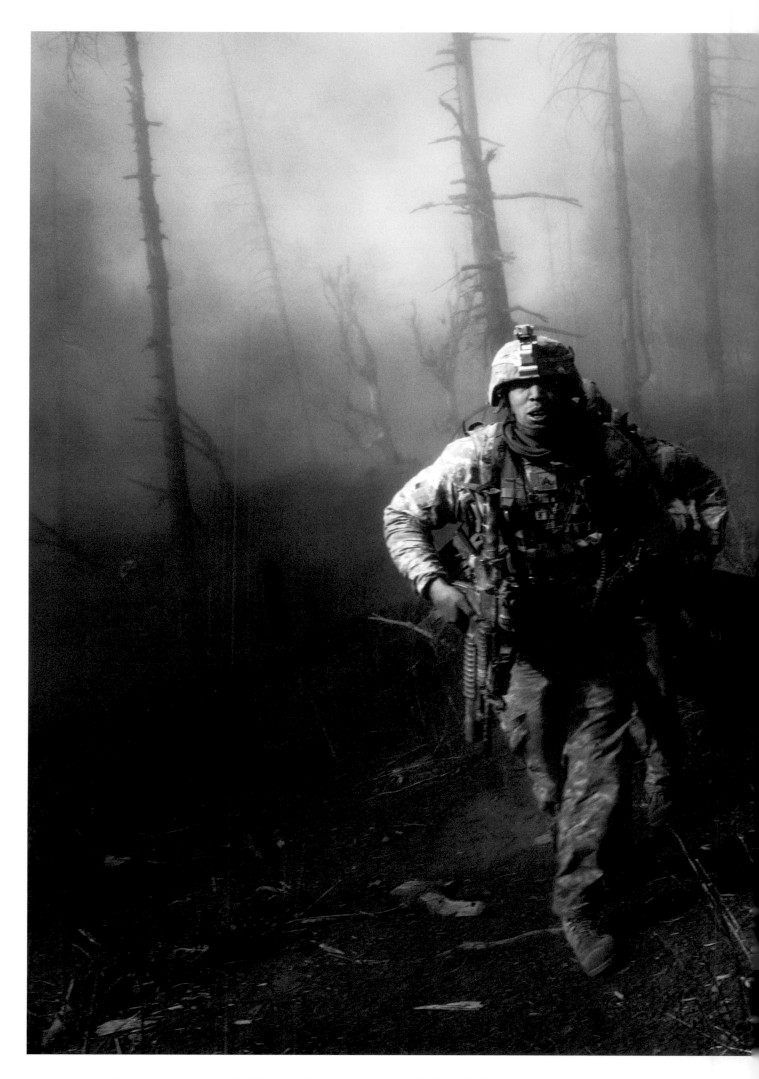

US troops carry the body of Staff Sergeant Larry Rougle, who was killed when Taliban insurgents ambushed their squad in the Korengal Valley, Afghanistan, October 2007.

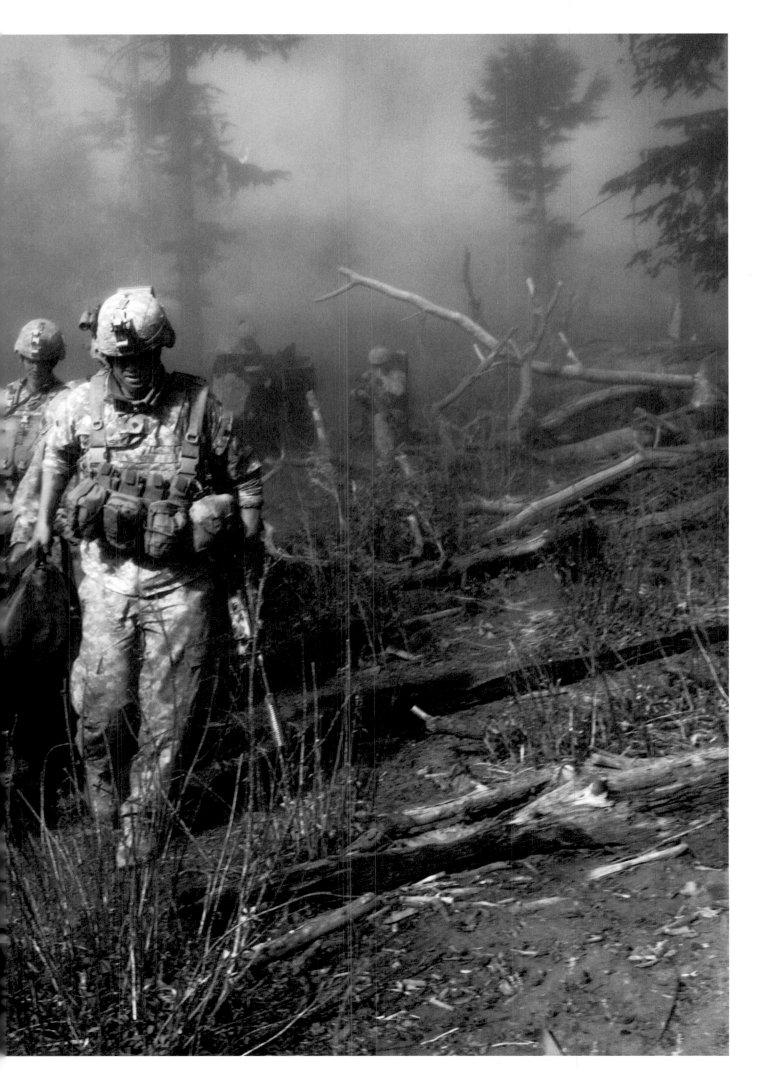

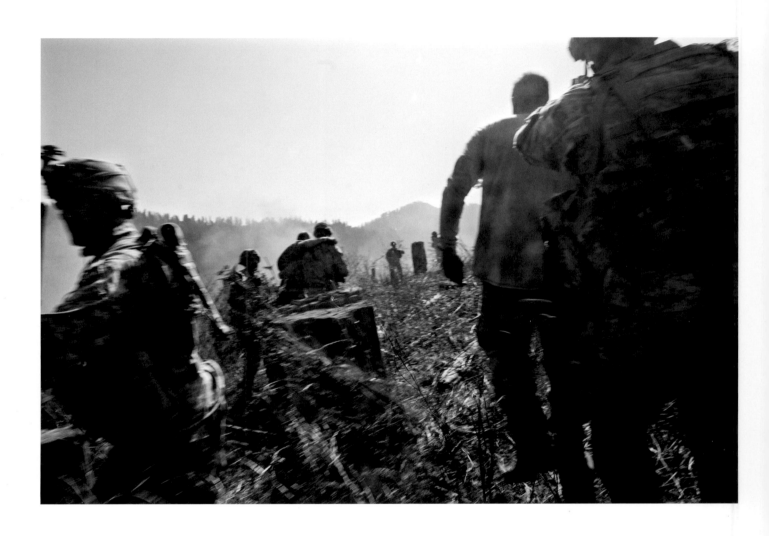

Though injured, Sgt. Rice and Spc. Vandenberge are able to walk toward a medevac helicopter.

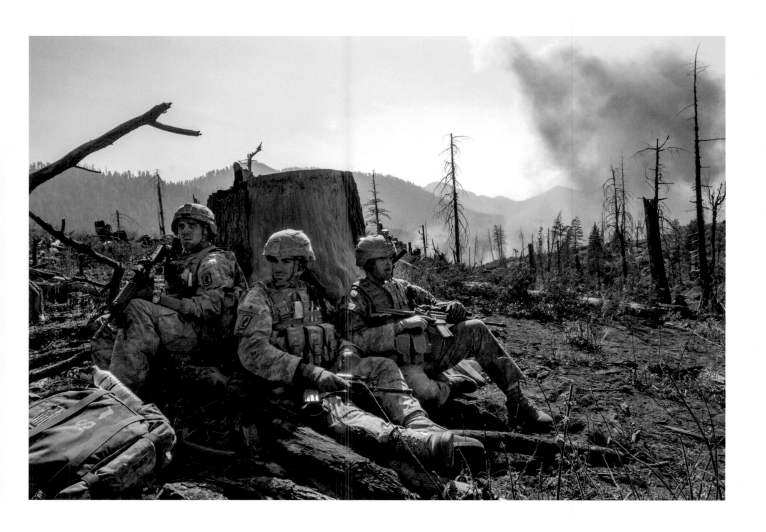

Soldiers stand guard behind a tree stump as they wait for a helicopter to evacuate
the body of Staff Sergeant Larry Rougle.

Iraq

A defaced mural of former Iraqi leader Saddam Hussein in Baghdad, Iraq, July 2003.

The Definition of Reckless

by Dexter Filkins

Whenever I headed into the streets of Baghdad, I got the feeling: *This might be my last trip—my last everything*. It was a tiny feeling at first, in 2003, right after the US invasion: a little poke in the ribs. In the beginning of the American occupation, there was chaos, but most ordinary Iraqis seemed, if not enthusiastic about the US presence, at least reconciled to it. I'd go out, and I'd come back unscathed every time. Maybe I'd hear the rumble of a bomb or the rattle of gunfire, but usually it was far enough away that I could imagine none of it had anything to do with me. And maybe one of the Iraqis I went to see would tell me her life story or weep over a lost family member, and then, on the way home, an Iraqi standing on a street corner would smile and wave as I passed in my car. Iraq was crazy but not mortally dangerous. That feeling—the insistent little jab—could easily be ignored.

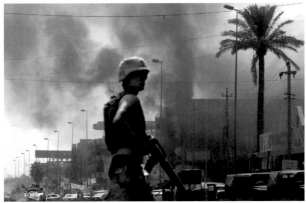

Scenes from Baghdad and Fallujah, Iraq, 2003-2004.

I didn't know it then but the Iraq I encountered in those days was the safest it would ever be. I didn't know—no one knew—that the country, shaky and unpredictable as it was, was edging toward a bottomless chasm of anarchy and death that would engulf it for years. Most of the Western correspondents who worked in Iraq in those days felt pretty much what I did—that the country, though chaotic, was survivable as long as you didn't do anything reckless. *Keep your head,* we told ourselves. *Fear is your friend. Make sure any gunfire you encounter stays in front of you— never behind—so you can get away. Do these things and you'll be safe.*

A lot of reporters and photographers were killed in that first Iraqi year, but most of them had just been unlucky. Elizabeth Neuffer of the *Boston Globe* died in a car accident. Mark Fineman of the *Los Angeles Times* collapsed from a heart attack in the heat. Paul Moran, an Australian television journalist, was killed by a suicide bomber—a freakish event that, at the time, no one imagined we'd ever see again. If we were careful, we told ourselves, we could manage the risks. We'd survive. I think our calculus was not unreasonable. Most of us there—the Western photographers and writers—had worked in hard countries before. And this one, we figured, would be no different.

In this particular Iraq on this particular day, we imagined we could accurately gauge our chances. We were horribly wrong, of course. Dead wrong. The trouble with our analysis, in retrospect, is perfectly clear: The Iraq we were inhabiting was not sitting still. It was changing so fast that the definition of "reckless"—of "recklessly insane"—was expanding by the day. From one day to the next, Iraq seemed a different country altogether.

Hindsight's cheap, the saying goes. It is, indeed—if you live. Looking back, I should have spotted the warning signs: the smiling Iraqi man, peering into my car window, dragging a finger across his throat; the silence that descended on Hajji Hussein's restaurant, in Fallujah, when we walked through the door; the whispers shared between Iraqi police at a checkpoint on a road outside of Balad. Maybe we weren't as savvy as we thought we were.

I remember the day everything turned. It was March 27, 2004. The American occupation of Iraq was almost exactly a year old. Lynsey and

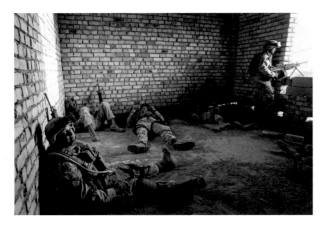

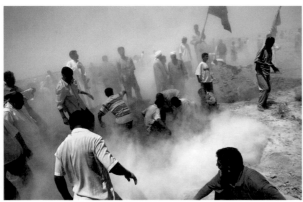

I got word that a group of US Marines had killed fifteen insurgents, which, if true, was big news. We jumped into a car and drove the thirty-five miles west to Fallujah's southern edge. Lynsey and I had known each other for a long time; we'd worked together in Afghanistan and Turkey and India. The most crucial thing about traveling with another journalist in a war zone is that you share a similar sense of risk; Lynsey and I did.

We knew something was different the moment we stepped out of the car. We were in a neighborhood called Al Askari. The locals were enraged; they were accusing the Marines of murder. When we walked deeper into the neighborhood, we came across a group of men in masks—a creepy sight, if you've never experienced it. They meant us no harm but told us they had sealed off Al Askari and would attack the Marines if they tried to return. In the past I'd felt safe walking around Iraqi neighborhoods, even in a city as volatile as Fallujah. I didn't feel safe in Al Askari that day; my legs felt funny.

Lynsey and I stopped in the street to talk to an Iraqi man, an electrician named Qassim Obeid. With a crowd of Iraqis gathered around him, Obeid told us in flawless English that a thin majority of his neighbors supported the Americans. Still, he seemed unsure of himself— and the locals unsure of him. "Come on, Obeid," one of the Iraqis taunted. "Speak Arabic so we can understand you."

"No, I prefer to speak English," Obeid said, turning back to us. "It's safer that way."

Lynsey and I got a similar sense of dread when we tried to enter Fallujah's main hospital, where many of the Iraqis who had been wounded by the Marines had been taken for treatment. A guard barred our way. "If you go inside, you'll be shot," he said. "The families are crazy, and they are armed."

Lynsey and I left Fallujah before sunset, feeling lucky to get away.

A few days later, I left Iraq for a break. The next week, on April 4, Fallujah exploded in violence after four contractors from Blackwater were killed and set afire by a mob that hung their burnt corpses from a bridge over the Euphrates and cheered their excruciating deaths. Then, with Fallujah in chaos, I got a call from my editor in New York. Lynsey and another colleague had been kidnapped by a group of masked men at a makeshift checkpoint outside the city. Everything seemed to go black then: for Lynsey, for me, for Iraq. It was to be a grim forty-eight hours before I got word that Lynsey was safe and free. The country, though, had left our grasp entirely, spinning away in a storm. It would be many years before we would ever get it back again.

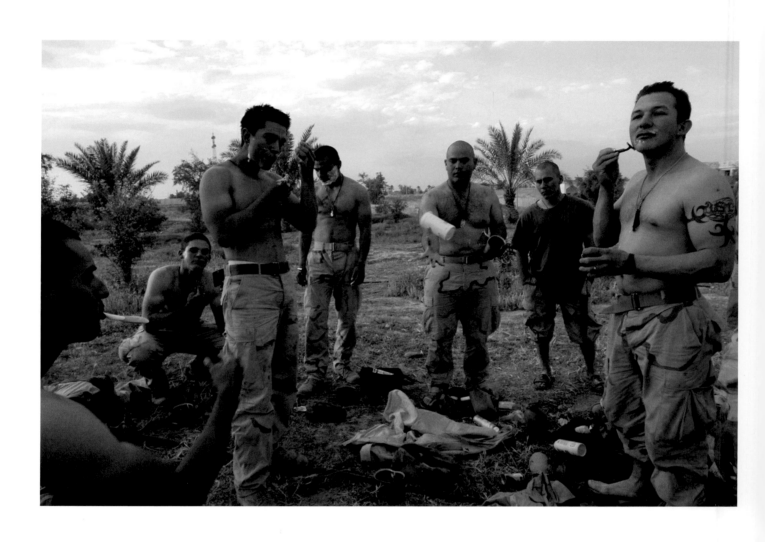

US Marines take a break to shave in front of one of Saddam Hussein's presidential palaces the day Tikrit fell from Republican Guard rule in Iraq, April 15, 2003. As the regime of Saddam Hussein fell across Iraq, proof of the many suspicions of how Saddam Hussein concealed his weapons came to light.

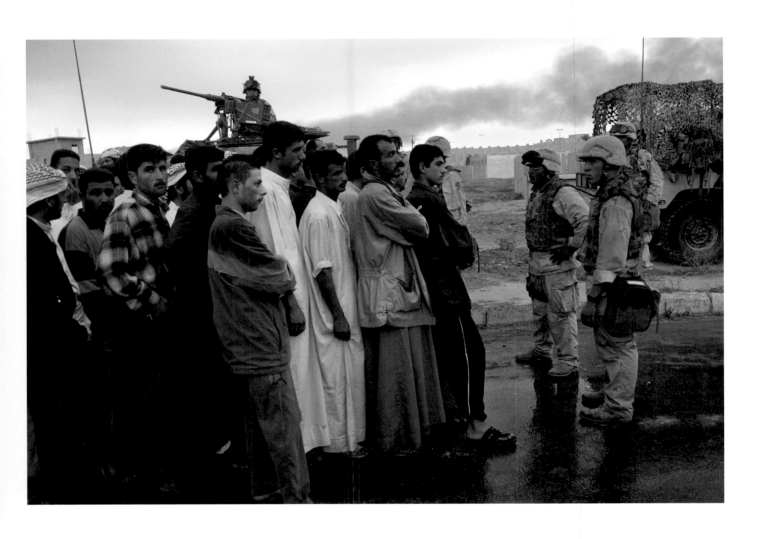

As US Marines stand guard, Tikrit residents line up on the bridge to exit Tikrit
for the first time since fleeing because of the war, days after the regime of
Saddam Hussein fell from power, Iraq, April 2003.

An Iraqi woman walks through a plume of smoke rising from a massive fire at a liquid gas factory as she searches for her husband in Basra, Iraq, May 2003.

Shiite Muslims mourn the death of Ahmed al-Waeli, a prominent cleric, behind
a flag of martyred Shiite leader Muhammad al-Sadr at a mosque in Sadr City,
Baghdad, Iraq, July 2003.

An Iraqi police clerk fills out a report in one of the old Baath party headquarters
turned police station in Old Basra, Iraq, May 2003.

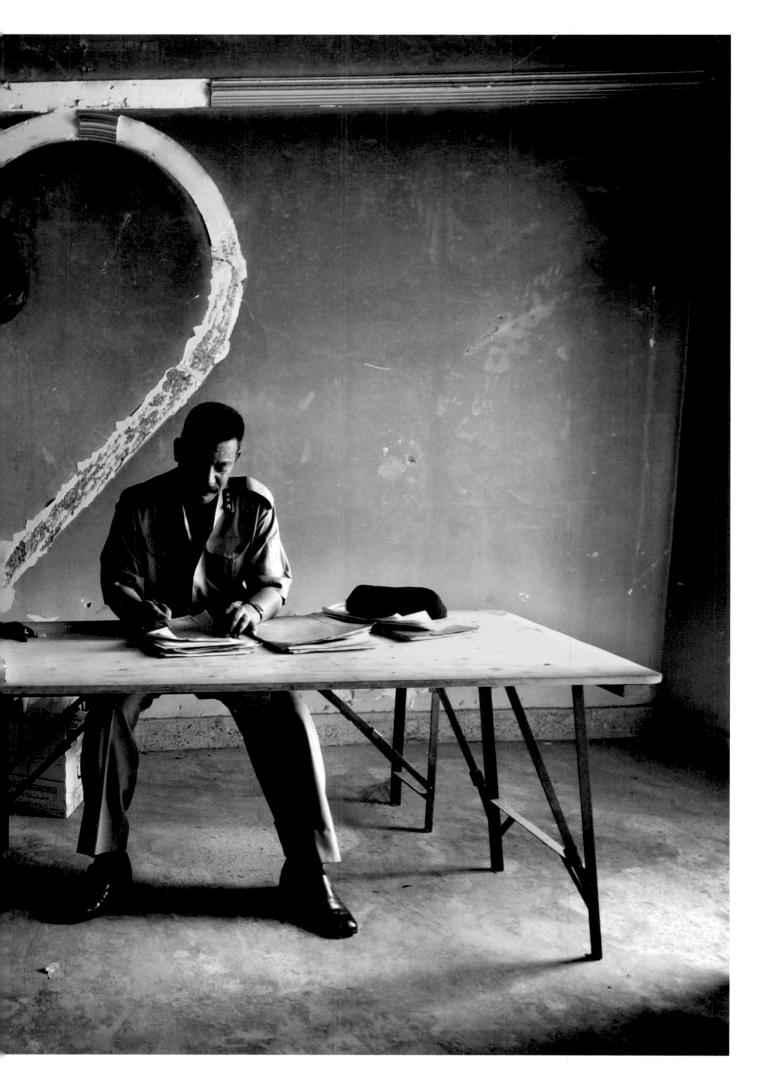

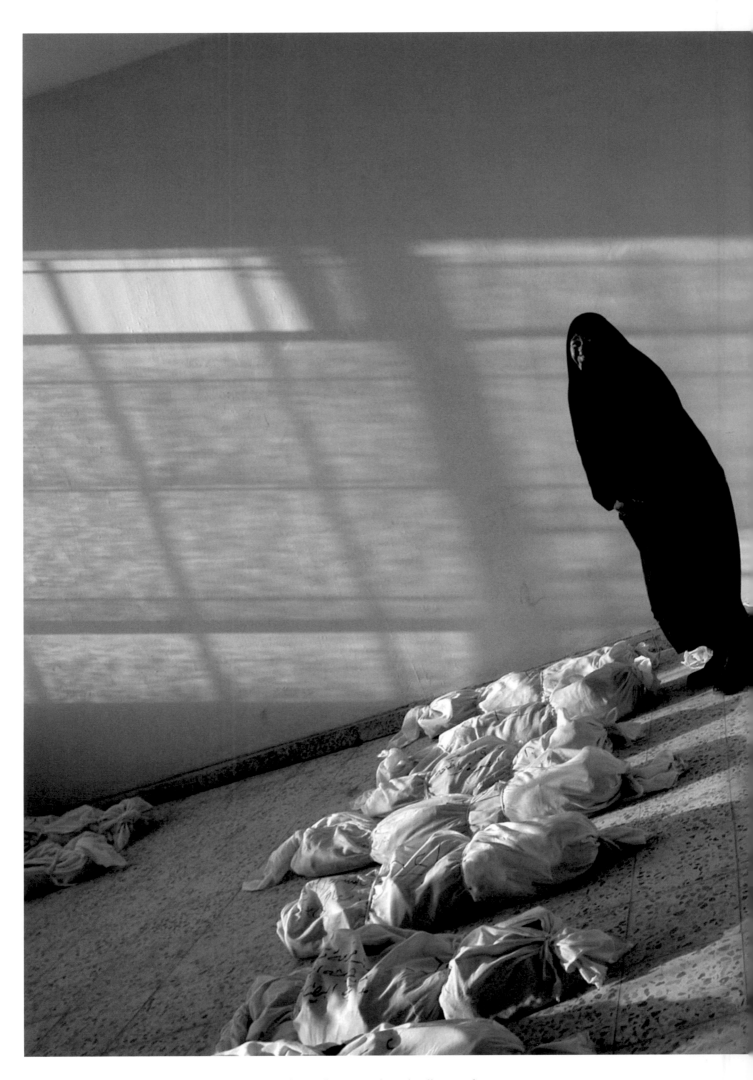

Iraqi women weep as they look for loved ones along rows of remains discovered
in a mass grave south of Baghdad, Iraq, May 2003.

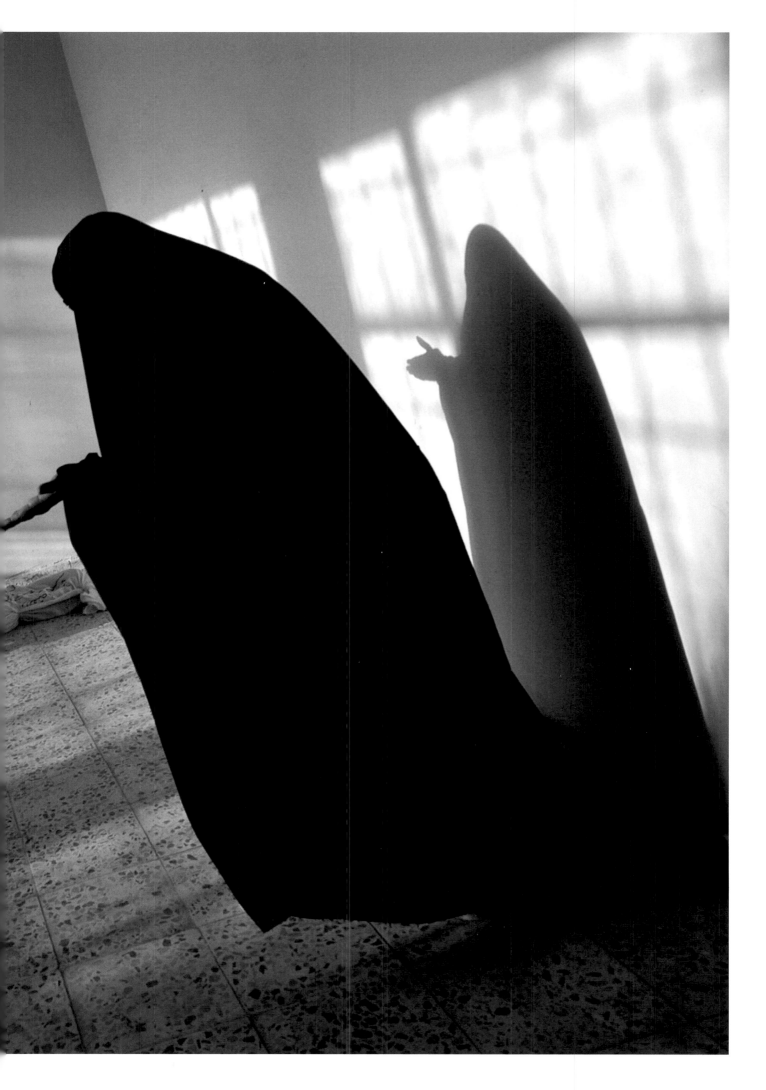

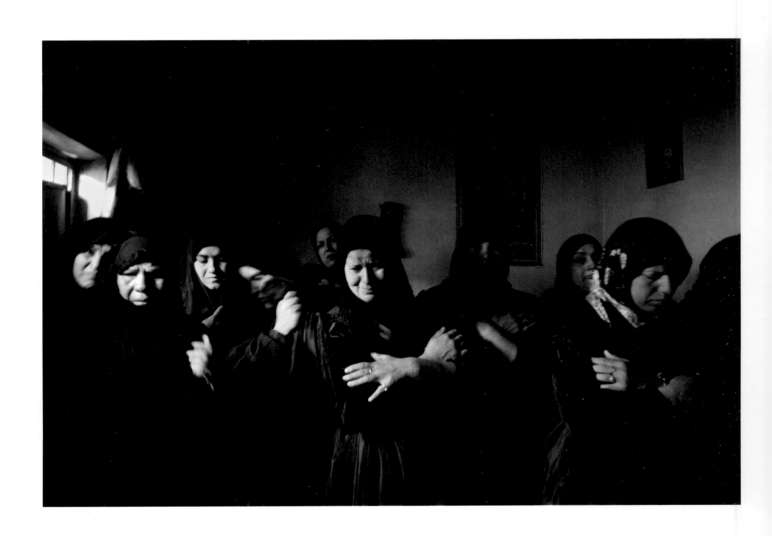

Relatives of Salman Nama Naser, sixty-three, mourn his death at their home in Sadr City, Iraq, April 2004.

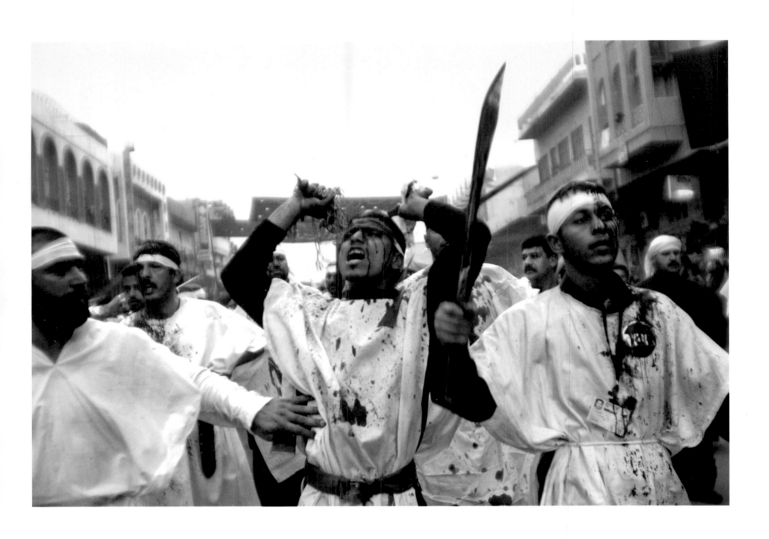

Iraqi Shiites slice their heads with a sword while celebrating the Shiite tradition for the holiday of Ashura, during Muharram, outside a Khadamiya mosque in Baghdad, Iraq, March 2004.

Feb 2004

Hi Mom,
so nice to hear from you. i'm doing well. still chasing explosions almost every day, though it seems quiet strangely. we don't usually find out about the bombs until three hours have already passed, and it makes the scene difficult to cover as a journalist. Typically, the americans seal the area and keep us so far away that we can't see anything, and the iraqis are so enraged about what has happened that they turn their anger on us.

i was going to call you yesterday because i had such a traumatic experience, but i decided against calling because often words can't describe what i have seen. i was doing a story in the children's cancer ward of this hospital in baghdad, where the hospital is in such bad condition that raw sewage mixes with the drinking water and patients end up sicker than when they first checked in. it is understood that there are hundreds more cancer victims in iraq since the gulf war, because the us used bombs which emit depleted uranium, and many people in the country are now suffering from cancer. so, i went to the cancer ward, and it was so emotionally overwhelming that i couldn't handle it. the first woman i saw was unrelated to these cases. she was the grandmother of a newborn with jaundice. the baby was the color of a banana, and the young newlyweds couldn't even look at the baby as it screamed over and over. the grandmother just sat on the bed, alone, rocking the baby, and at some point, she started asking for the doctor, calmly, saying

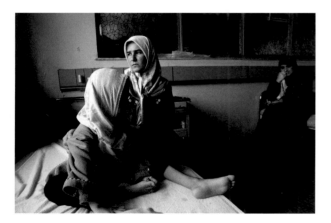

Miriam Hadi, six, sits with her mother and aunt (right) in the oncology ward of the central pediatric hospital in Baghdad, Iraq, February 2004.

that the baby was cold. the nurse walked over and bluntly said the baby was going to die, at which point the grandmother, still alone because the parents couldn't deal with the trauma, started weeping alone on the bed with her banana colored baby. i photographed her. the mother came in and stood off to the side. the grandmother continued weeping.

i then returned to abdullah, 11, who i had been photographing. he has leukemia. he wears a nike hat to cover his baldness, and is now too weak to hold a pencil. he used to be at the top of his class, and his mother just sat on his bed, complaining how he no longer can play, can go to school, can do anything but sleep and cry. the nurse called out his name to give him his daily medication dose before his chemo treatment, and his mother went over to collect 25 bottles of fluid to be injected in him for the day. one day. he lied on his side, swimming in this medication, and his mother started looking for a nurse to give him the chemo. we went into a bare room, where the boy started crying at the mere sight of the needles. apparently they missed his vein in his hand in the morning, and he was in a lot of pain. the mother, father, and doctor stood by the bed while another child with cancer waited behind him, bald, who had been undergoing treatment for three years already. Omar was about 12 years old. as the doctor put the needle in abdullah's hand, he started screaming at the top of his lungs, and his father, a sturdy, proud, arab man, started crying as he tried to calm his son. the mother left the room. abdullah continued screaming. the father walked away to wipe his tears. i was crying so hard at this point that i just kept the camera in front of my face in shame, and i eventually had to go out on the balcony because i couldn't stop crying.

then i thought how little it would take to help these kids and their families. maybe enough so they had medication or tissues or a cafeteria where the food wasn't boiled in sewage. i don't know, mom. i've seen so much money and so much poverty, and i can't understand why they aren't more equally distributed.

love you, lyns

April 5, 2004

J,

I am still in baghdad. I almost died yesterday, and the day before, and am tired and stressed, and counting the days before I can come home, or find the most deserted beach on earth (and possibly a boyfriend for rent), so i can sit down with some chilly margaritas and watch the ocean swallow my feet. this country has sunken into the depths of hell. there is the potential for a complete uprising against the americans almost any day now, and with every fight between the americans and the iraqis, it becomes more and more difficult to work. My judgement of what is dangerous and what is reasonable are so skewed right now that, last night, I drove into the middle of a gun-battle in Sadr City, the Shiite neighborhood in Baghdad, and skipped out of the car while my armed escort, a heavily bearded, former iraqi army guy, cowered in the front seat, adamantly refusing to get out of the car to offer me protection. Tires burned along the sides of the main roads, the air thick with black, rubbery smoke, and the streets were barren, save for the occasional man, warning any pedestrian who dared to enter Sadr City to get out. They were worried—'get out, get out . . .

pointed at my driver, qais, and I . . . they will kill you . . . she is a foreign woman . . . get out.' I spotted Muqtada al Sadr's office, in flames and at the end of an infernal road, and pointed my camera and began shooting. I had faith the Iraqis wouldn't kill me, and was in this zone of immense concentration, when I felt qais' hand heavy on the nape of my neck. I was confused . . . shots rang out, louder and louder until they were deafening, and qais started screaming, 'the Americans are coming . . . tanks, Americans . . . ' repeatedly. I had always had this feeling that in the end, my fate might be at the hands of the Americans . . . and this was the end, I was sure. The tanks plowed towards us, opening fire from I have no idea where, and I froze. qais, clenching my abeya, and wrapping arms around my waist, ran me into the nearest home which opened his door to us. Everything remains a blur. We scampered through puddles of raw sewage on the main floor, and I remember thinking of my obituary—she was found face-down in a puddle of raw sewage, and I got a bit depressed. I had a little bulletproof vest hidden under my abaya, with basically two plates that I had no confidence could save me from a stabbing much less tank fire. Qais and the Iraqi man led me up a concrete stairwell, up half a flight, and qais and I crouched low underneath a window, behind the continuation of the stairwell, him covering my body with his own. the owner of the house crouched directly beneath the window, and I thought—shit, I should be taking photos. Only in times like this do I actually pray and revert back to ten hail mary's I once recited after my first confession, when I lied to the priest because I had nothing to confess. I told him I had stolen bubble gum and was instructed to recite the same hail mary's I always start saying when I am about to die . . . maybe because it is the only prayer I ever actually learned growing up? the sound of tank fire ricocheted all around me, that I realized I am completely crazy.

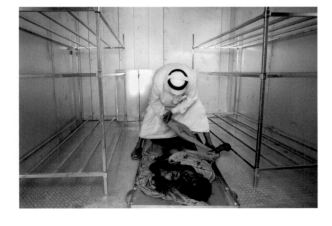

Abdul Munim Ali Hamood wraps the body of his only son in the Al Karama morgue after he was killed in a car bomb attack in Baghdad, Iraq, June 2004.

April 7, 2004

By Jay DeFoore

'NY Times' Photographer,
Reporter Kidnapped in Iraq

Freelance photographer Lynsey Addario and New York Times
reporter Jeffrey Gettleman were detained at gunpoint
on the road to Falluja today at approximately 4:00 p.m.
Iraqi time. They were held for about three hours and
later released unharmed, according to Times foreign
picture editor Cecilia Bohan.
 A spokesperson for Corbis, Addario's agency, described
the photographer as "shaken" but "fine and safe." Addario
and Gettleman were reportedly on the road to Falluja,
a flashpoint in the violent Sunni uprising, when the
abduction occurred.

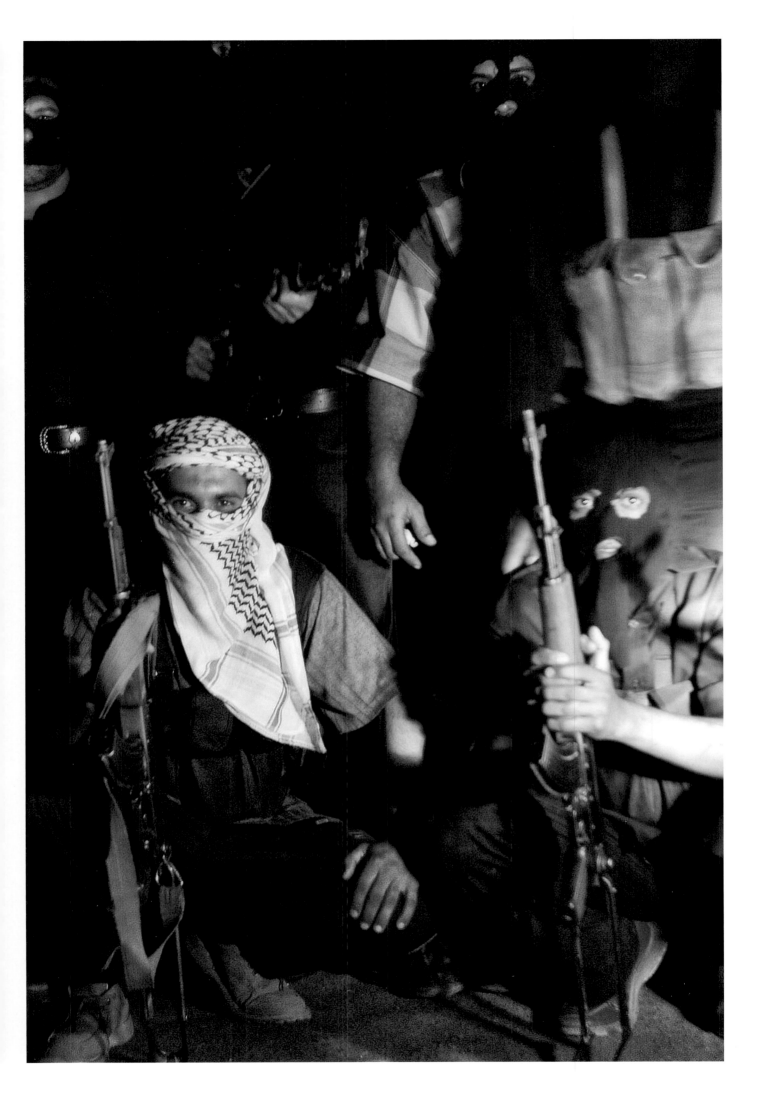

Members of the Mahdi army patrol the streets in Sadr City, Iraq, July 2004.

American soldiers from the Eighty-second Airborne Division, Second Brigade, walk through a house in the Aldora section of Baghdad during an early-morning house-to-house search for weapons, June 2003.

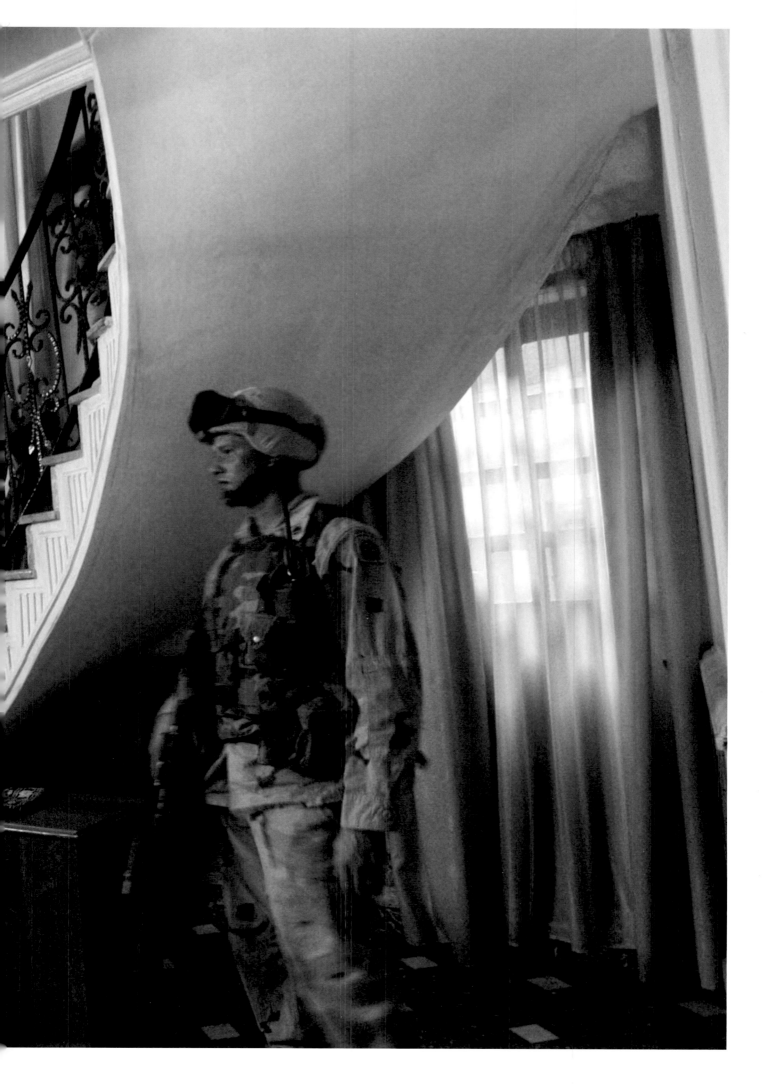

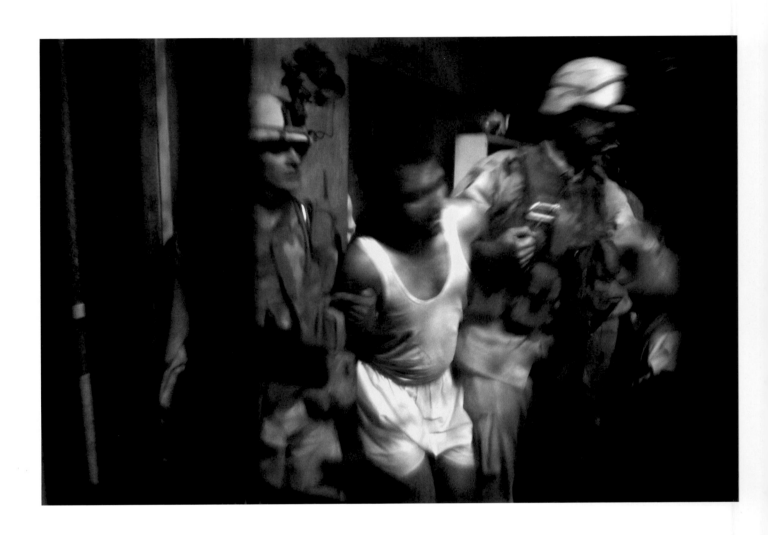

Soldiers with the Fourth Infantry Division detain an Iraqi found on a compound.
American intelligence indicated that the compound belonged to members of the
Baathist party and supporters of former Iraqi leader Saddam Hussein, near Balad,
Iraq, June 2003.

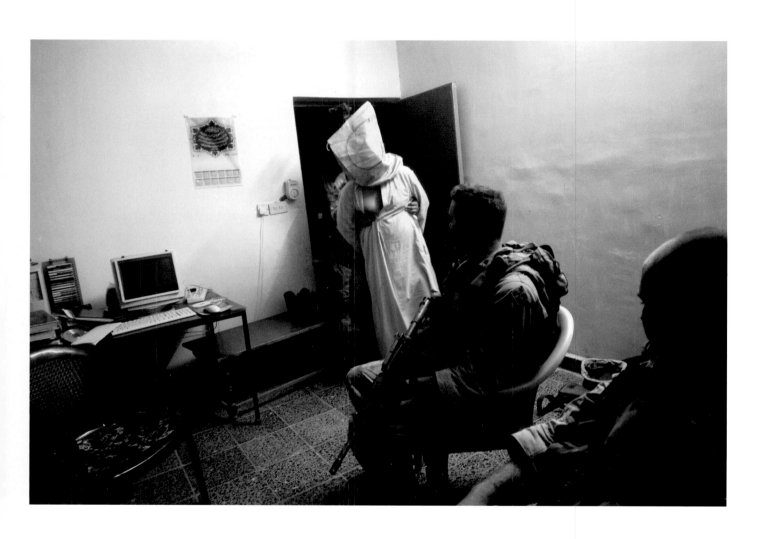

Soldiers with the Fourth Infantry Division escort a detainee to be photographed
in a compound thought to belong to members of the Baathist party and supporters
of former Iraqi leader Saddam Hussein, about thirty kilometers north of Baghdad,
near Balad, Iraq, June 2003.

93

An Iraqi man detained by soldiers with the Fourth Infantry Division stands
bound against a wall, near Balad, Iraq, June 2003.

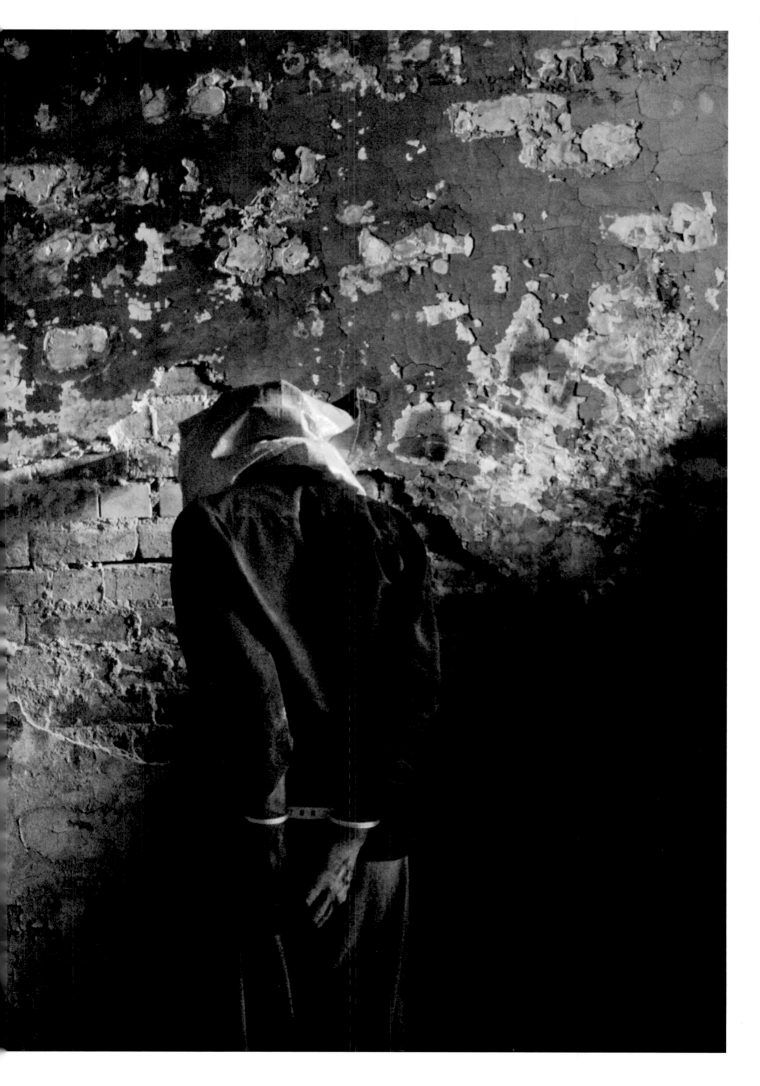

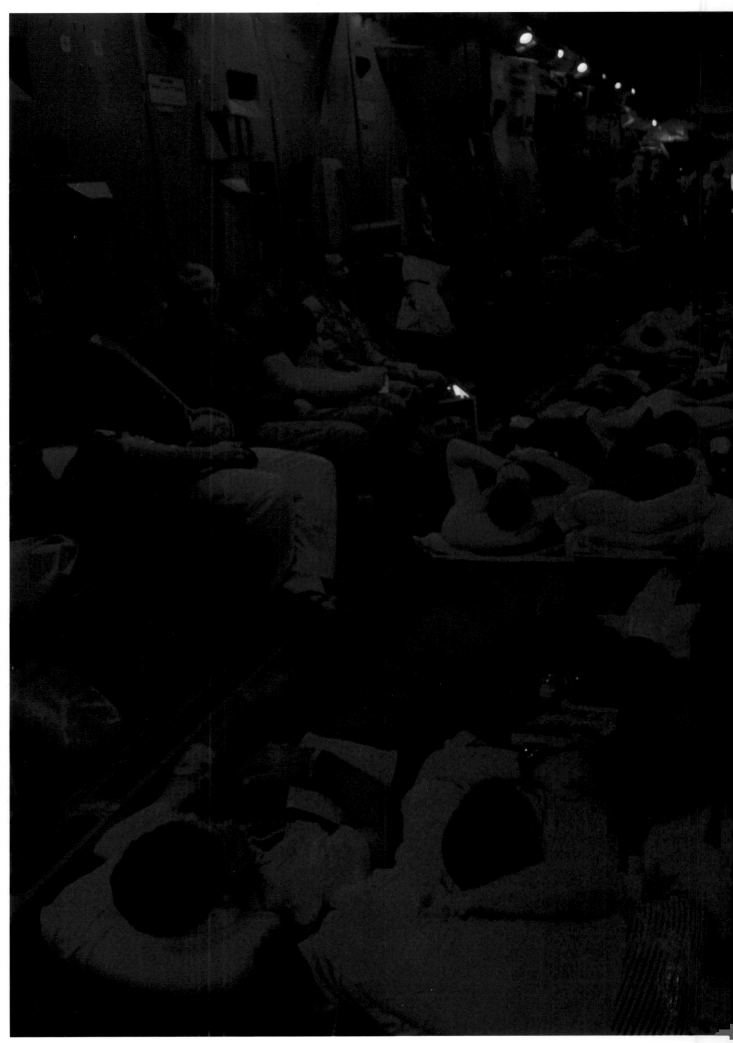

Injured US soldiers are loaded onto a cargo plane before taking off for Germany from the Balad Air Base in Iraq. The interior lights of the plane are red because of an "alarm red" code, indicating the base is under attack, November 2004.

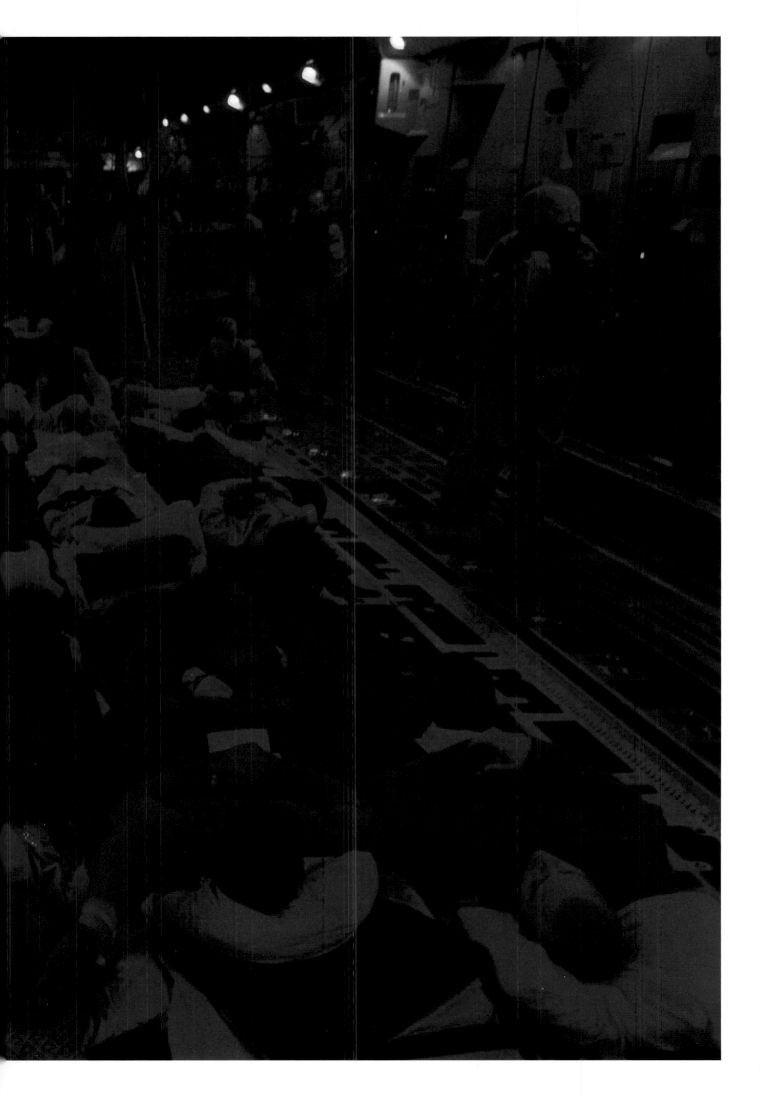

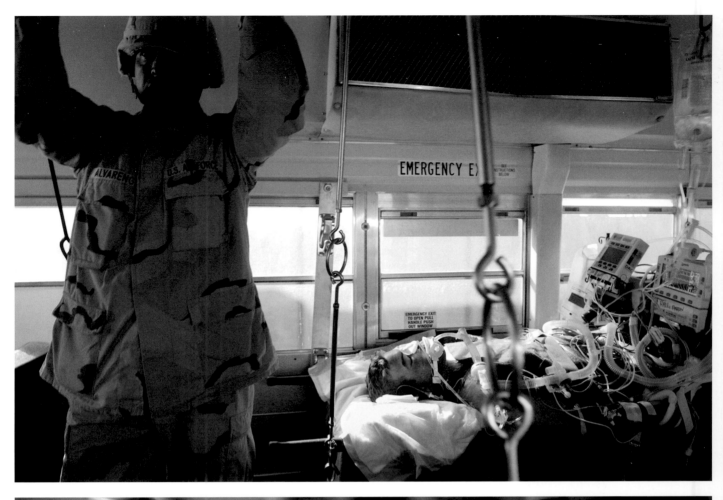

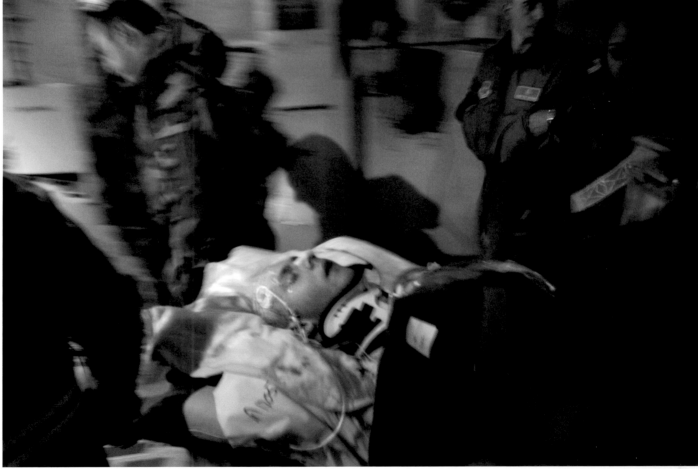

US Marines wounded in the Battle of Fallujah are treated by Navy doctors and prepared
for evacuation to Germany at the Balad Military Hospital, Iraq, November 2004.

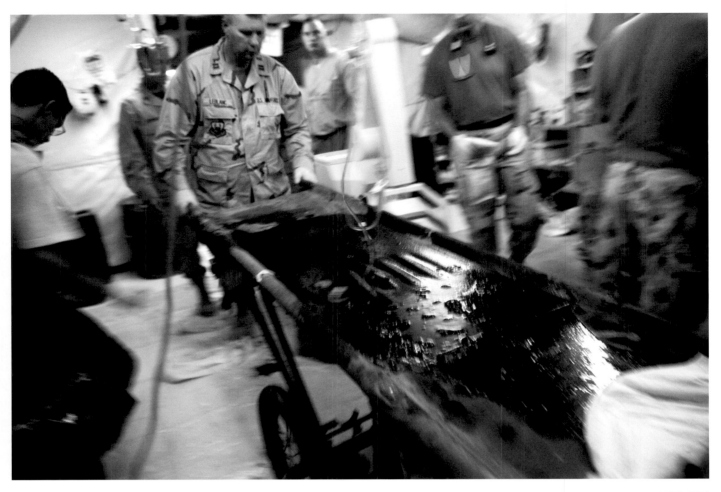

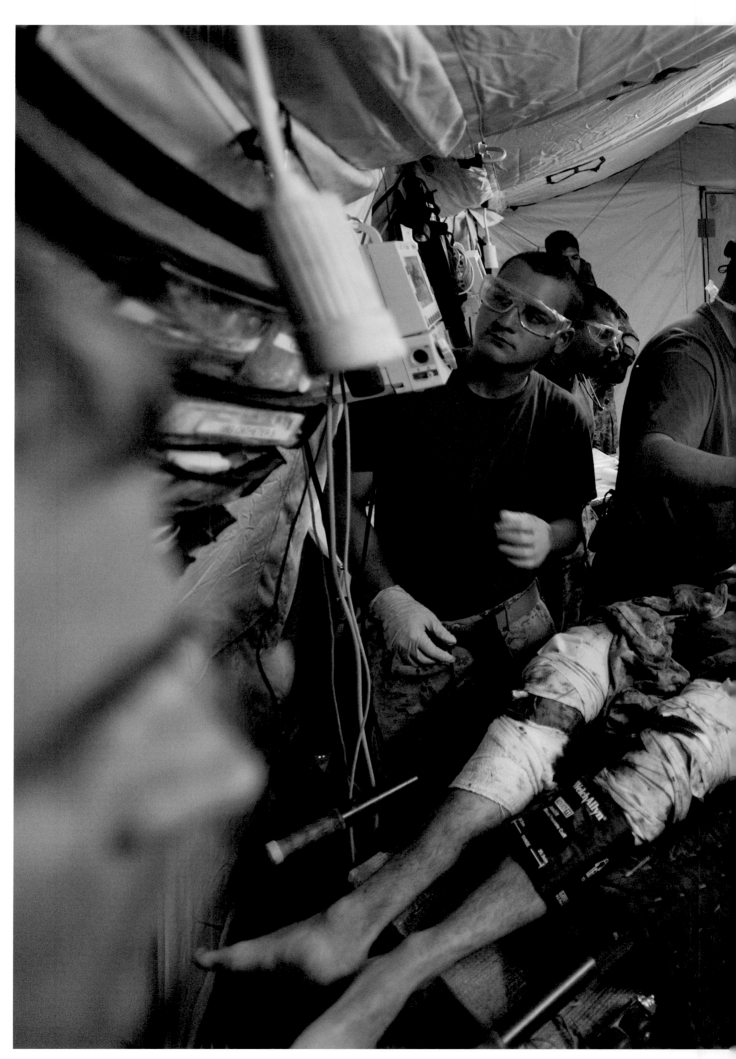

Above and following pages US Navy doctors attached to the Marines in southern Afghanistan try to save the life of Lance Corporal Jonathan A. Taylor of Jacksonville, Florida, after he stepped on an explosive device during a patrol in Helmand Province, Afghanistan, December 2009.

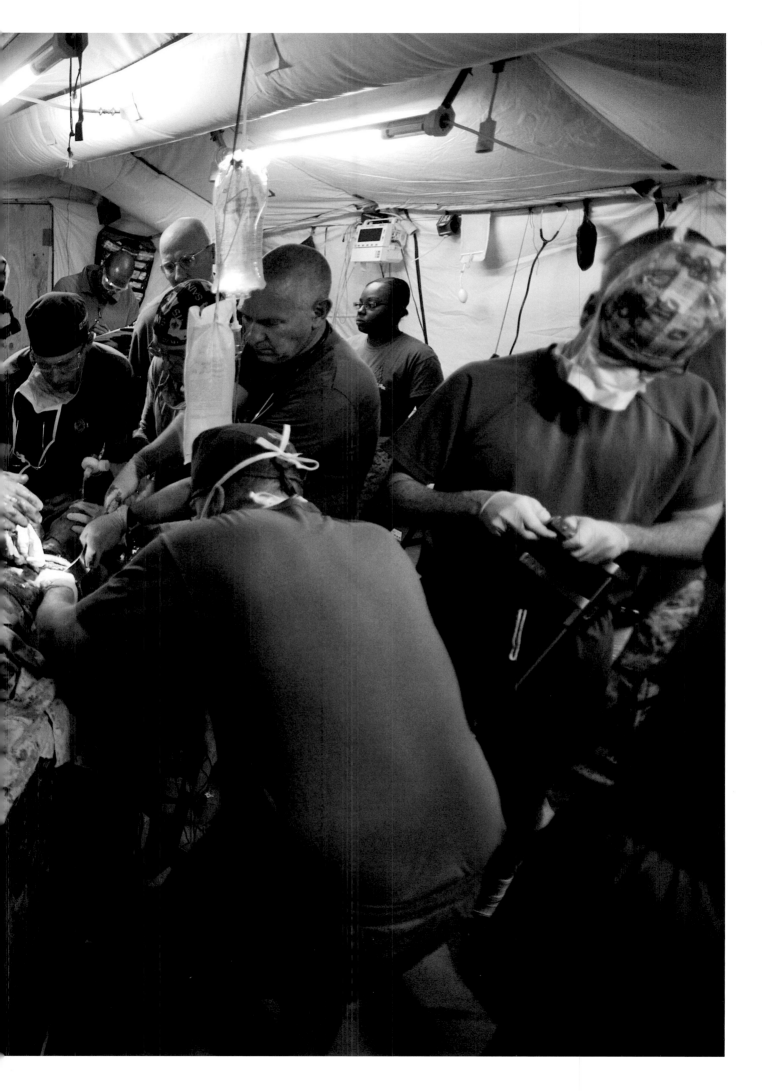

101

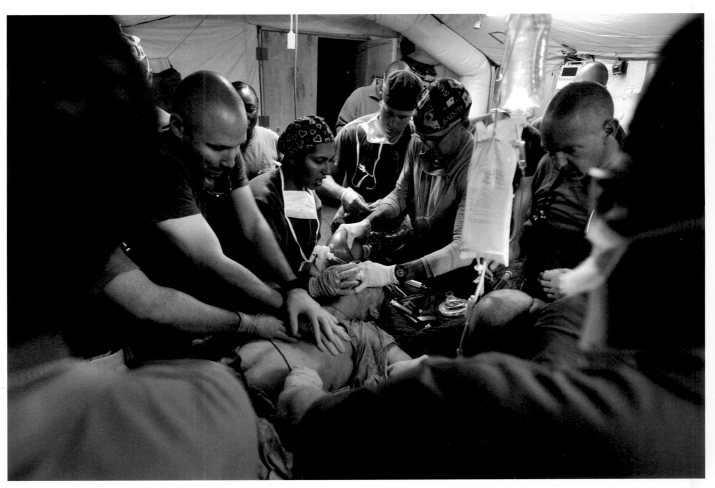

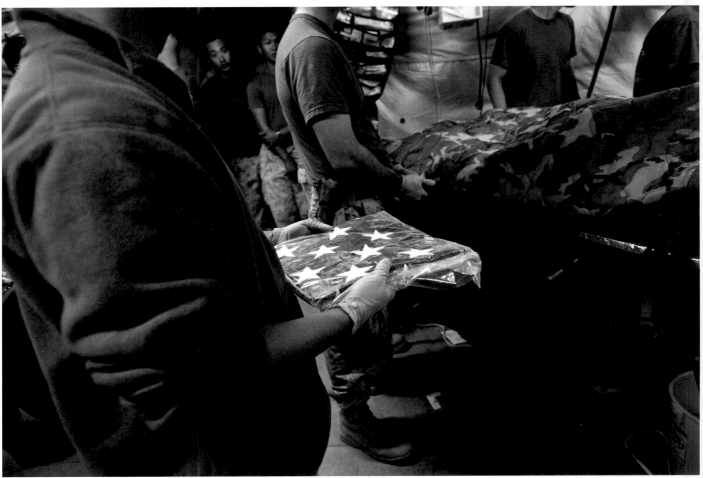

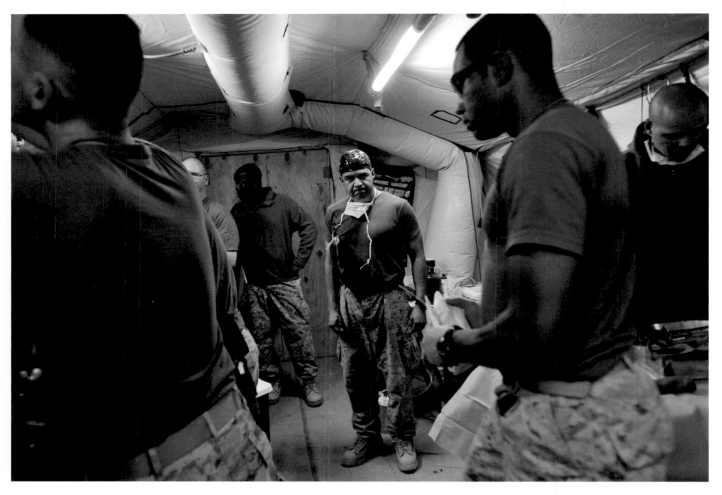

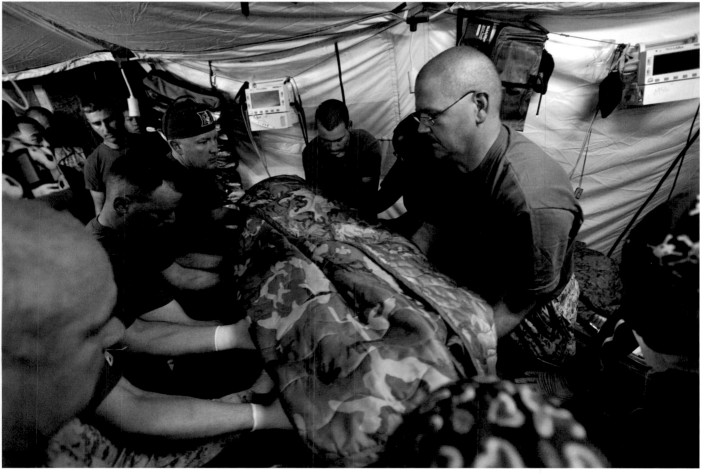

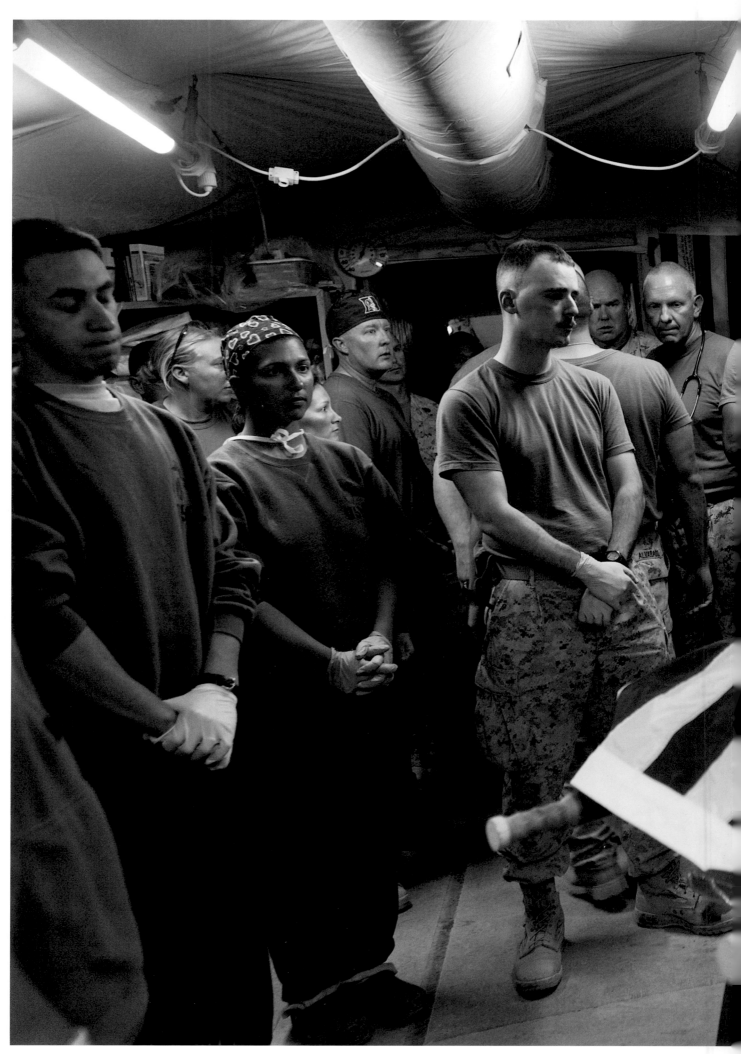

Doctors and corpsmen pay their respects to Lance Corporal Jonathan A. Taylor minutes after he was pronounced dead at Dwyer base in Helmand Province, Afghanistan, December 2009.

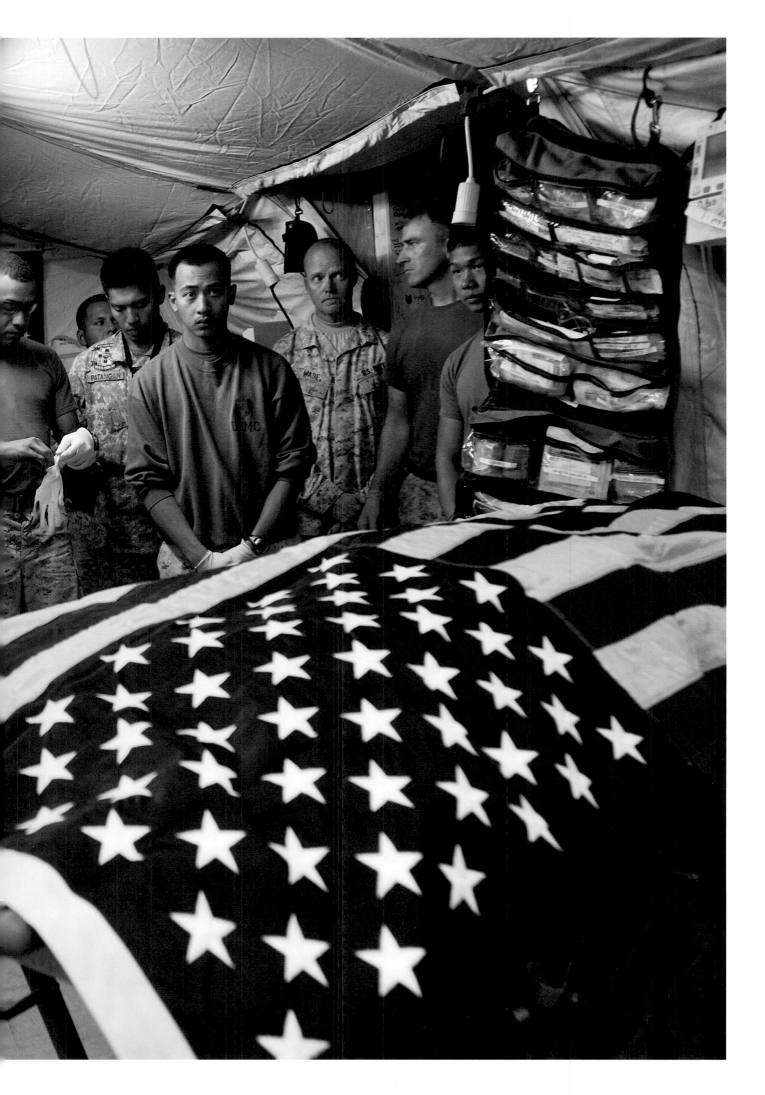

Doctors and corpsmen transfer the body of Lance Cpl. Taylor to a temporary morgue
on the base, Helmand Province, Afghanistan, December 2009.

Women
in the
Military

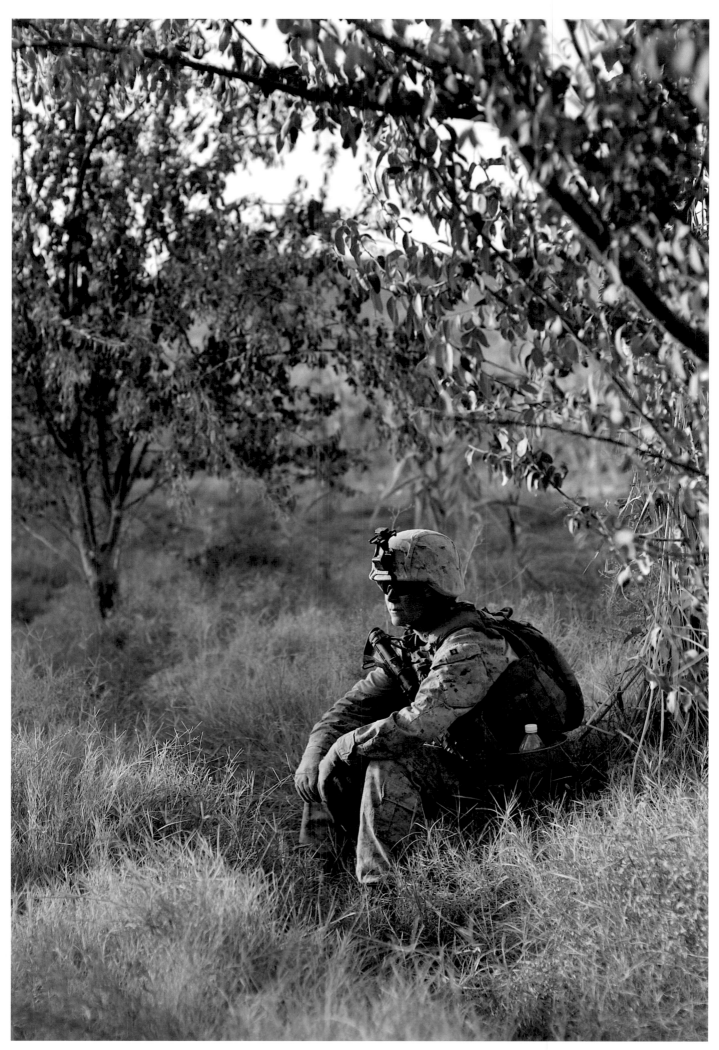

US Marine Captain Emily Naslund with a female engagement team from
the Second Battalion, Sixth Marine Regiment, rests while on patrol in Marjah,
southern Afghanistan, September 2010.

What Women Bring to War

"Female engagement teams" (FET) were all-female units attached to all-male infantry patrols in southern Afghanistan. These teams were the US military's way of engaging and winning over the half of the Afghan population it hadn't been able to access with all-male troops. They were also some of the first female units allowed to patrol on the front line.

For years I had been covering the US military on the front lines of wars in Iraq and Afghanistan: From the Special Forces in Kandahar in December 2001, to night raids in the Sunni Triangle, Iraq, with the US Army in 2004, to a two-month embed in the explosive Korengal Valley in 2007, I was always either the only woman or one of a few women among dozens of twentysomething-year-old men, bursting with testosterone. So when I was assigned to cover the FET for the *New York Times* in 2009 and 2010, I was immediately situated in the all-female hooches, or living quarters, at remote bases.

The female living quarters were off-limits to men, and I was thrilled to have the privilege of seeing what other women on the front line looked like. What did *they* bring with them to war? Did they, like me, pack their bags with delicious-smelling moisturizing lotions to remind them of home? Or, like me, put on makeup in the shadow of their helmets in an attempt to retain some semblance of femininity even as we also tried to be strong and tough enough to keep up with the men? When female units began appearing on the front lines of war in Afghanistan, I finally felt like I was one step closer to documenting a perspective of war that I had experienced but that outsiders had rarely seen.

Top Chief Warrant Officer 2 Jesse Russell, a US Army pilot with the medevac unit from the Eighty-second Airborne, Charlie Company, does a test run-up before flying at Dwyer base in Helmand Province, Afghanistan, December 2009.
Bottom US Marines with female engagement teams attached to the Third Battalion, First Marines.

Packing List

Over the years I developed a ritual for packing before I went on a trip. A few days before I traveled, I laid out a set of clothes appropriate for whatever destination and spent the subsequent few days before my flight weeding out what I really didn't need.

I had a "work" closet. Inside it were jeans, linen tunics, head scarves, abayas, travel towels, silk sleep sacks, sleeping bags, raincoats, North Face jackets, earth-toned pocketed hiking pants, thin thermal tops for layering on military embeds, my favorite Banana Republic cashmere zip-up hoodie, a set of exercise clothes, running shoes, hiking boots, flip-flops, and one or two nice outfits or easily packable dresses and a pair of heels, because I inevitably passed time everywhere by spending one or two nights out on the town—even in Kabul—and I didn't like looking frumpy. I also stored different hijabs that were appropriate for different Muslim countries: Sudan, Saudi Arabia, Iran, Afghanistan. Each country had a different style and required a different degree of modesty, and it took me years to amass the proper variation in dress. If I was going on a military embed, I added a flak jacket (bulletproof vest), helmet, warm clothes or loose pants, and nothing camouflage, as I never wanted to be mistaken for a soldier.

I prepared my 90ml travel containers full of my favorite shampoo, conditioner, body lotion, shower gel, and face soap. I packed saline solution, bug spray, toothpaste, wet wipes, hand sanitizer, antibiotics like Cipro, and, somewhere around age thirty-five, I began adding expensive antiwrinkle serums and creams.

For sustenance, I carried enough Starbucks instant coffee packs for at least two cups of coffee per day, a ziplock bag full of nondairy creamer, and another one with sugar (because my coffee was the one thing I couldn't live without), as well as a wide variety of energy bars to avoid losing my mind if forced to live on them every day. (My favorites were Pure Protein Vanilla, thinkThin Peanut Butter, and Harvest Energy and Clif bars for breakfast.)

Most of the weight in my bag would be allotted to cables. Electricity was always iffy, so I carried cables and accessories for everything: an inverter to run a laptop or satellite phone off a car battery, a satellite dish for transmitting images, a Thuraya handset satellite telephone, an electric coil to heat water, a multi-outlet power strip, a spare cell phone for a local SIM, three to four pocket drives to store and back up images, a laptop, an extra charger in case one blew out, a headlamp, USB cables, my cameras, extra batteries, and enough compact flash cards to sustain me for at least a few days.

And last but not least, there were the scents. A dear friend and photographer for the *Miami Herald,* Carl Juste, taught me a very valuable lesson about packing early on, in Baghdad, during the summer of 2003. I was staying in his room at the Al Hamra Hotel for a few weeks after Saddam fell, and was surprised to find his bathroom full of oils, lotions, soaps, and delicious-smelling candles. *Girl, you got to smell goooooooood. You have to bring your things with you from home, so you feel goooooooood when you are working hard in a war zone.*

It made sense. If I could find space in my bag for a flak jacket, helmet, and head scarves, why couldn't I bring my L'Occitane lotion and verbena soap, which made me so happy? Since then, I always made sure I had travel candles and incense with me, too.

Me, on patrol with the female engagement teams and the Marines in Helmand Province, Afghanistan, September 2010.

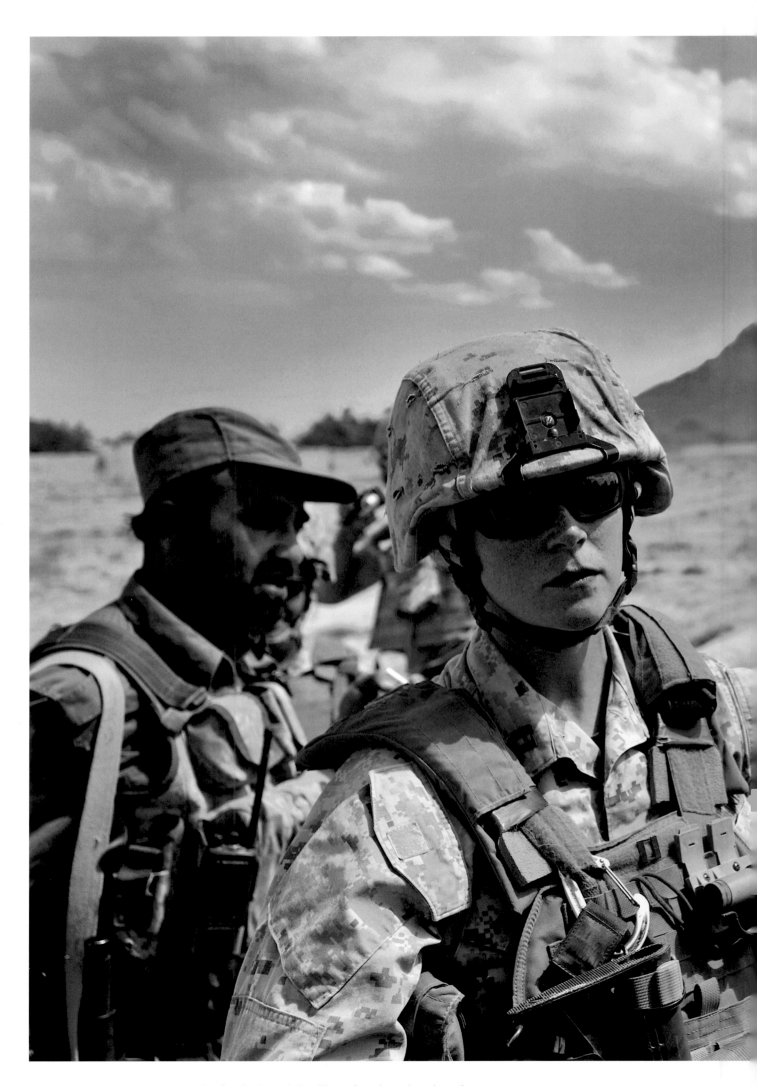

Marine Captain Naslund walks through the village of Soorkano, in Helmand
Province, Afghanistan, May 2010.

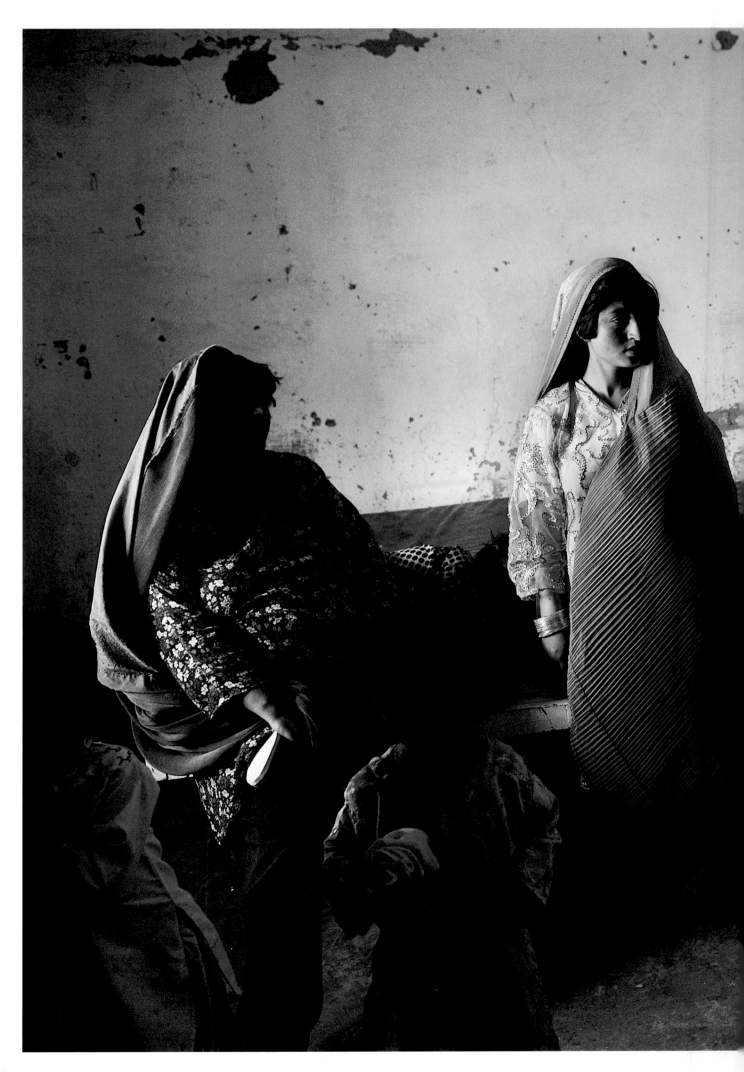

Lance Corporal Elisabeth Reyes, twenty, visits with Afghan women and their children at the clinic in Nowzad, in northern Helmand Province, Afghanistan, May 2010.

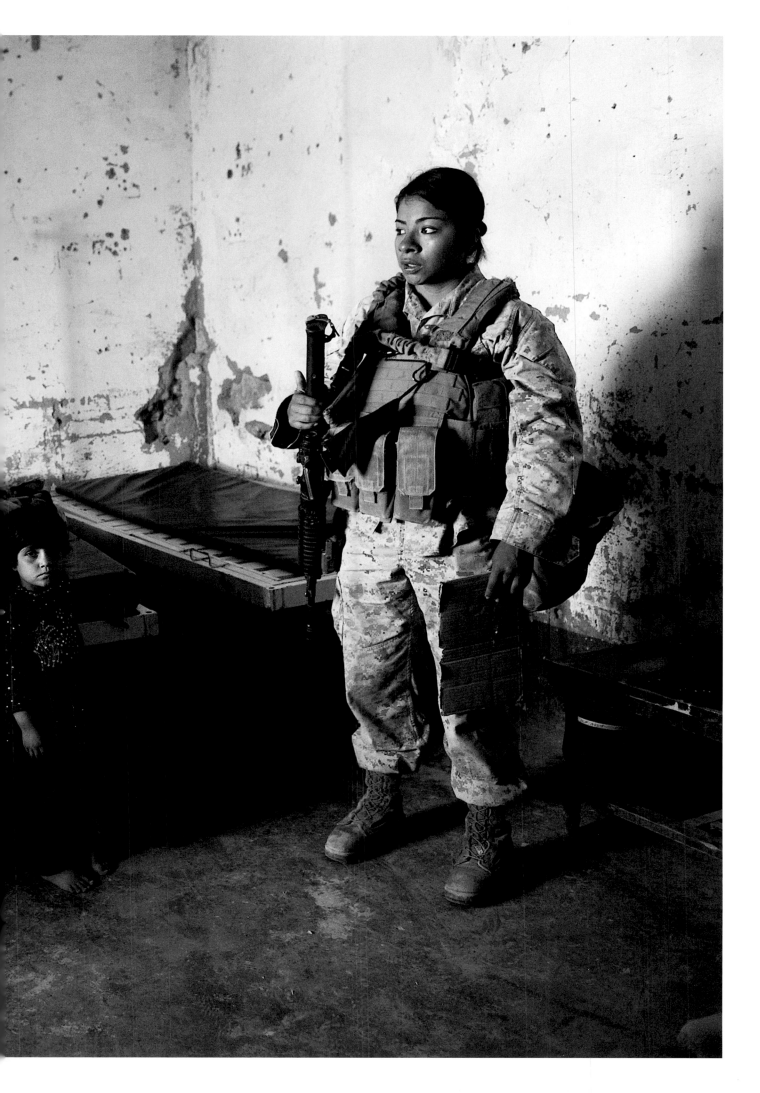

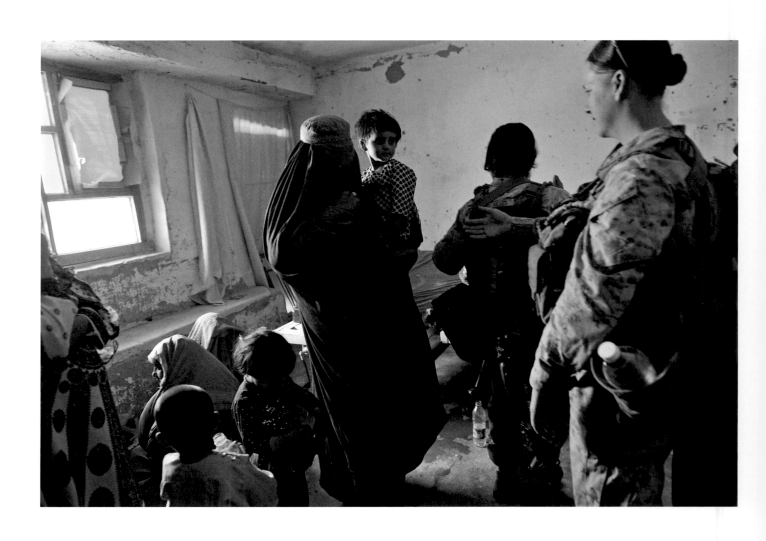

Lance Corporal April Whitham, twenty-seven, greets Afghan women
and their children at the clinic in Nowzad, Afghanistan, May 2010.

Corporal Lisa Gardner takes the vitals of a group of Afghan women in the village
of Lakari during a medical outreach in Helmand Province, Afghanistan, May 2010.

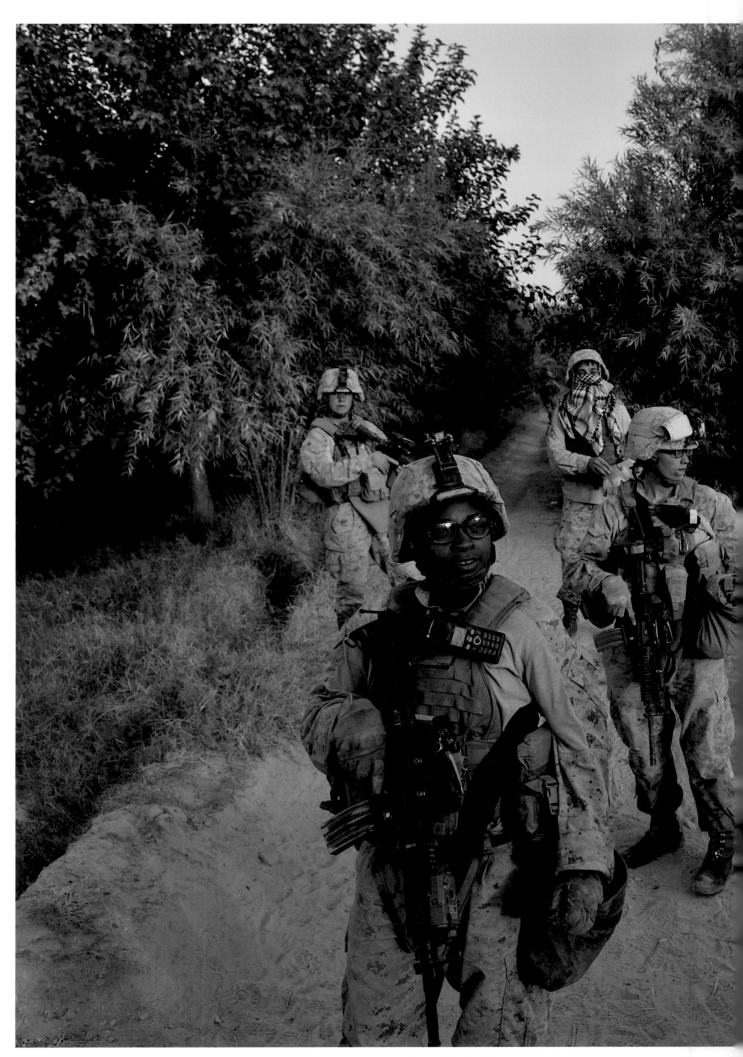

Corporal Christina Oliver (center), twenty-five, stands among members of the female engagement teams attached to Second Battalion, Sixth Marine Regiment, during a patrol through the village of Sistani, in southern Marjah, Afghanistan, September 2010.

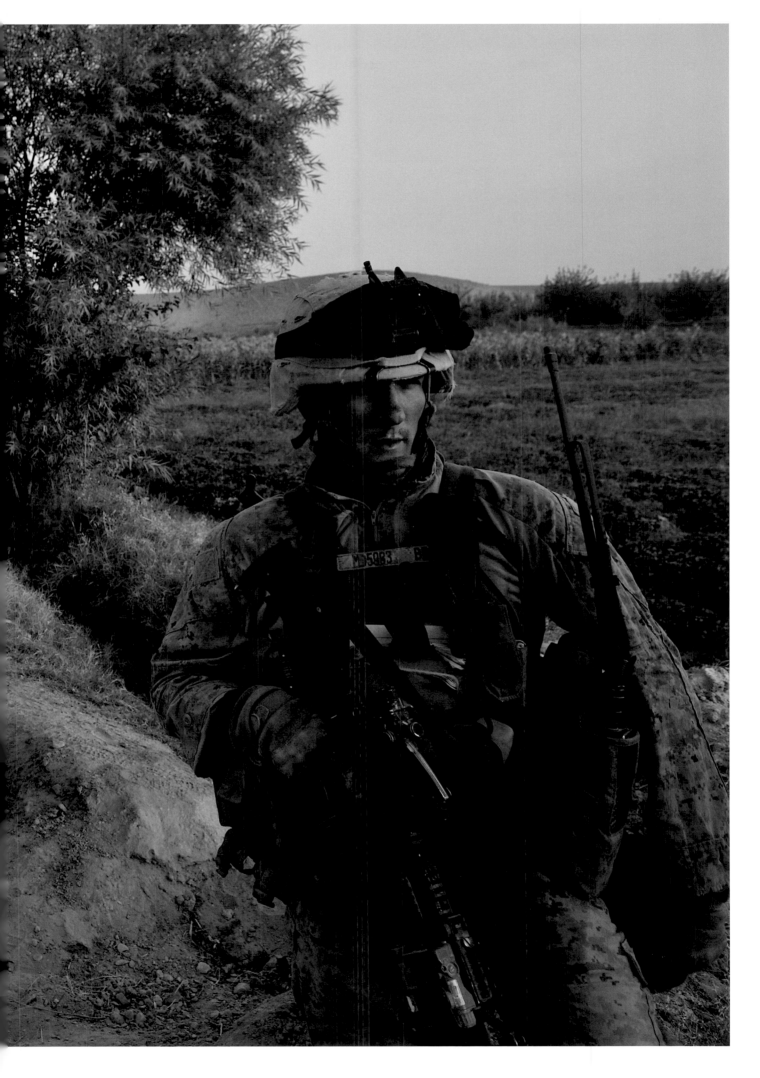

Chief Warrant Officer 2 Jesse Russell checks her helicopter before flying
at Dwyer base in Helmand Province, Afghanistan, December 2009.

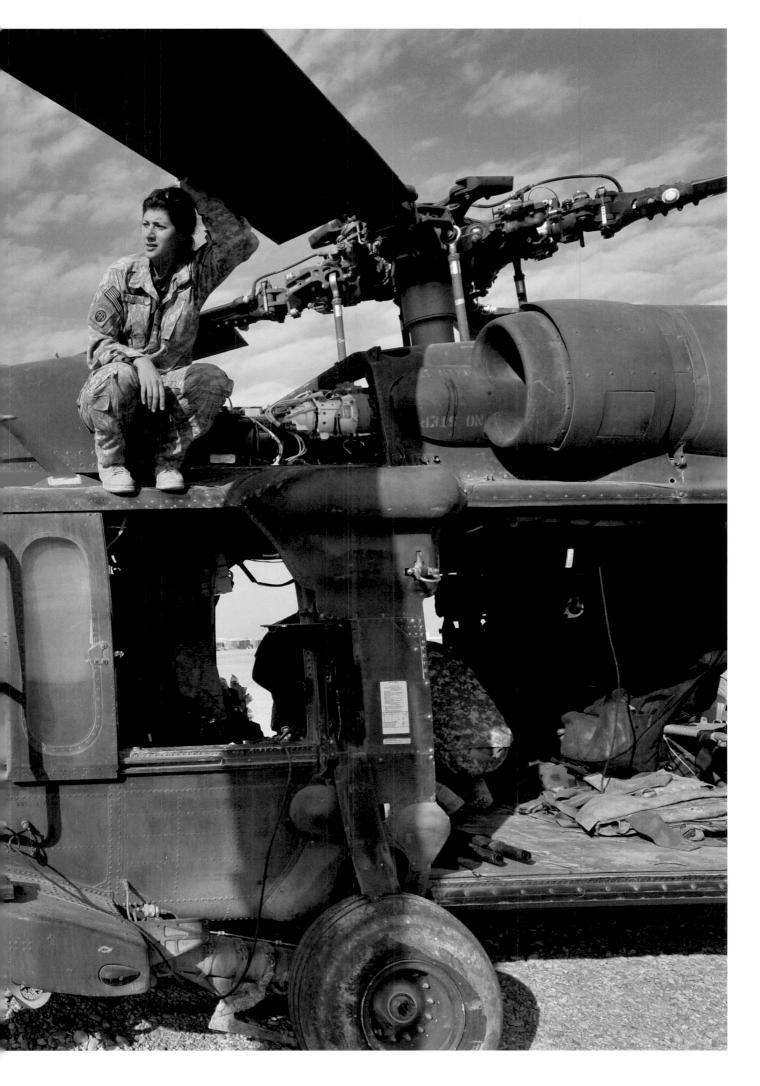

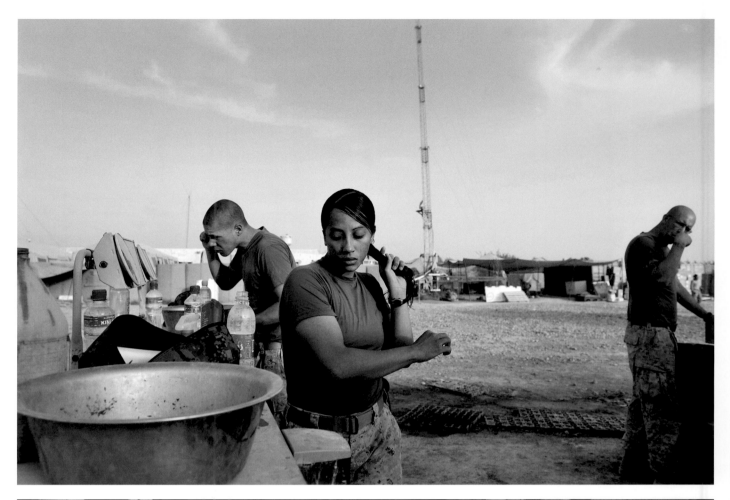

Top Lance Corporal Darlene Diaz, twenty, washes up in the morning at the makeshift sinks at COP Sher, in Helmand Province, Afghanistan, May 2010.
Bottom A Marine fixes her hair during downtime in Nowzad, Helmand Province, Afghanistan, April 2010.

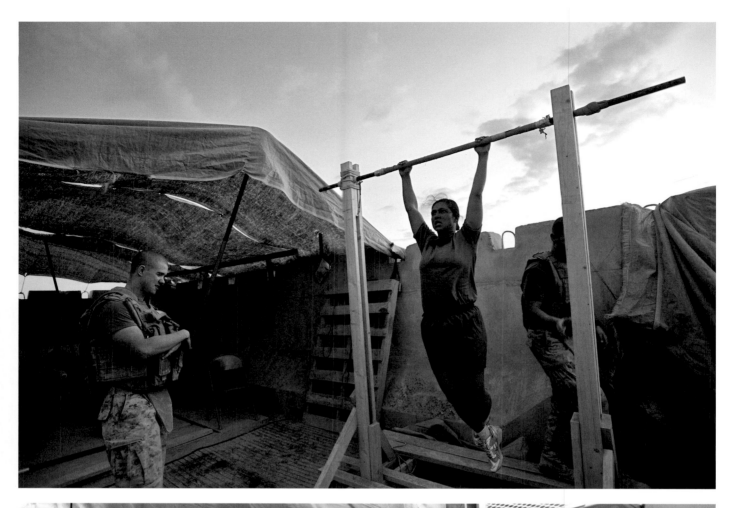

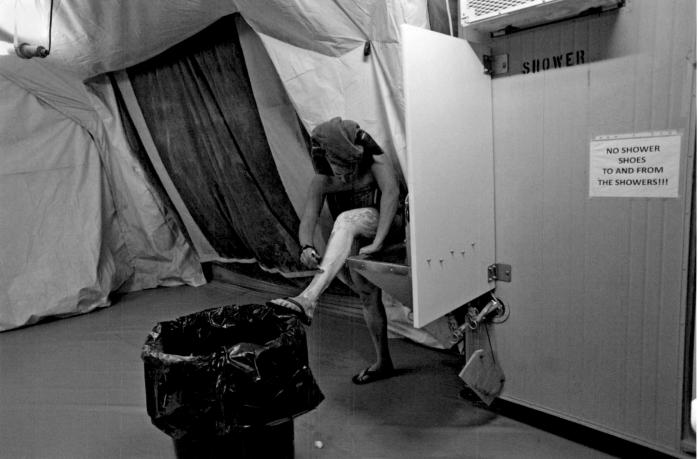

Top Navy Lieutenant Commander and anesthesiologist Rupa Dainer works out with fellow troops at Camp Dwyer, in southern Afghanistan, December 2009.
Bottom Navy Lieutenant Amy Zaycek, Nurse Corps, with the First Medical Battalion, Alpha Surgical Company, Shock Trauma Platoon, shaves her legs in the female bathroom at Camp Dwyer, in Helmand Province, Afghanistan, December 2009.

Hospital 2 Corpsman Elena Woods, twenty-four (right), cleans her gun after
returning from Forward Operating Base (FOB) Delhi, in Helmand Province,
Afghanistan, April 2010.

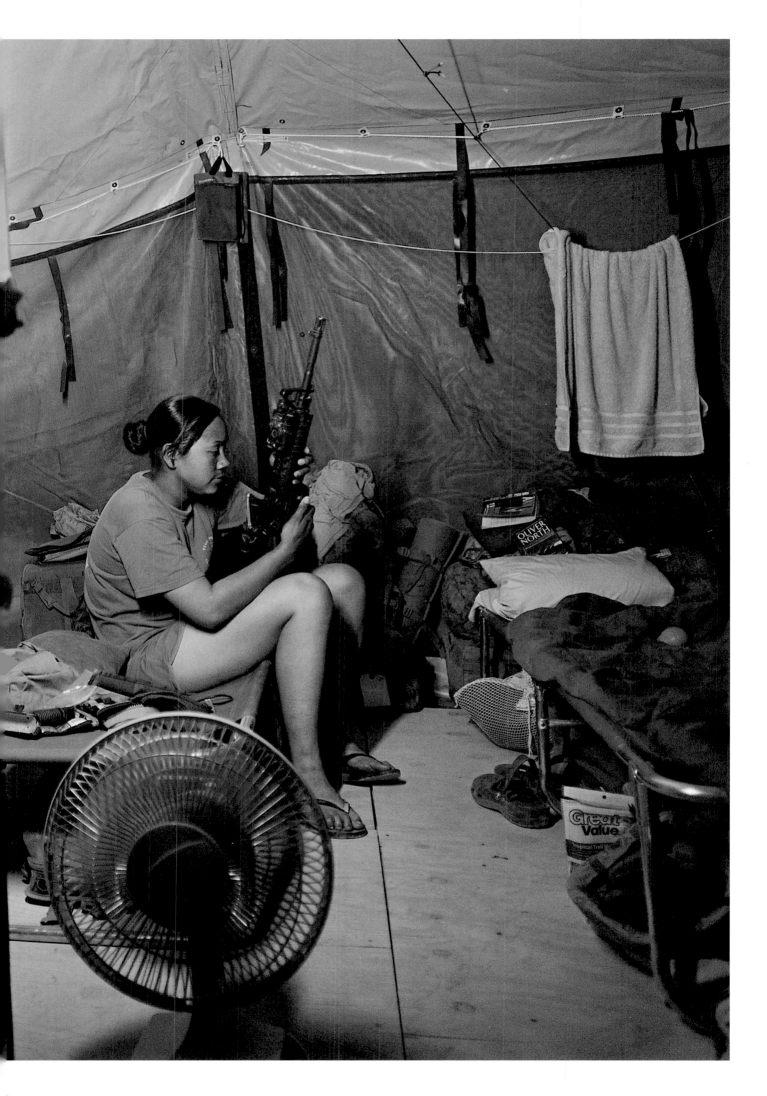

Lance Corporal Stephanie Robertson, twenty, a member of a female engagement team attached to Second Battalion, Sixth Marine Regiment, watches *Finding Nemo* on her laptop at a forward operating base for Fox Company in southern Marjah, Afghanistan, September 2010.

Women's
Issues

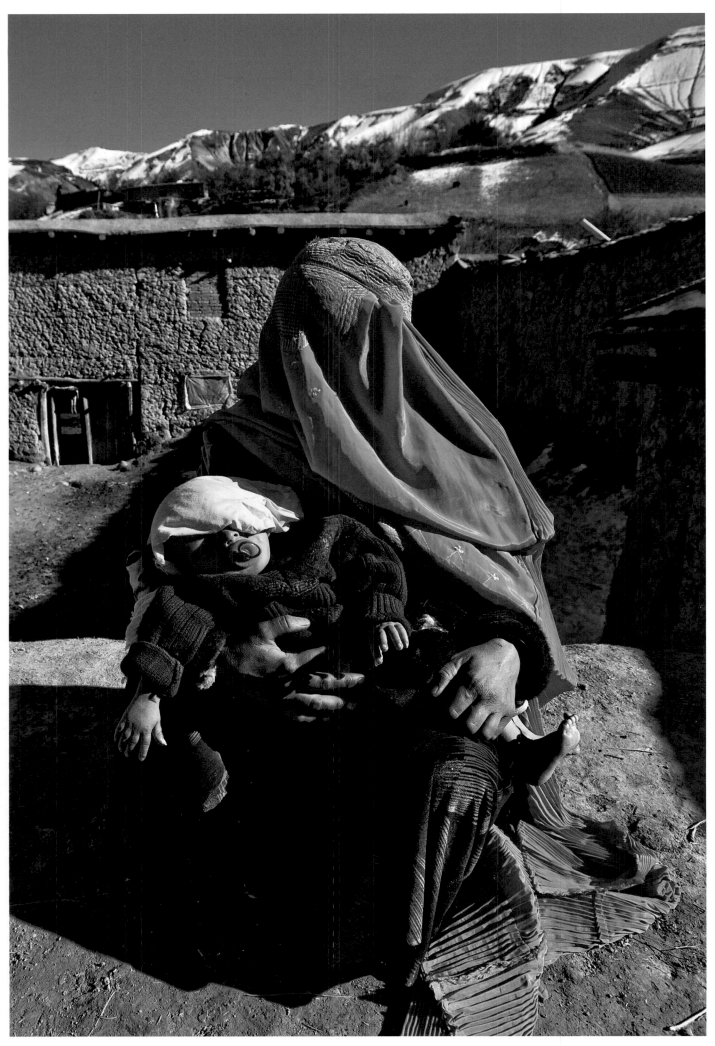

An Afghan woman sits with her baby while awaiting a medical check from a midwife with the
NGO Merlin, sponsored by the United Nations Population Fund (UNFPA), in the compound
of a private home in a village in the Shahr-e Bazorg district, Afghanistan, August 2009.

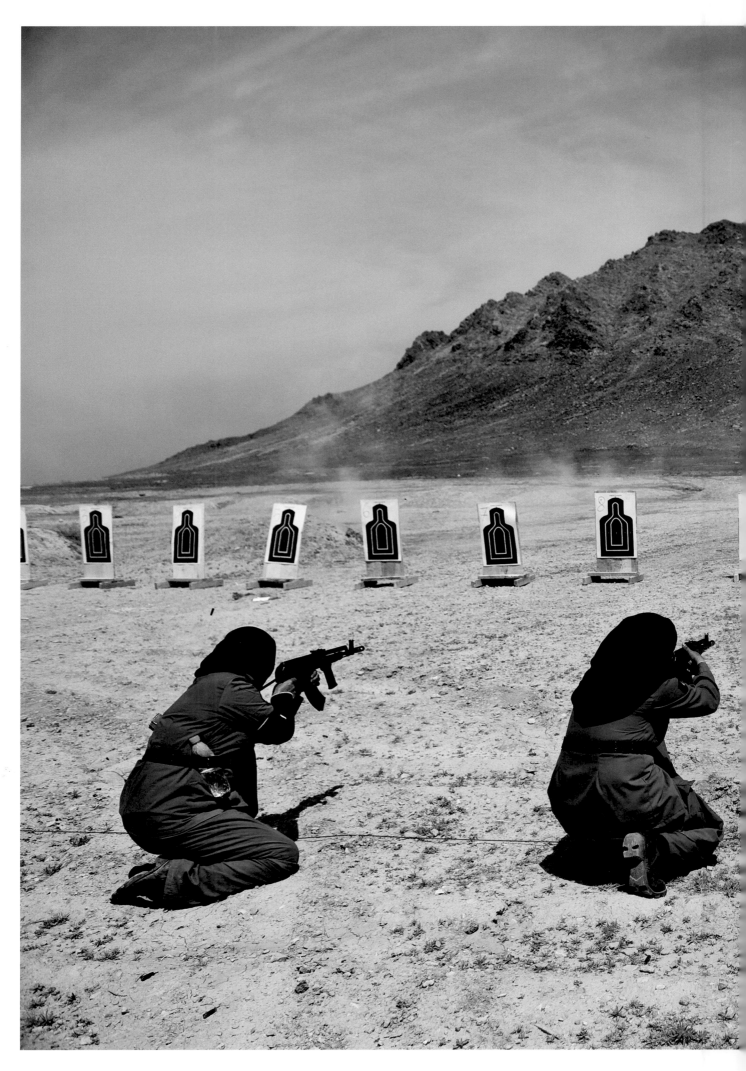

Afghan female police are trained at a firing range by the Carabinieri of the Italian military, outside Kabul, Afghanistan, April 2010.

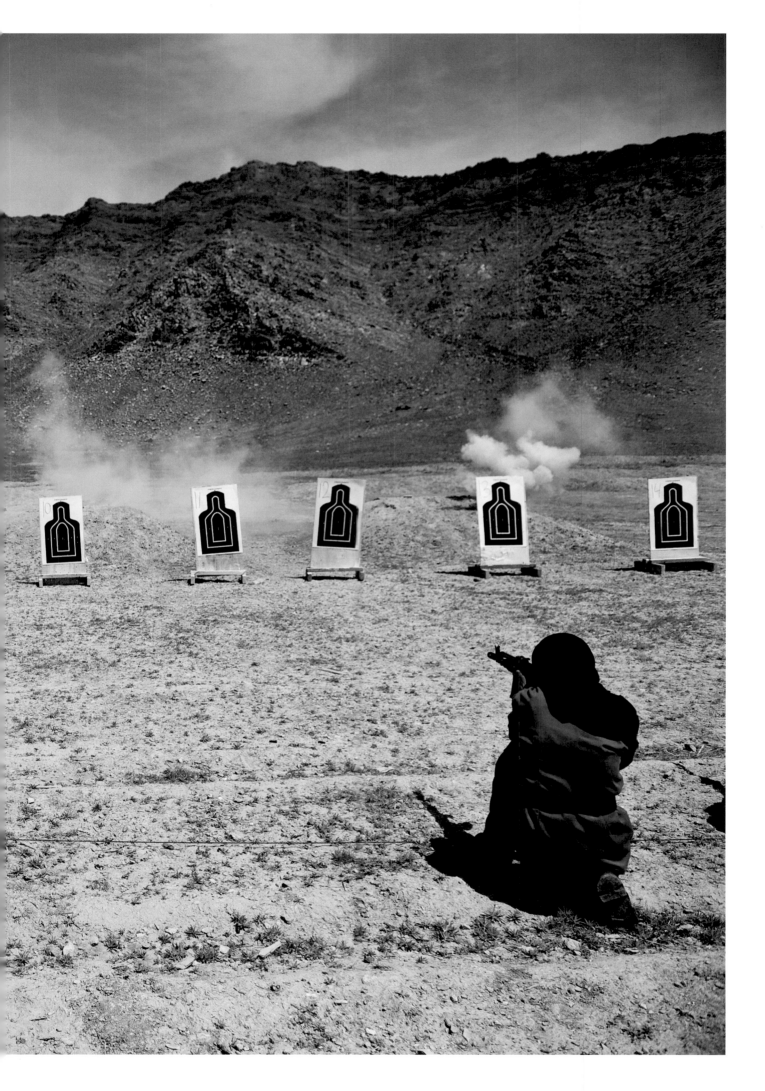

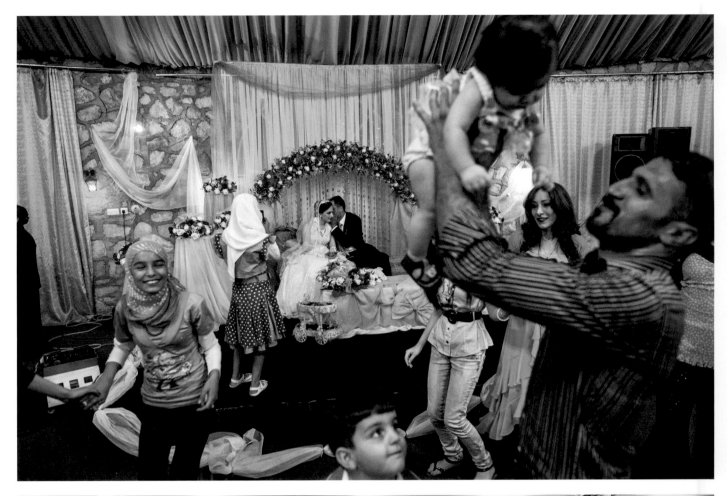

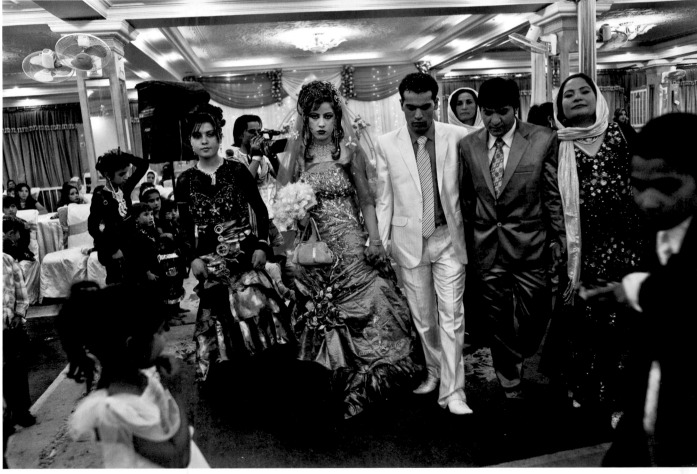

Top Some three hundred guests celebrated for two days when bride Heelan Muhammad, twenty-three, married Husham Raad, thirty. "Daily life isn't always easy," says Raad Ezat-Khalil (with baby), the groom's cousin and matchmaker, but "the most important thing is how strong and determined people are." Baghdad, Iraq, October 2010.
Bottom At this wedding, the groom is Amin Shaheen, son of film director Salim Shaheen. The bride, Fershta, is eighteen years old. Kabul, Afghanistan, October 2009.

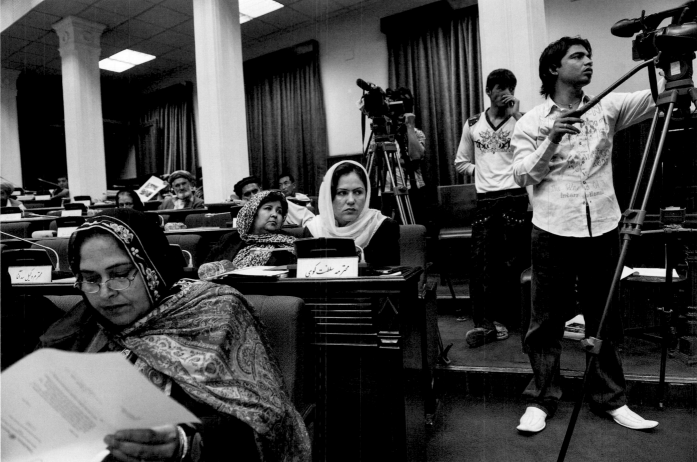

Top Fatima, twelve, puts on makeup as her little sister, Sarah, seven, watches before they go to a party in Kabul, Afghanistan, September 2009. The two girls are the daughters of Afghan parliamentarian Shukria Barakzai, who was born in Afghanistan and has lived in Kabul her entire life. Shukria's siblings and her parents live abroad. She is an Afghan politician, journalist, and entrepreneur, and a prominent champion of women's issues and rights in Afghanistan.
Bottom Afghan parliamentarian Fawzia Koofi attends a session of Parliament in Kabul, Afghanistan, April 2010.

133

When Women's Fate Is in the Womb

by Christy Turlington Burns
CEO and Founder of Every Mother Counts

The images in this chapter depict the plight of those who are born female in some of the most dangerous places in the world right now. Although most of these women are clearly vulnerable and struggling daily to survive, these images capture their inherent strength and resiliency. The photos are powerful reminders of all that women endure because they must, not because they have any choice in the matter.

By all accounts, worldwide, being born female is as inherently dangerous today as it ever was, because women are disproportionately affected by war, conflict, famine, and poverty. That may not come as a huge surprise, given that much of the world's population lives in extreme poverty, with the majority still being denied many of their basic rights. According to a 2017 study by the Guttmacher Institute, it is estimated that more than 200 million families have an unmet need for contraception. Giving birth is a death sentence for countless women and girls in the twenty-first century.

In some countries, to be pregnant is to have one foot in the grave because death in childbirth is so commonplace. Hundreds of thousands of women and girls die each year from complications related to pregnancy or childbirth. Ninety-nine percent of maternal deaths occur in the global south, with more than 60 percent found in just eleven countries. Many of these deaths occur in the countries in conflict depicted in the pages of this book, such as Afghanistan, Pakistan, India, South Sudan, Sierra Leone, and Libya.

Most women in these countries live miles away from health services or providers of any kind and have inadequate nutrition and lack transportation to medical care. There are not enough skilled health workers to handle the number of pregnancies. Many mothers are so young and malnourished that their babies are unable to survive pregnancy and childbirth. Other women bleed to death or die from infections long before they can get to the care they need, often because there are so many delays in identifying complications in time to save them.

For every woman who dies in childbirth, there are twenty to thirty more who suffer from long-term disabilities that can make life a living hell.

Preventing maternal deaths begins with the recognition that all women's lives have equal value. We know how to save lives. Now we must generate the political will to address the underlying systemic barriers that keep women at risk.

The hard truth is that a woman's fate is determined in the womb—the odds are stacked against her from the moment she draws her first breath. The fate of the girl child, no matter where she is born, may vary, but there are far too few places where she will be guaranteed equal rights. In some countries the question is: Will she get a chance to go to school, let alone complete her primary education? Girls who complete secondary education are more likely to delay pregnancy, have fewer children, and space out subsequent pregnancies. In other countries it is likely that she will become a child bride or sold into slavery before she reaches adolescence. The access to reproductive health information and services that can better ensure her ability to someday control and protect her own body to prevent or delay pregnancies—and the freedom to choose motherhood—remains precarious.

When a girl child has the misfortune of being born during war or a humanitarian crisis, the odds of surviving and thriving diminish even further. Should she survive labor, how does a mother provide for her family when food and water are scarce? What if she is forced to flee her country for safety while pregnant or with small children? Or, worse, what if she is raped while seeking asylum? Imagine being displaced from everything that you once knew and attempting to raise your family in a refugee encampment. The plight of women continues and will go on until the rest of the world wakes up and opens its eyes.

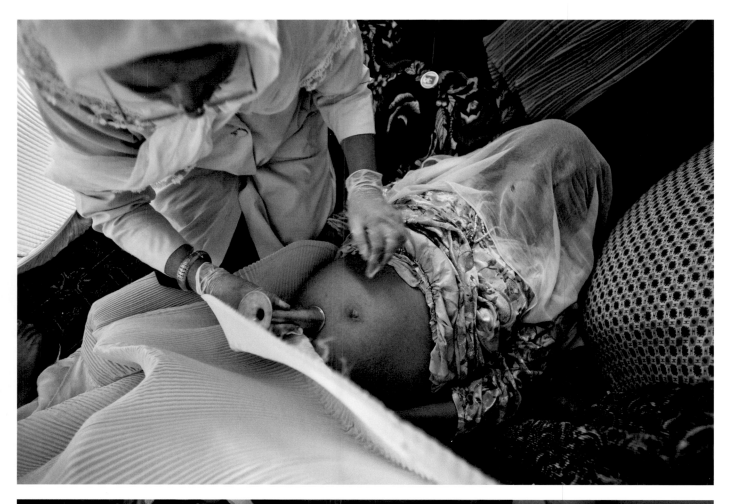

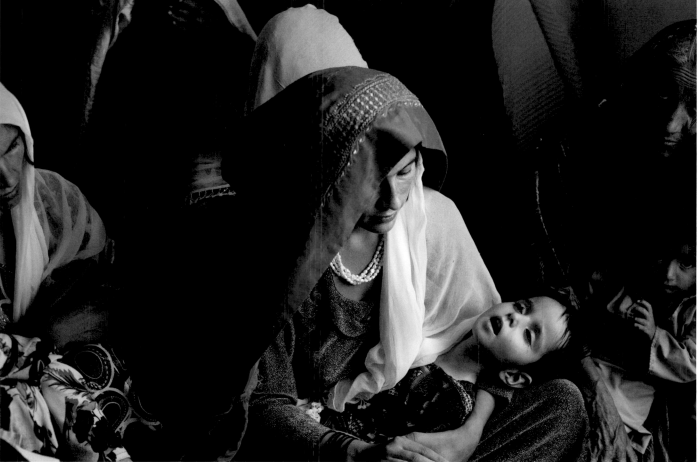

Above and following pages Afghan women are offered prenatal and postnatal care and given counseling by Dr. Zubeida, a midwife from the mobile health unit funded by UNFPA, in Charmas village, a remote area of Badakhshan Province, Afghanistan, August 2009.

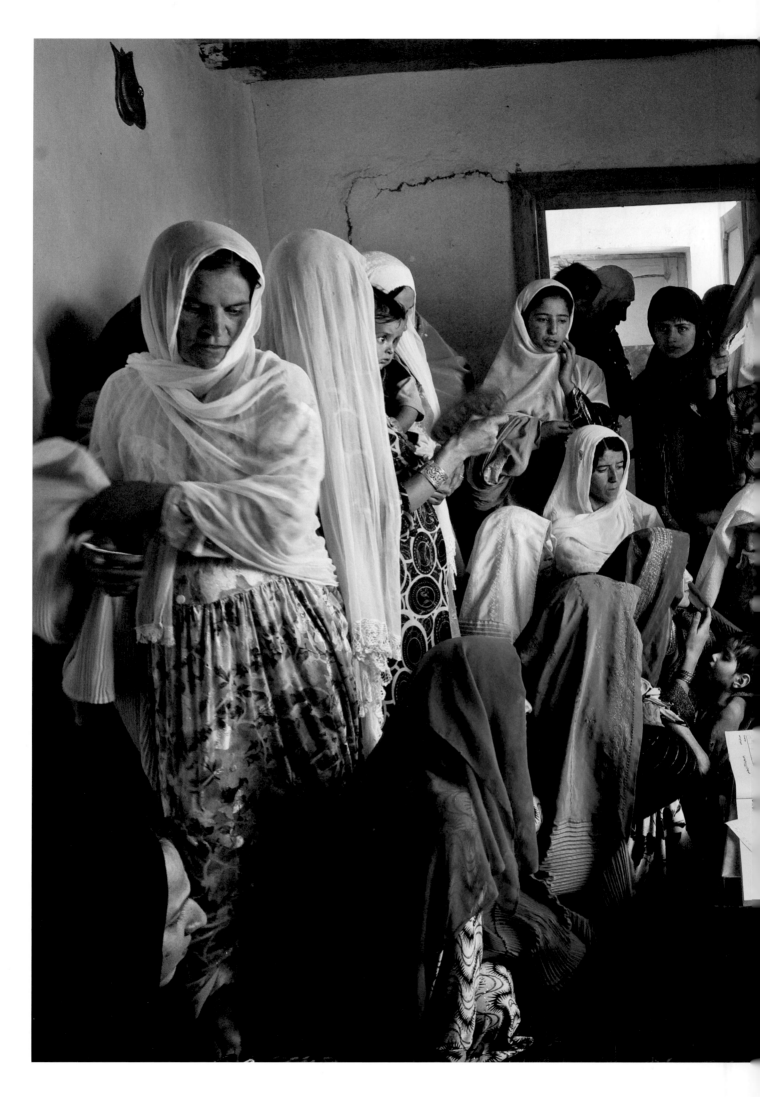

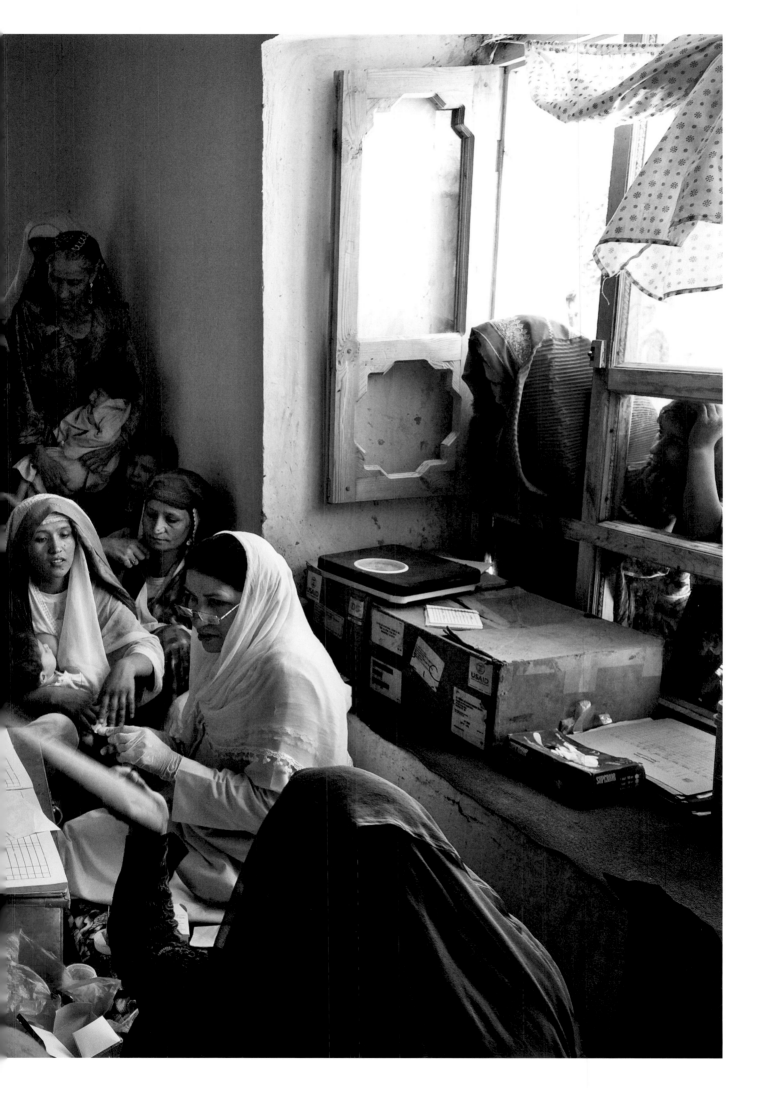

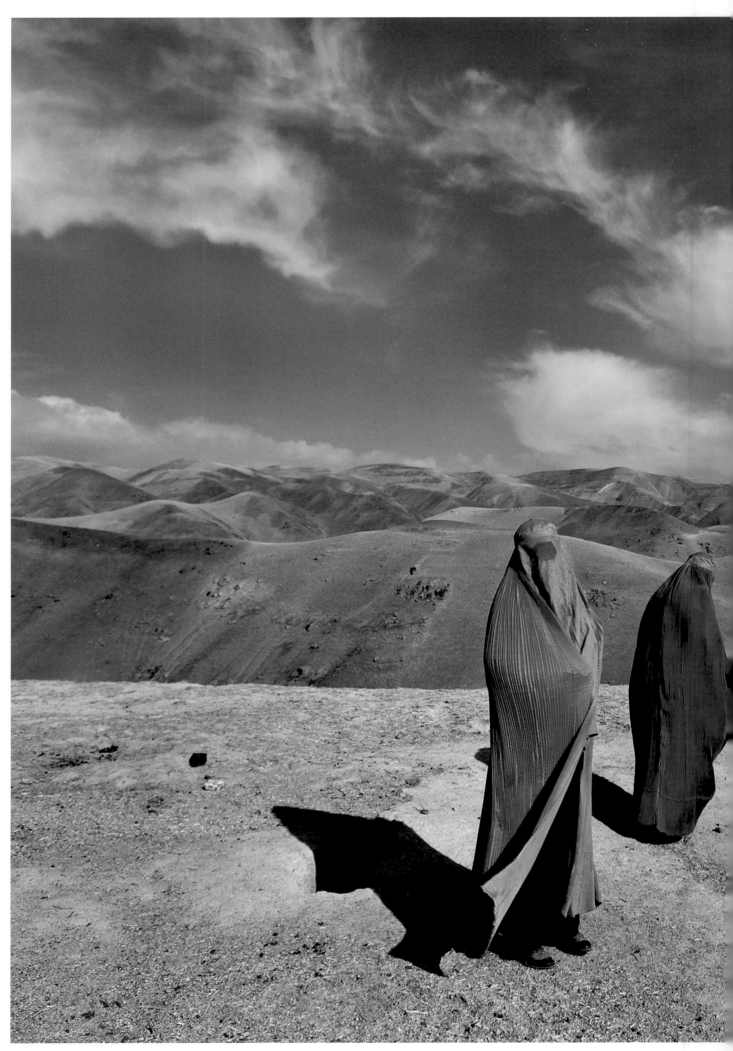

Noor Nisa, eighteen (right), in labor and stranded with her mother in Badakhshan Province, Afghanistan, November 2009. Her husband's first wife died during childbirth, so he was determined to get her to the hospital, a four-hour drive from their village. His borrowed car broke down and I ended up taking them to the hospital, where Noor Nisa delivered a baby girl.

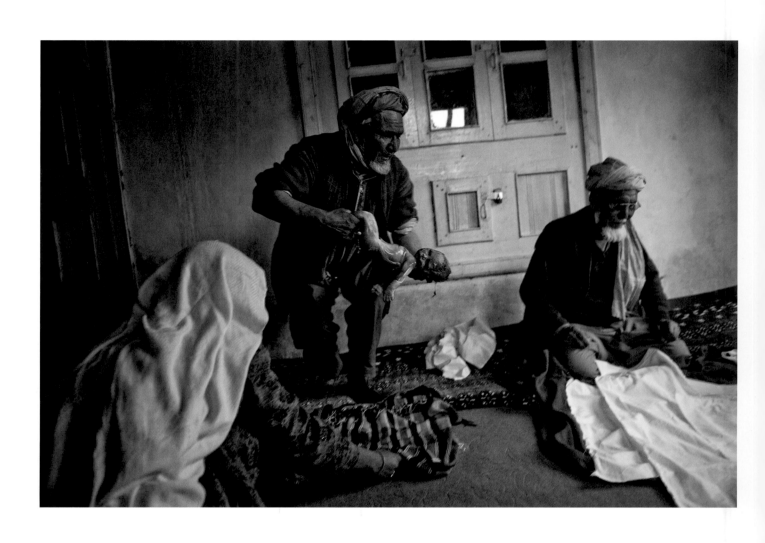

Haji Mohammad Nayeem, sixty-three, washes his stillborn grandson as he prepares him for burial in Daray Khawal District, near Saidabad, Afghanistan, August 2009.

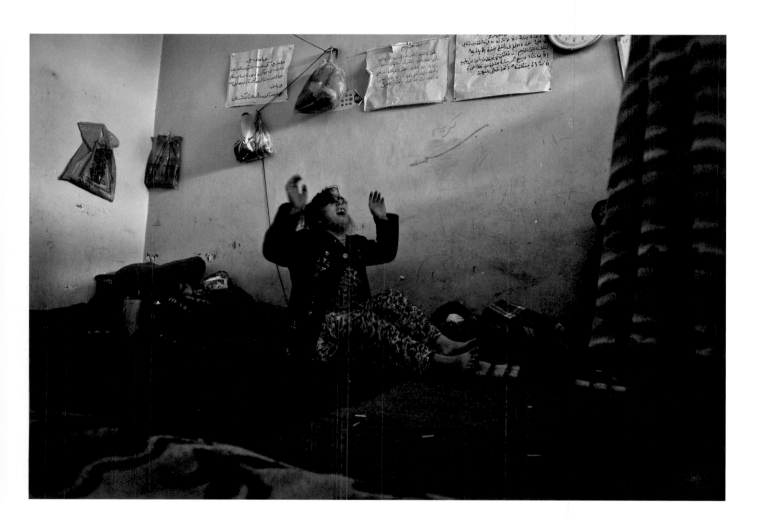

The release of a woman held in a Mazar-i-Sharif prison prompted Maida Khal, twenty-two, to cry out because she is still trapped in her cell. When Khal was twelve years old, she was married to a man of about seventy. "I was so young, I couldn't carry him because he was so heavy, so his brothers would beat me," she said. When she asked for a divorce four years ago, she was imprisoned. "I am in jail because I don't have a *mahram* [male guardian]. I can't get a divorce, and I can't leave prison without a man. I have had a difficult life." About half of the country's 476 female prisoners are in jail for similar "moral crimes." Afghanistan, November 2009.

The Story of Bibi Aisha

Only a few days after Bibi Aisha arrived—
stunned and mutilated—at the Kabul shelter
run by Women for Afghan Women, I received
a call from Manizha, its founder and director.
I had been working on stories about the
injustices against Afghan women for a decade,
and Manizha and I had worked together before:
For years, she rescued and provided shelter
for countless Afghan women, and I helped
document and tell their stories. When I met
Bibi Aisha, her wounds were still relatively
fresh. Her trauma was palpable. *How could
this happen?* I wondered.

She was married when she was twelve.

Her husband beat her repeatedly from the
time they were married. One day, she left home
in search of help from the relentless abuse.
Angered that she had left the house without
his permission, her husband took her and
pinned her down in front of a group of men—
fellow Taliban members—and cut off her nose
and ears to shame and punish her.

As they sliced off her nose, the men shouted,
"This is your punishment." She was shouting
as well, but no one came to help her.

"If I had the power, I would kill them all,"
Bibi Aisha told me.

Manizha confided in me: "I tried to be strong
and instill the confidence in her that she would
be OK, because my tears would say, in essence:
Yes, he did destroy you. I told Bibi's story to
friends who work in fund-raising. We were able
to find plastic surgeons willing to reconstruct
Bibi's face for free." Bibi Aisha traveled to the
United States for reconstructive surgery, and
never returned to Afghanistan.

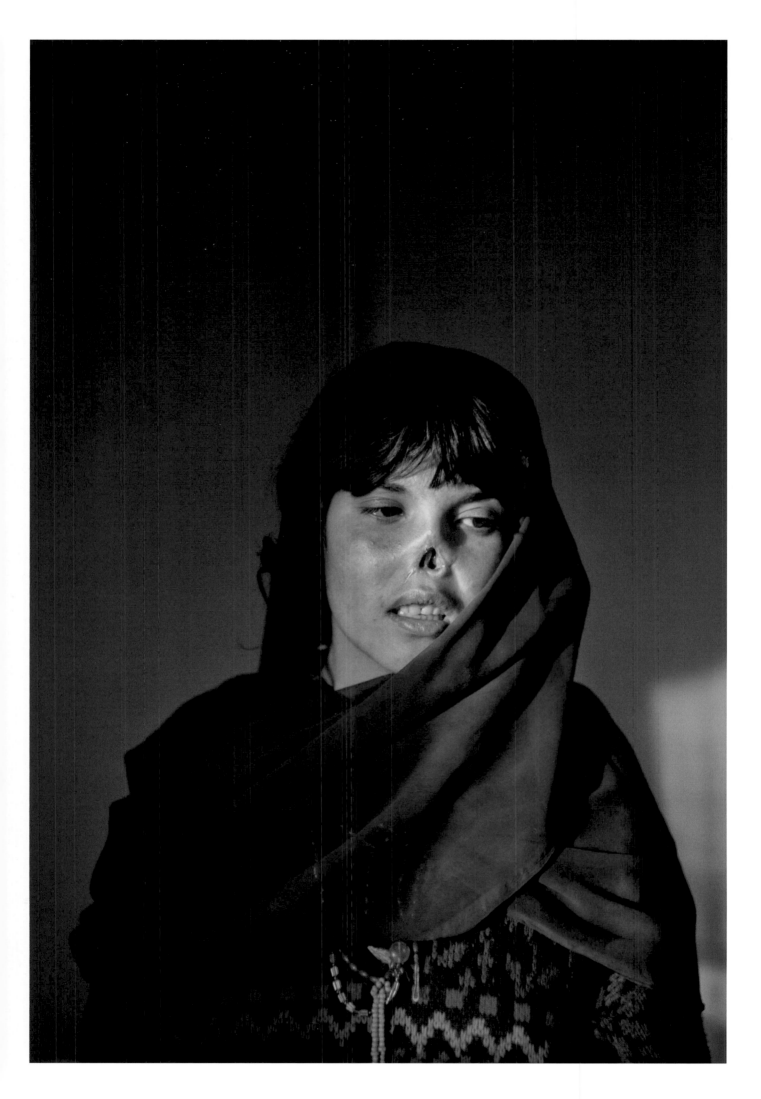

Anything to Escape

I first traveled to Afghanistan in 2000, when the country was still under Taliban rule. I immediately recognized that my gender was an asset for being able to tell the stories of women in a deeply conservative society where men and women were often segregated by gender.

Afghanistan has been at war and mired in conflict for almost forty years, and the violence against women there is also extreme. I don't know what percentage of women are subjected to domestic violence in the country, but I have witnessed extraordinary suffering. Many women have few rights, and few ways to escape hardship. These Afghan women—especially in the provinces, which comprise most of the country—rarely choose whom they marry, where they live, whether or not they can study past puberty (which is often marrying age for young women), or whether they will work. When they are born, they are the property of their fathers, and when they marry, they become the property of their husbands. If their husbands beat them, they cannot ask for a divorce without being ostracized or, worse, killed by family members they have shamed with such a request. They cannot live alone without speculation that they might be promiscuous.

Many Afghan women in the provinces choose self-immolation as a form of suicide, but some don't die right away. If they survive, they are often mutilated and ostracized. The hospital in Herat and the Isteqlal Hospital in Kabul treat many of these women as they wait to die. I saw women with burns covering large percentages of their bodies. Many never survived their wounds.

One day, after hours in a burn ward in western Afghanistan, I was overcome with anger. I asked my interpreter, Fatima, if we could take a break and go somewhere beautiful in the city of Herat. She suggested a shrine. When we arrived at the women's section, it was almost empty, save for a young woman crouched over and crying into her flowery hijab. "Fatima," I said, "please go ask her why she is crying." I will never forget her words: "I am crying because my husband beats me twice a day with eight cables wrapped around his wrists. I have miscarried twice, which makes him more angry. I asked my mother-in-law, 'Please, could you ask your son to beat me only once a day?'"

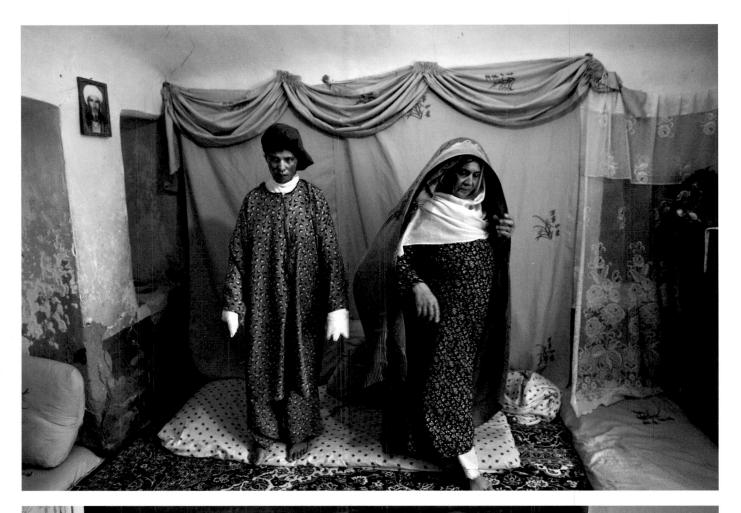

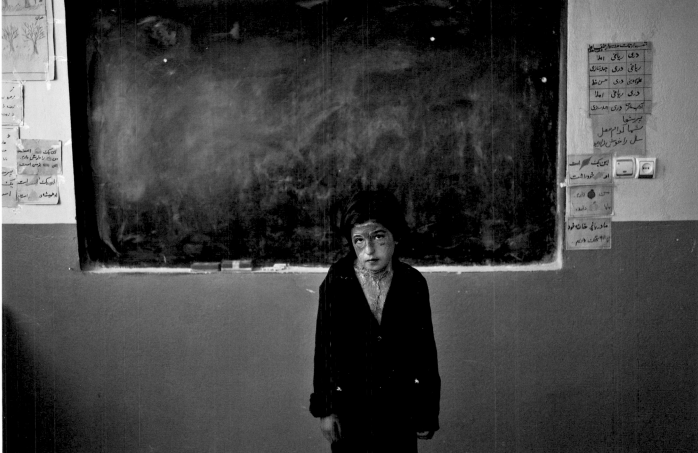

Top Farzana stands alongside her mother at home as they prepare to go to a private clinic in Herat, Afghanistan, August 2010. Farzana tried to commit suicide by self-immolation after being beaten by her in-laws. Farzana and her brother were engaged to two siblings, and when her brother took another woman, Farzana suffered the wrath of her in-laws as retaliation. She burned herself to escape the abuse. *Bottom* "I took a bottle of petrol and burned myself," Fariba, eleven, told me. "When I returned to school, the kids made fun of me. They said I was ugly." She added, "I regret my mistake." The reason for her action is unclear. A feeling of shame can prompt self-immolation. Many women who survive their wounds may lie and say they have been injured in a gas explosion when they were cooking, but doctors often know that the act was intentional from the smell, shape, and location of the burns.

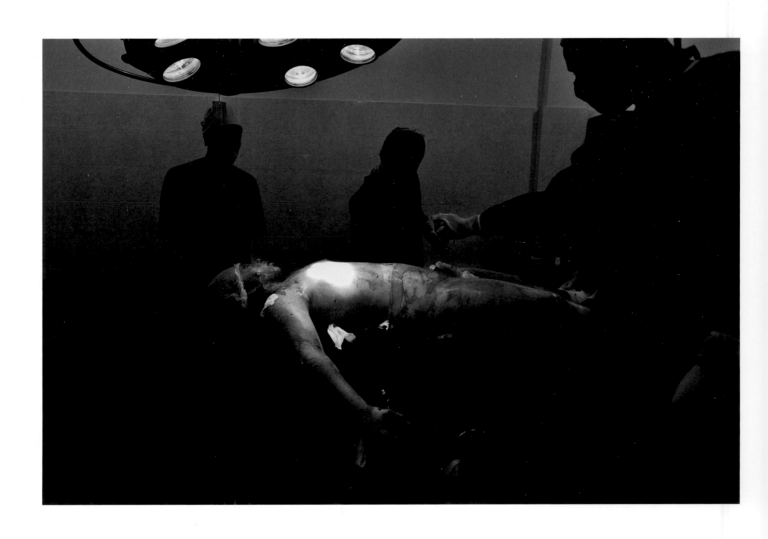

Zahra, fifteen, from Mazar-i-Sharif Province, lies on an operating table at the
Isteqlal Hospital in Kabul, Afghanistan, after trying to commit suicide by setting
herself on fire. October 2009.

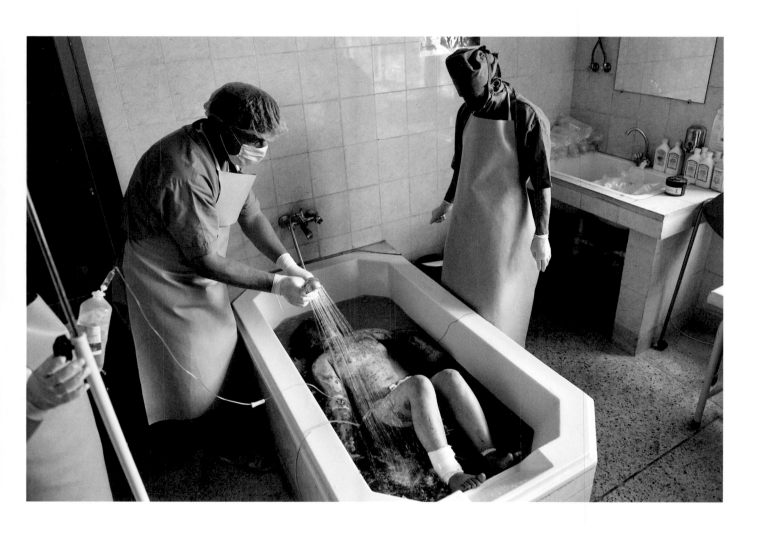

Nargis, an Afghan woman from Kabul who burned herself because her husband beat her repeatedly, has her bandages changed in the burn unit of the Isteqlal Hospital in Kabul, Afghanistan, August 2010.

Sub-Saharan
Africa

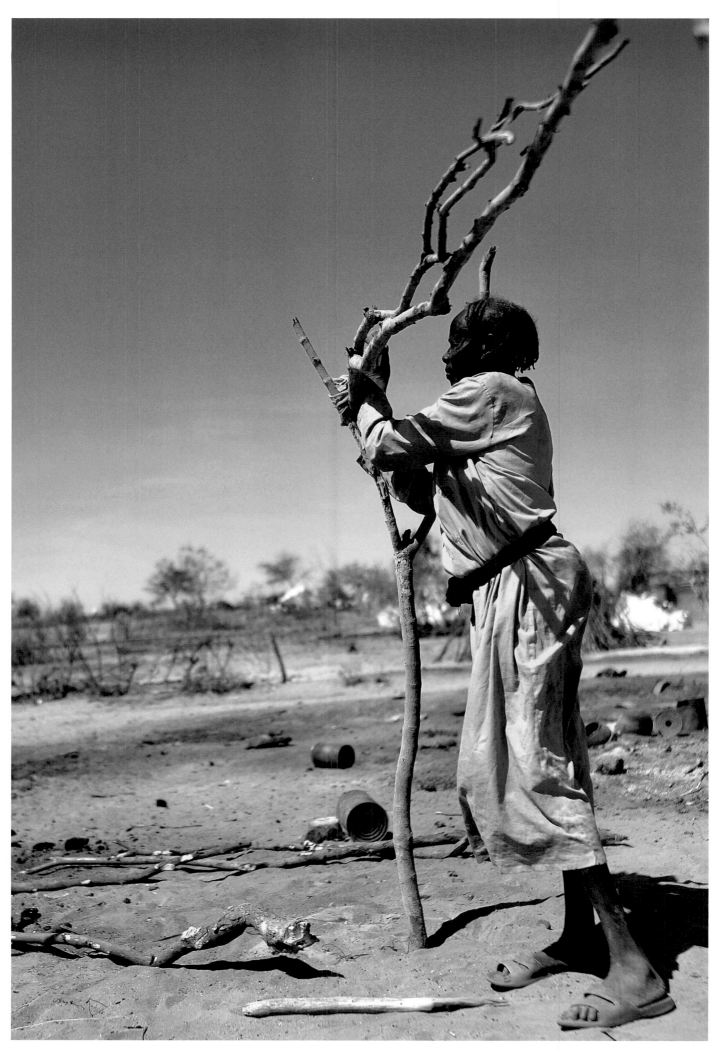

Sudanese civilians pick through the remains of their burned-out huts in the village
of Abu Suruj, which was bombed on February 8, 2008, by the Sudanese government.
West Darfur, Sudan, February 2008.

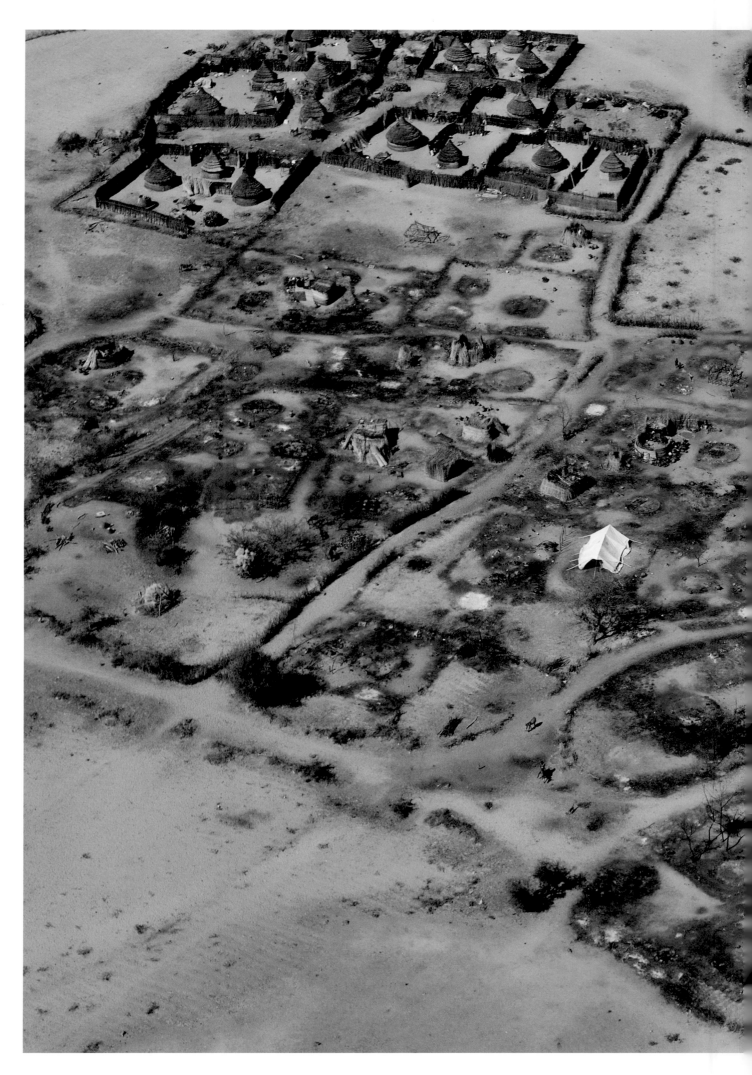

An overhead view of the remains of the village of Abu Suruj, in West Darfur,
Sudan, February 2008.

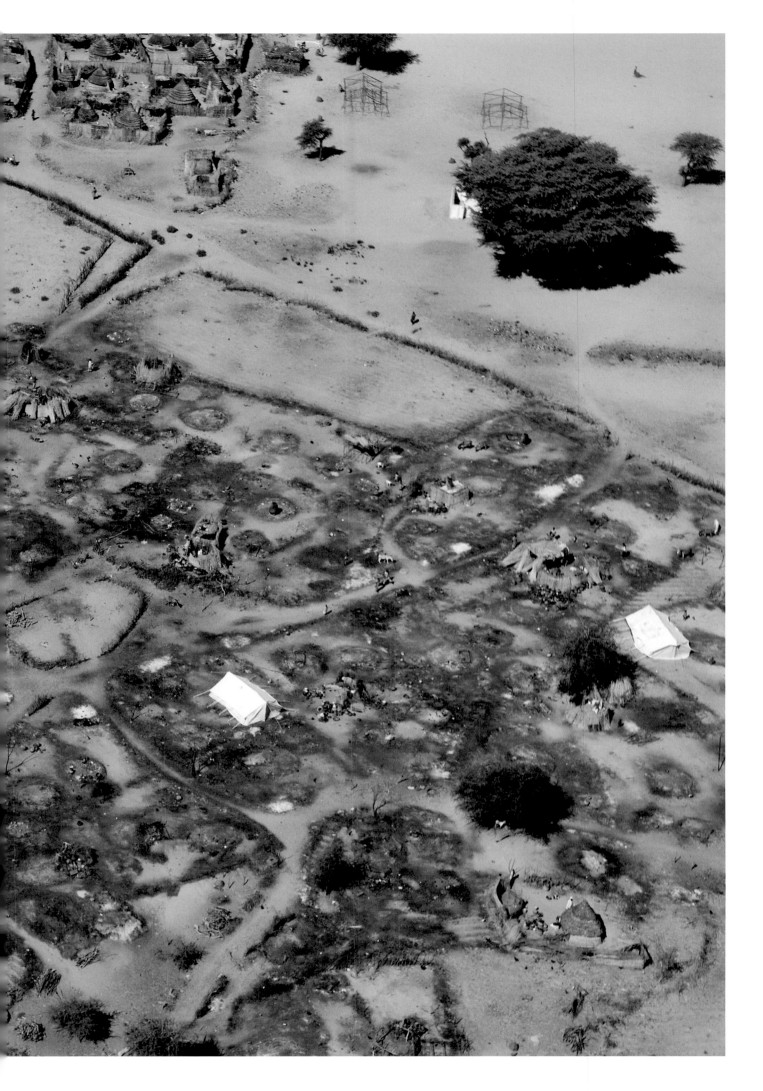

African Union soldiers find the village of Tama freshly burning more than a week after it was originally attacked by Arab nomads backed by government forces north of Nyala, in South Darfur, Sudan, November 2005.

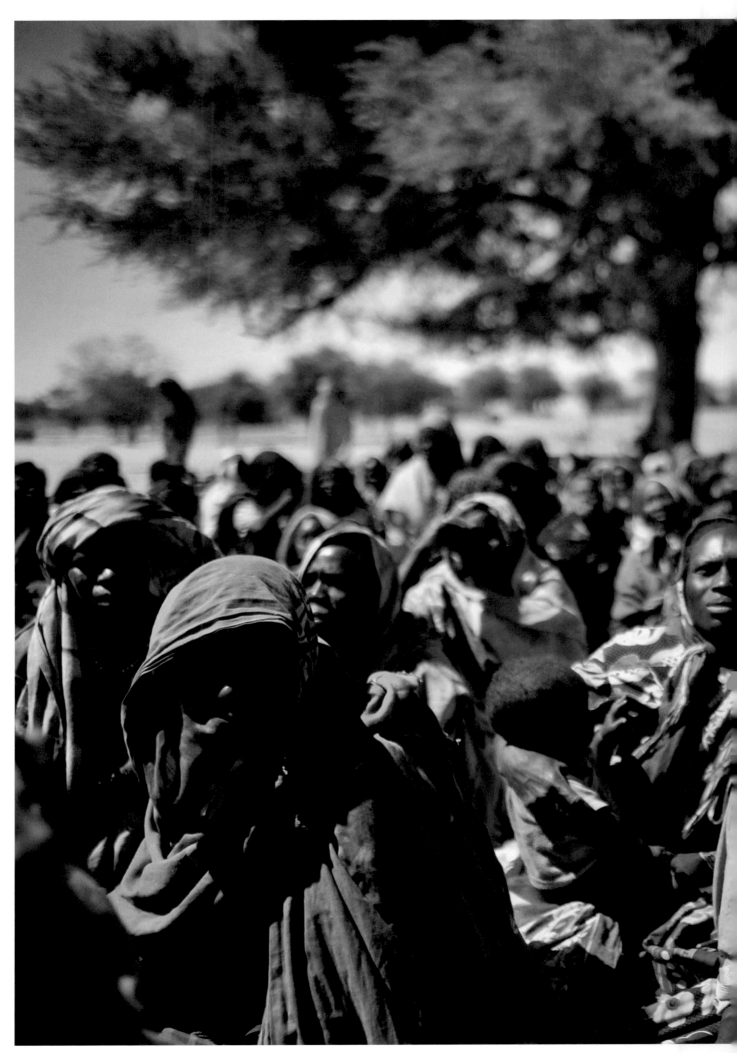

Sudanese women sit and await food and nonfood items distributed by
international humanitarian organizations in the recently bombed village
of Selea, in West Darfur, Sudan, February 2008.

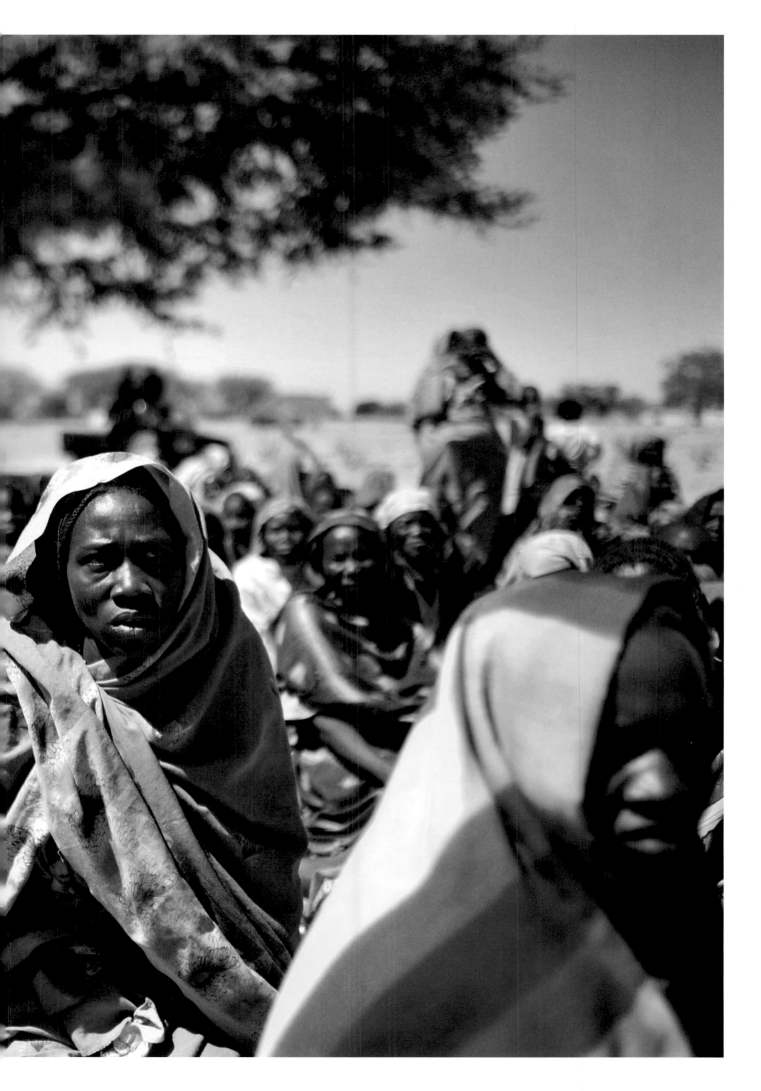

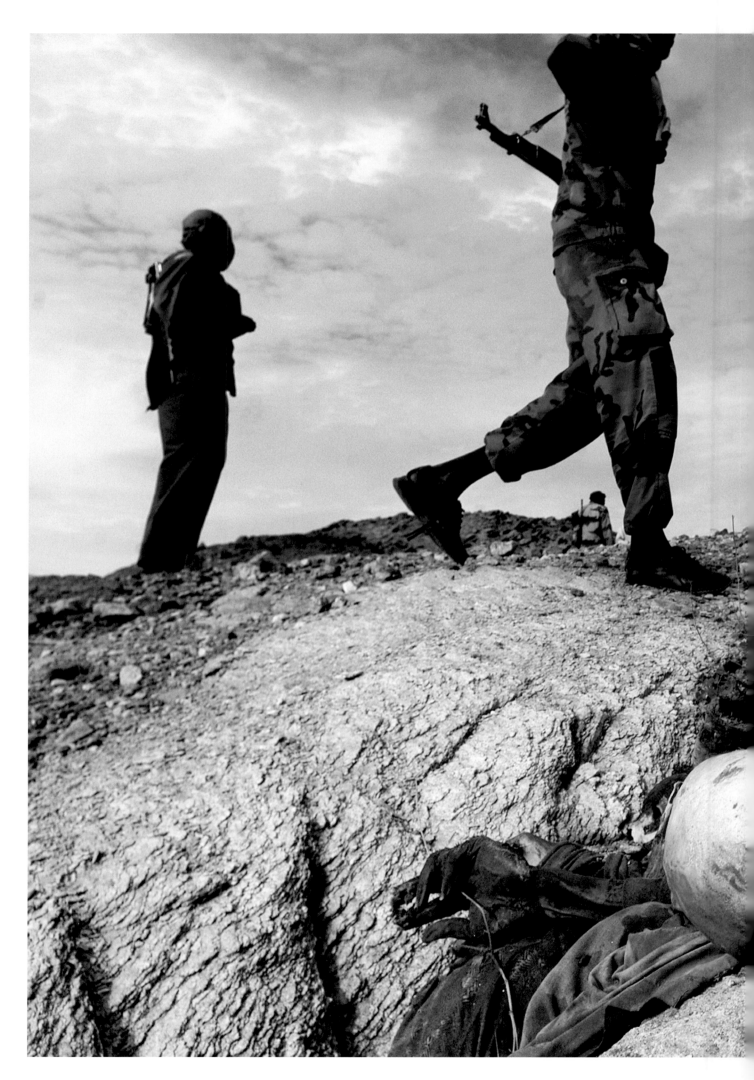

Sudanese People's Liberation Army soldiers walk past a skeleton left from an attack on civilians in the district of Farawiya, in northwest Darfur, August 2004.

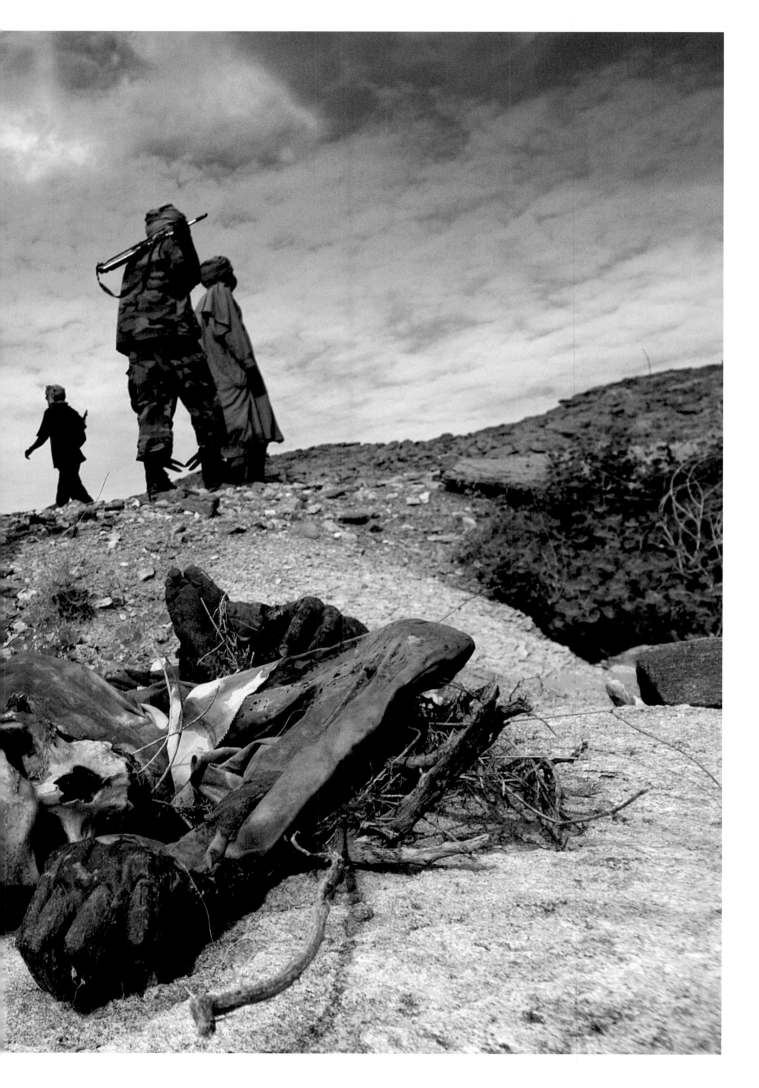

A Sudanese People's Liberation Army soldier walks through the remains of
Hangala village, which was burned several months prior by Janjaweed, near
Farawiya, in Darfur, Sudan, August 2004.

Two women walk though a sandstorm in Bahai, Chad, along the border with Darfur, Sudan, August 2004.

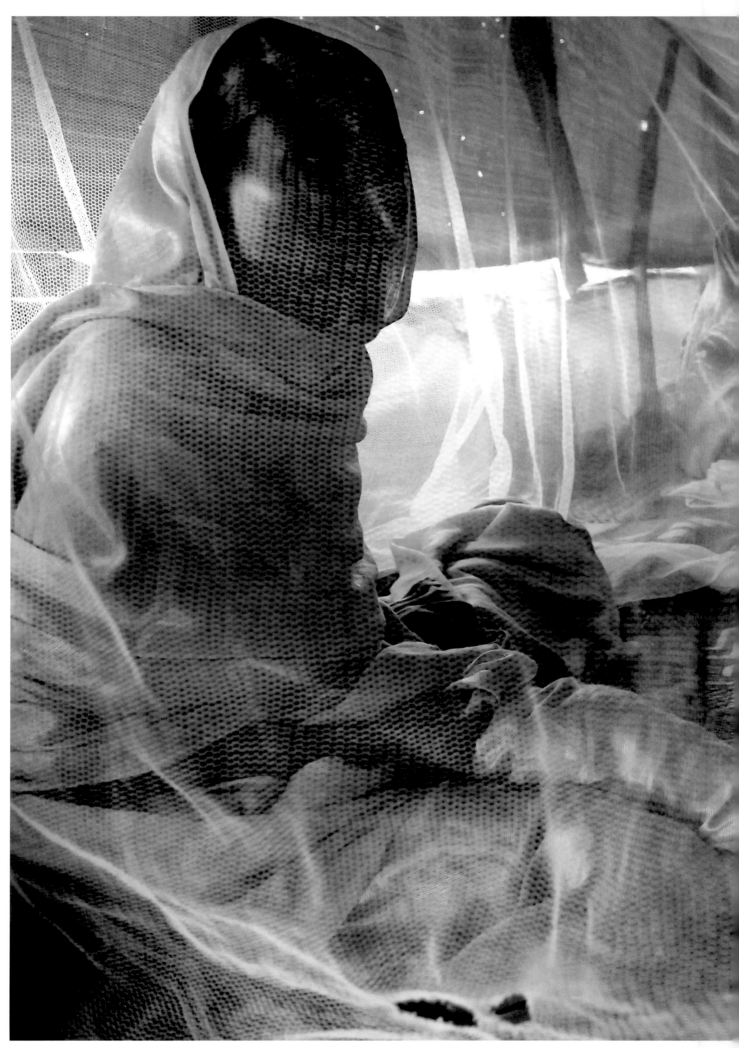

An internally displaced mother and daughter sit beneath a mosquito net while being treated for malnutrition at the Kalma camp in Nyala, South Darfur, Sudan, November 2005.

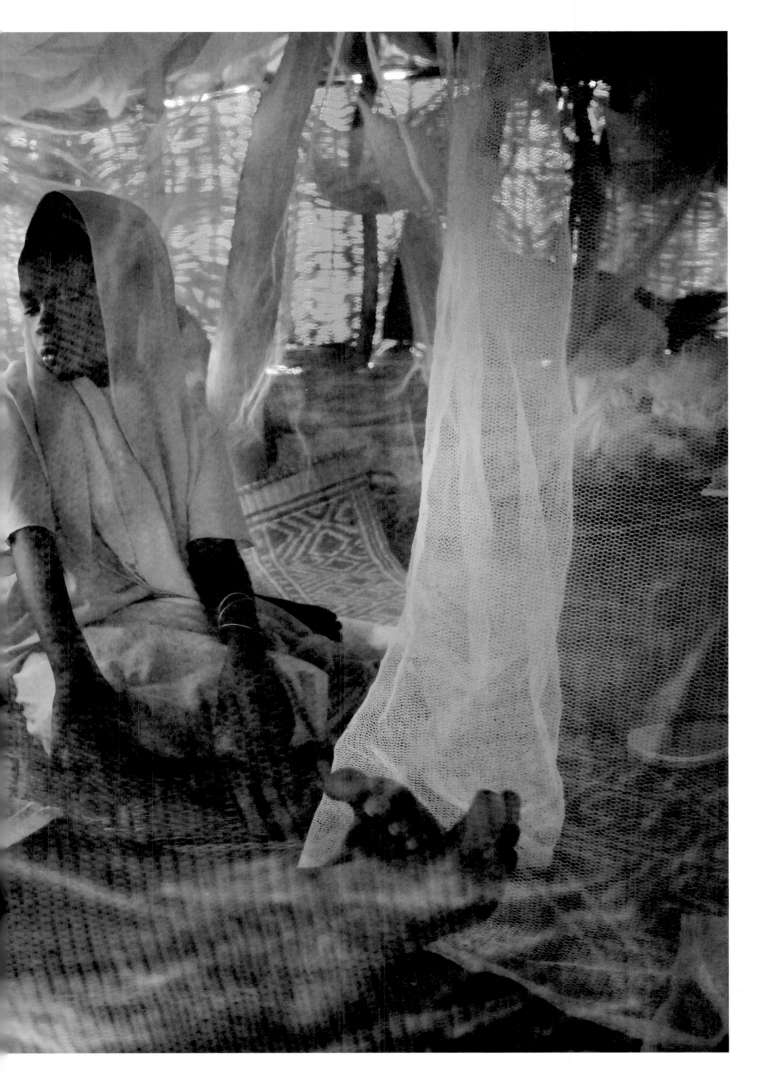

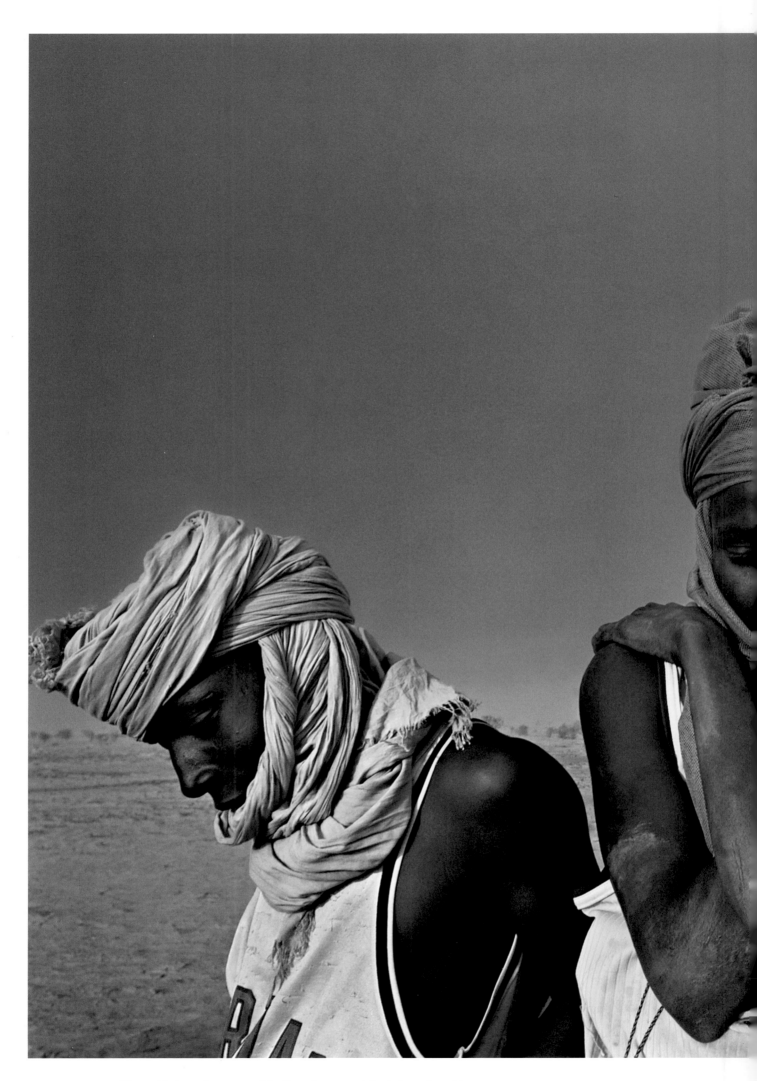

Soldiers with the Sudanese People's Liberation Army sit by their truck, waiting
for it to be repaired, as a sandstorm approaches in Darfur, Sudan, August 2004.

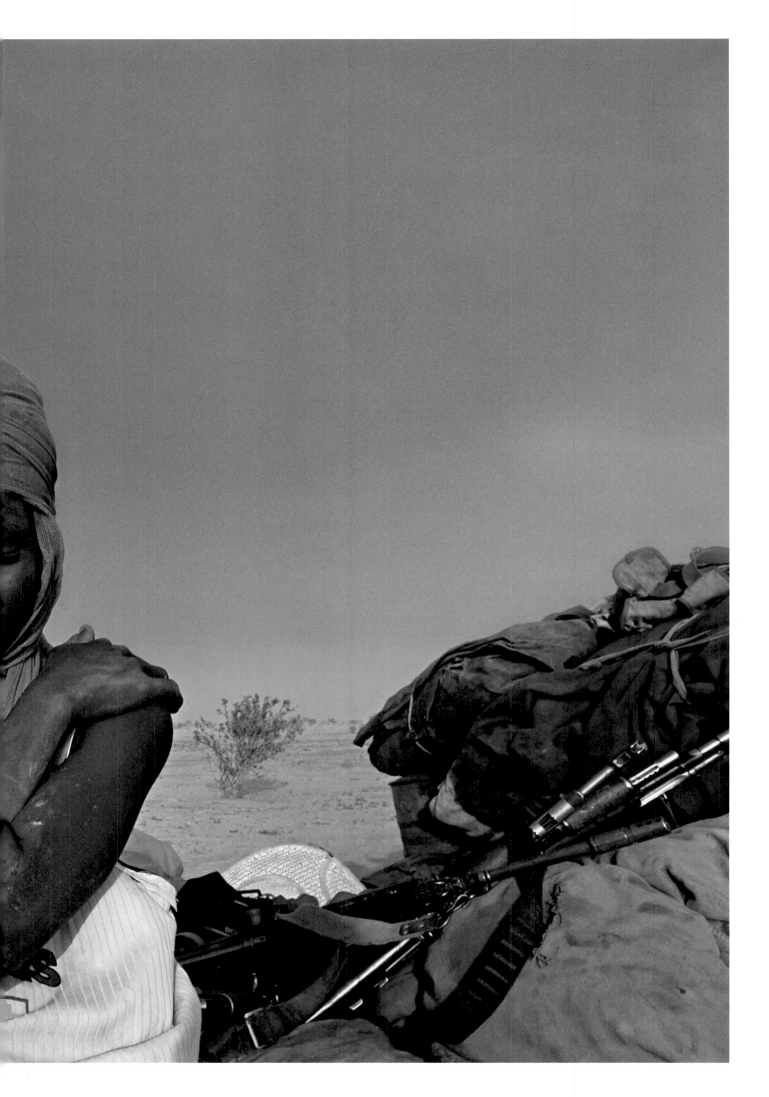

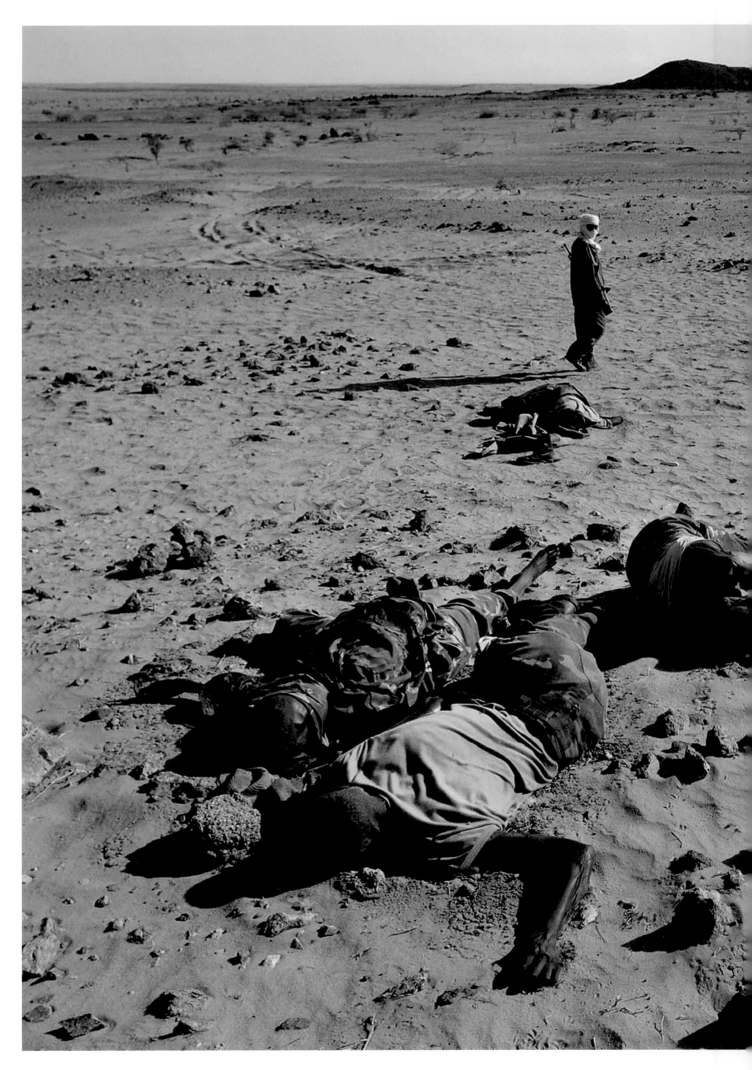

As they walk through a temporary military camp near the Darfur-Chad border, Sudanese rebels with the National Redemption Front pass dead Sudanese government soldiers in Darfur, October 2006.

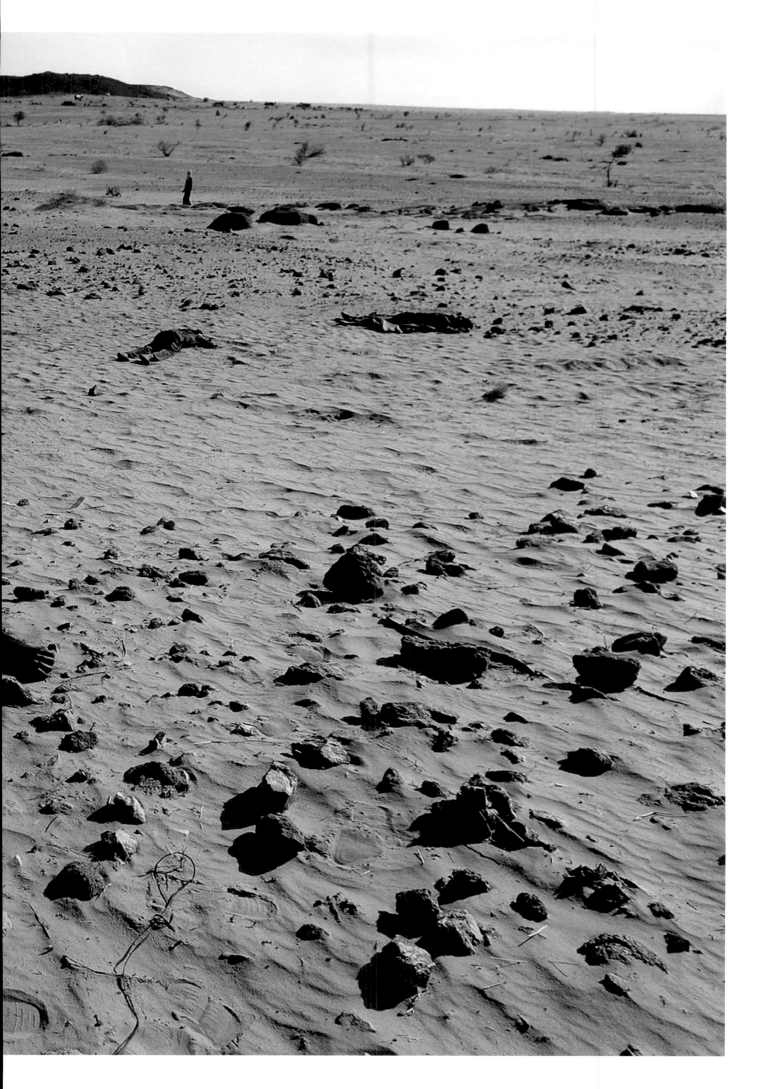

Conflict in the Congo
by Lydia Polgreen

There are certain stories that seem so vast in their heartbreak and drama that it's almost impossible to imagine a way to capture their totality. Few places meet that description better than the Democratic Republic of the Congo.

The country had long been a plaything of powerful global forces. In the nineteenth century, Belgium's king, Leopold II, took hold of the Congo as his personal property and profit center, enslaving and brutalizing its people to enrich himself.

During the Cold War, the United States drove the country's first democratically elected prime minister, Patrice Lumumba, from power and replaced him with a rapacious and pliable kleptocrat, Joseph Mobutu.

And in the twilight of the twentieth century, the Rwandan genocide ricocheted into neighboring Congo, sparking a series of interlocking conflicts that killed more people than any conflict since World War II.

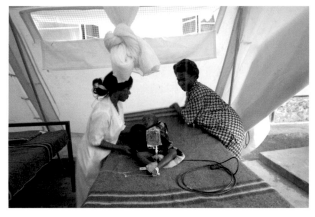

I wanted to understand how the conflict had become so deadly, especially for Congolese children. And that is how Lynsey Addario and I found ourselves at the bedside of a toddler named Amuri in the eastern Congolese town of Rutshuru in the summer of 2006.

He was a very sick little two-year-old. He was covered in spots, a telltale sign that he had contracted a killer but highly preventable illness: measles.

His mother, Maria Cheusi, had rushed him from her village to the hospital in Rutshuru. But she was too late. Not long after Amuri arrived, his little lungs rattled. His eyes rolled back in his head. His slender chest stilled. He was gone.

"Mama, Mama," Maria cried as a nurse wrapped his lifeless body in a scrap of cloth. "My only son, my only son."

Maria had already buried three children who had died from ordinary sicknesses that seldom kill in the West: malaria, malnutrition, dehydration. None of her children had been vaccinated against measles and childhood illnesses like it because the state health care apparatus, never very strong in rural areas like hers, had completely collapsed.

Already that day, two other small children had died of a respiratory infection and tetanus; the day before it had been malnutrition and malaria.

At that time one in four Congolese children would die before their fifth birthday. By 2007, 5.4 million people had died in the Congolese civil war, according to the International Rescue Committee, making the war the deadliest conflict by far of the post–WWII era. About half of the dead were children.

Maria's grief at her son's bedside was quiet and dignified. Lynsey and I barely knew each other. We were working together for the first time. But we fell into each other's arms, sobbing like broken children. It was going to be a long day.

We spent much of the day and night in the maternity ward with women waiting to give birth. The conditions were grim. Women not yet in labor lay two to a single bed while those in the throes of contractions roamed the halls in agony, their screams echoing off the bare concrete walls. These women would deliver their babies, full of hope tempered with fear. And then, months or years later, they would return with those same children, now sick

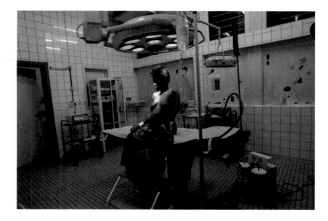

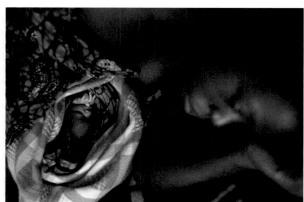

with treatable illnesses, almost always a few days too late.

That night a woman named Esperancia arrived, six months pregnant and bleeding severely. It was far too early for her baby to be born, but the Belgian surgeon on duty was worried about placenta previa, a dangerous pregnancy complication that could scarcely be managed in this bare-bones hospital. He had no choice but to deliver the baby.

I will never forget how Esperancia looked that night, seated on the operating table, her swollen belly illuminated by the surgery lights. She blinked with nervous agitation, and veins in her neck pulsed as her heartbeat fluttered. I struggled to find the words to describe her in the article I wrote about it that night, but when I saw Lynsey's image of her, so filled with emotion and care, the words poured forth. Bathed in the otherworldly glow, she looked, I wrote, like a careworn Madonna.

As a writer, you are always seeking to capture that moment of authentic intimacy, especially in the most extreme circumstances. Sometimes it is only through the wordless truth of images, like the unforgettable ones Lynsey made that day, that you can truly tell the story of a horror like the Congo.

Esperancia's baby weighed little more than two pounds. After the surgery, Esperancia held her little girl tight.

"I buried one child already," Esperancia told me. "I cannot bury another. She may be small, but she will grow. She will live."

But when I asked the surgeon what the baby girl's chances of surviving here were, in a hospital with no equipment for premature babies, he was blunt.

"Zero," he said.

And the Congo's grim arithmetic would soon take another victim.

Lynsey and I covered many stories together after that devastating trip to the Congo, in harsh places like Darfur, Chad, again in the Congo, and in Zimbabwe. But our bond as lifelong friends and collaborators was forged that night, through tears, as we documented the greatest humanitarian catastrophe the subcontinent had known.

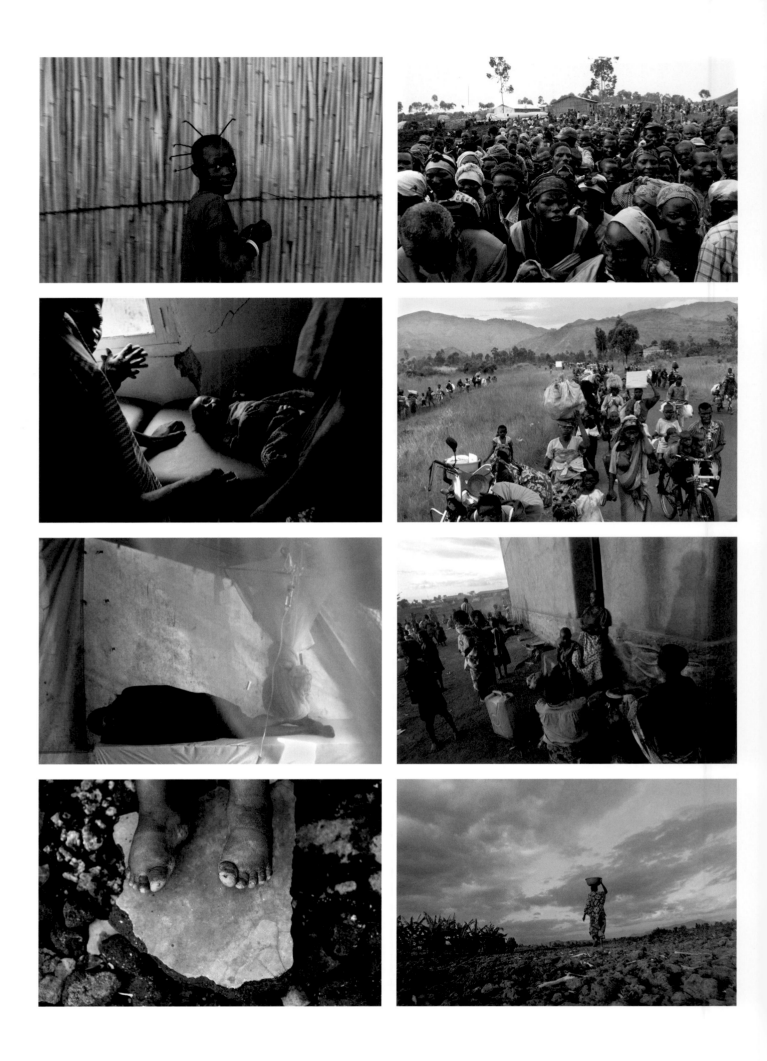

War and its toll in the Democratic Republic of the Congo, 2006–2008.

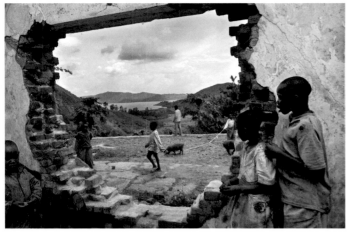
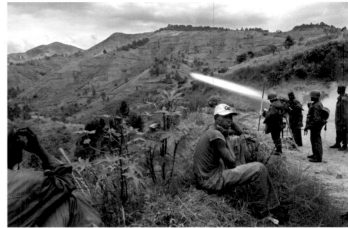
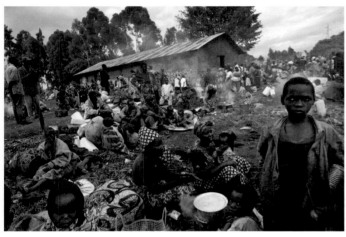
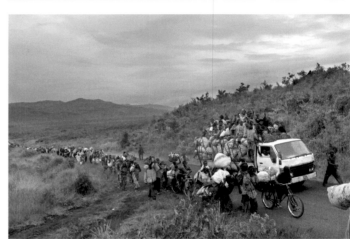

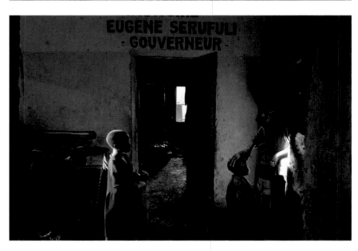
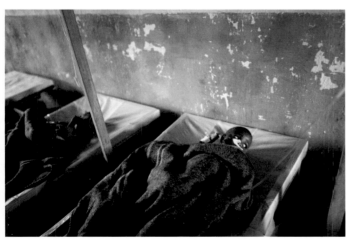
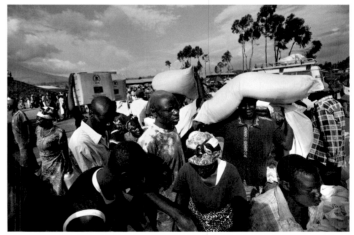

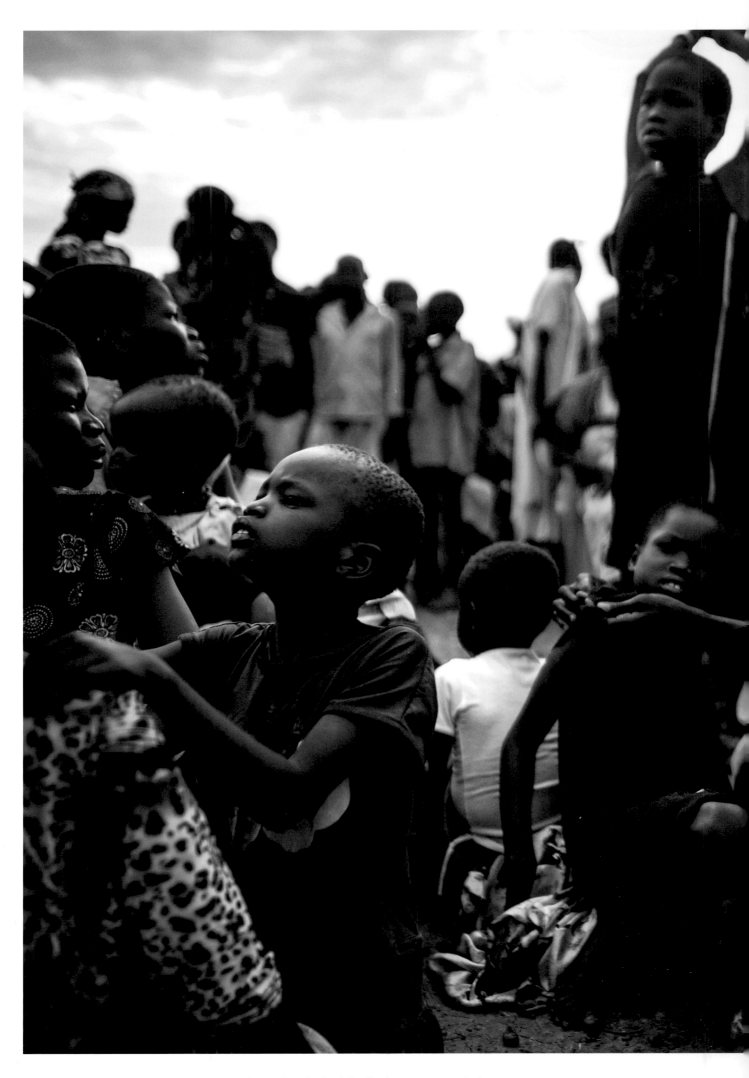

Internally displaced people wait to register for food distribution at a camp at the base
of the United Nations Mission in South Sudan, in Bentiu, South Sudan, May 2014.

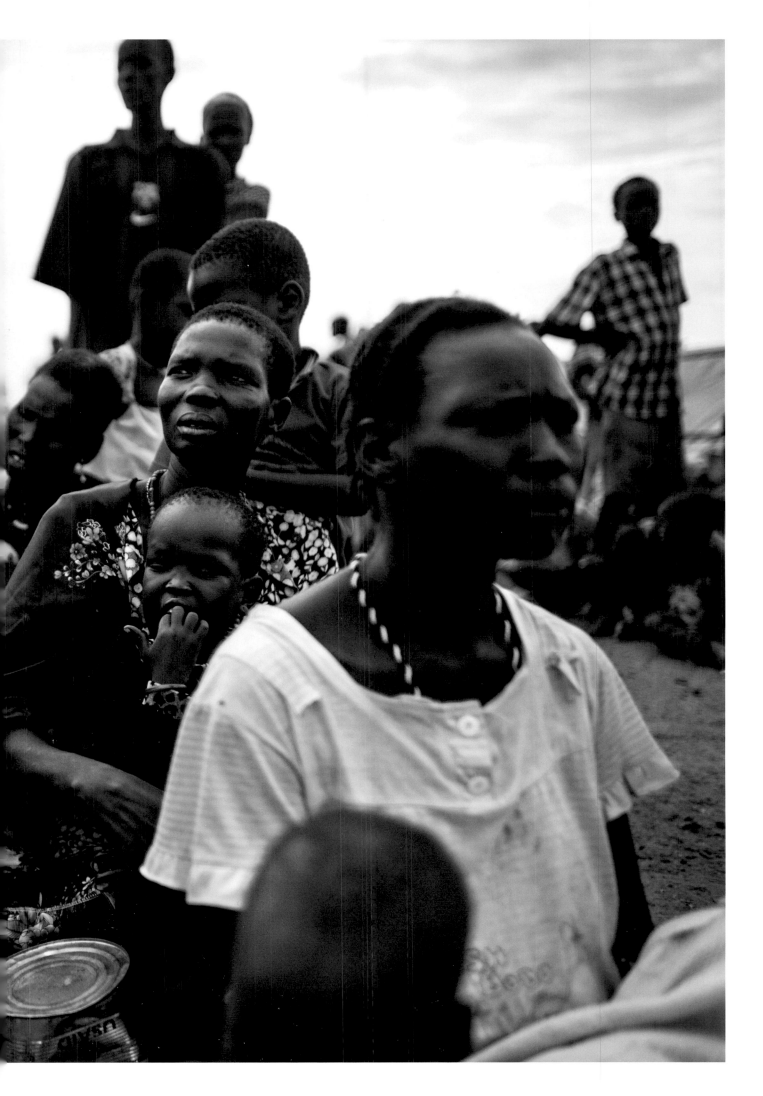

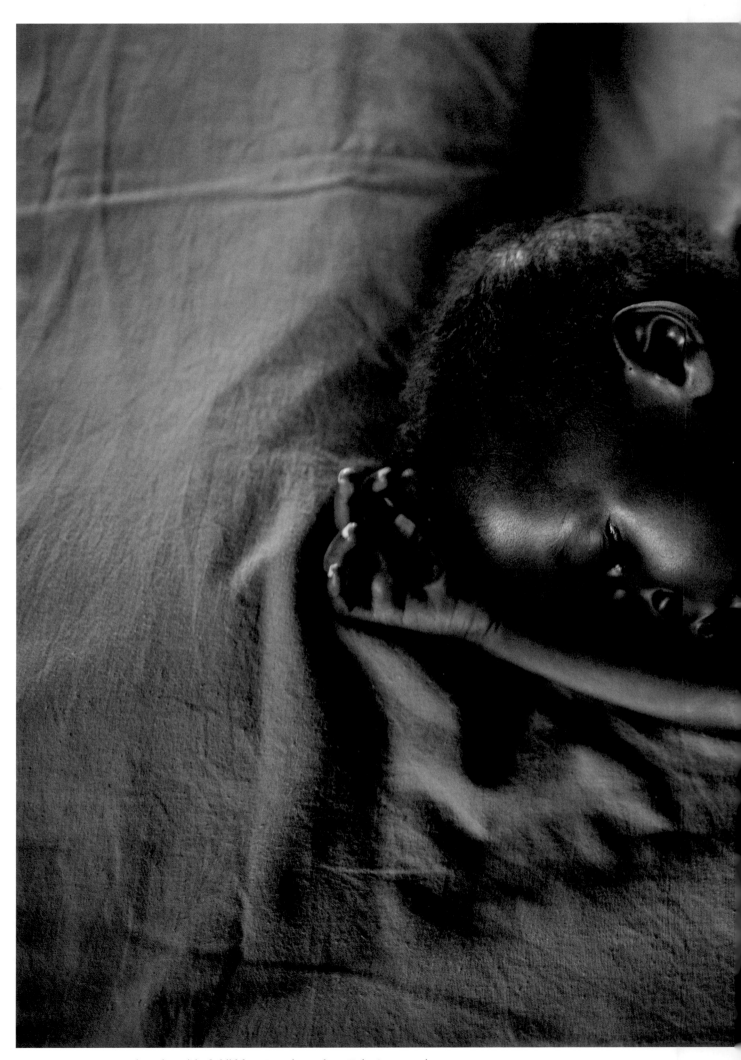

A severely malnourished child from Leer, in southern Unity State, receives treatment at the inpatient ward run by International Medical Corps at the Protection of Civilians site in Juba, South Sudan, March 2016.

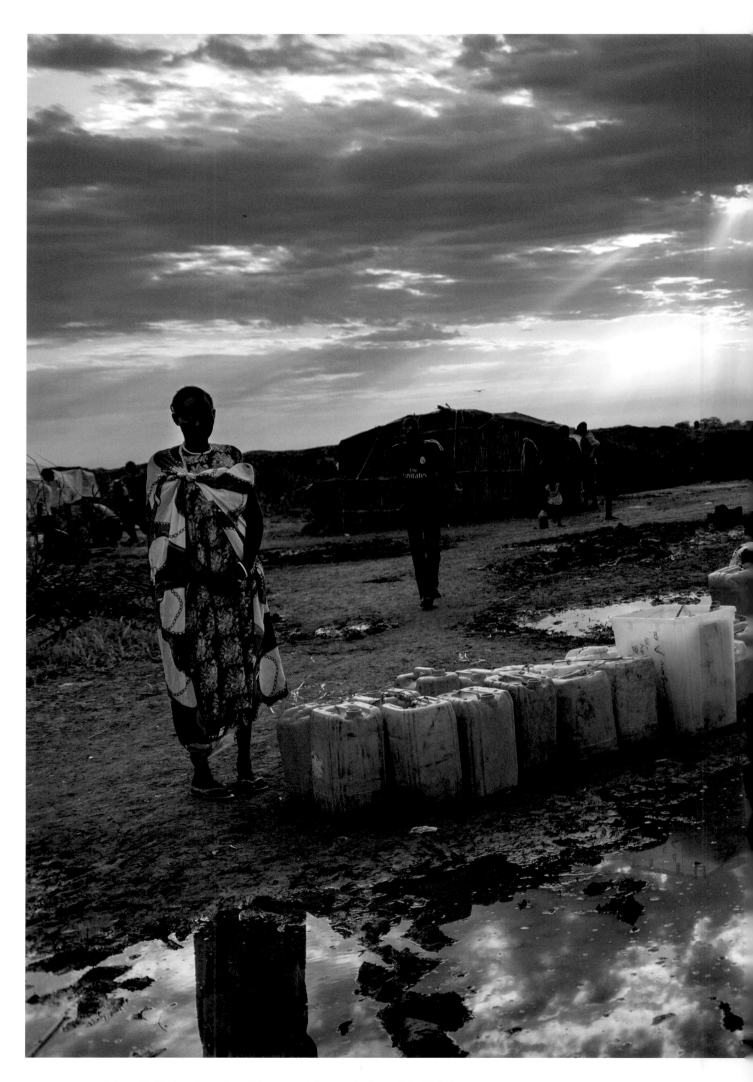

Internally displaced people wait for water at dawn at the base of the United
Nations Mission in South Sudan in Bentiu, South Sudan, May 2014.

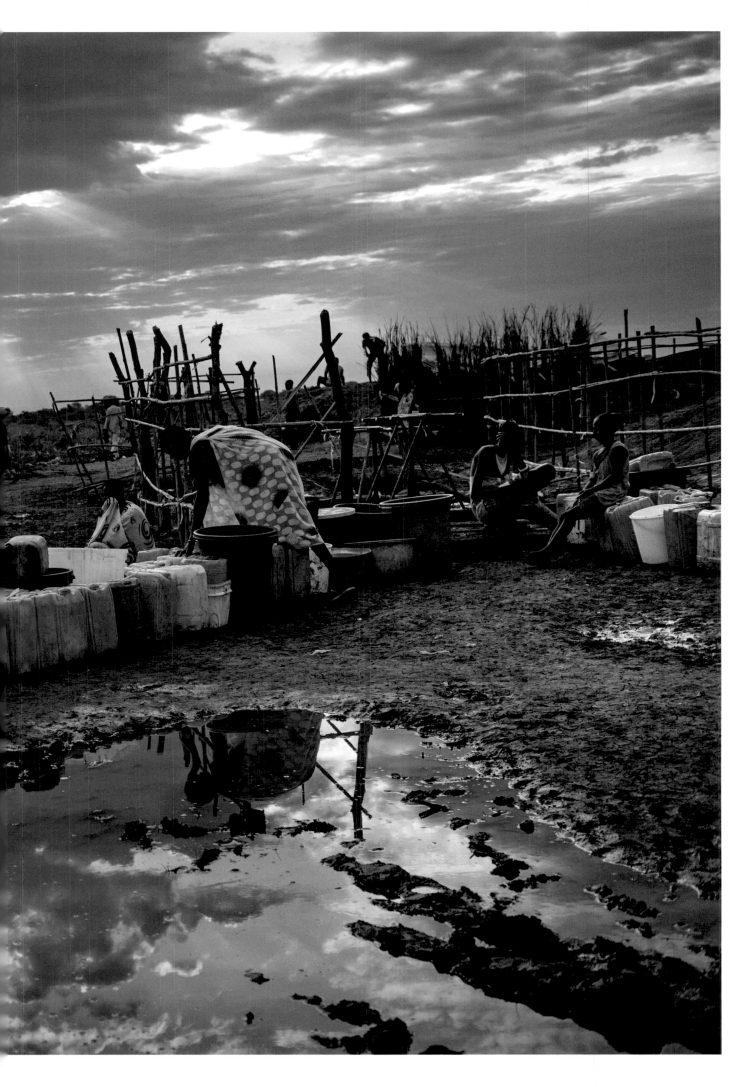

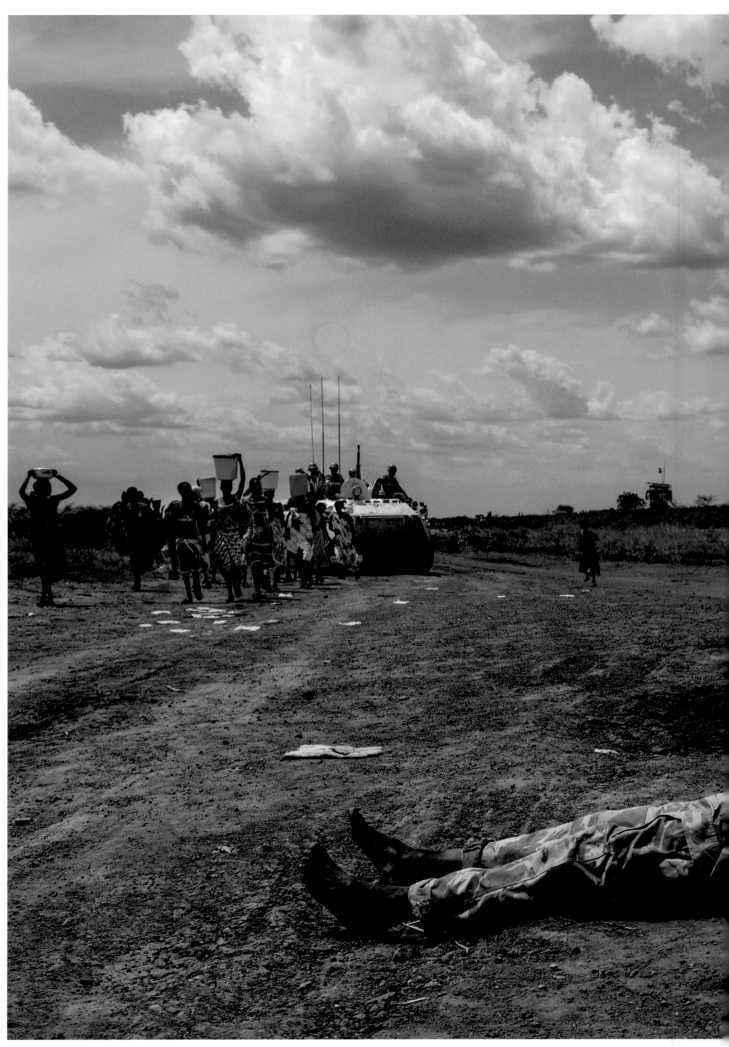

A dead government soldier with the Sudanese People's Liberation Army lies in the road in front of the base of the United Nations Mission in South Sudan as civilians with supplies from town pass by during a lull in fighting between government and opposition forces in Bentiu, South Sudan, May 2014.

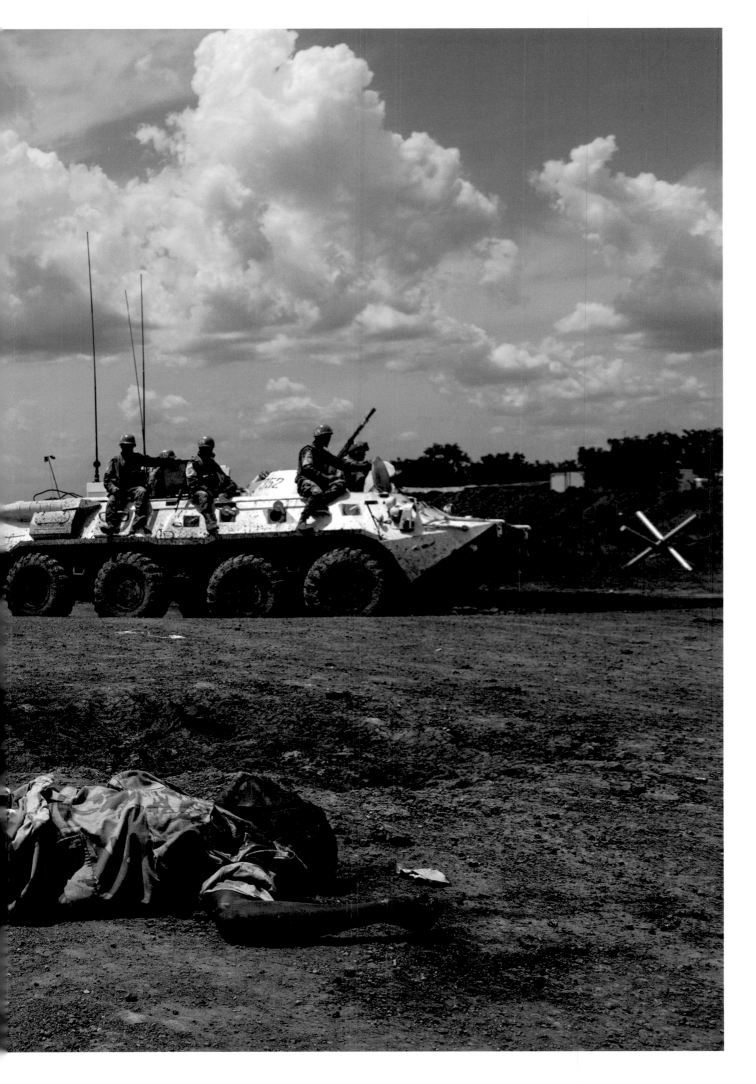

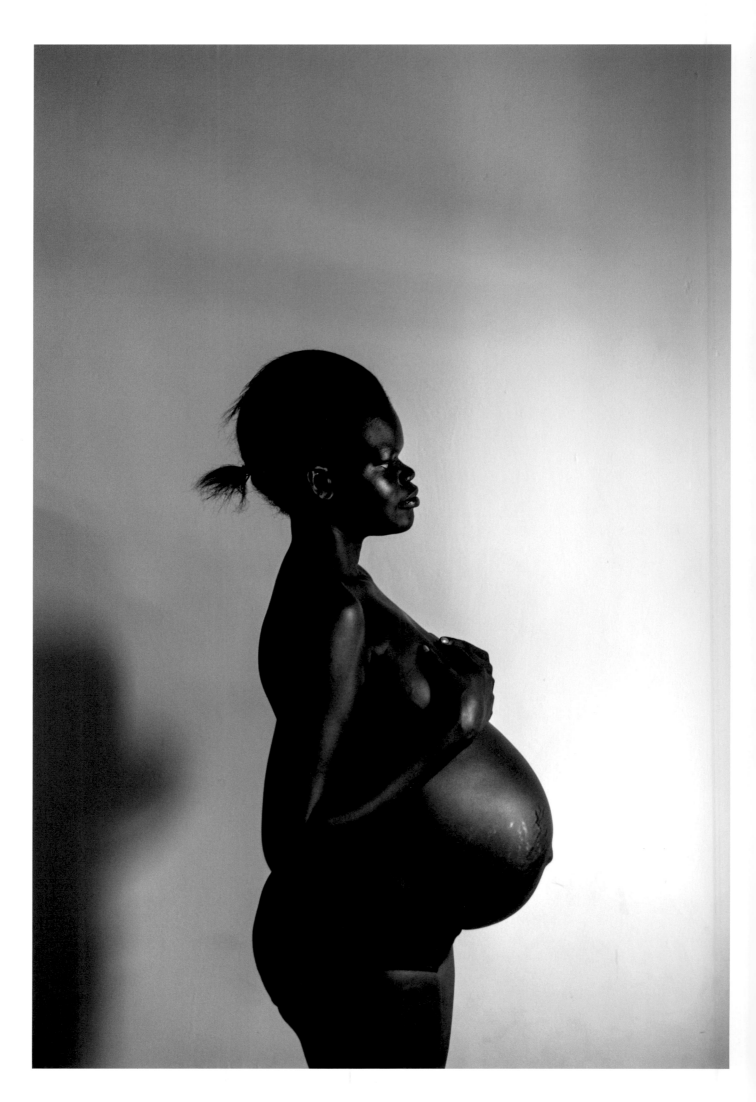

Ayak

At the time I met Ayak and Mary, two survivors of the war in South Sudan who were seeking temporary refuge at a residential house run by the American NGO Make Way Partners in Uganda, I had been photographing victims of rape as a weapon of war for more than ten years. It is an extremely delicate process. Photography is invasive, and the photographer risks further traumatizing the victim. *Time* magazine correspondent Aryn Baker and I spent an afternoon listening to the stories of Ayak and Mary—both of whom had been repeatedly sexually assaulted and impregnated months earlier during a period of heavy fighting across South Sudan. The first day I just listened and observed and didn't take any pictures.

The next morning I asked Ayak whether she felt comfortable being photographed. I explained that her image would be published in *Time* magazine (we showed her a copy of the magazine and said it was a very well-known publication in America and overseas) and that her picture would appear both in print and online as well as (most likely) on Facebook and social media, and thus be seen by hundreds of thousands of people worldwide. I explained to her that I had documented survivors in the past, and many had decided not to show their faces, but that this was her decision. Our aim, I told her, was to reveal the unjust and violent crimes against women and civilians taking place in her country through the voices and images of brave women like her. I believe that if a viewer is offered an intimate perspective, then that viewer can better identify and empathize with victims of even the most horrific, incomprehensible crimes.

I spent several hours photographing Ayak, from the back and in profile, wearing a long, flowing, flowery dress; her stomach formed a perfect ball emerging from her tall, slim body. Despite the sexual assault that led to her pregnancy and the horrors she had experienced in South Sudan, Ayak was excited about the imminent birth of her child. I contemplated possible additional photographs as I fell asleep, and when I woke up the next morning, I knew that if I wanted Ayak's photograph to speak to the consequences of rape as a weapon of war, then the most natural way for me to do this was to focus on her belly. I envisioned an image of Ayak as proud and beautiful as she was, even though she was carrying her perpetrator's child. I wanted the simplicity of the human body to tell her story, to engage the viewer, though I didn't want to ask something of her that she might find distressing or disrespectful.

So I asked the advice of Kimberly L. Smith, the American founder and CEO of Make Way Partners, who had been working in the region for many years and had focused on helping survivors of sexual violence and children orphaned by the ongoing conflict. I trusted Kimberly's judgment because she had been helping Ayak for months and was responsible for bringing her to Uganda for sanctuary. Kimberly herself had survived multiple attacks while setting up orphanages on the border between Sudan and South Sudan, and had also been raped. Like my own experience with sexual assault in Libya, Kimberly's past did not deter her from continuing her life's work—despite that it meant putting herself back into vulnerable situations. Both of us survivors had made the decision to share our stories as part of the catharsis of dealing with trauma. I also chose to speak openly about my own sexual assault to help chip away at the stigma associated with sexual violence.

Together we went to Ayak to ask how she felt about being photographed without her dress on. I explained my vision for her portrait. She understood immediately what I was trying to convey, and as I photographed, I showed her the images on my camera to ensure that she understood what I was capturing. During those two days, the three of us all shared deeply personal experiences, which often ended in tears and sometimes in laughter. Photographing Ayak and listening to her story was a privilege—and an extremely intimate moment among three women who had all experienced some form of rape or sexual assault as a weapon of war in our lives. And we all chose to share our stories with the goal of helping others come forward as survivors, not victims.

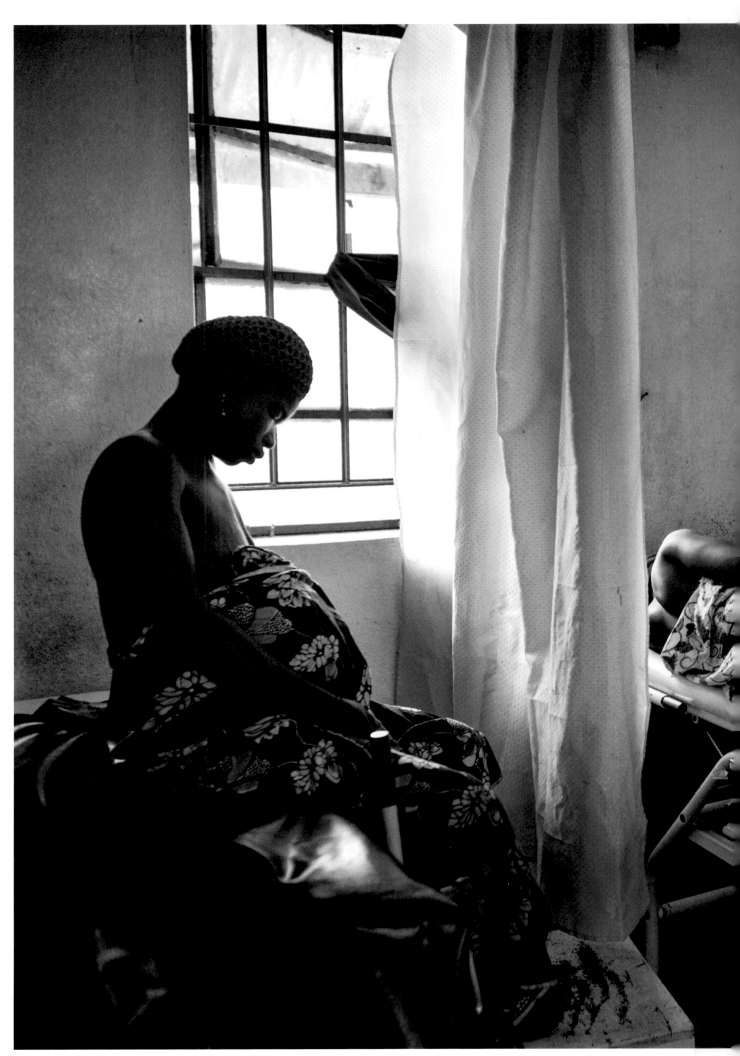

Medical staff with Doctors Without Borders assist women in Sierra Leone with labor and postnatal care at the Gondama Referral Center, in Gondama, Bo District, Sierra Leone, October 2012.

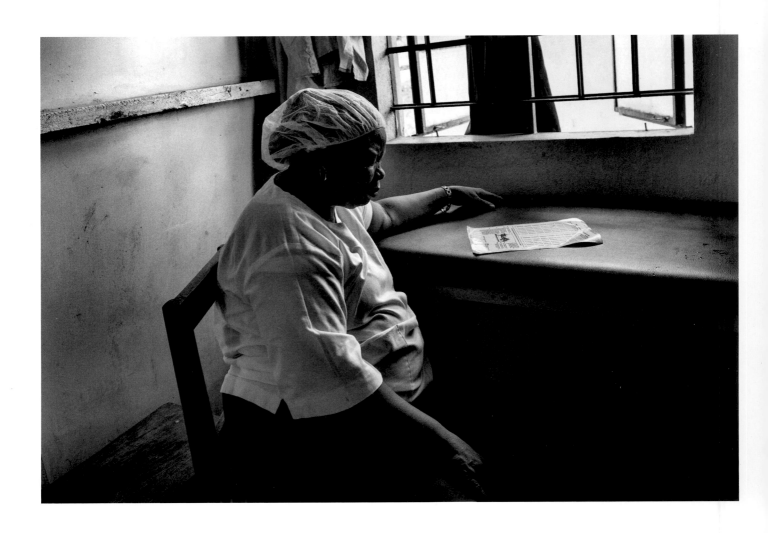

Nurse Florence Lahai, forty-two, prays after successfully delivering a baby during a complicated birth at the Gondama Government Clinic in Bo District, Sierra Leone, October 2012. Sierra Leone has one of the highest rates of maternal mortality in the world. Though the government of Sierra Leone introduced free health care to pregnant and lactating women and to children under five across the country in 2010, the services and trained medical staff are inaccessible to much of the population.

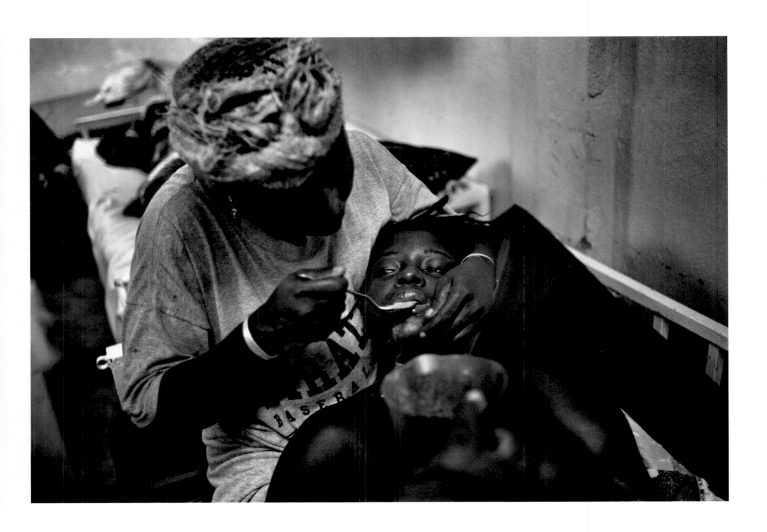

Rukiatu Gbassah feeds her daughter, Adama Gbassah, thirty-one, who remains in a coma due to complications associated with preeclampsia days after delivering her first child at the Gondama Referral Center in Bo District, Sierra Leone, October 2012.

Kadiatu faints on the floor of Magburaka Government Hospital upon realizing that her sister may not survive, October 2012. Her sister, Zainab Conte, twenty, a third-year medical student, lies in a coma after suffering from postpartum hemorrhaging following the delivery of her baby at a government clinic at Mile 91 outside Freetown, Sierra Leone.

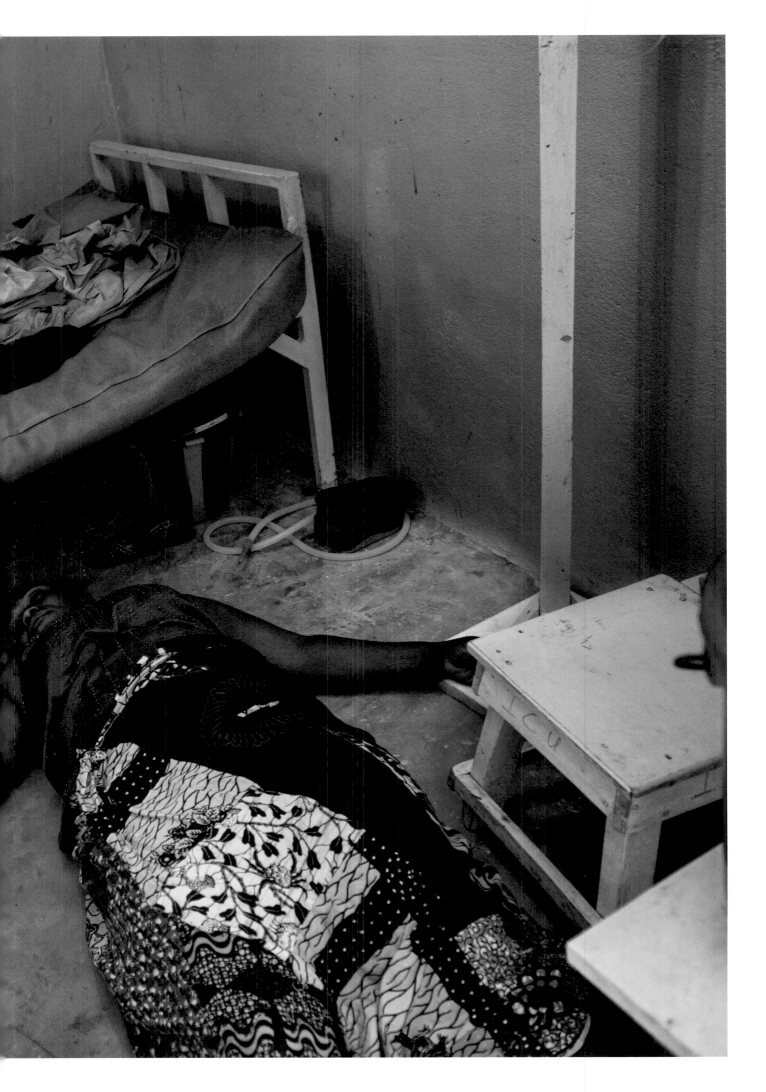

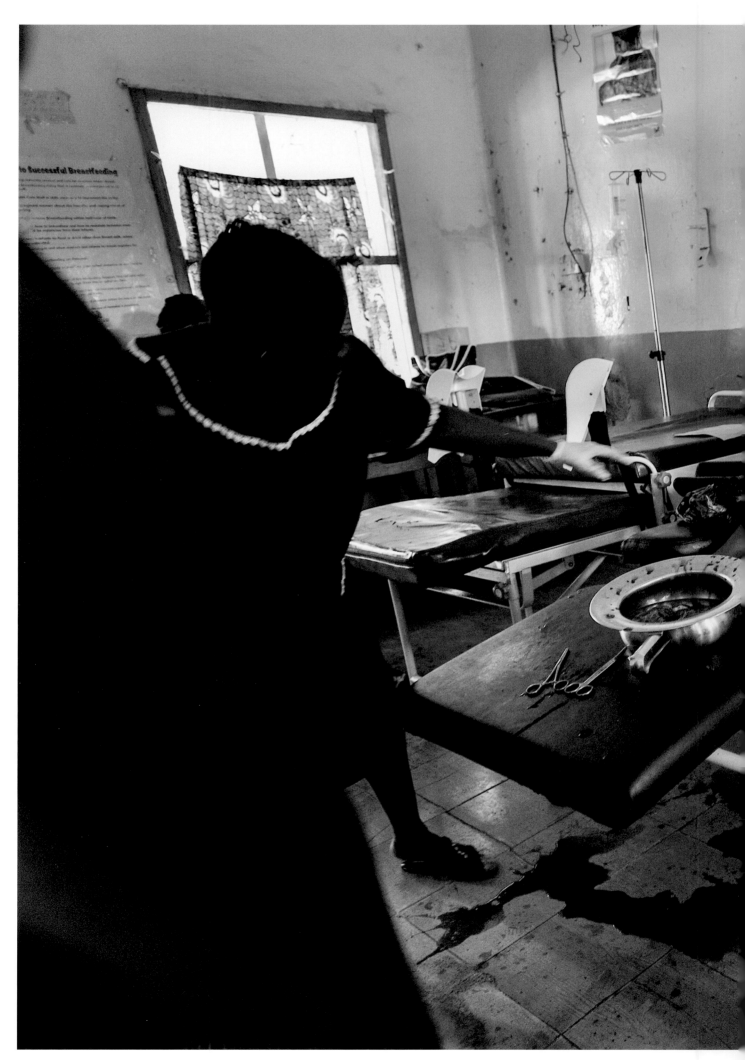

Blood continues to leak from Mamma Sessay, eighteen, shortly after she delivered the second of her twins as her sister, Amenata, helps prop her up at the Magburaka Government Hospital in Sierra Leone, May 2010. Hemorrhaging postpartum, Mamma said repeatedly, "I am going to die," as she lay on the delivery table.

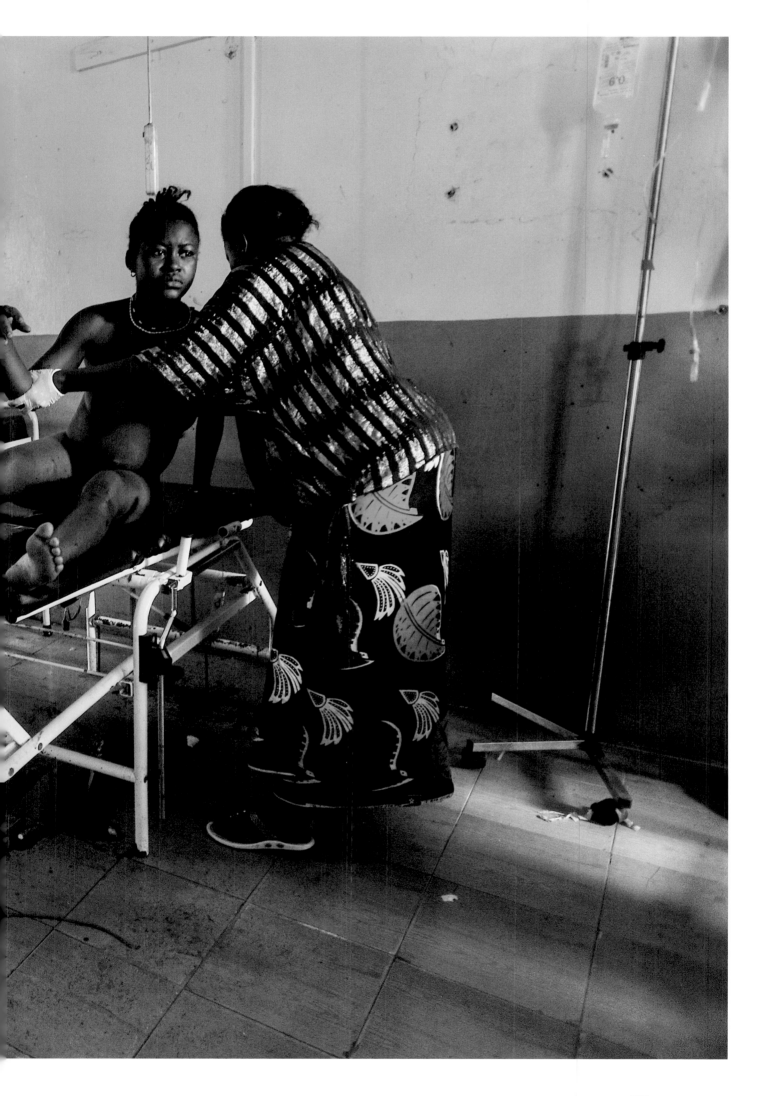

189

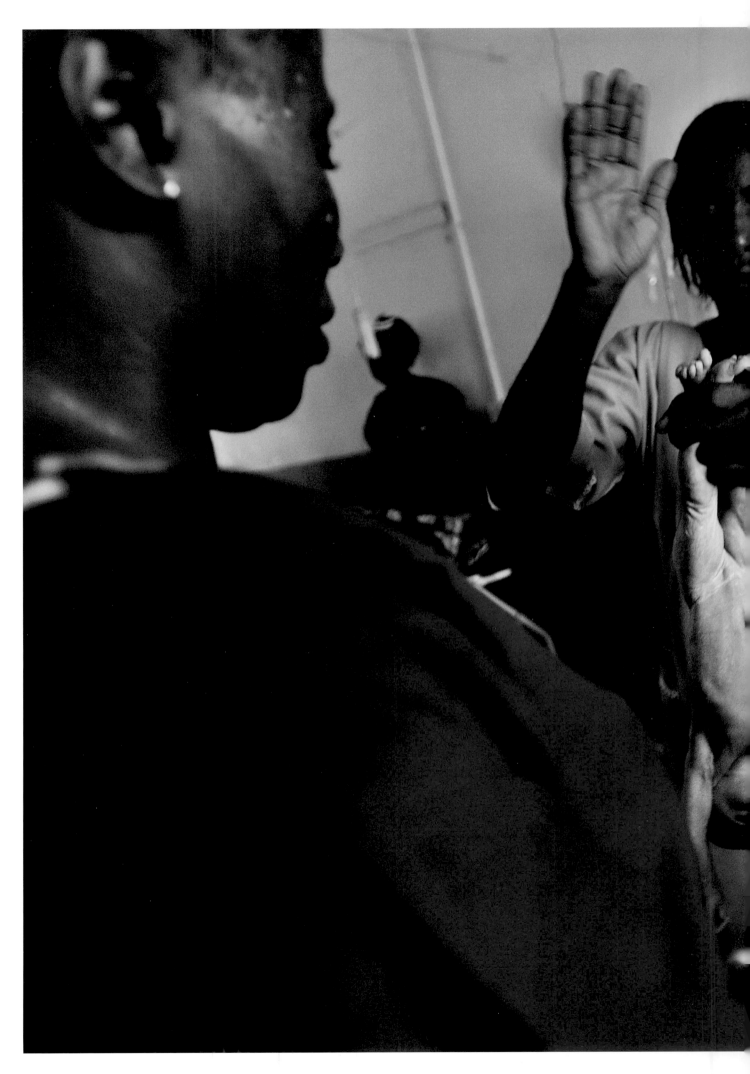

A nurse tries to resuscitate the second-born twin of Mamma Sessay after the baby was delivered a day after the first child.

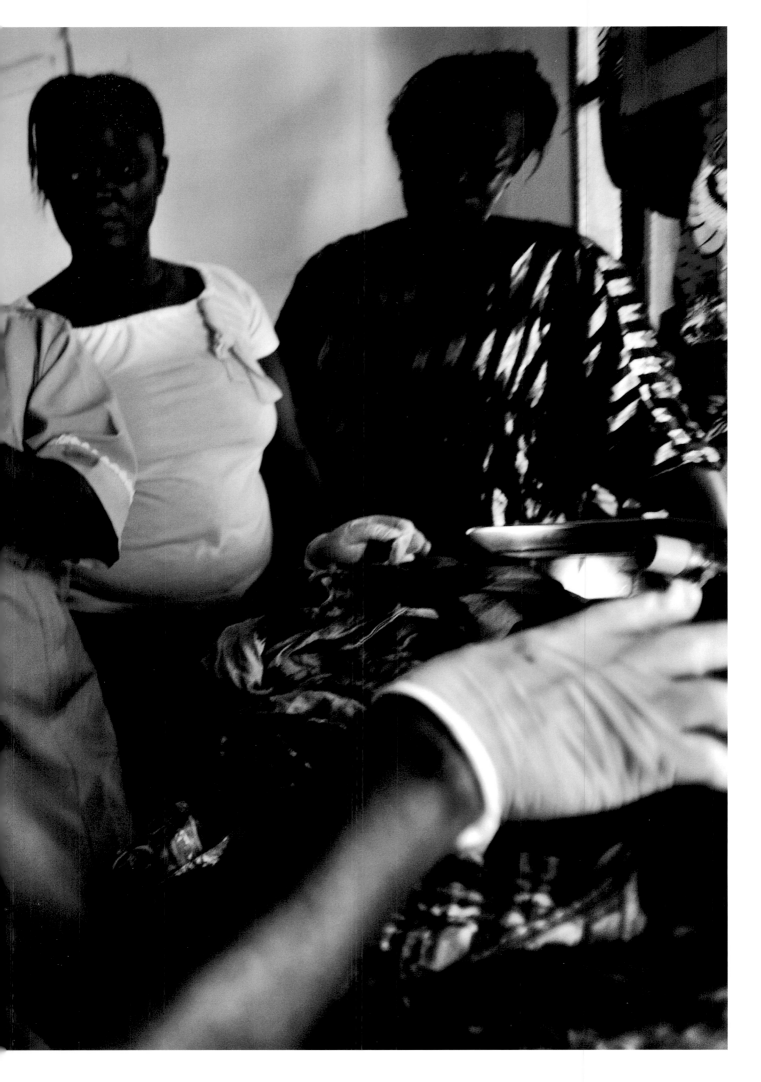

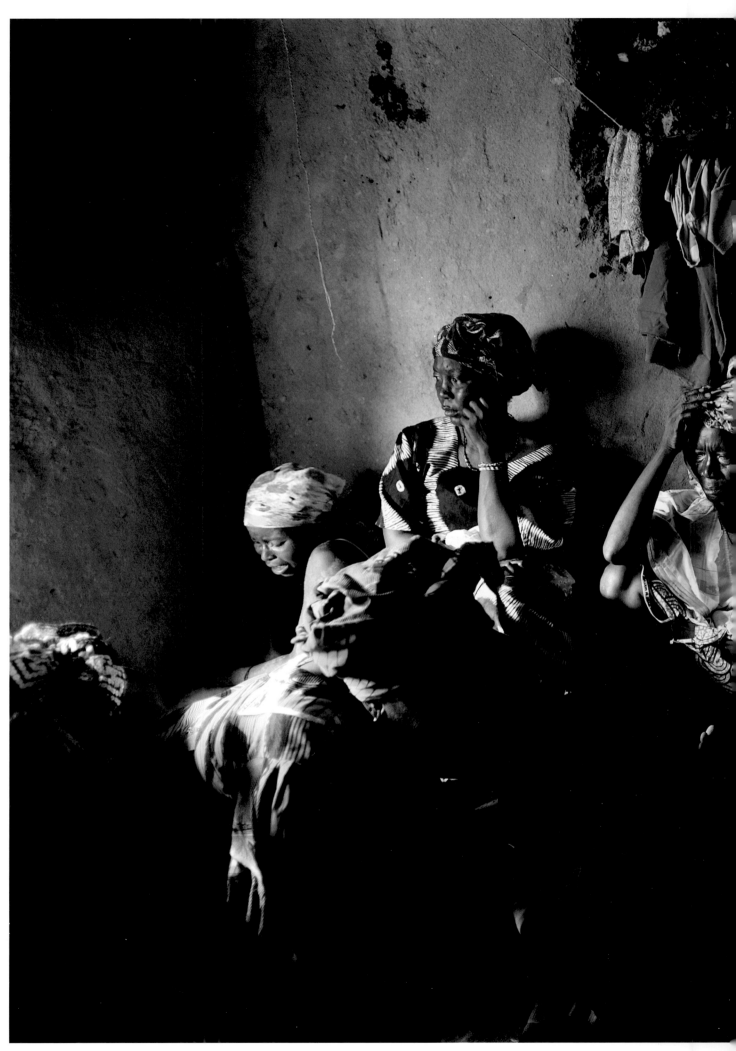

At Mamma Sessay's funeral, relatives have covered her face with ritualistic powder to ward off evil and prepare her for the afterlife. It will fall to her mother to care for the newborn twins. Mayogbah village, Sierra Leone, May 2010.

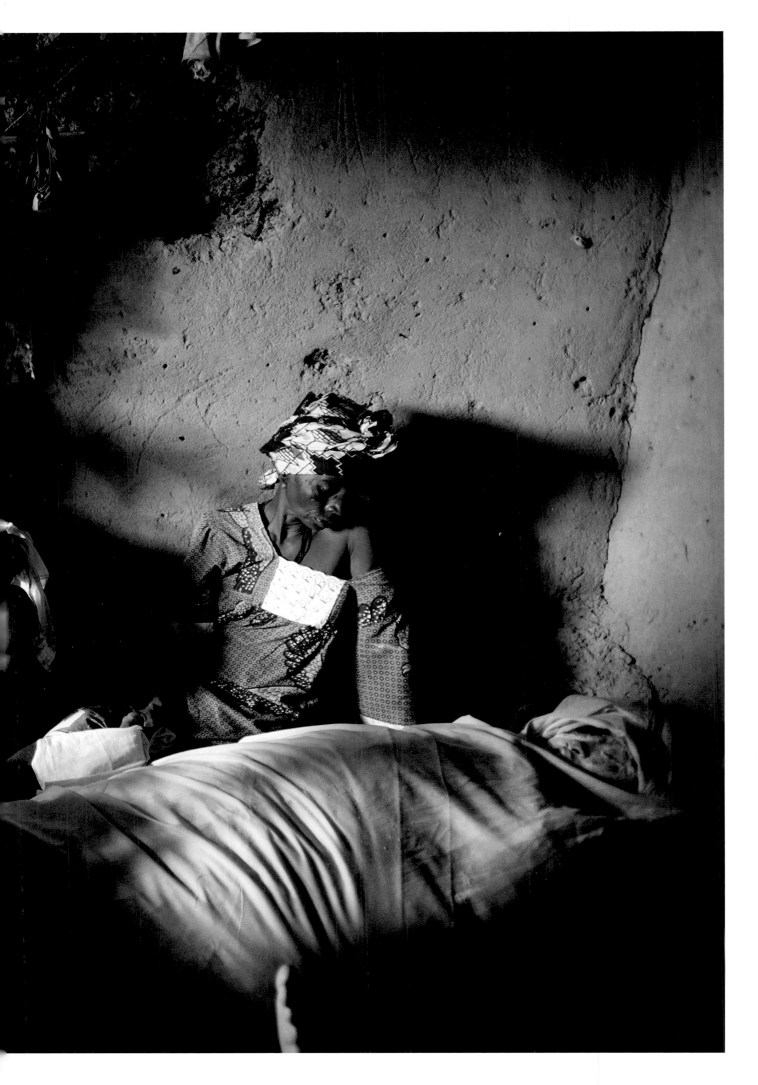

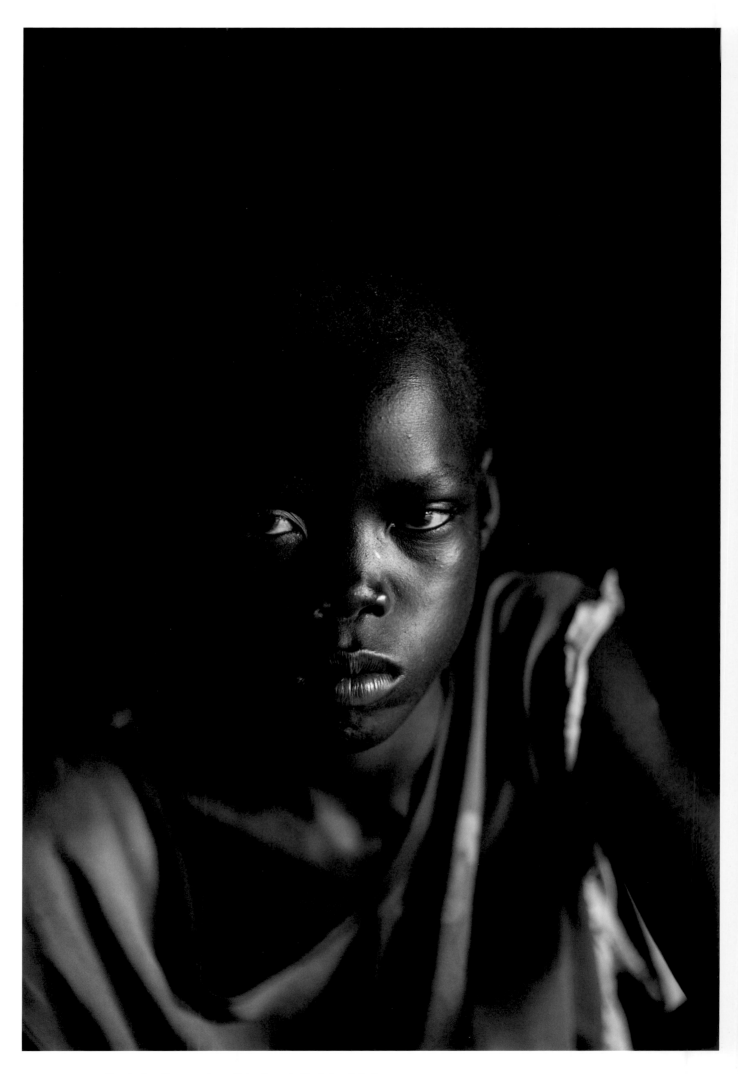

Chuol, nine, from southern Unity State, in Nyal, South Sudan,
September 2015.

Chuol and His Mother

One night in May 2015, a group of armed men from the Dinka tribe rampaged a small Nuer tribe village in South Sudan, raping the women, thrashing and pillaging homes, and executing residents. Although many hoped that South Sudan's newly established independence in 2011 might be the solution to years of conflict with Sudan, a tenuous power-sharing agreement between the South Sudanese president, Salva Kiir from the Dinka tribe, and the former vice president, Riek Machar from the Nuer tribe, broke down in December 2013, unleashing a brutal civil war countrywide. South Sudanese civilians in the Upper Nile region saw some of the worst violence, similar to this brutal attack in May.

As the men ransacked the town, a nine-year-old boy named Chuol and his eight siblings ran and hid in the bushes nearby. Chuol's mother also hid in the bushes, but Chuol's father was not as fortunate. The attackers locked him and the family's cattle in a *tukul*, a straw-thatched hut, and set it on fire, burning them alive. The following morning, while the bones of Chuol's father still smoldered, Chuol's mother, Mary Nyatal Phar Malet, made the hardest decision of her life: She sent Chuol away with her eldest daughter, Nyachot, and her own mother, Angelina. She instructed them to make their way to a refugee camp in Kenya while she stayed behind to care for her other small children.

Mary hoped that in the refugee camp Chuol—now considered the man of the family—would go to school, study hard, and, at some point in the future, return home. It was a great responsibility for a spindly, preteen boy who loved nothing more than playing soccer. As they parted ways, Mary and Chuol were not sure they would see each other again.

In a country lacking the most basic infrastructure—electricity, phone networks, and paved roads—most displaced people had no means of tracing loved ones. A village attacked often meant families were separated for years, if not forever.

After Chuol, Angelina, and Nyachot fled their village, they spent months traveling in canoes, carved out of logs, through crocodile-infested swamps, surviving on grass, lily pads, and hand-caught fish. Eventually they arrived in Nyal, an island in South Sudan's Unity State, situated in the Sudd, one of the largest swamps in the world, where thousands of South Sudanese had taken shelter after fleeing their villages. The camp was dense with civilians who had been forced to shove their belongings into satchels and flee with them atop their heads.

I met Chuol several months after he arrived in Nyal, in September 2015, when I accompanied a team of journalists to document his story for the *New York Times Magazine*'s virtual reality film *The Displaced*. At the time, Chuol was aloof. "I have been dreaming about being reunited with my mother and living with her again," he told me. "In the dream, I can see the fighters coming to attack, and I am wishing that our side would win. I am wearing the shorts I am wearing now"—black Manchester City shorts with the logo faded and tattered—"and my family is with me. My mother is wearing a long red gown when I see her." As Chuol spoke, I wondered if his mother was still alive.

During my last evening in Nyal, after I had finished photographing Chuol on the soccer field, he asked me to wait while he ran off into the dust. He returned some forty-five minutes later holding a live chicken, smiling sheepishly: "I would like you to have a nice dinner on your last night in Nyal," he said. He walked me back to our compound of tents set up within the confines of the camp and handed the chicken over to the cook to prepare for dinner. I left the next morning.

A few months later, Chuol and Angelina called me on my cell phone in London to say that they had arrived at Kakuma, the largest refugee camp for South Sudanese in Kenya, and that Chuol was enrolled in school. Since then I've spoken several times with Angelina and Chuol from their new home in Kenya, and with Chuol's cousin David, who had long before settled at Kakuma and spoke decent English. They often call to tell me how Chuol is doing and to ask about my family.

Roughly six months after I first met Chuol, in early 2016, the violence around Leer died down, and the South Sudanese government appointed a governor, installed troops to maintain an uneasy peace, and permitted a trickle of aid workers to return to Leer. At that point, I received an assignment from *Time* magazine to travel to Leer to investigate the humanitarian situation and the atrocities that had allegedly taken place in the area.

When I realized we would be traveling to Leer, I wondered if I might be able to track down Chuol's mother. I emailed Kim, a UNICEF staff person who had originally introduced me to Chuol, and asked if he had any information about Chuol's mother. He responded with an email, saying that Chuol's mother could very well still be alive. He advised that when I got to Leer, I should speak to UNIDO (United Nations Industrial Development Organization), the local UNICEF partner.

Leer was a ghost town. The once-prosperous area had been razed and ransacked. Sheets of corrugated-tin roofing were strewn on the ground next to bullet-ridden, wheelless trucks. Human skeletons littered patches of grass and dirt throughout the town. There was also a mass grave on the outskirts of town near the United Nations peacekeeping base. When we arrived, the International Committee of the Red Cross was preparing to register almost eighteen thousand people for food distribution. I realized that the food distribution site might be the best way to find Chuol's mother.

We set out at sunrise the next morning and arrived along with thousands of South Sudanese civilians coming from all stretches of the horizon. I had little hope of finding Mary, but I had been in Leer less than twenty-four hours when a young man working with UNIDO came up to me as I photographed. "We have found Chuol's mother."

I didn't believe it. How? There was no computerized database, no rhyme or reason or pattern to the crowds; no one wore name tags. As I walked toward Mary, she towered at over six feet tall. She wore a long, flowy dress—just as Chuol had dreamed, but not red in color—and a hardened look on her face. The man introduced me as a photojournalist from America and offered to translate from English into her local dialect.

I introduced myself and said I was doing a story about the situation in South Sudan. After asking her to describe what had happened to her and her family during the fighting in the village, I became convinced that this was the Mary I was looking for.

"I think I met your son Chuol, in Nyal, when he was making his way to Kenya," I explained.

"I am not aware of whether Chuol made it to Kakuma, because there is no communication, or if he is still in Nyal," Mary replied.

I said to the interpreter: "You can tell her that I spoke to him, and he is in Kakuma, and he is in school, and he is OK. He is with her nephew."

Mary's face was blank. She stared down at me, and I thought that perhaps she was skeptical of me, the same way I was of her.

"Does she want me to tell him something?" I asked. "Because I can call him after I leave here." There was no phone service in the area.

She thought for a moment, looked off into the distance, and said yes. She waited for me to open my notebook to a fresh page. "When you meet Chuol, or call him on the phone, you will tell him that we have survived with my grandmother and children."

My eyes welled up, and I fought to compose myself.

"Also you will tell Chuol that all the cows were taken by the government. And here the living situation is very worse. There is no work, and I am not working. And we are suffering with my grandmother and the children. We are

Chuol living among other internally displaced in Nyal, South Sudan, while on the run to Kakuma refugee camp in Kenya, September 2015.

"My son, my son." Chuol's six siblings filed into the room, one by one, grabbing at the copy of the magazine and peering at the images as if they would come to life. Mary looked intently at the images of her son, and traced her finger over the shiny pages. Finally, she wept.

I wondered if she had any other message she would like to deliver to her son on camera.

She sat up straight and began: "Tell him your mother said, 'My son, you study. Study with all your heart. Although we are suffering, and when you come back learned, we will be better. Your brothers are here with me, and they have nothing to eat, but when you study, all our problems will be solved. I don't want you to come to me, because we have nothing to do here. You study.' You tell that to him; that was what your mother has said."

In the autumn of 2016 I flew to Kakuma to bring Chuol the message from his mother. Sitting in a small, dark *tukul* surrounded by Angelina, Nyachot, and his cousin David, Chuol watched his mother's video message to him.

I looked for tears in his eyes that never arrived. Instead he was focused, resolute, and more determined than ever to study hard and return home. He was just like his mother.

depending on the UN relief and what the organizations are giving us."

Tears were streaming down my face. But like countless other South Sudanese men and women I have interviewed over the years who had survived the unspeakable, Mary did not betray emotion. I promised her I would pass on the message.

The next morning I visited Chuol's mother again. Mary waited for us at the edge of the village and walked us toward the small thatched hut where the family had moved after the attack the year before. Inside, Mary's grandmother, Chuol's great-grandmother, sat, emaciated and fragile, fanning herself from the flies. I introduced myself through our interpreter and, now that I knew for sure this was Chuol's family, presented a tattered copy of the *New York Times Magazine* with Chuol on the cover. The grandmother began to rock back and forth, reaching for the magazine, crying,

Top Chuol in school at Kakuma refugee camp in Kenya, October 2016.
Bottom Chuol watching his mother's video message in Kakuma refugee camp, October 2016.

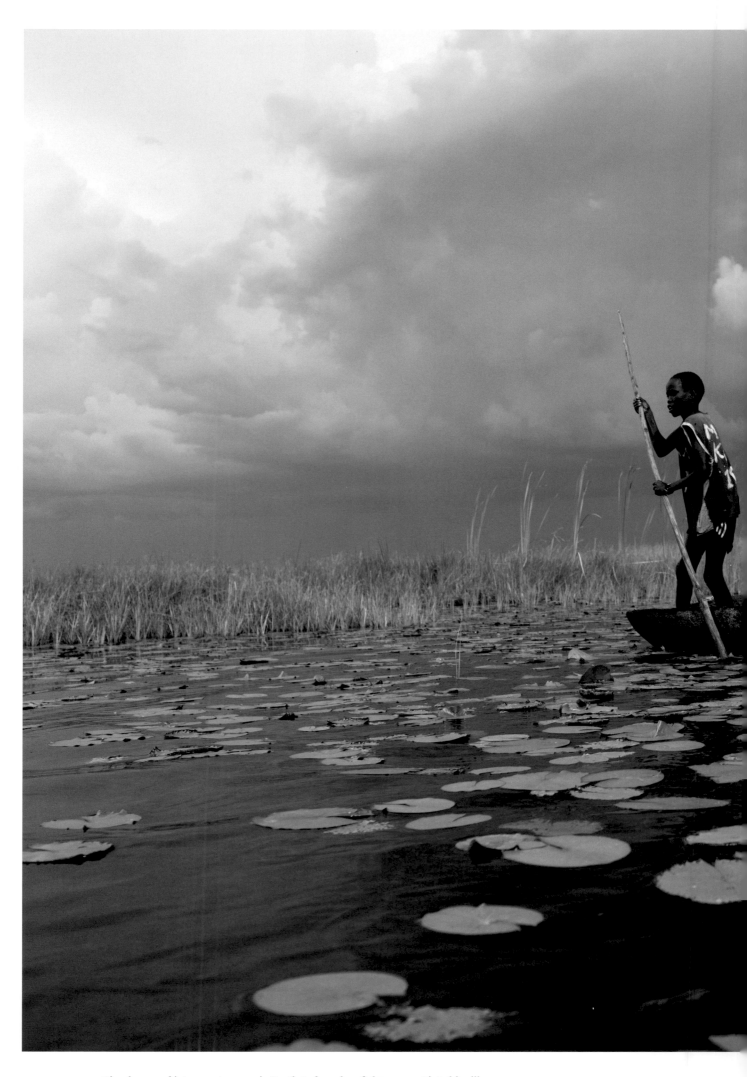

Chuol escaped into a vast swamp in South Sudan when fighters swept into his village,
September 2015.

Libya

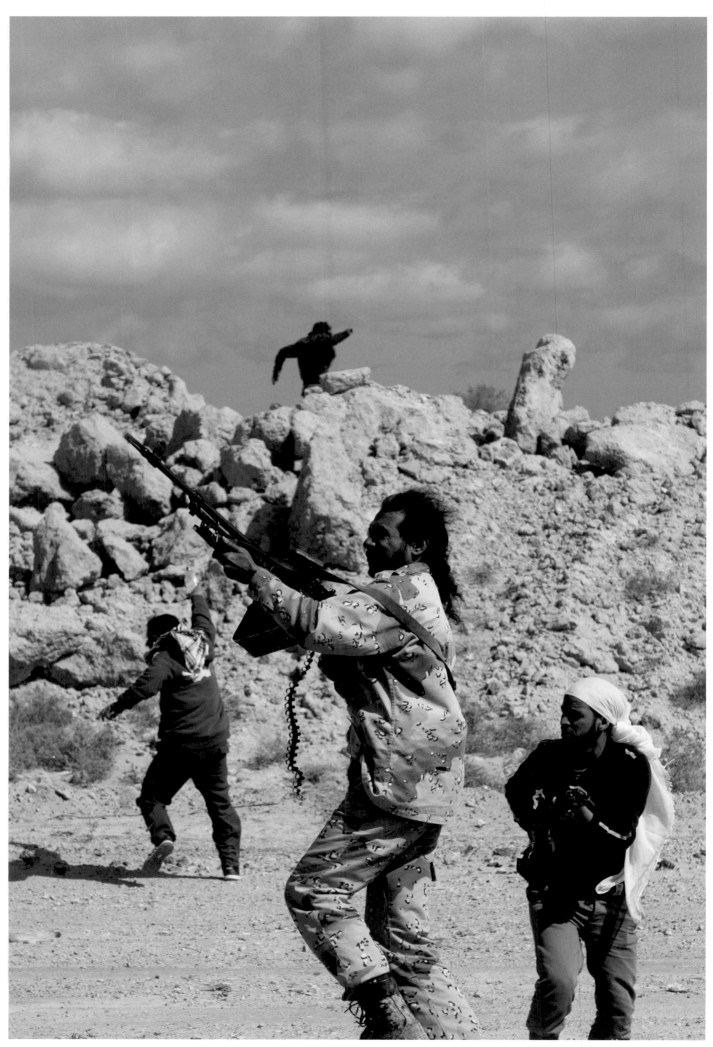

Opposition troops fire at a government helicoptor spraying the area with machine guns, as the opposition is pushed out of Bin Jawad toward Ras Lanuf, in eastern Libya, March 2011.

Anatomy of a Kidnapping

When I arrived in Benghazi at the end of February 2011, it was a newly liberated city, a familiar scene to me, like Kirkuk after Saddam or Kandahar after the Taliban. Buildings had been torched, prisons emptied, a parallel government installed. The mood was happy. One day I visited some men who had gathered in town for a military training exercise. It resembled a Monty Python skit: Libyans stood at attention in strict configurations or practiced walking like soldiers or gaped at a pile of weapons in bewilderment. The rebels were just ordinary men—doctors, engineers, electricians—who had thrown on whatever green clothes or leather jackets or Converse sneakers they had in their closets and jumped into the backs of trucks loaded with Katyusha rocket launchers and rocket-propelled grenades. Some men lugged rusty Kalashnikovs; others gripped hunting knives. Some had no weapons at all. When they took off down the coastal road toward Tripoli, the capital city, still ruled by Qaddafi, journalists jumped into their boxy four-door sedans and followed them to what would become the front line.

We traveled alongside the men, watched them load ammunition, and waited. Then one morning, one of the first days on that lonely strip of highway, a helicopter gunship suddenly swooped down low over our heads and unleashed a barrage of bullets, spitting at us indiscriminately. The gaggle of fighters shot up the air with Kalashnikovs. One boy threw a rock; another, his eyes wild with terror, ran for a sand berm. I ducked beside the front of a tin-can car and took a picture of him and knew this would be a different kind of war.

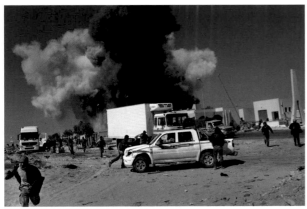

The front line moved along a barren road surrounded by sand that stretched flat to the blue horizon. Unlike in the wars in Iraq and Afghanistan, there were no bunkers to jump into, no buildings to hide behind, no armored Humvees in which to crouch down on the floor. In Libya, when we heard the hum of a warplane, we went through the motions: We stopped, looked up, and cowered in anticipation of rounds of ammunition or bombs and tried to guess where they would land. Some people lay on their backs; some people covered their heads; some people prayed; and some people ran, just to run, even if it was to nowhere. We were always exposed to the massive Mediterranean sky.

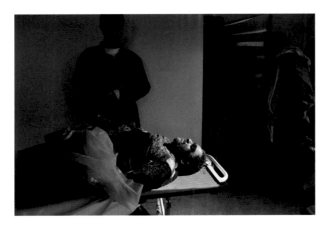

I had been a conflict photographer for more than ten years and had covered war in Afghanistan, Iraq, Sudan, the Democratic Republic of the Congo, and Lebanon. I had never seen anything as scary as Libya. The photographer Robert Capa once said, "If your pictures aren't good enough, you're not close enough." In Libya, if you weren't close enough, there was nothing to photograph. And once

Scenes from the front line in Libya, from Benghazi to Ras Lanuf, March 2011.

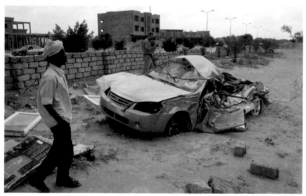

you got close enough, you were in the line of fire. That week I watched some of the best photojournalists in the business, veterans of Chechnya and Afghanistan and Bosnia, leave almost immediately after those first bombs fell. "It's not worth it," they said. There were several moments when I, too, thought to myself, *This is insane. What am I doing?* But there were other days when I felt that familiar exhilaration, when I thought, *I am actually watching an uprising unfold. I am watching these people fighting to the death for their freedom. I am documenting the fate of a society that has been oppressed for decades.* Until you get injured or shot or kidnapped, you believe you are invincible. And it had been a few years since anything had happened to me.

You have two options when you approach a hostile checkpoint, and both are a gamble. The first option is to stop and identify yourselves as journalists and hope that you are respected as neutral professionals. The second option is to blow past them and hope they don't open fire on you.

"Don't stop! Don't stop!" Tyler was yelling.

But our driver, Mohammed, was slowing down, sticking his head out of the window.

"*Sahafi!* Media!" he yelled to the soldiers. He opened the car door to get out, and Qaddafi's soldiers swarmed around him. "*Sahafi!*"

In one fluid movement the doors flew open and Tyler, Steve, and Anthony were ripped out of the car. I immediately locked my door and buried my head in my lap. Gunshots shattered the air. When I looked up, I was alone. I knew I had to get out of the car to run for cover, but I couldn't move. I spoke to myself out loud, a tactic I used when my inner voice wasn't convincing enough: "Get out of the car. Get out. Run." I crawled across the backseat with my head down and then out the open car door, scrambled to my feet, and immediately felt the hands of a soldier pulling at my arms and tugging at my two cameras. The harder he pulled, the harder I pulled back. Bullets whipped by us. Dirt kicked up all around my feet. The rebels were barraging the army's checkpoint from behind us, from the place we had just fled. The soldier pulled at my camera with one hand and pointed his gun at me with the other.

We stood like that for ten interminable seconds. Out of the corner of my eye I saw Tyler running toward a one-story cement building up ahead. I trusted his instincts. We needed to get out of

the line of fire before we could negotiate our fate with these soldiers.

I surrendered my waist pack and one camera and clutched the other, pulling the memory cards out as I ran after my colleagues, who, in the chaos of bullets, had also escaped their captors. My legs felt slow as my eyes stayed trained on Anthony ahead of me. "Anthony! . . . Anthony, help me!"

But Anthony had tripped and fallen to his knees. When he looked up, his normally peaceful face was wrenched with panic, oblivious to my screams. His face looked so unnatural that it terrified me more than anything else. We had to reach Tyler, who had sprinted ahead and seemed likeliest to escape.

Somehow the four of us reunited at the cinder-block building set back from the road, sheltered from the gun battle that continued to rage behind us. A Libyan woman holding an infant stood nearby, crying, while a soldier tried to console them. He didn't bother with us, because he knew we had nowhere to go.

"I'm thinking about making a run for it," Tyler said.

We looked into the distance. The open desert stretched out in every direction.

Within seconds, five government soldiers were upon us, pointing their guns and yelling in Arabic, their voices full of hate and adrenaline, their faces contorted into masks of rage. They ordered us facedown into the dirt, motioning to us with their hands. We all paused, assuming this was the moment of our execution. And then we slowly crouched down and begged for our lives.

I pressed my face into the soil, sucking in a mouthful of fine dirt as a soldier pulled my hands behind my back and kicked open my legs. The soldiers were all screaming at us, at one another, pointing their weapons at our heads as the four of us sank into silent submission, waiting to be shot.

I looked over at Anthony, Steve, and Tyler to make sure we were all still there, together and alive, and then quickly looked back down at the sand.

"Oh God, oh God, oh God. Please, God. Save us."

I raised my eyes from the ground and looked up into a gun barrel and directly into the soldier's eyes. The only thing I could think to do was beg, but my mouth was so dry, as if my saliva had been replaced with dirt. I could barely utter a word.

"Please," I whispered. "Please."

I waited for the crack of the gun, for the end of my life. I thought of Paul, my parents, my sisters, and my two grandmothers, well into their nineties. Each second felt like its own space in the universe. The soldiers continued barking at one another, with their guns leveled at our heads.

"*Jawaz!*" one of them suddenly yelled. They wanted our passports, and we surrendered them. The soldier leaned down and started searching my body for my belongings, pulling things out of my jacket pockets: my BlackBerry, my memory cards, some loose bills. His hands moved quickly, skipping over my second passport, which was secretly tucked into a money belt inside my jeans, until they reached my breasts. He stopped. And then he squeezed them, like a child honking a rubber horn.

"Please, God. I just don't want to be raped." I curled as tightly as I could into a fetal position.

But the soldier was preoccupied with something else. He removed my gray Nikes with fluorescent yellow soles, and I heard the whipping sound of the laces being pulled out. I felt air on my feet. He tied my ankles together. With a piece of fabric he pulled my wrists behind my back and tied them together so tightly they went numb. Then he pushed my face down into the filthy earth.

Will I see my parents again? Will I see Paul again? How could I do this to them? Will I get my cameras back? How did I get to this place?

The soldiers picked me up by my hands and feet and carried me away.

The Aftermath

After I got out of Libya, Paul and I went to Goa for four days to decompress. The Zen destination that Indian friends had recommended to Paul was full, but the owner graciously offered us his private home on the resort grounds by a small creek. We were overcome with exhaustion. What might have been a celebratory, passionate several days was, in fact, a somber hibernation. Neither of us cried. We didn't make love nonstop. We simply held each other, kissed tenderly, slept, walked, swam, ate, drank, and slept some more.

That handful of days was enough for Paul and me to recenter ourselves before heading to New York; by that time, after so many years of travel and distance, five days together was the equivalent of five weeks of rest. My three colleagues and I had to debrief the *Times* and do press interviews. We didn't realize it while in captivity, but our kidnapping had made a lot of news, and we had been asked to appear on several news programs and talk shows. Our first stop was the *New York Times*.

Walking into the shiny *Times* building, I was ashamed at what we had put our editors through with our kidnapping. I knew that countless hours of time and energy had gone into securing our release, and I steeled myself for reproachful glances. Journalists who got kidnapped several times were not necessarily heroes in our business. Bravery was one thing, recklessness another.

I went to find Michele McNally, the paper's director of photography, with whom I had worked for almost a decade and whose job it was to decide whether or not to send correspondents to this war or that revolution. It was one of the most stressful jobs at the paper, and she cared for us as though we were her children. When she saw me, she crumbled in my arms. Everyone in the photo department and others from the foreign desk surrounded us, took pictures, and clapped and cried. Everyone celebrated us. I felt like an idiot for having caused so much grief.

And while I thought I was stable, seemingly meaningless statements or normal emotional reactions from friends or family turned me into a quivering mess. The four of us shuffled from a brief appearance on the *Today* show to an hour-long session—like therapy—with Anderson Cooper on CNN. We trudged dutifully from interview to interview because we felt, as journalists, it would have been hypocritical to turn down interviews with our peers. We spoke collectively about the guilt and sorrow we felt for possibly ushering our young driver, Mohammed, to his death. I spoke openly about being sexually assaulted but not raped; it was important to me to set the record straight, publicly, about what happened to me in captivity. We had been completely at the Libyans' mercy. But we had lived. I felt lucky. I had interviewed suffering people all over the world, and they never felt like victims. They felt like survivors. I had learned from them.

Everyone asked us the inevitable question and my answer was yes. I knew I would cover another war. The hardest part about what happened to us in Libya was what we had put our loved ones through, but that had long been the excruciating price of the profession—my loved ones suffered, and I suffered when they suffered. Journalism is a selfish profession. But I still believed in the power of its purpose, and hoped my family did, too.

Levent Sahinkaya, center, the Turkish ambassador to Libya, at the Turkish Embassy in Tripoli, Libya, with the four freed *New York Times* journalists: from left, Stephen Farrell, Tyler Hicks, Lynsey Addario, and Anthony Shadid.

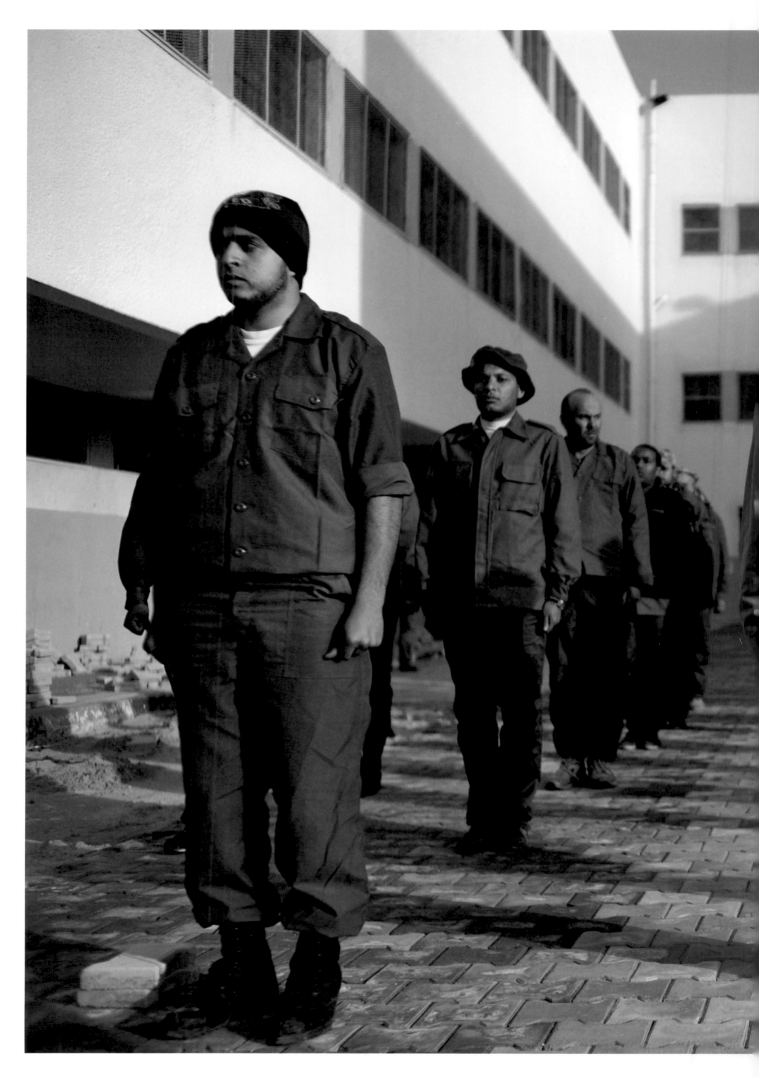

New volunteer fighters loyal to the opposition movement attend their first day of training at a base in Benghazi, eastern Libya, March 2011.

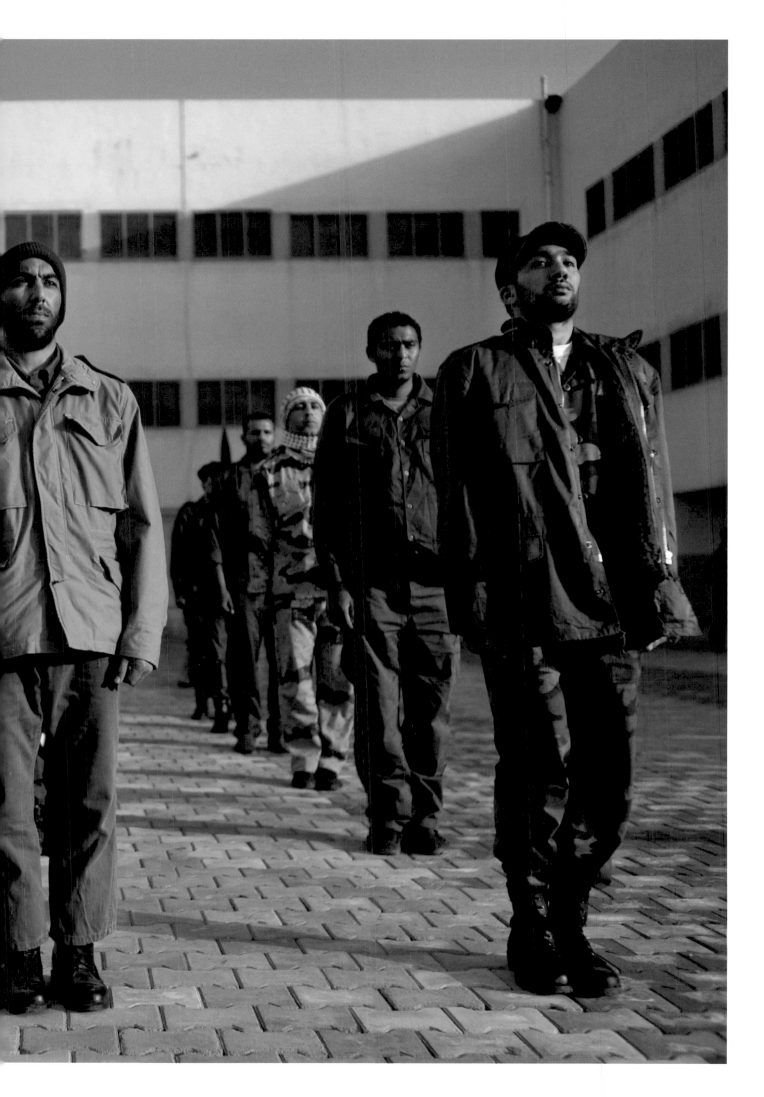

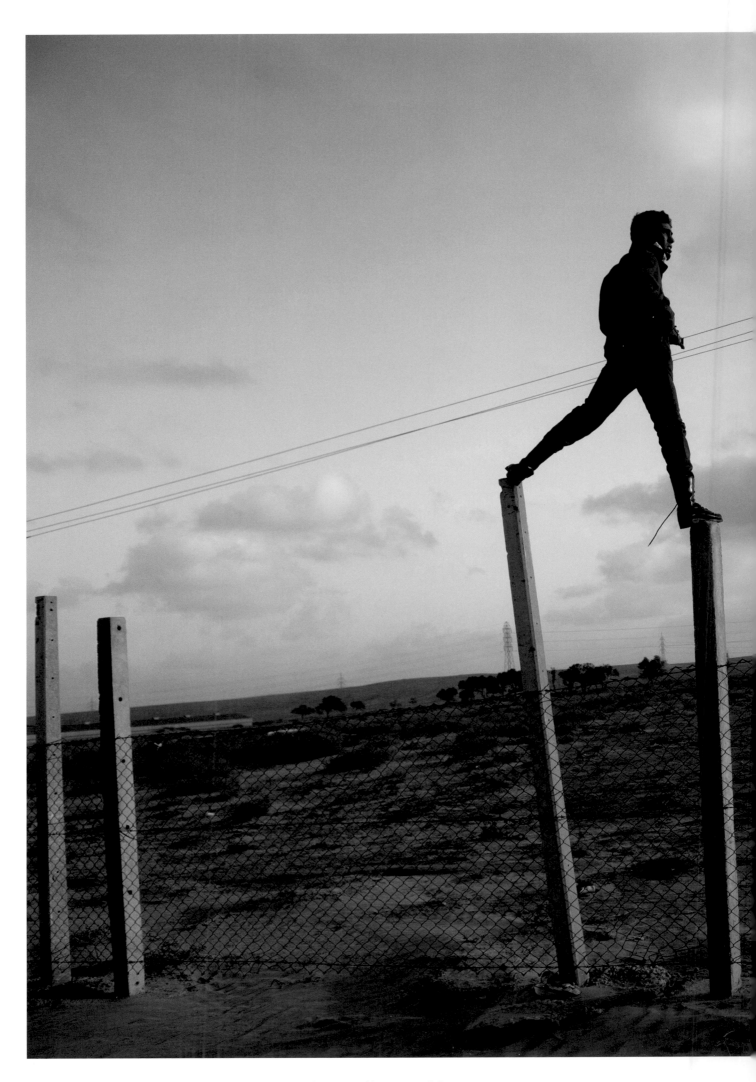

Opposition troops take positions as they push west outside Ras Lanuf after
taking the city back from troops loyal to Qaddafi, in eastern Libya, March 2011.

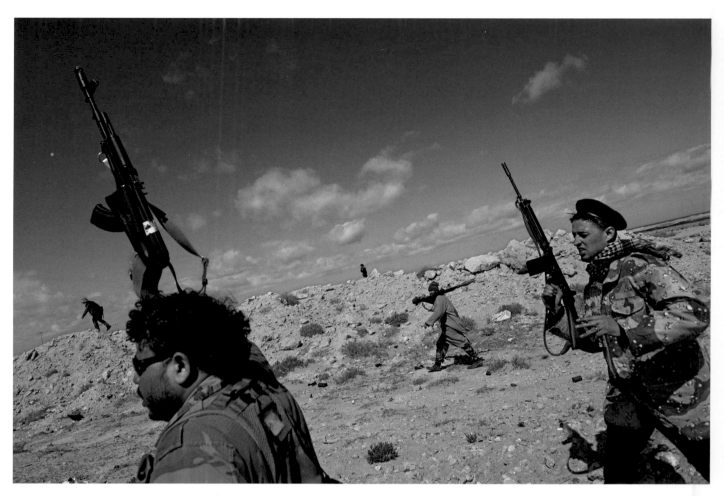

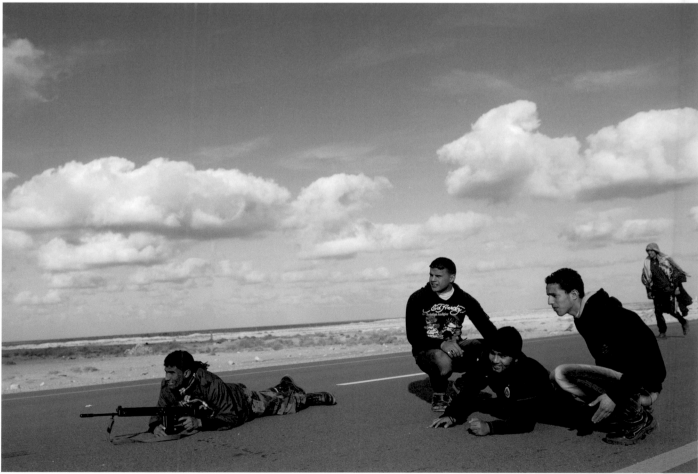

Top Opposition troops shoot at a government helicopter that is spraying the area with machine-gun fire, pushing them back east out of Bin Jawad toward Ras Lanuf in eastern Libya, March 2011.

Bottom Opposition troops crouch down on the front line during heavy fighting, shelling, sniper rounds, and air strikes near Bin Jawad in eastern Libya, March 2011.

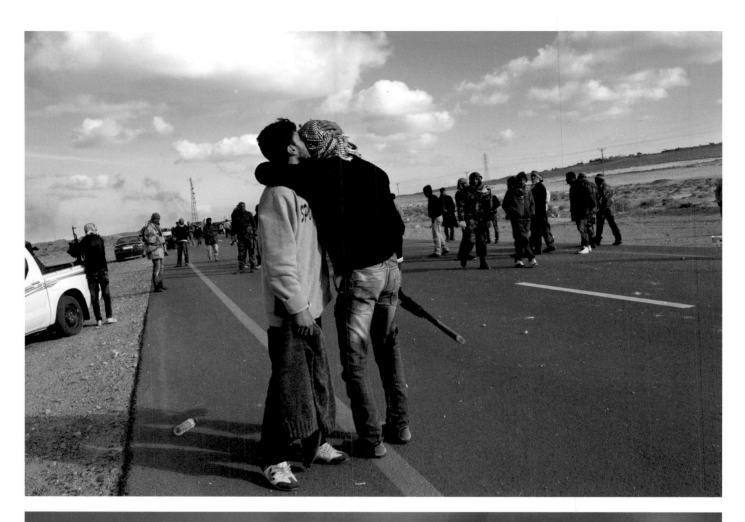

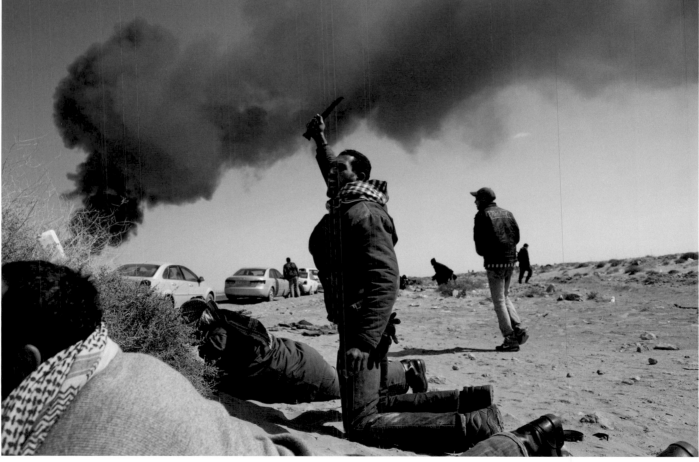

Top Opposition troops embrace as they recapture territory from soldiers loyal to Qaddafi, and gain more ground west of Bin Jawad, March 2011.
Bottom Opposition troops pull back from the main checkpoint near the refinery in Ras Lanuf as troops loyal to Qaddafi shell the area in Ras Lanuf, eastern Libya, March 2011.

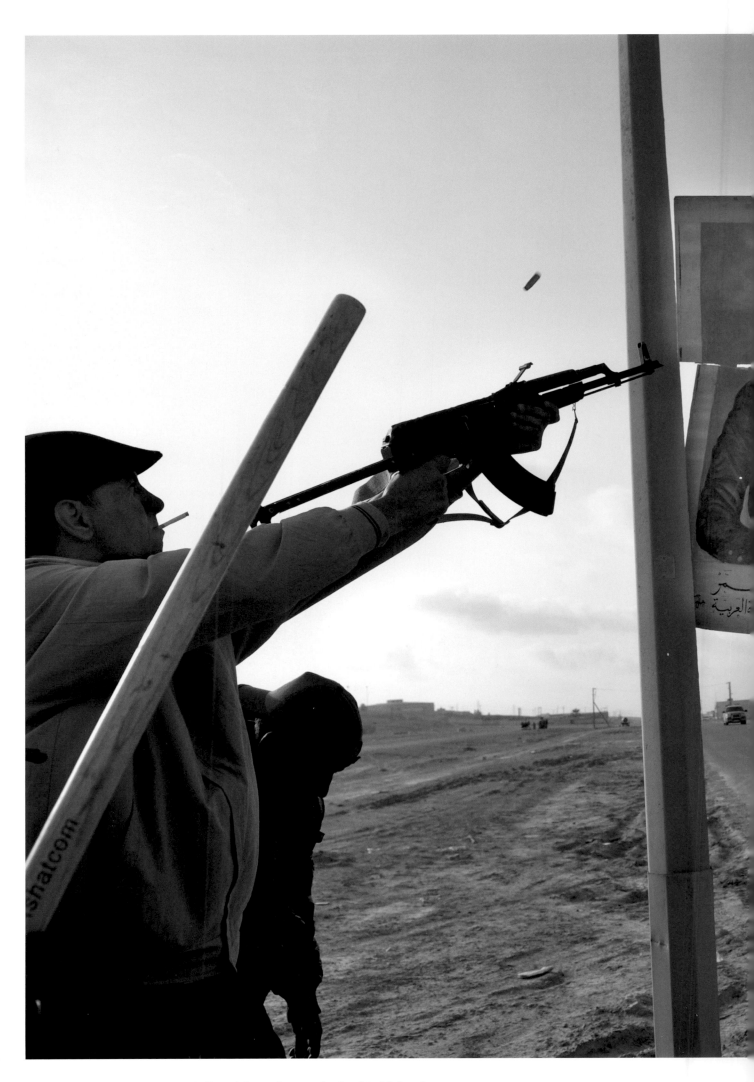

Opposition troops defile and destroy images of Colonel Qaddafi as they recapture
territory west of Bin Jawad, March 2011.

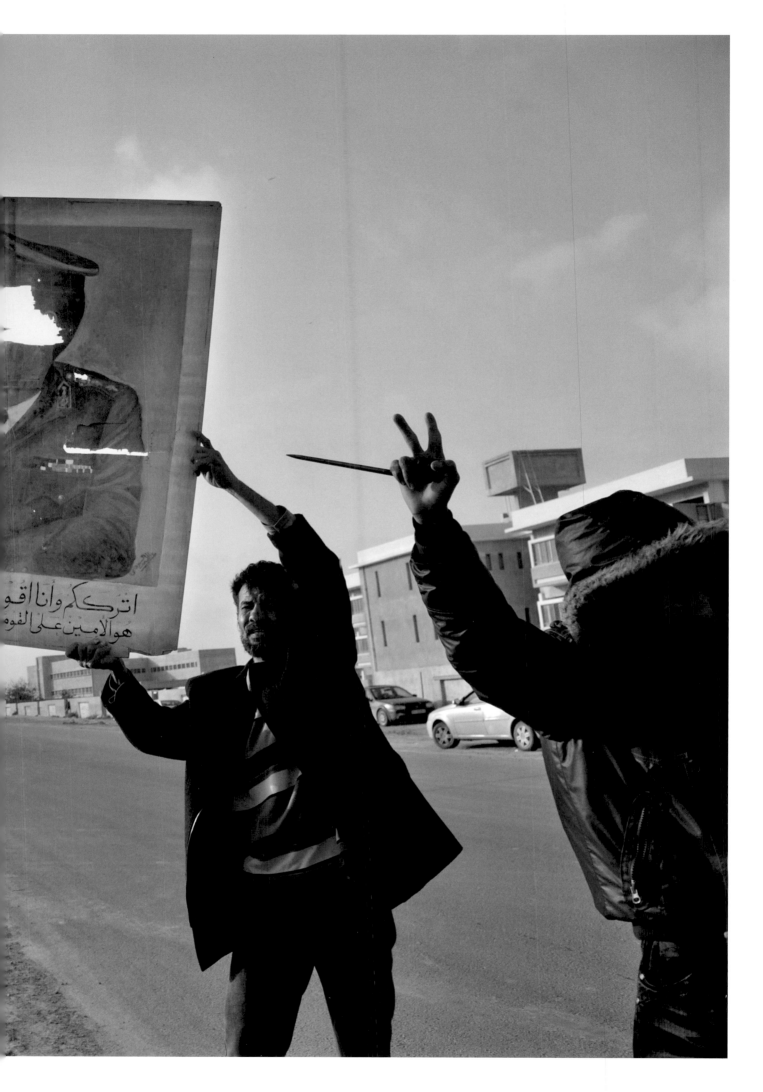

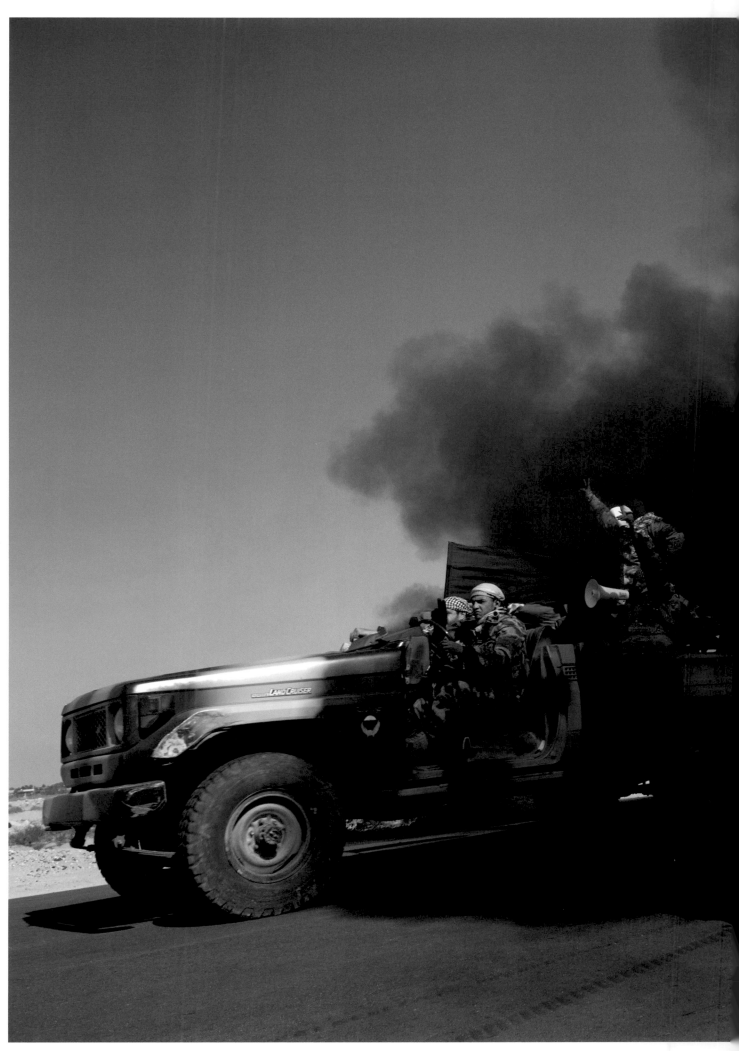

Opposition troops burn tires to use the thick smoke as cover from air strikes at the main checkpoint near the refinery as rebel troops pull back from Ras Lanuf in eastern Libya, March 2011.

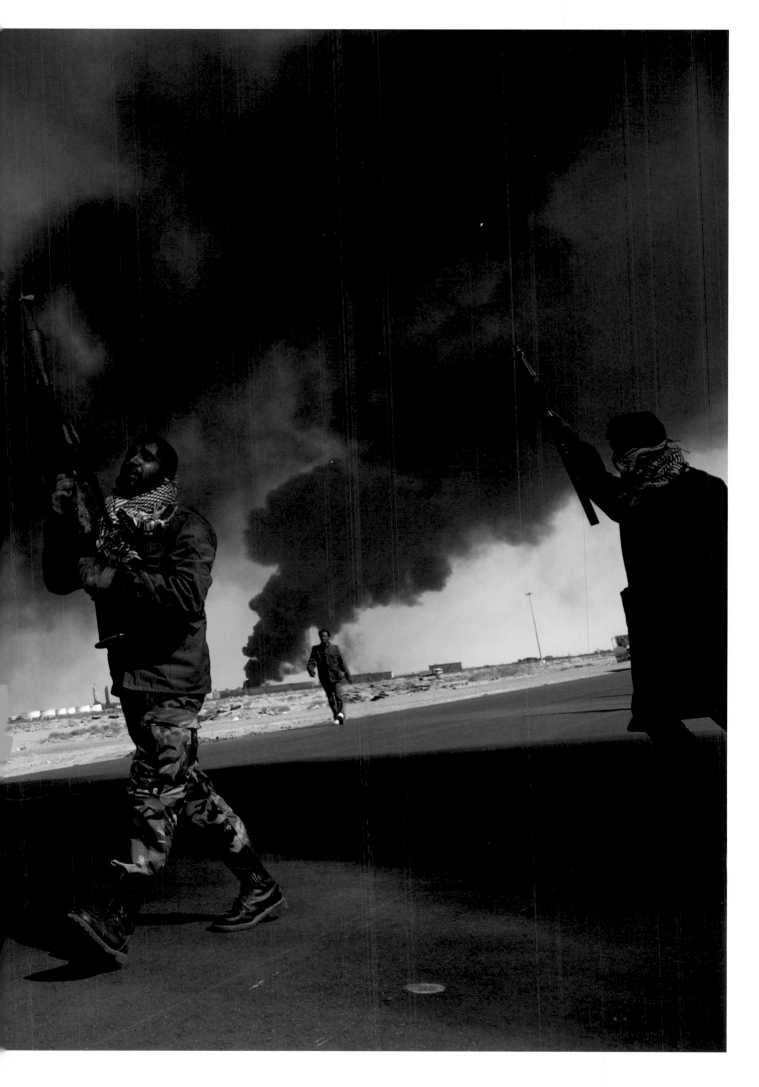

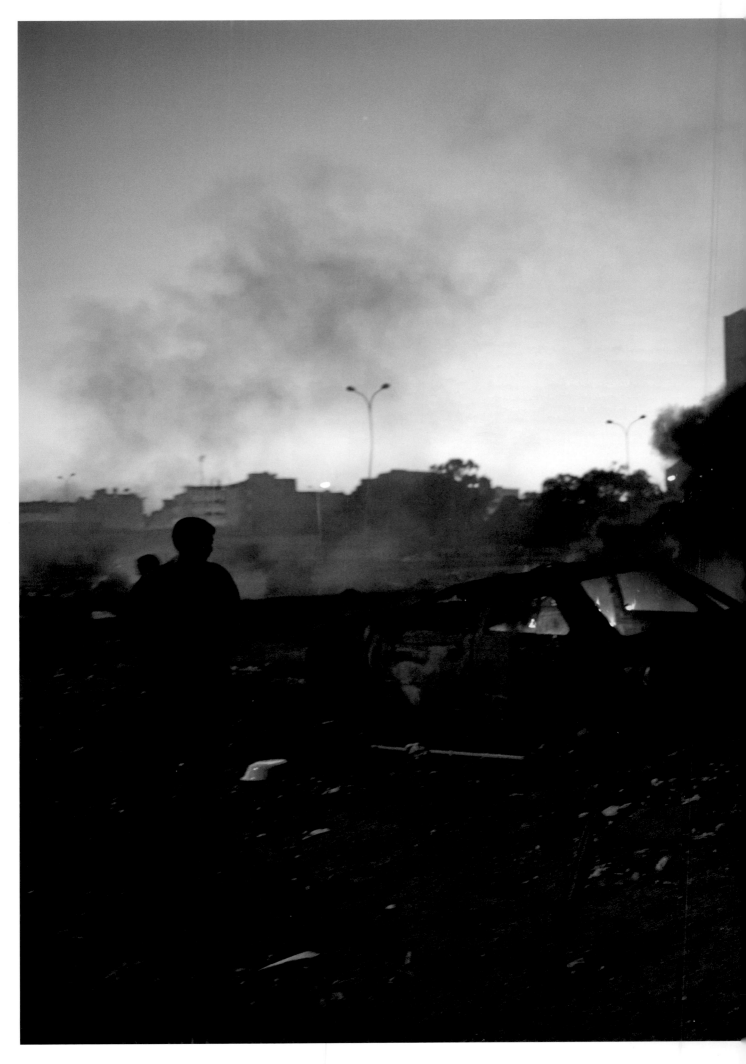

Libyans walk through the old military base in Benghazi, eastern Libya, February 2011.

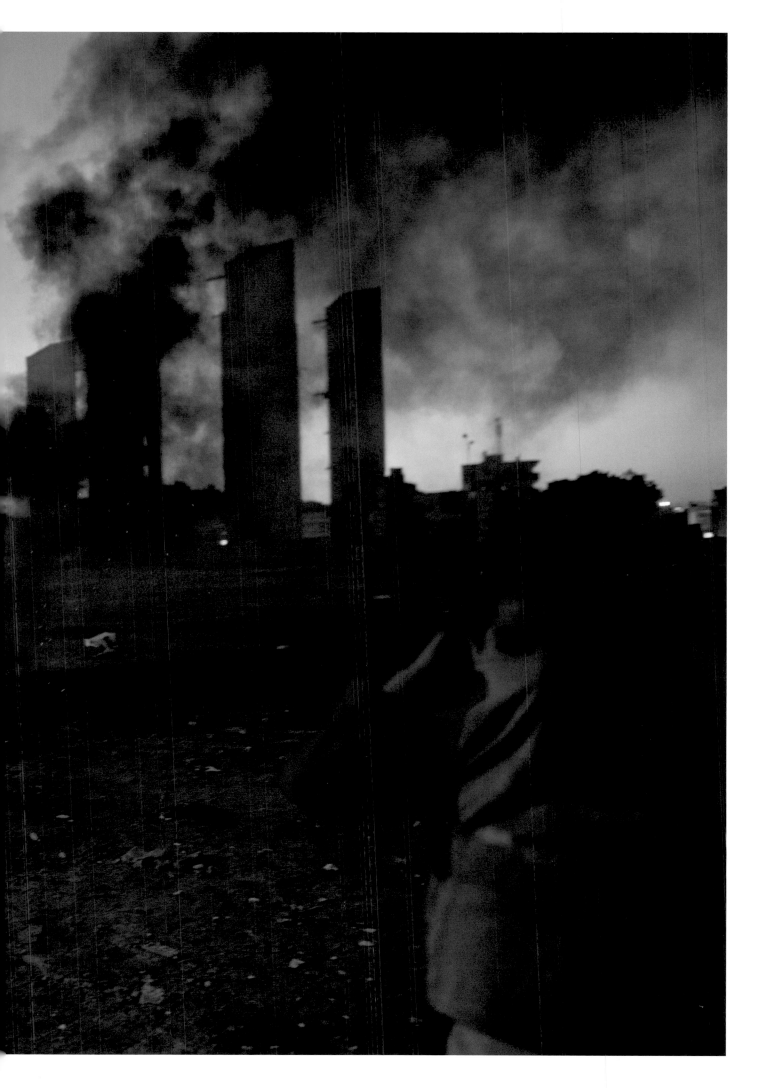

*On
the
Move*

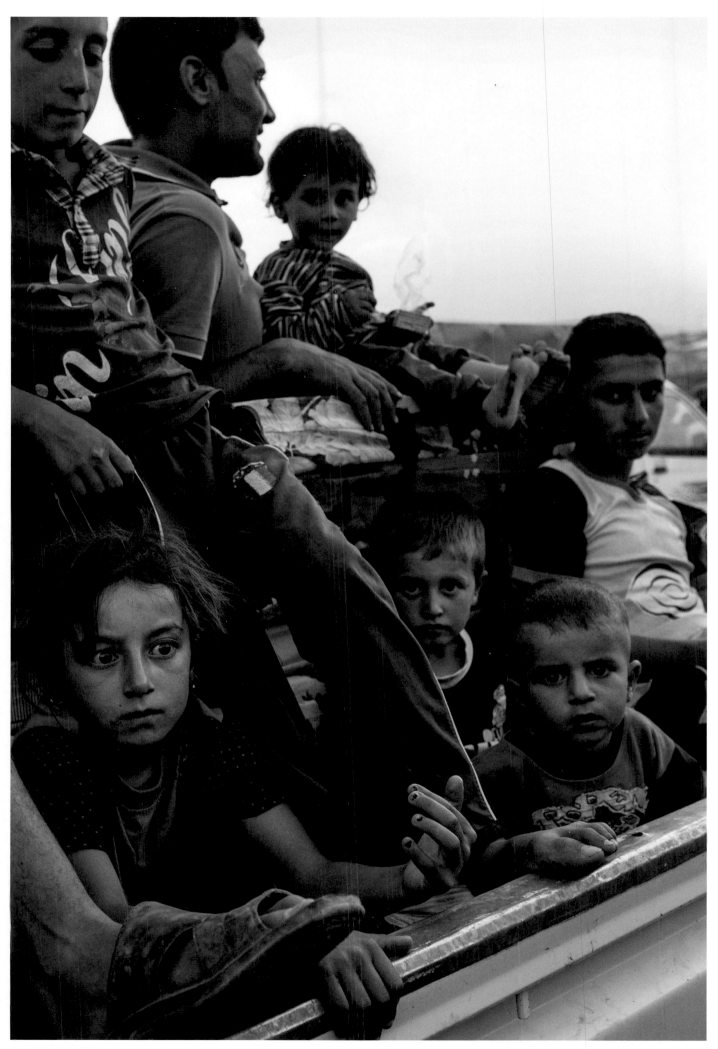

An Iraqi Yazidi family from Sinjar arrives at the Bajid Kandala camp in northern Iraq, August 2014.
Since fighters with the Islamic State started pushing through Iraq and Syria and terrorizing and murdering
civilians, hundreds of thousands have been displaced from their homes.

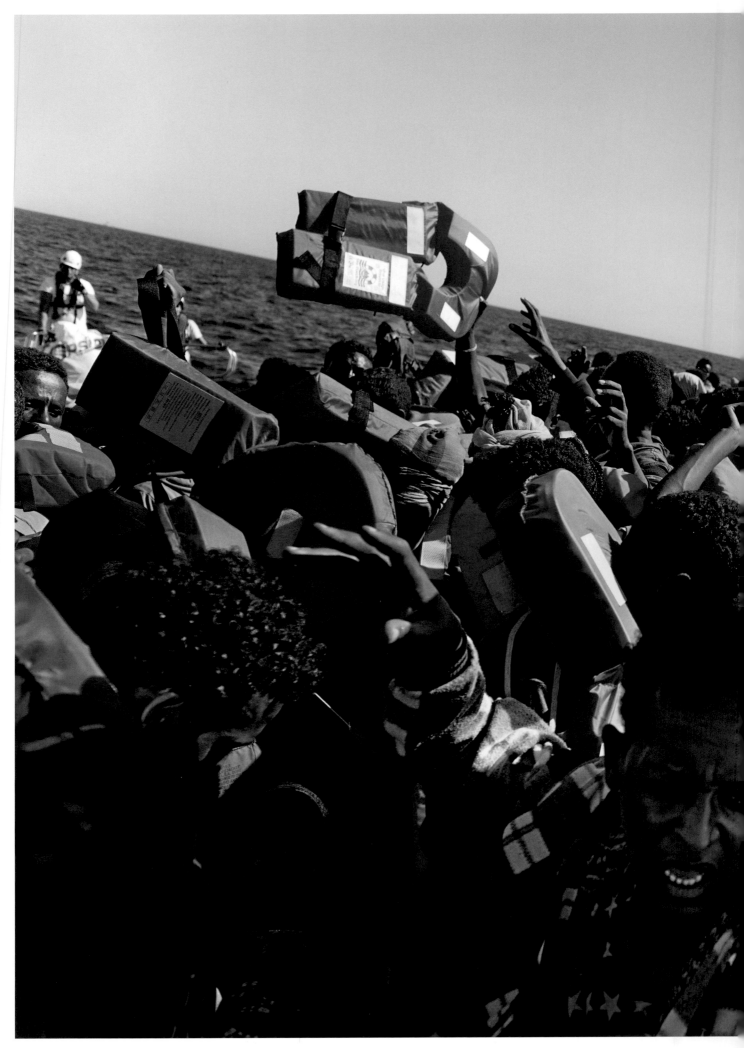

On the Mediterranean Sea, about twenty-five miles off the coast of Libya, search-and-rescue staff and medics jointly run by SOS Mediterranean and Doctors Without Borders on the MV *Aquarius* rescue 134 refugees from the African continent, August 2016.

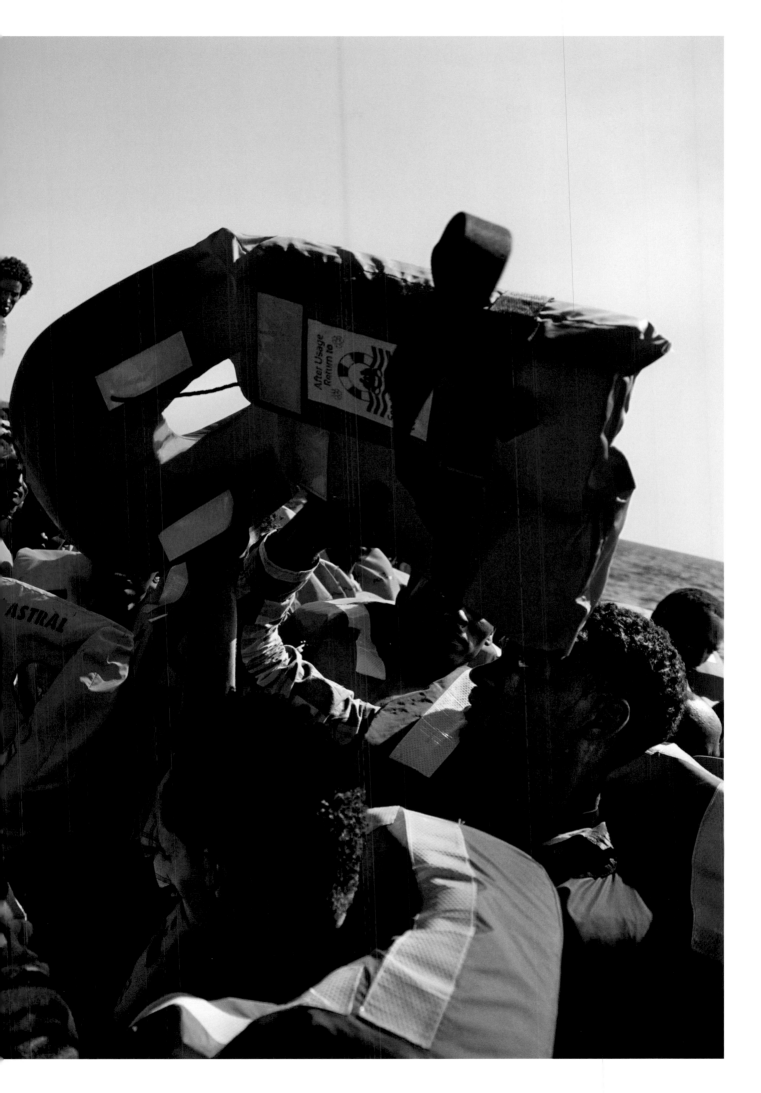

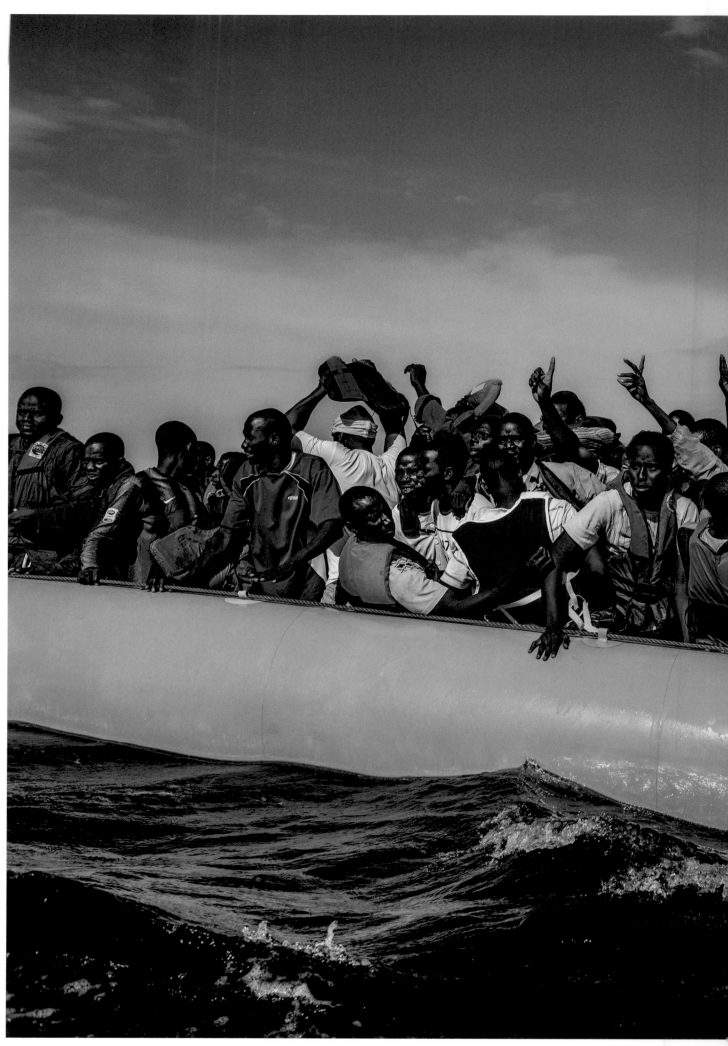

One hundred nine African refugees from Gambia, Mali, Senegal, Ivory Coast, Guinea, and Nigeria are rescued by the Italian navy from a rubber boat in the sea between Italy and Libya, October 2014.

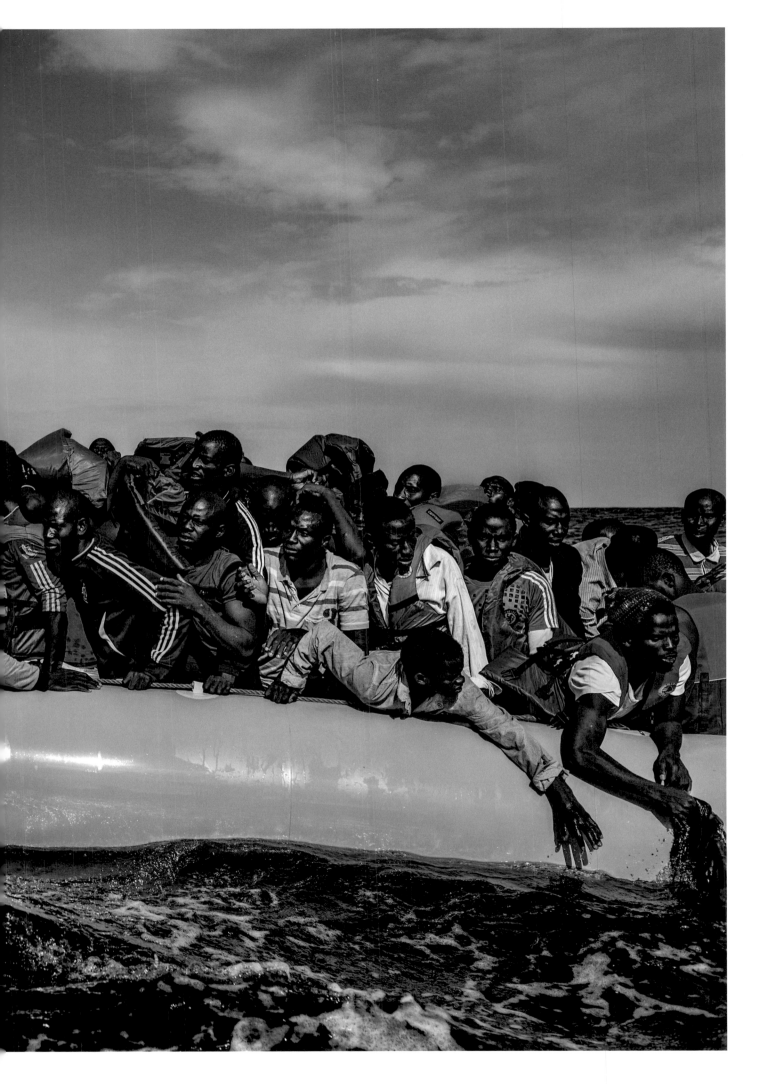

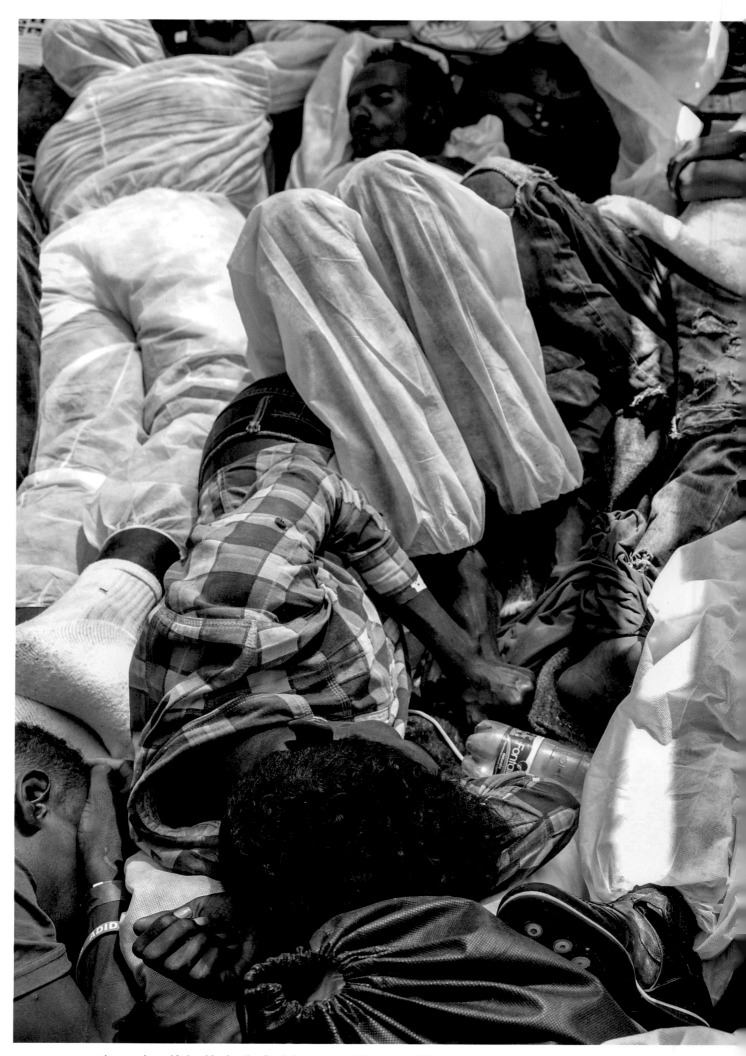

Eritreans sleep side by side shortly after being rescued off the coast of Libya by search-and-rescue staff and medics on the MV *Aquarius* on the Mediteranean Sea, August 2016.

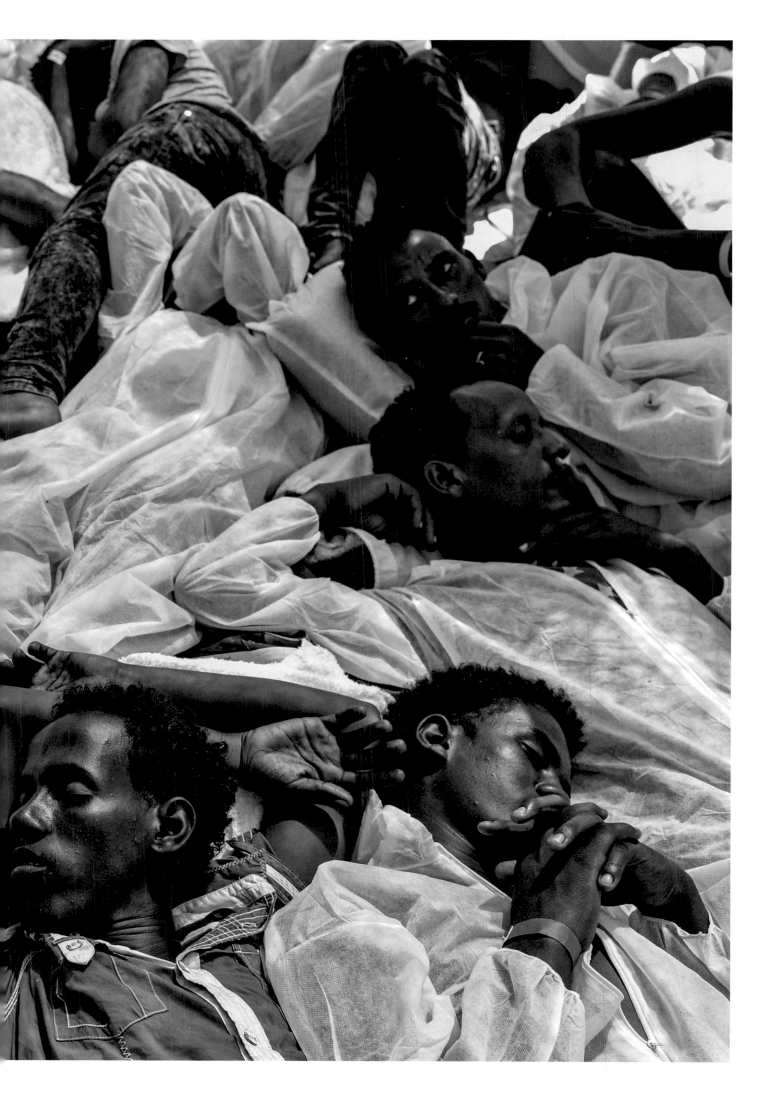

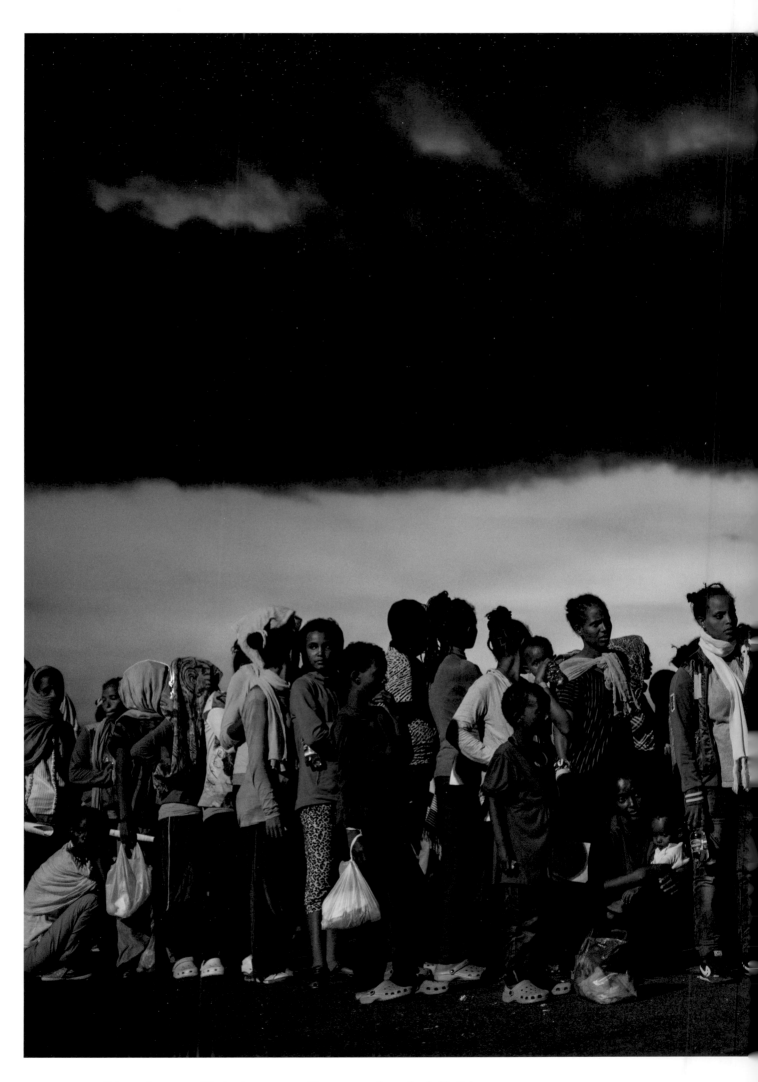

Between January and September 2014, roughly 120,000 refugees landed in Italy,
more than double the total for the entire year of 2013.

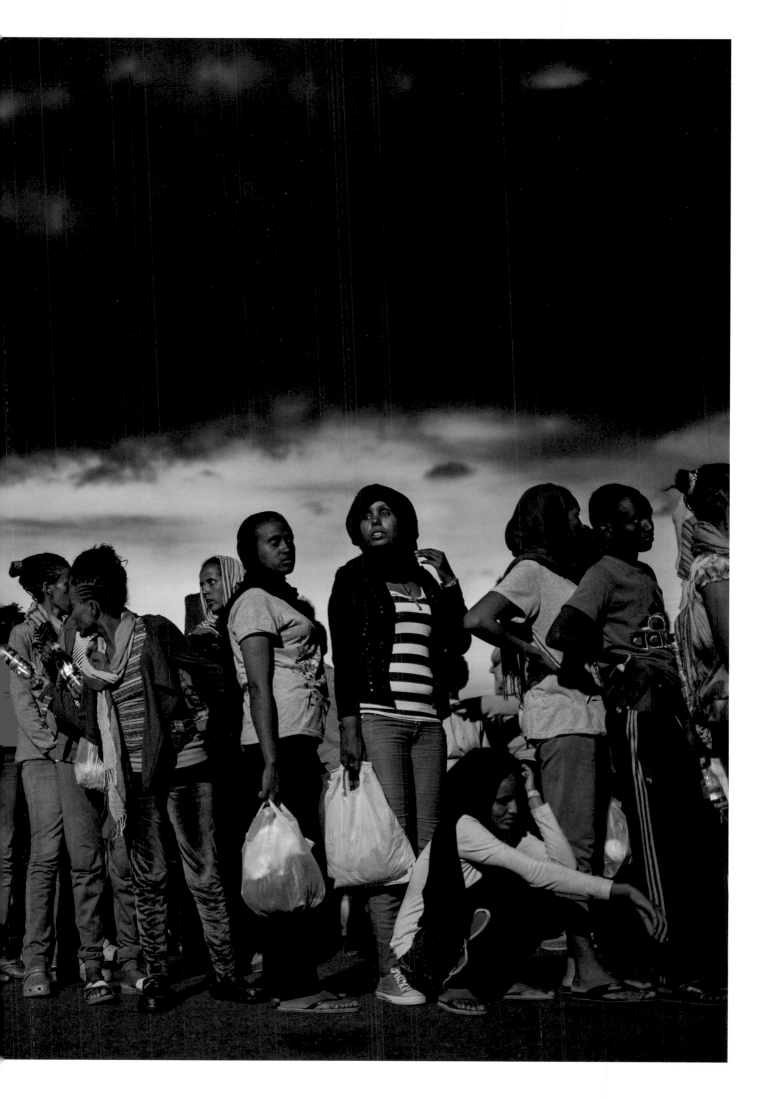

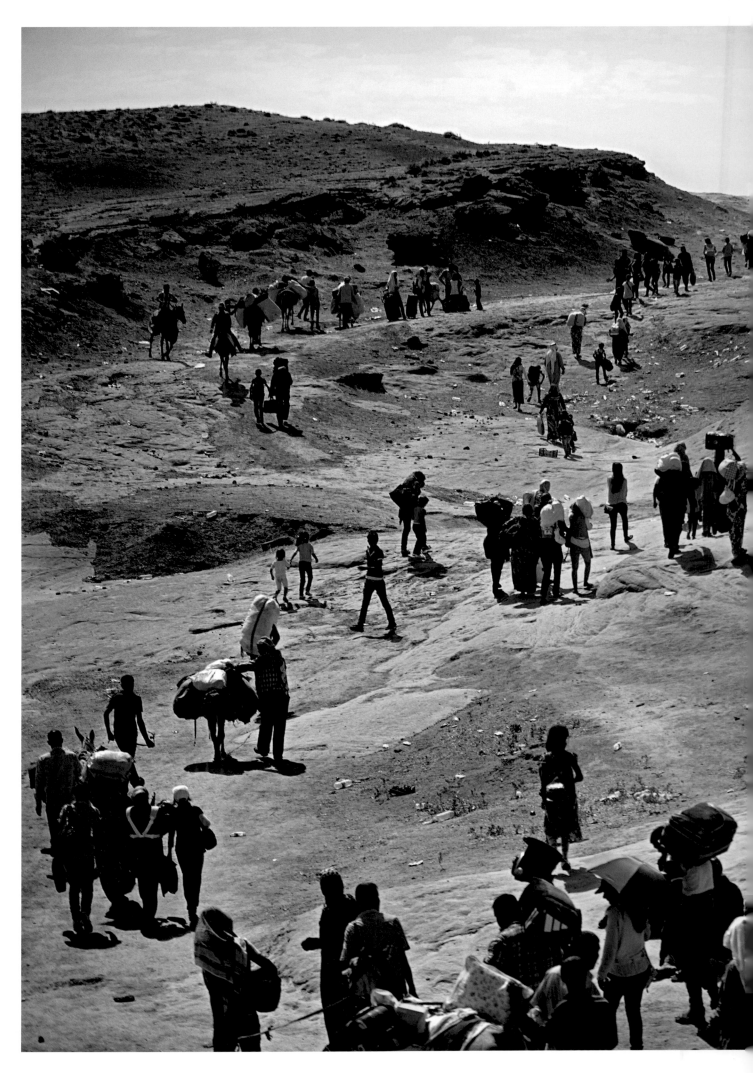

Thousands of Syrians cross from Syria into northern Iraq near the Sahela border point in Dahuk, northern Iraq, August 2013.

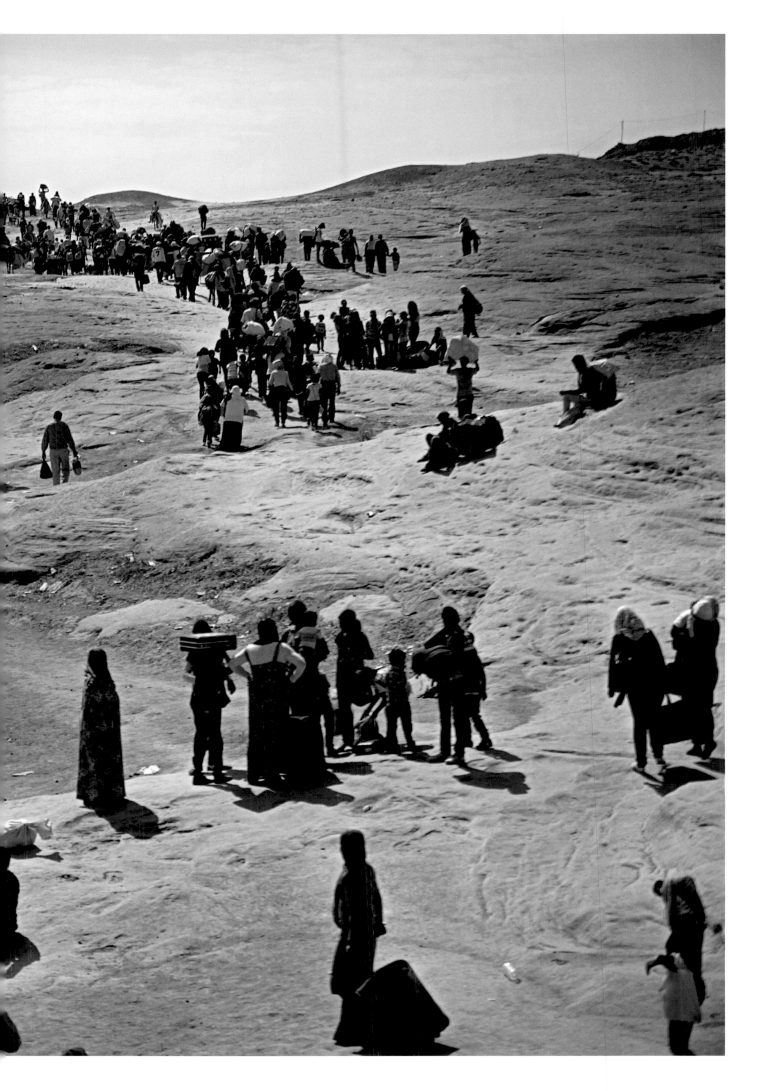

A Syrian man sits among discarded water bottles handed out to Syrian refugees crossing into northern Iraq near the Sahela border point in Dahuk, northern Iraq, August 2013.

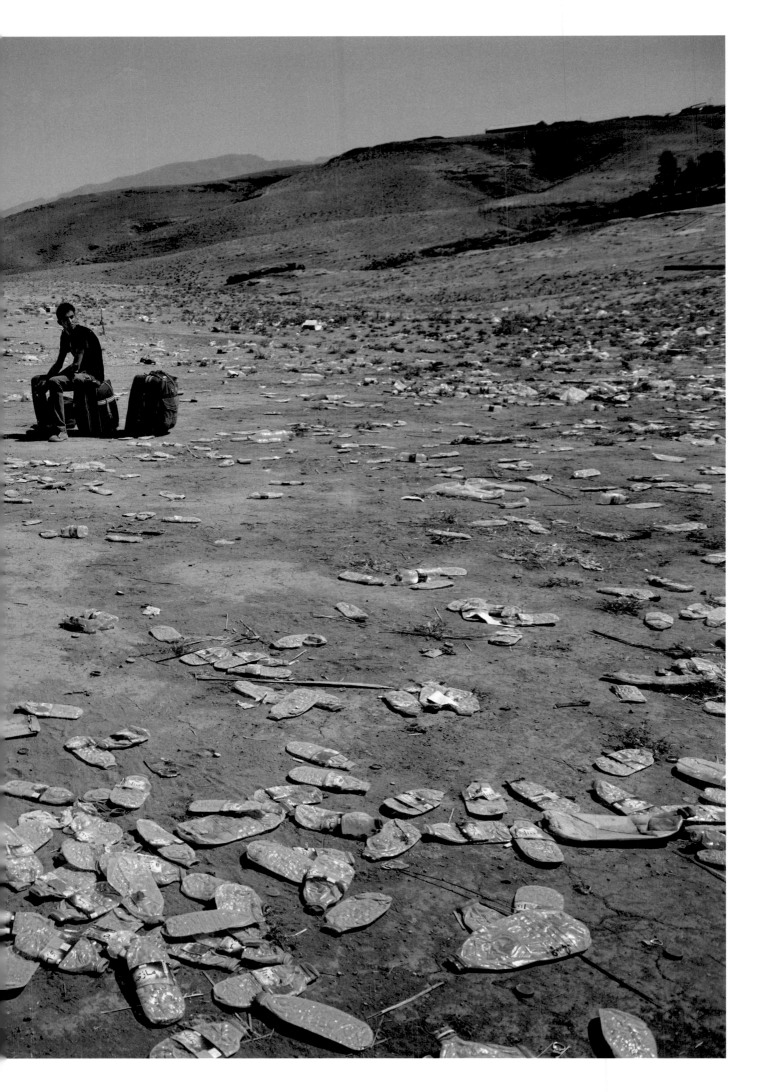

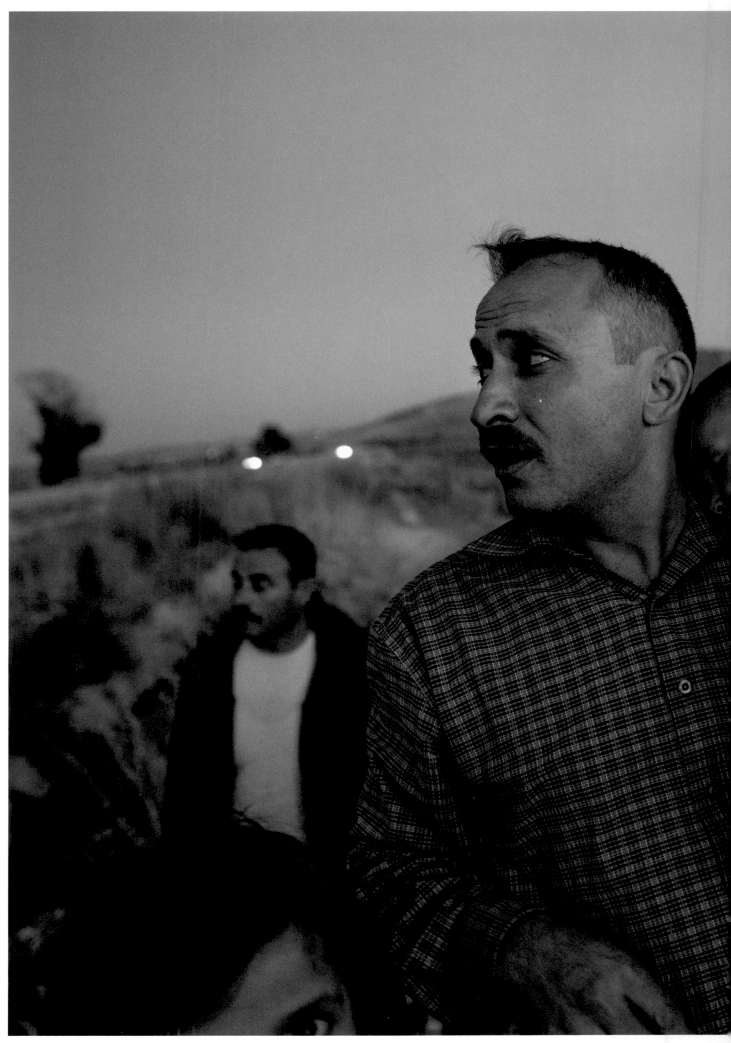

Syrian refugees cross into Turkey after the Muslim holiday of Eid al-Adha
through unofficial border crossings in villages around Reyhanli and Hacipasa
in Turkey, October 2013.

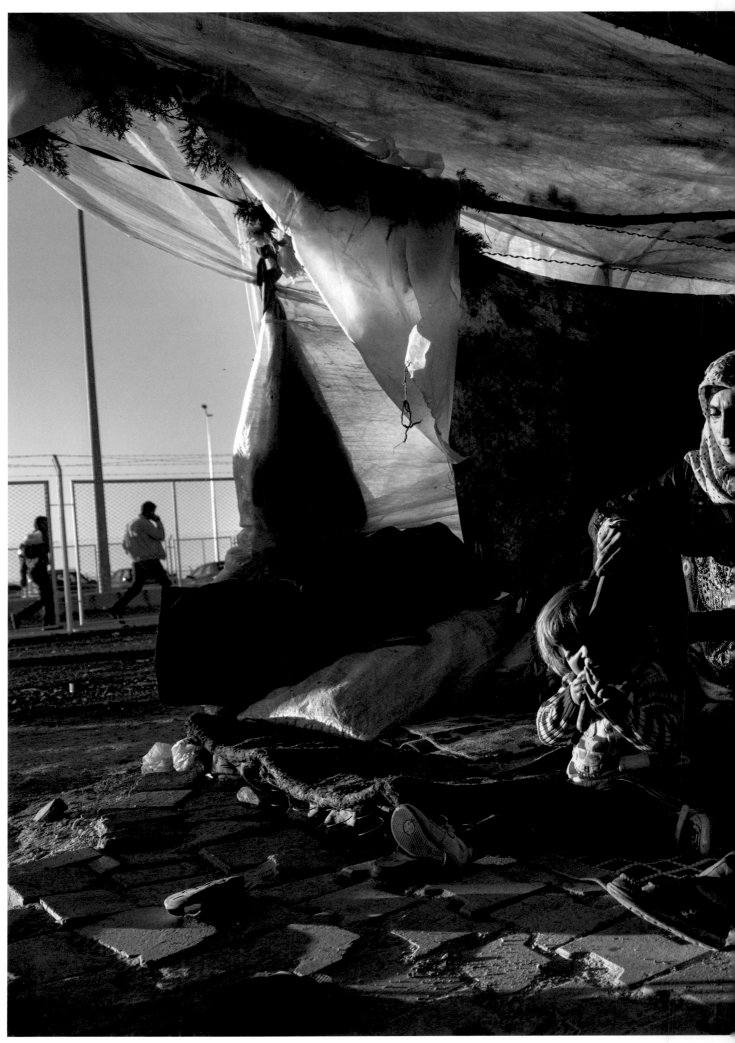

Iman Zenglo, thirty, sits with her five children in the squalid conditions of their squatters tent outside the Kilis camp on the Turkish side of the Turkish-Syrian border, October 2013.

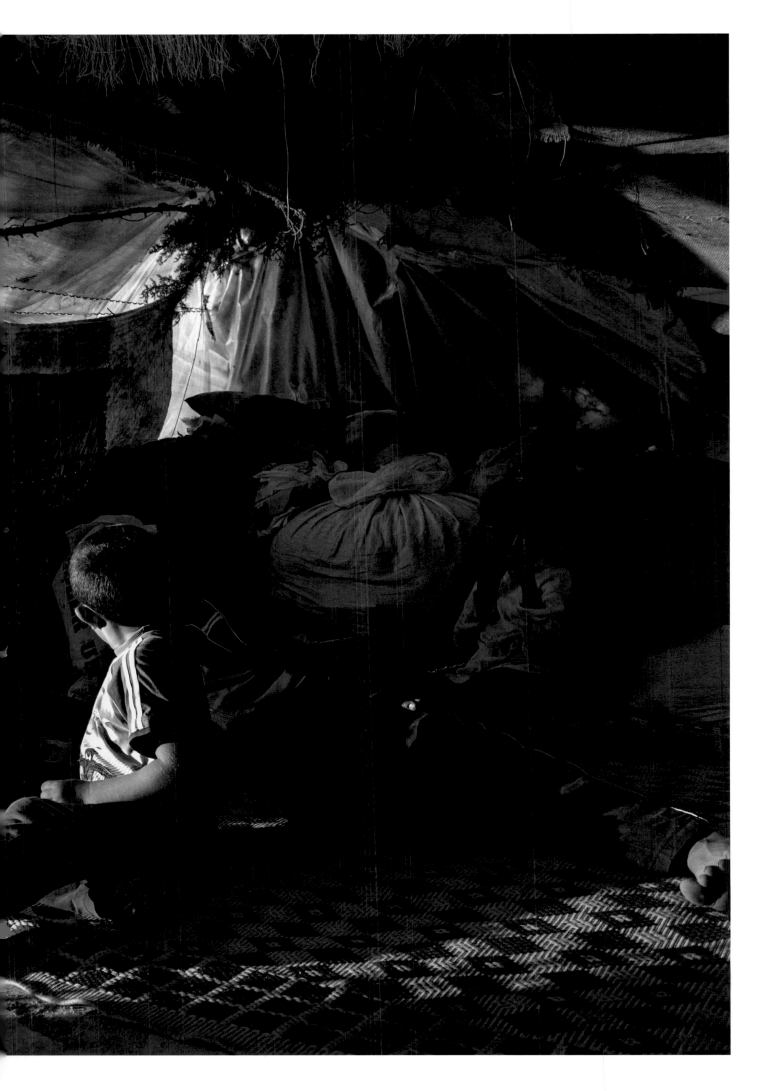

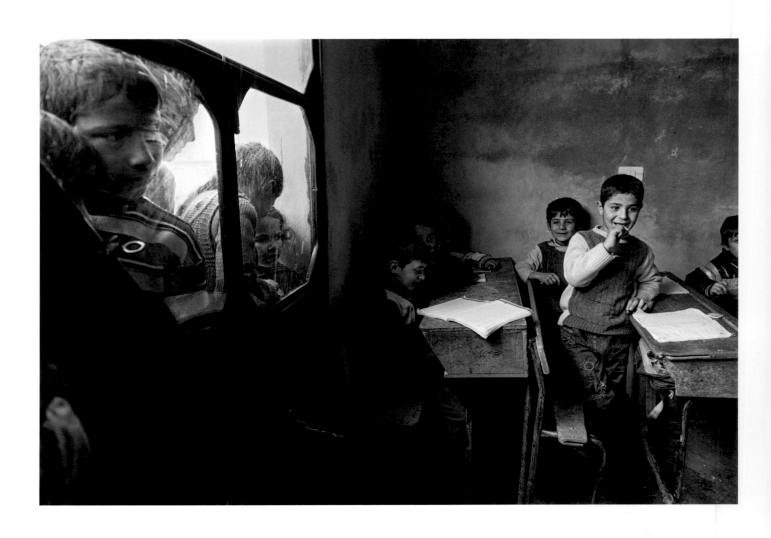

Syrian children go to a small shuttle school set up for families who were afraid to send their children far in the midst of war, in the village of Tlalin, northern Aleppo, February 2013.

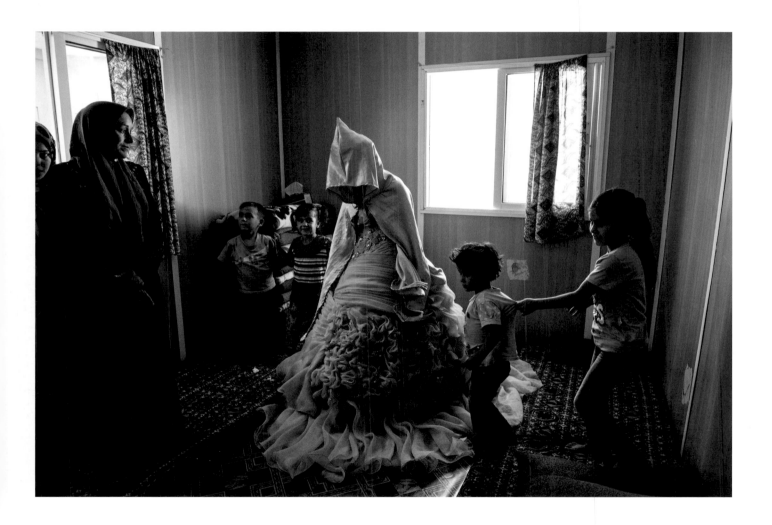

Rahaf Yousef, thirteen, a Syrian refugee from Daraa, poses for a portrait in her family's trailer as she is surrounded by female relatives on the day of her engagement party at the Zaatari refugee camp in Jordan, August 2014. Rahaf will get married to another Syrian refugee, Mohammed, eighteen, in about twenty days. While marriage under the age of eighteen was common before the start of the civil war, more and more Syrian girls are marrying at a younger age because of the insecurity caused by the war. Many families feel the girls may be sexually harassed if they are not under the care of a husband; additionally, there is the prospect of alleviating the financial burden of one or more mouths to feed.

Hana takes a nap under a mosquito net in her tent in the informal tented settlement she lives in with her family. Since before dawn, she had spent a long morning picking cucumbers with other Syrian refugees in the Bekaa Valley, between the cities of Zahlé and Baalbek, in Lebanon, August 2015.

Dalal, a Syrian refugee from the Damascus suburbs, stands in front of the cave she and her family have been staying in since crossing into Lebanon a week prior, in Baalbek, Lebanon, January 2013.

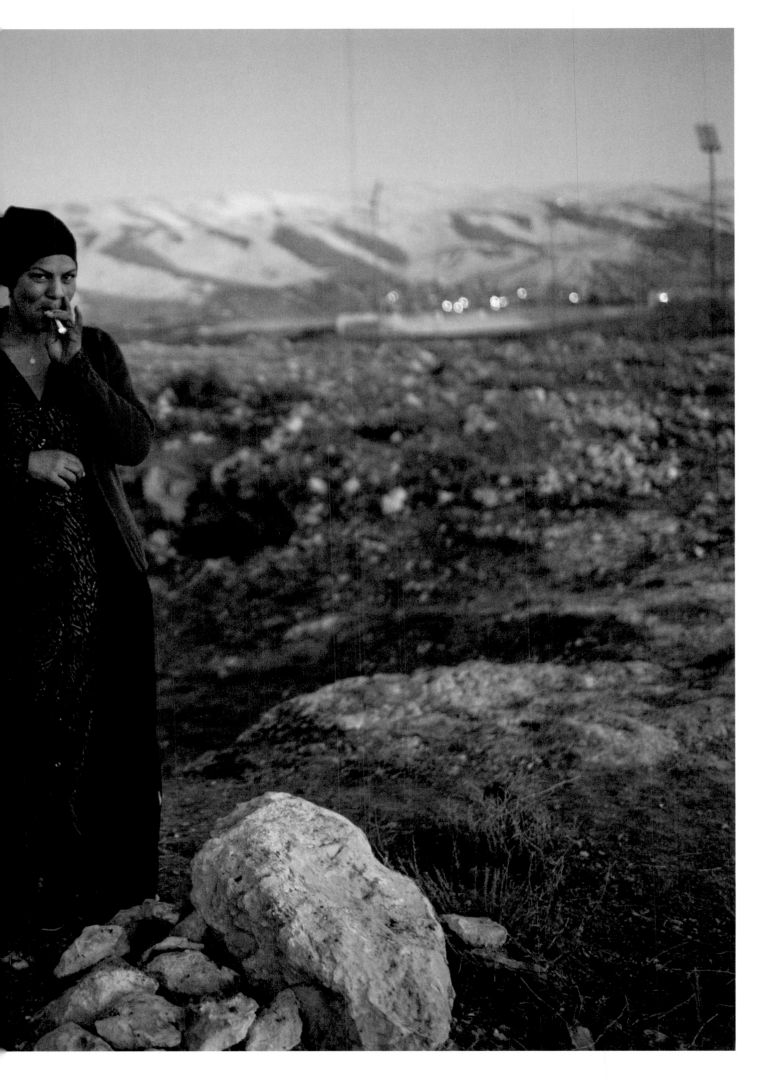

Syrian women prepare a meal for the funeral of a Free Syrian Army fighter who was killed across the border in Aleppo, while his family members sought refuge in the Lebanese village of Saadnayel, in the Bekaa Valley, Lebanon, January 2013.

Female Syrian refugees dance at a wedding celebration in a refugee camp in Marj El-Khokh, in Marjaayoun, Syria, March 2014. The father of the groom spoke about the wedding: "We want to create life out of death and from sadness we want to create happiness. People should not continue to be morbid."

Squalid conditions in a squatters area outside the Kilis camp on the Turkish side of the Turkish-Syrian border, October 2013. Many Syrian refugees cross back and forth from Syria into bordering countries to work as laborers and to visit family.

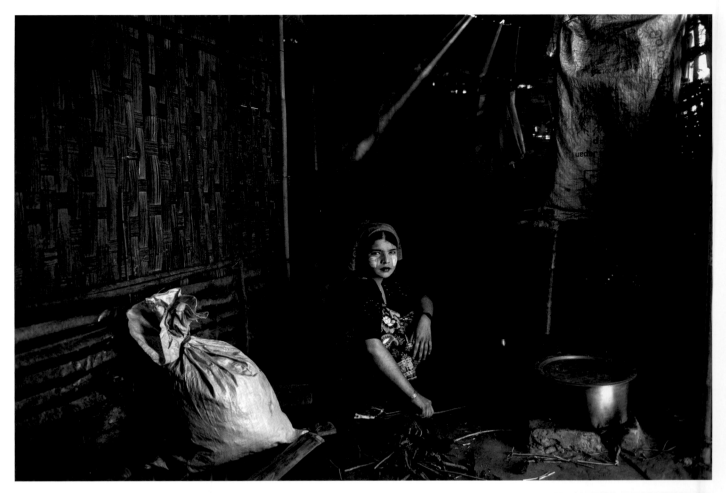

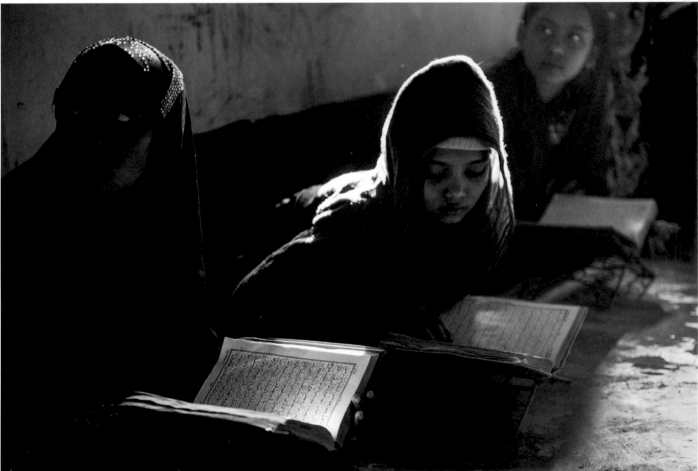

Top Aisha Begum, eighteen, cooks in her family home in the Say Tha Mar Gyi camp for internally displaced Rohingya, in Sittwe, Myanmar, November 2015. An estimated one million stateless Rohingya have been stripped of their citizenship and forced to live in modern-day concentration camps, surrounded by government military checkpoints. The Rohingya do not have access to basic medical care or food and most aid groups are banned from entering the camps.
Bottom Rohingya children read the Koran in an informal settlement in Shamlipur, in Bangladesh, January 2016. The Rohingya are systematically marginalized, and must live in makeshift camps across Bangladesh and Myanmar.

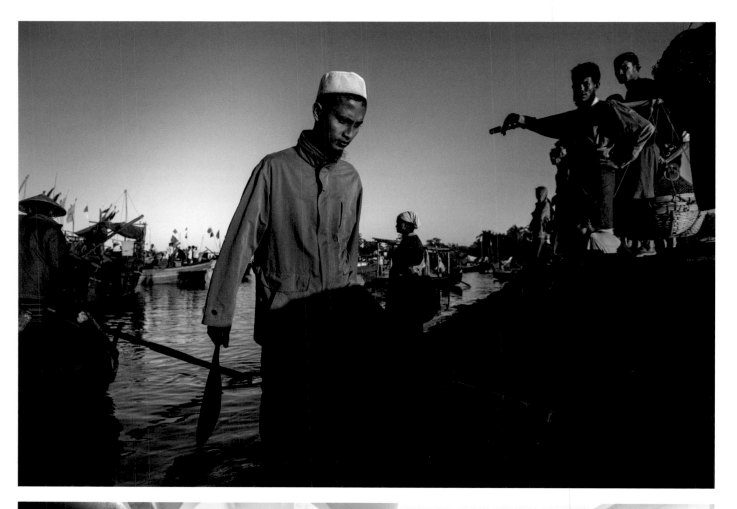

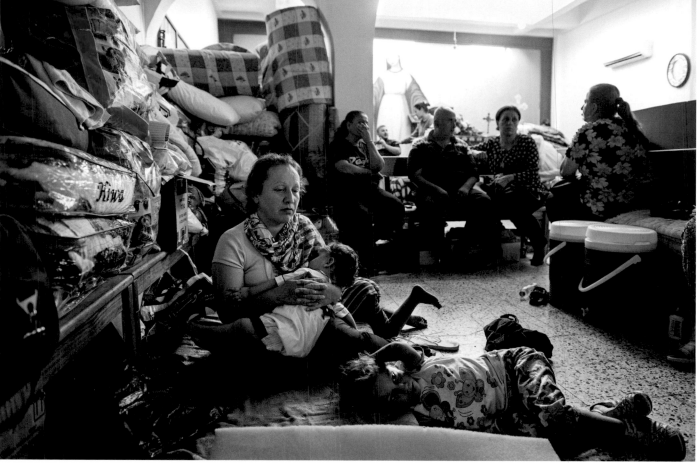

Top Rohingya fishermen arrive with fresh fish at the fishing port in the Thay Chaung
camp for internally displaced Rohingya near Sittwe, in Myanmar, November 2015.
Bottom Iraqi Christian families from Qaraqosh live inside a church and on its grounds
in Ankawa, in Erbil, northern Iraq, August 2014.

A Love Letter from 'A' to Rana

A love letter written in the Egyptian dialect of
Arabic on the back of a cigarette package was
found at the port where roughly 250 refugees
from Egypt and Syria, among other countries,
disembarked from an Italian ship after being
intercepted and rescued at sea en route to
Pozzallo, Sicily, Italy, September 2014. The
letter translation is: "Rana, I wanted to be with
you. Don't forget me. I love you very much. My
wish is for you not to forget me. Be well my love.
A loves R. I love you."

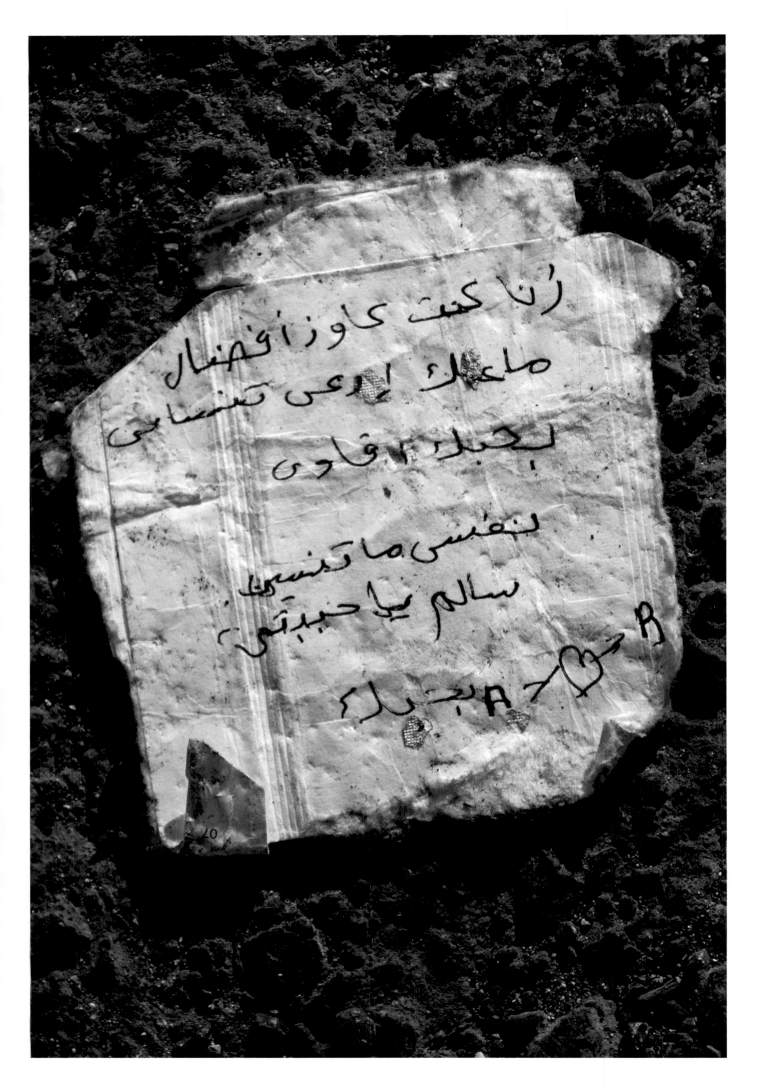

Finding Home
by Aryn Baker

"Are you pregnant?" "How many months?" Lynsey and I must have asked these questions dozens of times as we canvassed the refugee women sheltering inside an abandoned tobacco warehouse located on the outskirts of Thessaloniki, Greece. With each answer we probed further. "How are you feeling?" "Will you go to the clinic?" The international NGO Médecins du Monde ran a maternal health clinic several days a week. "Can we meet your family?" Finally, after a long conversation conducted in the semiprivacy of the woman's family tent, with her husband, we began to explain our project. We wanted to follow the first year of life for a baby born in a refugee camp to better tell the story of the refugee experience. "Oh, and by the way, how do you feel about us photographing you while you give birth?"

Due to a confluence of war, unrest, drought, and famine, the years 2015 and 2016 saw more people on the move than at any other point since World War II. The numbers were staggering: Emergency shelters for the internally displaced and refugee camps from Bangladesh to South Sudan, Kenya, and Iraq were overwhelmed. Some seven million Syrians spilled into Lebanon, Jordan, and Turkey while Libya, lawless and ungoverned, became the launching point for hundreds of thousands of Somalis, Eritreans, and other sub-Saharan Africans so desperate to reach Europe that they risked their lives on decrepit wooden dinghies and rubber rafts in the hope of staying afloat long enough to reach Italian shores. Meanwhile, a similar number of Syrians were doing the same in Turkey, hoping to reach the islands of Greece and from there hopscotch to the refugee-friendly countries of northern Europe. In 2015 more than a million migrants reached European shores by traversing the Mediterranean, a flood of misery and hope that threatened to overwhelm the capacity for human compassion.

To break through that numbers fatigue, Lynsey and I wanted to tell the story of a refugee mother's struggle to raise a newborn in a foreign land. It was a story that was as universal—the miracle of childbirth, the joy of that first smile, the first steps, the first words—as it was revelatory: the challenge of bathing a newborn when there is no running water and you are allotted only three bottles a day. What is more important when you are far from home and have no money: diapers or phone credit to access the Internet for parenting advice when your own mother is out of reach? We wanted our readers to pause long enough to see the world from a refugee's eyes. *Time* magazine videographer Francesca Trianni joined us for the eighteen-month project. We called it Finding Home.

Photographing women during their most intimate moments is a challenge under any circumstances. Persuading Syrian women, who are generally conservative by nature— as well as their husbands, who consider their wives' modesty a reflection of their own honor— to let us accompany them on nearly every step of their journey as new mothers was not easy. We had to earn their trust, spending hours with the families just chatting and hanging

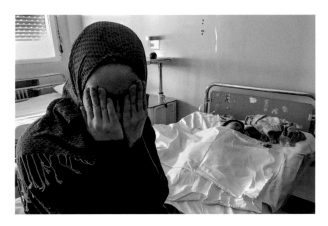

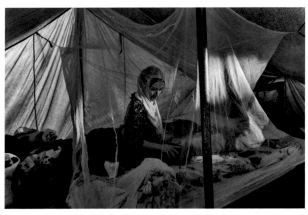

Top Syrian refugee Taimaa Abazli sits with her four-month-old daughter, Heln, who was diagnosed with an acute bronchial infection, in a hospital in Athens, Greece, January 2017.
Bottom and opposite top Taimaa, twenty-four, with her week-old daughter, Heln, in a refugee camp in Thessaloniki, Greece, September 2016.

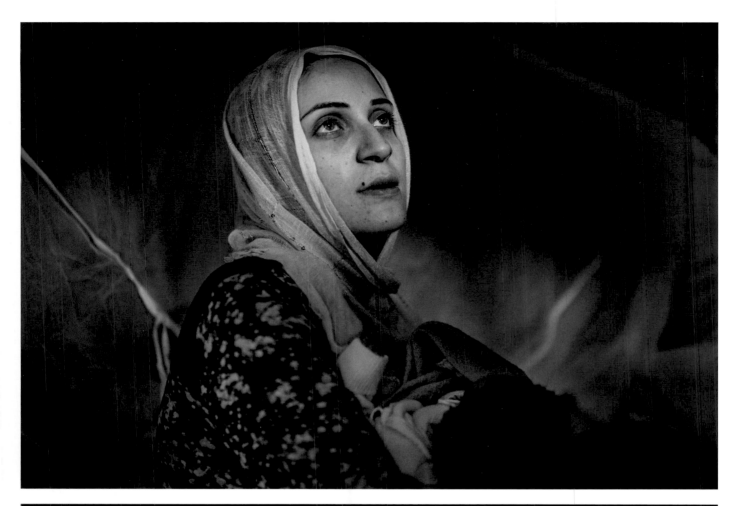

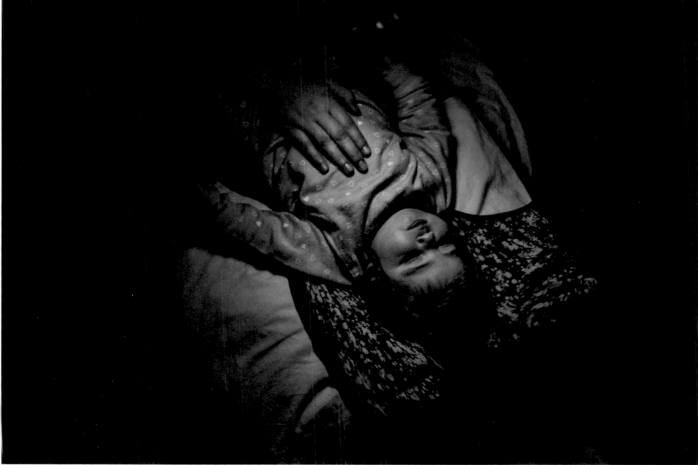

Bottom Helm is rocked to sleep with the light of an iPhone by a Syrian refugee camp friend of Taimaa's the night before the family travels from Athens to Estonia, April 19, 2017.

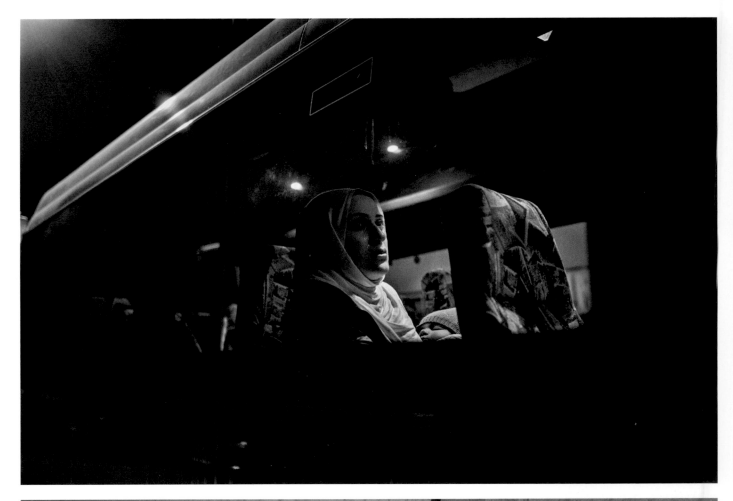

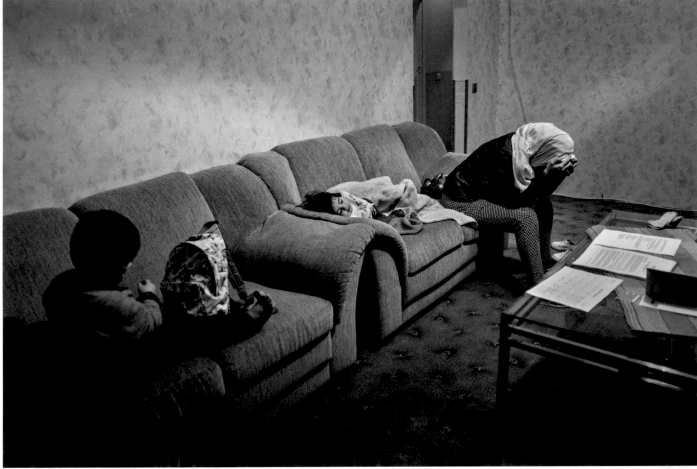

Top Taimaa Abazli weeps as she holds baby Heln and looks out the van window at her family's new apartment building after another long, grueling day of travel and upheaval, from Athens to Polva, Estonia, April 20, 2017.
Bottom Taimaa sits, exhausted and overwhelmed, with her two children, Heln and Wael, moments after entering the family's new apartment for the first time, Polva, Estonia, April 2017.

out. Several times I watched Lynsey's hand reflexively grab her camera when a perfect shot appeared, only to set it back down again, photo untaken because she had not yet requested permission. But her patience paid off. By the time Lynsey began taking photographs, our characters were so comfortable with her around that she was able to capture extraordinary moments between the women and their families. When the subjects of our project grew tired of the camera, we stopped. When they wanted space, we left. When they needed help, we did what we could, ever mindful of journalistic ethics but with a knowledge that morally, sometimes you just have to be ready to offer a laboring woman a ride to the hospital.

Lynsey and I have been working together for several years. Though we have covered many compelling stories of women and of refugees (and even simultaneously), those projects rarely lasted longer than a few weeks. Finding Home covered three families in intimate detail and lasted eighteen months. A project of that depth and duration required a different kind of collaboration. Our three-person team lived on three continents, which often meant that we had to rely on each other for reporting, insights, and planning. We communicated daily on WhatsApp, with each other, with our fixers, and with the characters themselves.

Videographers and photographers rarely work well together. They want the same angles, they get in each other's view frames, and camera shutter clicks are an audible curse for videographers. But Francesca and Lynsey developed a rare, intuitive rhythm. Francesca was already lifting her camera to film as Lynsey was putting hers down. At key times, Lynsey switched to a shutterless camera so both could capture those moments. Most important, they managed, through an acute sensitivity to the mood in the room, not to overwhelm our characters.

By the project's conclusion, in December 2017, the three of us had formed an extraordinary bond with the three mothers in our stories. One mother remains in Greece; one is newly pregnant and getting settled in Verl, Germany; and Taimaa Abazli finally arrived in Germany after a difficult month in Estonia. The assignment might be over, but I have no doubt we will be following the lives of these women and their children for a long time to come.

Top Taimaa Abazli walks with her daughter, Heln, in Thessaloniki, Greece, November 2016.
Bottom Taimaa and Mohannad Abazli celebrate the first birthday of their daughter, Heln, who was born while they were living in a refugee camp in Greece. One year after the birth, the family is still trying to start their lives outside Syria, outside a camp, in Kusel, Germany, September 2017.

255

It's
What
I Do

On Photojournalism:
A Conversation with Lynsey Addario

Suzy Hansen, my longtime friend and the editor of my memoir, *It's What I Do: A Photographer's Life of Love and War*, has watched me navigate the world of photojournalism for more than a decade.

From my relationships with editors, to questions of professional integrity, to the juggling of motherhood with the demands of assignments, to the often cutthroat nature of this work, she has been a tireless sounding board, counselor, and friend. In December 2017, Suzy and I sat down to talk through many of the topics we have discussed in the past, including questions I am commonly asked as a photographer—and those that, to my surprise, I am not.

Some of my first attempts at photographing, circa 1985.

When you look at this book, how does it make you feel? What does it mean to you?
I guess the strangest thing is for me to realize I have actually been in all those places and situations. It feels almost like an out-of-body experience in the sense that I am constantly so hard on myself and feeling like I haven't accomplished a tenth of what I want to, haven't at all covered all the stories I want to cover. I have borne witness to so many intimate and poignant moments. I can't believe how much access people give me. It never ceases to amaze me what people let me photograph.

Why?
Sometimes journalists function almost as therapists. A lot of the people I photograph are really alone, or they live in societies that are judgmental, so they don't have this objective listener around who has little stake in their life or their future. My only reason for being there is to provide a platform for their voices, and to give the rest of the world some perspective, to inform policy. I am not going to judge the people I photograph. I think they sense that. A lot of it, too, is how any documentary photographer enters a situation. I think people sense I am sincere and feel strongly about telling their stories. I also give people the option to say no, of course; I don't go in assuming I have the right to do whatever I want. I will tell them why I am there and why I think it's important, but then I leave the decision up to the subject.

Do any of these photos look differently to you now from what they did then?
For some of them I wish I was a better photographer when I had the access I had.

Like which ones?
Darfur. At that time, in the early 2000s, a lot of photographers couldn't get in there. It was my first time in Africa, and I wasn't sure of the photographic boundaries—how people would respond to the camera, how close I could get, and how to approach people. I eventually learned these things, and my first trip to Darfur ended up igniting the beginning of a long love affair with Africa, and some of my strongest storytelling in photography.

In Iraq there were a few early military embeds that, had I been a better and bolder photographer, and quicker on my feet with knowledge of how to deal with soldiers who were skeptical of

And that's the beauty of waiting to make a book. Because later on—in, say, the Korengal Valley in 2007—I had learned from those mistakes and developed a tactic to deal with the often paralyzing fear I felt under fire: I would talk to myself out loud through a situation in order to be able to continue photographing even when my instinct was to shut down.

But is photography like writing in that the early stuff can be fresher and rawer?

I wasn't getting assignments when I started out. So those panoramics in Afghanistan were just me following the light, following what I was interested in; no one was telling me what to shoot, and I didn't have to fulfill the requirements of a story. It was just following my curiosity and discovering a place. Some of those creative moments fell away over time; because I was busy telling stories, I forgot to just tell little beautiful moments.

India was the first major place you lived and worked as a photojournalist, in your early twenties. You were very lonely.

It was really hard. What I realized every time I moved to a new country—and I have lived in eight—is that . . . I had no ease of familiarity. And I was so poor for so long. I never had any money. Among my old letters, I am begging my sister Lisa for twenty-five hundred dollars to go to Afghanistan. I left New York for India with a few thousand dollars. I had worked at the Associated Press and waited tables and worked at a shirt company. So I was often working at home . . . to save money to go to a foreign country to photograph.

Did it seem impossible to become successful?

I just wasn't even thinking that far ahead; it was really assignment to assignment. And over time in those first years, I realized the subjects I was interested in and why I was doing this—race, justice, human rights.

How did you deal with rejection?

I just moved through it. I kept going.

Were there other female photographers around then?

There were female photographers, but in war zones much less.

embedded journalists, I wouldn't have missed the moments I missed while under fire. To this day I lament not photographing those moments. For example, in 2004, I covered my first gun battle between the Marines and insurgents in a village outside Fallujah. For most of the ambush, I was paralyzed with fear, and trying to get out of the line of fire. I ended up forgetting to take pictures for most of that battle—because I was preoccupied with saving my own life. I missed almost everything, except for a few average pictures of Marines lined up on a berm, returning fire. At the end of the battle, as we were pulling out of the village, everyone's adrenaline was surging. A car pulled up behind the seven-ton military vehicle we were traveling in, and the Marines just opened fire, until the men in the car were riddled with bullets. Now, I have so much experience that I would know how to navigate that kind of situation. I would know how to seek cover and shoot at the same time. Instead, that entire day will forever be seared into my mind because during a major ambush like that one—something so rare for a photojournalist to experience even in wartime—I wasn't able to do my job. I watched.

Articles from (top) the *Telegraph Magazine*, March 21, 2015, and (bottom) the *New York Times Magazine*, February 8, 2015.

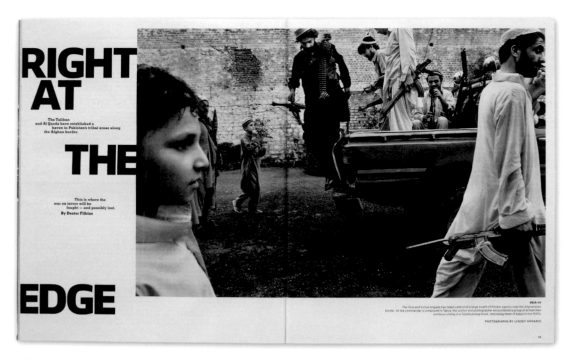

RIGHT AT THE EDGE

The Taliban and Al Qaeda have established a haven in Pakistan's tribal areas along the Afghan border.

This is where the war on terror will be fought — and possibly lost.
By Dexter Filkins

DÉJÀ VU The vice-and-virtue brigade has taken control of a large swath of Khyber agency near the Afghanistan border. At the commander's compound in Takwa, the author and photographer encountered a group of armed men and boys sitting on a Toyota pickup truck, reminding them of Kabul in the 1990s.

PHOTOGRAPHS BY LYNSEY ADDARIO

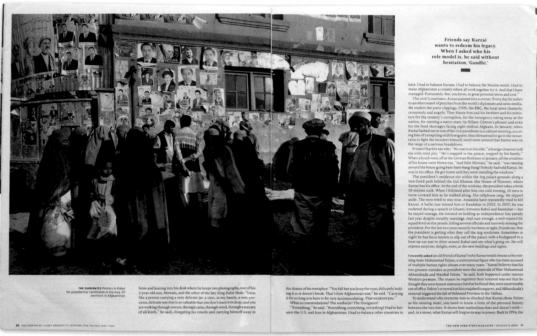

Friends say Karzai wants to redeem his legacy. When I asked who his role model is, he said without hesitation, 'Gandhi.'

THE CANDIDATES Posters in Kabul for presidential candidates in the Aug. 20 elections in Afghanistan.

PHOTOGRAPHS BY LYNSEY ADDARIO/VII, FOR THE NEW YORK TIMES

THE NEW YORK TIMES MAGAZINE / AUGUST 9, 2009

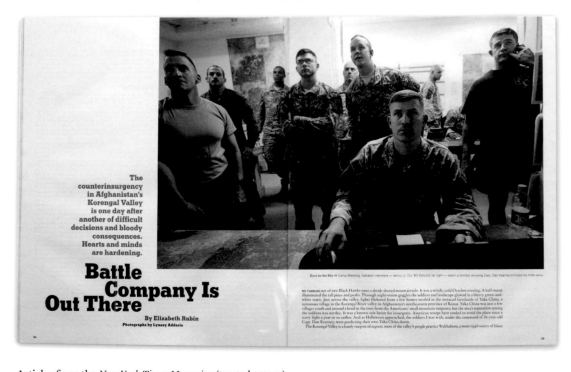

The counterinsurgency in Afghanistan's Korengal Valley is one day after another of difficult decisions and bloody consequences. Hearts and minds are hardening.

Battle Company Is Out There

By Elizabeth Rubin
Photographs by Lynsey Addario

Eyes in the Sky At Camp Blessing, battalion members — led by Lt. Col. Bill Ostlund, far right — watch a monitor showing Capt. Dan Kearney's troops six miles away.

Articles from the *New York Times Magazine* (top to bottom):
September 7, 2008; August 9, 2009; February 24, 2008.

Why do you think so?

I don't know. Perhaps the toll it takes on someone's personal life. You really can't have one. Whenever I looked around, most of the men had women waiting around for them back home. Societal norms say a woman doesn't leave her husband at home with small children while she covers war.

Also, it's difficult to watch people suffer and die all the time.

When you put it that way, it seems ridiculous that people say war photographers are adrenaline junkies and conflict junkies.

It's one of my least favorite questions in interviews—do you do this work for the adrenaline?—but it's not ridiculous. Because I have experienced that adrenaline, and I have felt it in Iraq and other places, and that adrenaline is very attractive. It's fun and exhilarating, and it's life or death and everything is more dramatic. You're living in this bubble of a world where you can have relationships and affairs and, in one day, you experience an entire range of emotions that you almost never get in real life. In real life

you have to answer to tedious commitments; war absolves you of all those responsibilities. That is addictive.

And the reasons why we all go to cover war are very different. Some people do think it's cool and glamorous. For me, it was when I saw that photos had an impact on policy. I had never planned to cover war before that.

In Iraq and Afghanistan—did they want the world to see this enormous thing that was happening to them?

Yes, most of what I said earlier about [how I approach people before I photograph] has to do with subjects like maternal health and women's issues. But in the wars it was absolutely the case that people knew the whole world was watching. People wanted to show that there were so many civilian casualties, that their privacy in their homes was often being violated by troops with the American military, that their country is being uprooted. It was important for them to show the world what was happening. And now what has happened is that in Iraq and Afghanistan, they don't want journalists anymore because they feel like—well, what's the point? These pictures and stories aren't making a difference. The violence continues. In some case, the troops are still here.

You, like many members of your generation, spent many years in Iraq and Afghanistan, where the US military was present. How was Libya in 2011 suddenly so different for you all?

It was so scary. We thought it would be like Egypt and Qaddafi would step down and that would be it. Many of us didn't even bring flak jackets. So often journalists are dependent on the advice and information from military actors, but the Libyan rebels had no intelligence.... It was really like witnessing the origin of an uprising. Everyone just jumped into a truck to head toward Qaddafi's army, which was advancing from the east. There was no front line yet; we were the front lines. I'd never seen that. I had always shown up after a war started.

And then, of course, because of the terrain—which was completely flat and empty—there was no cover to protect us from bullets or mortar rounds or air strikes. When I looked at all my Libya photos again, I really couldn't believe how close I was to the action. I should be dead a hundred times over. There were bombs

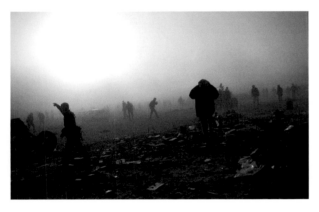

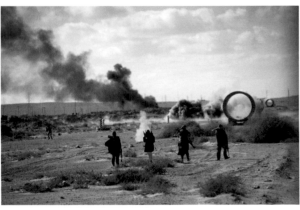

Top The aftermath of an air strike on positions occupied by anti-Qaddafi troops along the front line in Ras Lanuf, Libya, March 2011.
Bottom Opposition troops are hit with artillery fire as they are pushed back east out of Bin Jawat toward Ras Lanuf, the day after taking Ras Lanuf back from troops loyal to Qaddafi, in eastern Libya, March 2011.

exploding two hundred feet from me. I had to jump in a car window fleeing from the front line at one point because of the crossfire. I look at these and I think I was insane. When you're there, though, somehow it feels so right.

In Libya you were kidnapped with three other _Times_ correspondents, and your life changed significantly.

It was six days of a terrifying kidnapping in which many of us were hit or abused. Our driver, Mohammed, died in that kidnapping; collectively, we did not listen to him [when he advised us to leave the front], so it was our fault. I was very sad and regretful and guilt-ridden. And then when [photographers] Tim Hetherington and Chris Hondros were killed, it was the genesis of a breakdown. It was as if trauma from years and years came out. Survivor's guilt is a powerful trigger. I couldn't understand why we were alive and they were dead. It didn't make sense. I had to watch the videos of their bodies being found to convince myself they were dead.

That was a really painful process to realize what this job does to our loved ones. Becoming a mother caused me to pull back from frontline work. And when Anthony Shadid, another friend, died in Syria, and the legendary correspondent Marie Colvin died there, too—if she could get killed, then anyone could. Then Jim Foley and others were beheaded by ISIS. A lot of friends were suffering from terrible PTSD. João Silva

had lost his legs in Afghanistan. Starting with João in 2010, there was just a succession of horrific things that happened to this community.

Many journalists have said that they risked their lives, for example in Syria, because they believed that their coverage would inspire the international community to stop the carnage. But that didn't happen. Do you still believe in photography's ability to change people's minds in the way you did when you began?

It's still the ultimate reason why I go to cover anything dangerous and why I risk my life. Because I cannot believe that a person in a position of power who sees what's happening and the gross injustices and human rights abuses and deaths of women and children won't be moved to action. It's unfathomable. The thing about photography is that it is proof. There is no disputing an image. Of course, a photographer can photograph only one side of the story, which is why I believe so strongly that photographers have to be good journalists. They have equal responsibility in capturing an image but also in providing an honest and factual caption.

It's almost like creating facts.

It's not just about the photograph; it's about doing the proper research, getting the photographs, and then presenting them with the accurate caption because it's so important for the viewer to have all the information.

The quintessential example is the Kevin Carter image of the emaciated child in Sudan: The child has collapsed in the road while a vulture lurks nearby, ostensibly awaiting the boy's death. After Carter received the Pulitzer Prize for that image, some readers questioned his integrity because he photographed the child and did not intervene or carry him to safety—for example, to a UN-run feeding center. In reality, the United Nations was on the ground tending to famine victims, and Carter did chase away the vulture before leaving the child. But for whatever reason, that information wasn't readily available to the public, and the natural target of people's grief and frustration was, as it often is, the photographer, because he was there. He had to be there to take the picture. But was it necessary to spell out in the caption that the UN was also there—nearby? We photographers know that in a lot of those situations there are

Cover of the _New York Times Magazine_, September 7, 2008.

FARHAD SEDDIQI
WASN'T IN THE MOOD
TO GO TO THE SERENA,
KABUL'S FINEST HOTEL.

(Body text of the magazine article within the image is not legible enough to transcribe.)

SHATTERED PEACE
A Kabul house wrecked by an American IAED or the aftermath of a Taliban attack.

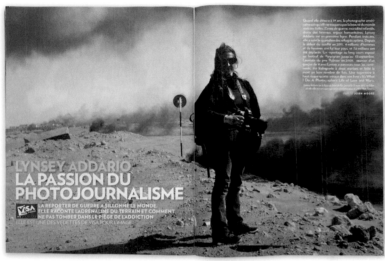

IRAK

AFGHANISTAN

POUR CES PHOTOS ET
POUR TÉMOIGNER, ELLE A
RISQUÉ SA VIE

LIBYE

SIERRA LEONE

LYNSEY ADDARIO
LA PASSION DU
PHOTOJOURNALISME

LA REPORTER DE GUERRE A SILLONNÉ LE MONDE.
ELLE RACONTE L'ADRÉNALINE DU TERRAIN ET COMMENT
NE PAS TOMBER DANS LE PIÈGE DE L'ADDICTION.
ELLE EST UNE DES VEDETTES DE VISA POUR L'IMAGE.

it otherwise and might have died in childbirth. But the one tricky thing is that you can't bring combatants, you can't help people in uniform.

You can't?

You shouldn't because then you can get in the middle of a conflict. The other side can say, "Why are you helping that side? You are no longer objective." It's very important [as a journalist] to not get caught up in the middle of armed groups . . . or whatever war is creating the humanitarian crisis.

How else did the outcomes in Syria affect journalists?

In Syria, journalists became a target more than in any other war we covered. When I started out in 2003, I felt invincible *because* I was a journalist. I would proudly wear a sign that said PRESS on it. We assumed that that gave us protection because people around the world respected journalists. They understand that we go in to serve the people and provide a record of what happened on the ground. That started to change in Iraq with the kidnappings there, including my own, but then it evolved in such a way that the war in Syria became almost uncoverable.

Is there any correlation between how long the war lasted and the fact that after around 2013 very few international journalists could cover it?

It's unbelievable to me that there is war where so many people are dying and the hospitals are being bombed and there are chemical attacks. . . . In my opinion, if you had more journalists on the ground, it would be more difficult to get away with these crimes against humanity. I think the reason why Assad and the various rebel factions can get away with atrocities on both sides is because there are so few objective observers showing what is happening. There are few people to document atrocities, and to provide proof. The kidnappings—and beheadings—of journalists made it impossible.

Because for war correspondents like yourself, there's a difference between taking normal risks on the job and taking unreasonable risks? Where is the line?

You can always end up in the wrong place at the wrong time. But it's totally different when journalists are actually targeted precisely because they are doing that work.

aid workers everywhere, but still the viewer asks why we aren't doing anything.

And the answer to that is—because that's not our job. Sure, if we are in a very desolate place and we're the only people around and we have a car, we can bring that person somewhere. If you can take the picture and bring the person to the hospital—then do it. I brought a pregnant woman to the hospital who probably would not have made

Articles from (top) *Time*, April 14, 2014, and (middle and bottom) *Paris Match*, August 3–September 9, 2015.

263

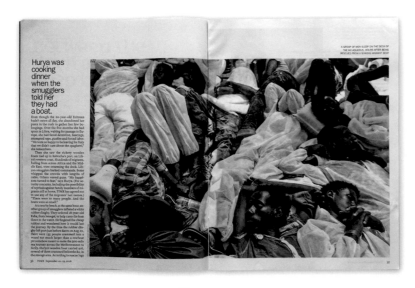

Hurya was cooking dinner when the smugglers told her they had a boat.

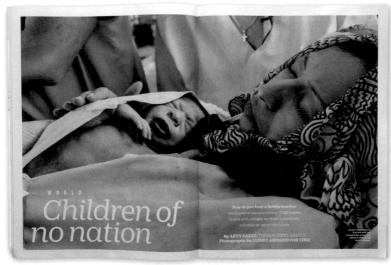

WORLD

Children of no nation

How do you keep a family together when you've lost everything? TIME begins a year with refugee mothers and infants entering an uncertain future.

By ARYN BAKER/THESSALONIKI, GREECE
Photographs by LYNSEY ADDARIO FOR TIME

The Year Ahead

2017 > Politics. Health. Science. Tech. Culture. Sports. Food & More

TIME

Finding Home.

> The crisis in Syria has sent millions fleeing. This year, follow the lives of four babies whose families escaped

Journalists, however, were able to cover the refugee crisis in Turkey and Europe. What was the impact of your and others' work on that issue?

There was the famous photograph of Aylan Kurdi, the drowned Syrian boy who had washed up dead on the shore in Turkey and looked almost to be sleeping. What came of that is extremely exciting and extremely depressing. The photo did motivate the international community to act and begin discussing the revision of their refugee policies, and ultimately the Europeans and the Turks decided to stem the flow of refugees escaping from Turkey to Greece by water. But the war goes on, and Syrians are still being forced to flee their homes because of the ongoing violence. In the cases of many families, half have made it to Europe, and half are trapped in camps around Turkey and Greece because Turkey and Greece have sealed their borders. The politicians need to find a solution to end the war in Syria so children do not continue to die while seeking asylum.

My work with refugees has been a kind of artistic or professional conundrum because I have been covering refugee crises for seventeen years. How do you suddenly cover that in a more intimate and compelling way than in the past? This is the challenge I face as a photojournalist who is trying to affect people. If every year people see pictures of refugees on the run, why would they be affected by the Syrian refugee crisis differently? For the viewer, the images just become a burden. So that was the impetus for the project Finding Home.

This was the yearlong project in *Time* magazine in which you followed three Syrian mothers who had recently given birth.

We tried to tell the story in a way that was more intimate, so we picked women and children, the birth of a baby, how to go through pregnancy, change diapers, breast-feed, and keep things hygienic.

The kind of stuff that doesn't occur to people.

That's the fundamental reason we did the story that way. Everyone was seeing the dramatic waves of refugees escaping their home, but not necessarily the monotony of daily life, mainly because it's not as dramatic as images of bodies being flung out of boats in desperation. But we imagined it could be just as affecting for viewers.

Articles from *Time*, December 26, 2016–January 2, 2017.

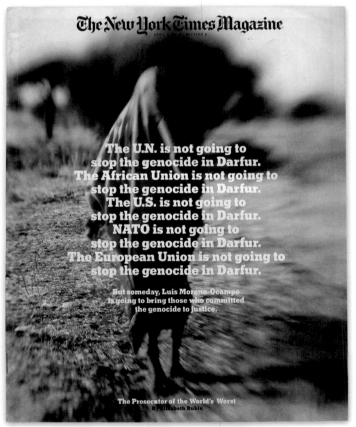

Covers from the *New York Times Magazine* (clockwise from top left):
November 25, 2007; February 24, 2008; April 2, 2006; August 9, 2009.

writing the proposal, doing the logistics, getting the visa, getting there, finding a place to stay, getting access to the subject, getting the subject to open up to me. Will they let me take their picture? Will they let me show their face? Will they want only their back? Will a series of people's backs be compelling and do justice to the story? All of these things—and then finally taking the photo. And then: Who will publish it? How many pages will they give? Will it be online only or in the magazine? All these questions.

What does "doing justice to the story" mean? You talk about this a lot.
There are periods in the storytelling process when I am witnessing a moment or a scene so powerful—a woman taking her last breaths as her family surrounds her in grief, the collective elation of a crowd as they enjoy freedom of expression for the first time after the fall of Saddam Hussein, the palpable trauma and heartbreaking loneliness of a woman who has been raped and then shunned by her husband and family on account of a crime she didn't commit—that I just don't know if the photograph could transmit the devastation, the joy, the frustration, and the heartbreak I experience firsthand when interviewing or documenting the situation. Will my images capture the essence of the moment enough to inspire the viewer to feel what I feel when I am shooting? Can I capture that reality in an image or a series of images?

When you are actually shooting pictures, do you still feel the same as you did twenty years ago?
So many stories I tell now I have told before. What I have to be careful of is that [feeling of] complacency. If I feel dread about doing a story because I have done it before, I have to ask myself if I should really be doing it. That's how I try to stay fresh. Right now I am not covering the front line as much because it feels to me [as if] I have done that so much; maybe I will revisit it in the future, but it doesn't feel as fresh as America does to me right now. If I don't feel that freshness, I don't put myself up for a job.

For example, I did want to go to Mosul, and I asked my editor if I could go on assignment there—this was a publication I routinely worked for—and my editor told me, "You have a family now, and you're not going to Mosul."

A yearlong project requires tremendous resources. How has the economics of photography changed in your twenty years of shooting?
There are very few resources now. In the beginning, say, during the invasion of Iraq in 2003, I used to be put on assignment for months on end, which at day rates of four hundred to six hundred dollars, and including things like hotel and food and transport and translator and driver expenses, could add up to thousands of dollars. Now what you hear from editors is: "Can you shoot that story in four days? Can you piggyback a flight you already have somewhere and pay for it that way?"

Has this affected the way you work or the results of your work?
I still am that person who is stressed about what I will achieve before every single assignment. I panic that my pictures will be flat or not compelling, or I won't get access or tell the story well enough. That's the voice in my head.

I think the thing most people don't understand is that taking a photograph is a tiny percent of what it is to be a photographer. It's also everything else: doing the research, getting the access,

An old passport.

Really?

If I am going to risk my life, I want to make sure that it's for a publication that has my back if something goes wrong. And this was one of those publications that has journalists' backs. But this time they told me I couldn't go to war because I was a mother. I wondered whether any of the male war correspondents I worked with faced the same discrimination.

I didn't protest too much, though, because I did feel I covered that story before. I was in Mosul in 2003. I was in Fallujah in 2004. I've covered the fall of Iraqi cities. I covered the invasion. I have to ask myself: Do I feel like getting shot at? Do I feel like ducking mortars? Do I feel like living on the front line? You have to be really physically, emotionally, and intellectually engaged in a subject in order to risk your life for it. So the minute I was told I wasn't going, I thought about [my criterion for going]: Will my individual coverage really contribute to the collective?

What does that mean?

What brought me into this work in the first place was [to tell] a story most people were not covering.

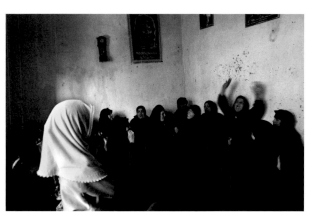

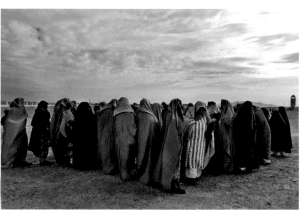

Take the women in Afghanistan in 2000. I went there because I felt no one was telling their story from their perspective; it was a lot of Westerners speculating about what it felt like to be an oppressed Afghan woman. If it's a story that everyone is flocking to and my photos will be competing with so many others and not necessarily adding new information, do I want to risk my life for that? Sometimes the answer is yes. I felt that way in Iraq, Afghanistan, Congo, Darfur, South Sudan, Lebanon, Libya, Somalia, and so many others—I really wanted to bear witness there. I really felt my coverage would add something. But for Mosul—or maybe at this stage of my life—I wasn't able to convince myself.

You don't have regular bouts with PTSD. Why do you think you process trauma well?

The most basic explanation is that I come from a solid family, and they offered so much support. It wasn't a perfect story; my parents got divorced, and my father came out as gay when I was eight years old. I had three older sisters and we fought a lot. But as much as we fought, there was a huge amount of laughter and expression and humor and love among the family. My parents' main concern was, how do we support our daughters so they have the courage to continue on in the face of adversity? Obviously, for Italians, family is everything, so if we can maintain that semblance of a family, then everything would be fine, and it was.

My parents let me know I could always come back to this safe place, to this solid community of family and friends. I feel like anything I endure—whether it's the kidnapping in Iraq or the one in Libya or being thrown out of a car in Pakistan, knowing that two of my drivers have died working with me—I know that I can pull back and find sanctuary in my family and recalibrate and decide how to move forward again. That's a very privileged position. They're there, there's no guilt, there's no [asking], "How can you do this to us?" I remember when I got out of Libya after I was kidnapped, and the first words my dad said to me after "I love you" were, "It's not your fault." His words meant everything to me. None of them were ever judgmental.

Also, I think it's important to have those difficult discussions, to talk them through, and to face things head-on. After Libya, for example, I wanted to talk about my experience openly, to give interviews, to talk about sexual assault, to set the record straight that I wasn't raped, to talk

Top Relatives of Salman Nama Naser, sixty-three, mourn his death at their home in Sadr City, Iraq, April 2004.
Bottom Friday prayer after the fall of the Taliban in Kandahar, Afghanistan, December 2001.

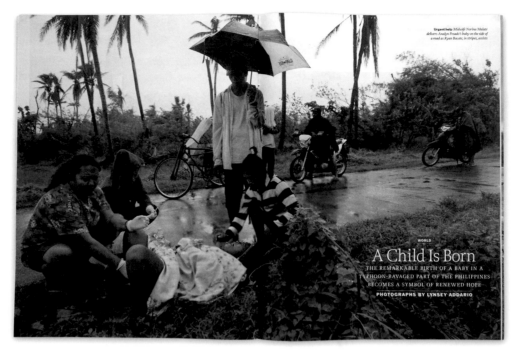

A Child Is Born

THE REMARKABLE BIRTH OF A BABY IN A
TYPHOON-RAVAGED PART OF THE PHILIPPINES
BECOMES A SYMBOL OF RENEWED HOPE

PHOTOGRAPHS BY LYNSEY ADDARIO

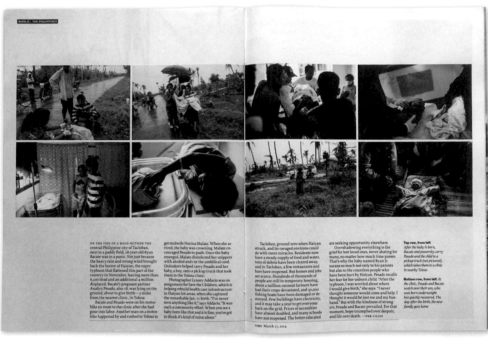

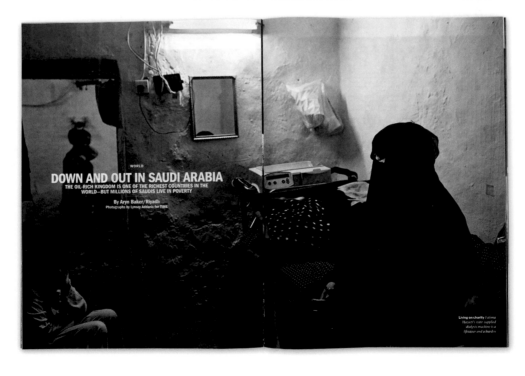

DOWN AND OUT IN SAUDI ARABIA

THE OIL-RICH KINGDOM IS ONE OF THE RICHEST COUNTRIES IN THE
WORLD—BUT MILLIONS OF SAUDIS LIVE IN POVERTY

By Aryn Baker/Riyadh
Photographs by Lynsey Addario for TIME

Articles from *Time*: (top and middle) March 17, 2014; (bottom) June 3, 2013.

about the death of our driver and take responsibility for that. We're in the post–Harvey Weinstein era now, and women come forward about sexual harassment and abuse, but in the past, journalists didn't talk about sex harassment because we didn't want to lose our jobs.

What do you mean?

We never, ever wanted to be seen as more vulnerable than our male colleagues. No one would send us to cover anything if so.

Do you think you were discriminated against as a woman in the beginning?

In the sense that people didn't take me seriously because I was so young and so green, yes. But if I got myself into position and got the photo, the editors would give me a chance.

And now? Do you think other editors hesitate to give you assignments because you are a mother?

Yes, but most people won't say that out loud. I think what happens with a woman who is a parent is that there is a knee-jerk reaction against sending mothers on assignment to war that doesn't exist for my male colleagues who have children. Also, I am less flexible with my

schedule, so I don't have the ability to be as spontaneous as I did before. I have to arrange with my husband and a nanny and all that. It's easy for an editor to say that I am not available, or it's difficult to work with me.

And then there's a lot of judgment [of me] because I am a mother that men simply never get. When men are killed while working, no one ever asks why he was there when he had two kids, as if fathers are less important than mothers.

What about discrimination not as a mother but as a woman in general? At this point in your career, after so many assignments and wars and awards, and after being awarded the MacArthur Foundation "genius grant" and twenty-three years of working, do you still experience straightforward gender discrimination?

In a weird way, the more successful someone gets, the harder it gets, because editors assume you aren't as hungry, or that you don't need the work. And a lot of editors want to feel like they made you and made someone's career. At this point in my career, no one can say that because I have been around a long time. So there is age and gender discrimination both.

One of my editors said to me, "Do you really want to be running around in these places and shooting in your fifties?" And I said, "Of course!" My feeling is: How dare anyone make that decision for me? Just like how dare anyone decide if I can continue to cover war as a mother. That's why I hid my pregnancy from everyone for five months. Because the fact is, most editors would have decided, unconsciously or consciously, not to send me to, say, Somalia because I was pregnant. But that's my decision. It's up to me and my husband.

And what was your reasoning for going into Somalia?

I was five months pregnant, working in Kenya, and doing this story on refugees fleeing a drought, and everyone I interviewed was from Somalia. I felt like that was where half of the story was. And as a journalist I never did a half-assed job.

So this was also symbolic.

Yes, because I was pregnant and didn't want to start doing journalism irresponsibly. I started making phone calls to colleagues and asked them how feasible it was, and the good thing was that everyone said just go for two to three days.

Top Article from *Vanity Fair*, June 2016.
Bottom Me with my three sisters, circa 1976.

How Coal Fuels India's Insurgency

In mineral-rich jungles Maoist militants find a foothold through violence and extortion.

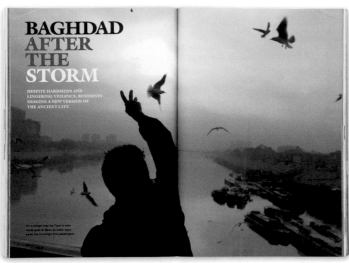

BAGHDAD AFTER THE STORM

DESPITE HARDSHIPS AND
LINGERING VIOLENCE, RESIDENTS
IMAGINE A NEW VERSION OF
THE ANCIENT CITY.

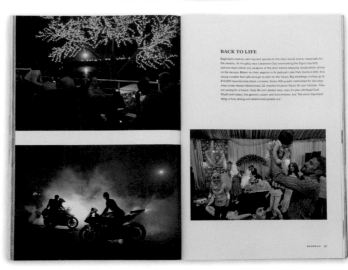

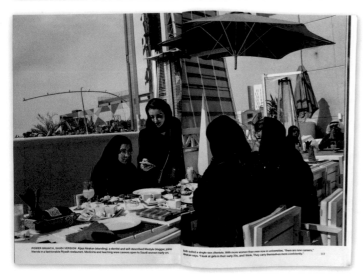

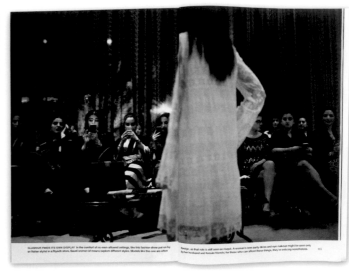

Articles from *National Geographic* (top to bottom): April 2015; July 2011; February 2016.

My other argument was that so many of the women I would be photographing were pregnant! Suddenly a girl from Connecticut can't be pregnant in the same place? What a lot of people don't understand is that in conflict zones, war happens in a span of five blocks, but otherwise, everywhere else, life goes on as normal. I was not going to any front lines.

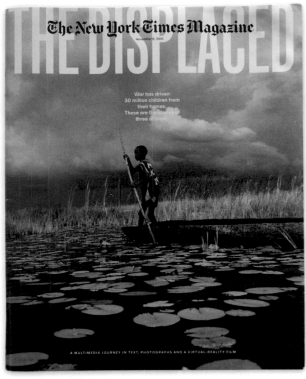

How has being a mother changed your work, though—in terms of shooting photographs?
It was always painful to watch women in pain, or watch children in pain, or watch women lose their children. But now, since having a child, it has become unfathomable. I actually do not understand how all of these women I have encountered have survived, how they are so resilient.

In this book, you write about meeting the South Sudanese mother of Chuol, a child who escaped when their village was burned, and you started crying. Do photographers usually experience such things emotionally, or do they try to hold it in?
I generally allow myself to feel that sadness when I am with that person. They're opening up a very dark and sad moment to me—what more appropriate time to share that sadness back? Sometimes I think I should compose myself so they don't think their life is as bad as it is. But I can't. Because if you tell me your son is dying or your husband was slaughtered, you drop yourself into that situation. That's what the mind does. I think about those things happening to [my son] Lukas, or [husband] Paul.

Sometimes it's embarrassing. When Chuol's mother was telling me how her village was attacked and her husband was burned and her son fled, and I was crying and crying, she was looking at me like I was crazy—why was I crying while she was completely stoic? These women have had a life of heartbreak and conflict, and they have learned to control themselves.

I don't know if it's good for photography because sometimes I am crying so hard I miss pictures. When I was in Uganda shooting the breast cancer story, in which a woman, Jolly, died and her daughters started screaming "Mama!" when they opened their mother's casket, I had just had Lukas. I was crying so hysterically that I was just holding the camera up and shooting, and half the pictures were out of focus.

I look at women like that and I just can't believe it never gets any better for so many people on this planet. When I look at this book, this body of work, I think, *Why are we so lucky to have been born in a country of no war? Why am I so lucky?* That's what I always come back to. That's what still plagues me.

271

PENGUIN PRESS
An imprint of Penguin Random House LLC
375 Hudson Street
New York, New York 10014
penguin.com

Photograph credits:
All images, unless credited below, are by Lynsey Addario.
Page 111: Emily Naslund
Page 203: © Bryan Denton
Page 205: Publicly distributed handout, courtesy of Associated Press
Pages 257, 270 (bottom), 271 (top): Courtesy of the author
Pages 259 (bottom), 260, 262, 265, 271 (middle and bottom): Some of the photos in this book originally appeared in *The New York Times Magazine* and are reprinted here by permission. Lynsey Addario © 2005, 2007, 2008, 2009, 2015 *The New York Times*
Page 259 (top): Used by permission of *Telegraph Magazine*
Pages 263 (top), 264, 268: TIME materials provided by and used with the permission of Time Inc.
Page 263 (middle and bottom): Used by permission of *Paris Match*
Page 269: Lynsey Addario/National Geographic. Used with permission of National Geographic
Page 270 (top): © 2018 Sean Thomas LLC—All Rights Reserved

Text credits:
Pages 72–73: "The Definition of Reckless" by Dexter Filkins. Published by arrangement with the author.
Page 134: "When Women's Fate Is in the Womb" by Christy Turlington Burns, Founder & CEO of Every Mother Counts. Published by arrangement with the author.
Pages 168–169: "Conflict in the Congo" by Lydia Polgreen. Published by arrangement with the author.
Pages 195–197: "Chuol and His Mother" is adapted from an article by Lynsey Addario that first appeared online at *The New York Times Magazine* on March 30, 2017, under the title "Mother and Son, Separated During South Sudan's Civil War, Make Contact."
Pages 202–204, 205: Excerpts from *It's What I Do: A Photographer's Life of Love and War* by Lynsey Addario, copyright © 2015 by Lynsey Addario. Used by permission of Penguin Press, an imprint of Penguin Publishing Group, a division of Penguin Random House LLC. All rights reserved.
Pages 252 and 255: "Finding Home" by Aryn Baker. Published by arrangement with the author.

LIBRARY OF CONGRESS CATALOGING-IN-PUBLICATION DATA
Names: Addario, Lynsey, photographer.
Title: Of love & war / Lynsey Addario.
Other titles: Of love and war
Description: New York : Penguin Press, 2018.
Identifiers: LCCN 2018006212 (print) | LCCN 2018012134 (ebook) |
 ISBN 9780525560036 (ebook) | ISBN 9780525560029 (hardback)
Subjects: LCSH: War photography—Middle East. | Middle East—Social conditions—Pictorial works. | Africa—Social conditions—Pictorial works. | War and society—Pictorial works. | Addario, Lynsey—Travel. | Photographers—United States—Biography. | BISAC: PHOTOGRAPHY / Photojournalism. | PHOTOGRAPHY / Photoessays & Documentaries.
Classification: LCC TR820.6 (ebook) | LCC TR820.6 .A328 2018 (print) | DDC 779/.9355—dc23
LC record available at https://lccn.loc.gov/2018006212

Printed in Italy
10 9 8 7 6 5 4 3 2 1

Set in Lyon Text
Designed by SMITH;
smith-design.com
Caroline Cortizo, Allon Kaye, Claudia Paladini, Ana Rocha, Justine Schuster, Samantha Humble-Smith